MEMORY ON CLOTH

KODANSHA INTERNATIONAL
Tokyo • New York • London

MEMORY ON CLOTH
shibori now

YOSHIKO IWAMOTO WADA

I would like to dedicate this book to Kahei Takeda, the thirteenth-generation shibori merchant who wrote the first book on the shibori traditions of Arimatsu and Narumi, and to Hercules Morphopoulos, my life partner and my unwavering support throughout the process of shaping *Memory on Cloth* into a book.

NOTE FROM THE PUBLISHER:
Except for the names of people who lived prior to the Meiji period, Japanese personal names in this text have been written with the given name first.

For reference, the following chart shows the periods of Japanese history that will be most relevant to the discussion.

PERIOD NAME	APPROXIMATE DATES (A.D.)
Nara	710–793
Heian	794–1191
Kamakura	1192–1332
Muromachi	1333–1575
Nanbokucho	1336–1392
Sengoku	1467–1575
Azuchi-Momoyama	1576–1600
Edo	1603–1867
Meiji	1868–1911

(Historians do not agree on exactly when the various periods started and ended, so the dates given here are approximate.)

Distributed in the United States by Kodansha America, Inc., 575 Lexington Avenue, New York, NY 10022, and in the United Kingdom and continental Europe by Kodansha Europe Ltd., 95 Aldwych, London WC2B 4JF.

Published by Kodansha International Ltd., 17-14 Otowa 1-chome, Bunkyo-ku, Tokyo 112-8652, and Kodansha America, Inc.

ISBN 4-7700-2777-X
First edition, 2002
02 03 04 05 10 9 8 7 6 5 4 3 2 1

LIBRARY OF CONGRESS CATALOGING-IN-PUBLICATION DATA
Wada, Yoshiko Iwamoto.
 Memory on cloth: shibori now / Yoshiko Iwamoto Wada.
 p. cm.
 Includes bibliographical references and index.
 ISBN 477002777X
 1. Tie-dyeing. 2. Resist-dyed textiles. I. Title.
NK9505.5 .W299 2001
746.6'64'09—dc21 2001038280

www.thejapanpage.com

c o n t e n t s

inner journey: fabric and beyond

Hiroyuki Shindo, Yukiko Echigo, Michie Yamaguchi, Kaei Hayakawa,

Keiko Amenomori-Schmeisser, Junco Sato Pollack, Joan Morris, Ana Lisa Hedstrom,

Inge Dusi, Lynn Klein, Jean Williams Cacicedo, Marie-Hélène Guelton,

Chad Alice Hagen, Judith Content, Liz Axford, Jan Myers-Newbury, Mary Little,

Sharon Baurley, Masae Bamba, Yuh Okano, Moira Doropoulos, Terri Fletcher,

Emily DuBois, Elisa Ligon, Linda Lee Kerr, Lesley Nishigawara, Hélène Soubeyran

modern techniques

Heat-set on polyester or silk, heat-transfer on polyester, melt-off on metallic fabric, fulling,

dévorée, cloque, degumming silk, mixed fibers, dye discharge, dyes and tips

appendices

Yoshiko Iwamoto Wada has chosen her subject well. As the global authority on shibori in its myriad forms Wada has, for decades, been the driving force behind this tradition's popularization. She is also spearhead of the International Shibori Symposium (ISS). Even so, this author is not fully appreciated, even by those who know her, even by the many in her debt for opening doors to art expression or commerce. Perhaps because of her diminutive frame, seeming reticence, and prolonged youth, we don't recognize a Colossus spanning East and West, past and future.

Decades ago, when the San Francisco Bay area was the absolute Vatican of fiber development in the Americas, Wada first served as a conduit to Asian resist-patterning traditions. As a founder of Kasuri Dyeworks and instructor at Fiberworks, Center for Textile Arts, she nurtured innovators such as Ed Rossbach and Katherine Westphal. Perhaps more than anyone else, Wada caused the evolution of fiber focus from cloth structure to the dye patterning that we now recognize as surface design.

Through her first book, *Shibori*, and through her exhibits, lectures, and personal persuasion in every communication medium, Wada has single-handedly changed our field and its language. For instance, the Malay/Indonesian term *plangi*, first proposed by Swiss scholars and widely used for almost a century, is now less often heard than the Wada term, shibori—itself an umbrella for dozens of methods including fold-dye, stitch and clamp resists, and even a woven form.

Still more crucial at the dawn of the third millennium are shibori methods as the most dynamic of all textile aspects. While patterning with liquid resists (batik) or binding yarns to resist dyes (ikat) are by their nature limited, shibori resists embrace an extremely flexible universe. By providing both discipline and freedom in many mediums, shibori has the potential to transform post-industrial craftsmanship.

For example, any manner of pleats—random or precise—can be created through automation, then pad-dyed or transfer-printed, then opened—all *without* human involvement! Whether crisply defined or shadowy, the resulting pattern is as full of miniscule accidents for natural randomness as traditional shibori. Because we can perceive this marriage of liquid dyes and thirsty cloth, this "understanding of making" is a pleasure increasingly rare in an industrialized world. That this organic patterning is also three-dimensional makes it the optimal antidote to the monotony of mass production.

More recently we learned that shibori can also be used to *subtract* color (discharge) or fiber (burn-out) or even whole layers of cloth. We have also learned that using shibori methods for permanently pleating or shrinking cloth creates miraculous surfaces. Finally unlocking the potential of thermoplastic memory, we are using these new wrinkles to resist wrinkles, increase comfort, and widen ranges of size and fit.

Fortunately, Yoshiko Iwamoto Wada understands all this full well. She also knows the designers opening up these universes. *Crescendo!*

JACK LENOR LARSEN

the meaning
of shibori

Shibori is a Japanese word that refers to a variety of ways of embellishing textiles by shaping cloth and securing it before dyeing. The word comes from the verb root *shiboru*, "to wring, squeeze, press." Although shibori is used to designate a particular group of resist-dyed textiles, the verb root of the word emphasizes the action performed—the process of manipulating fabric. Rather than treating cloth as a two-dimensional surface, shibori techniques give it a three-dimensional form by folding, crumpling, stitching, plaiting, or plucking and twisting. Cloth shaped by these methods is secured in a number of ways, such as binding and knotting.

Shibori recognizes and explores the pliancy of the textile and its potential for creating a multitude of shaped-and-resisted designs. When the cloth is returned to its two-dimensional form, the design that emerges is the result of the three-dimensional shape, the type of resist, and the amount of pressure exerted by the thread or clamp that secured the shape during the cloth's exposure to the dye. The cloth sensitively records both the shape and the pressure; it is the "memory" of the shape that remains imprinted in the cloth. This is the essence of shibori.

During the Middle Ages in Europe tapestries epitomized visual artistic expression. During the early Renaissance the height of artistic expression was the painting of frescos on church walls. The classical European idea of art as an individual applying paint to canvas is a post-Renaissance phenomenon. In European culture, ongoing textile traditions such as weaving, lacemaking, and embroidery were overshadowed by painting. Eastern cultures, on the other hand, never developed an artistic bias in favor of paint on canvas. As a result Westerners need to cultivate an enlarged cultural/historical perspective in order to fully understand and appreciate textile art.

As the counterculture of the 1960s emerged, youth questioned establishment values and institutions, including art forms. Process became as important as product. Site-specific installations and performance art became more compelling than traditional painting, and artists extended the definition of their work to include craft. The fascination with tie-dye, batik, and other fiber arts was sparked by youths who traveled to the East seeking meaning in the ancient cultures and religions of Asia. Deeply impressed by the beauty and cultural significance of the textiles they encountered, they strove to create equivalents. Tie-dye became a major artifact of the new cultural rites of the late 1960s.

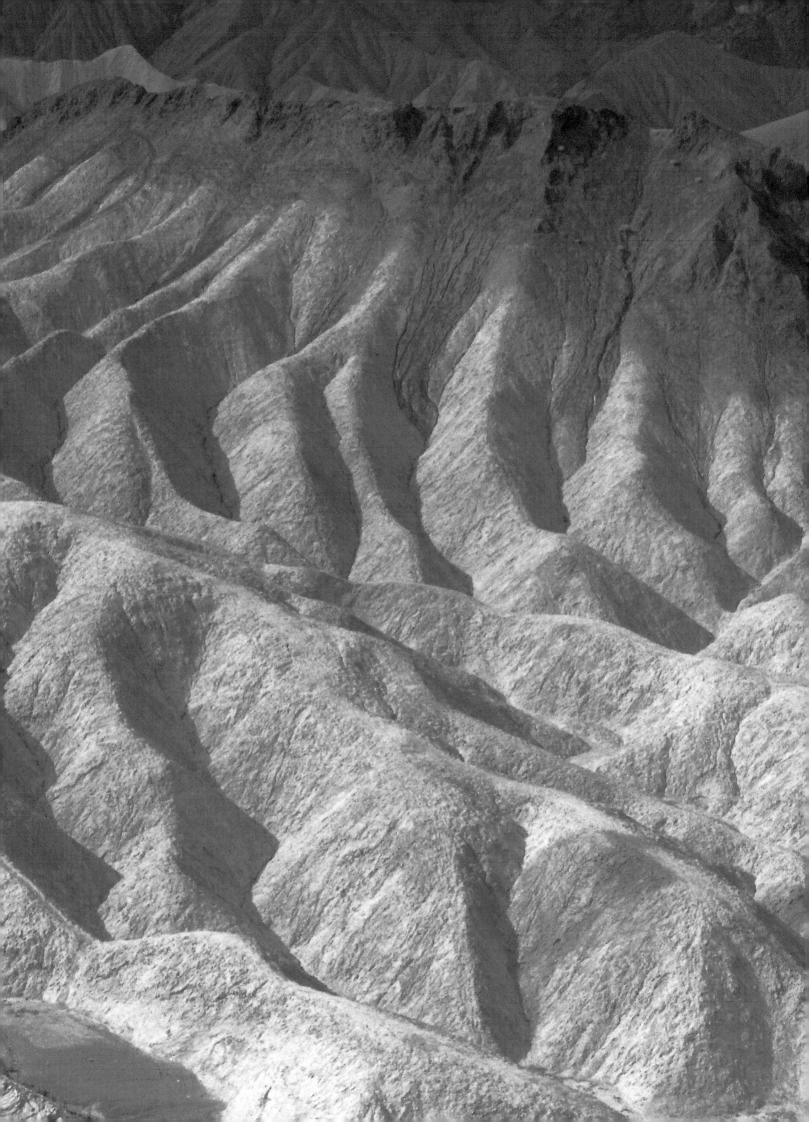

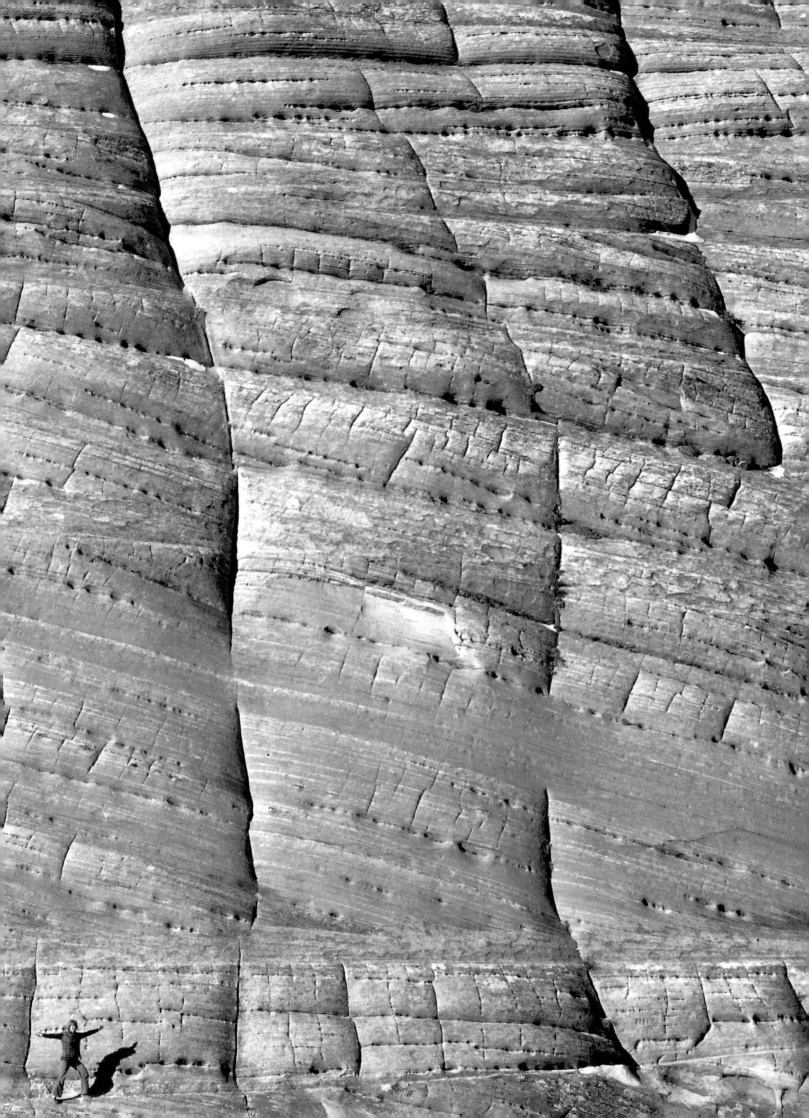

The artists and artisans included in this book respond to the tactile and living cloth surface just as the abstract expressionist and stain painters of the 1950s and sixties interacted with cloth canvas. This book records a variety of work—from the creative endeavors of the counterculture and bohemian youth of the 1960s to the technocrat and baby-boomer generation of the new millennium. What unifies them as a driving force in the creative field of surface design is their enthusiasm for the dimensional possibilities inherent in cloth and their fascination with the idea that cloth holds the memory of action performed on it.

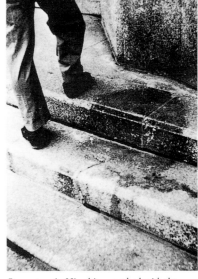

Stone steps in Hiroshima marked with the image of death: this shadow created by the heat of the atomic bomb is thought to be the remains of a person who had been sitting or leaning on the stairs. Photo courtesy of Chugoku Shinbunsha.

"Whole cloth is planar and pliable; it can be given volume. One can animate cloth: drape, crumple, and fold it; compress, pleat, and tuck it; festoon, swag, and swaddle it; bunt it and cut it; tear, sew, and furl it; appliqué, quilt, and fabricate it. Cloth is ductile; it expands and contracts. Cloth can be embellished with stitches, dyes, or print. Cloth can be burned or scored. It is for each generation to expand the vocabulary of approaches to cloth."[1]

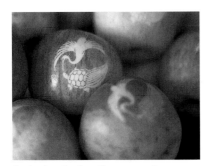

Resisted apples. Stencils were pasted on green apples and as the apples ripened, an auspicious crane-and-tortoise pattern emerged.

Cloth has a life of its own that transcends its origins in the wool of an animal, the fiber of a plant, or the bark of a tree. The fiber of the humble cotton plant can be spun into rough cotton to make a strong canvas sail or spun into gossamer and dyed with ethereal patterns to create the turban for a maharaja. The agent of transformation is the artist, who senses the life inherent in the material and actualizes it through the application of human touch, knowledge, and vision. To many artists, shibori is a means of recording a creative process imprinted by force—whether by dye, lye, or heat on cotton, metal, or polyester. Pioneering American shibori artist Carter Smith, who engages in a complex process of working with dyes and manipulating cloth, observes in the resulting pattern a certain mysterious quality that seems to have a life of its

◀ Pressures of the earth such as faults, folds, wind, and rain create dramatic natural resist landscapes of cliffs, desert sands, and canyons. Photos opposite and on pages 9 and 12 by Bradford Van Diver. Reprinted with permission from his book *Imprints of Time*, Mountain Press Publishing, 1988.

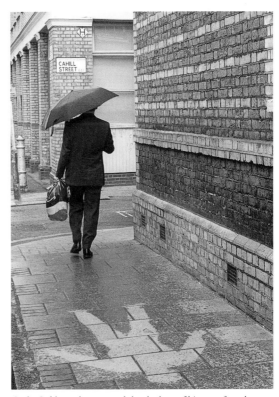

Andy Goldsworthy captured the shadow of his own form by lying on a London street from the beginning to the end of a rain shower, then getting up to take a photograph. Reprinted with permission from his book *Midsummer Snowballs*, Thames & Hudson/Abrams, 2001.

own. To him, individual works in shibori seem to possess a structure similar to DNA—a "genetic code" that determines their features and characteristics.

Artists who speak the language of shibori see shibori patterns everywhere in nature. The movement of tectonic plates produces mountains and ridges in a huge shibori process taking place over millions of years. Like dye in shibori, time is the force in nature that records the process of change. The flat, two-dimensional surface of sand is manipulated by the force of wind to form ripples, creating a three-dimensional textured surface. The varying weight and shape of grains create rippled surfaces in the field. Similarly the dyer imprints the action on the cloth—folding, manipulating, interacting with the material to produce patterns and textures. The process used by French artist Hélène Soubeyran (whose work appears in Chapters 3 and 4) is paralleled in the stratification and forming of the earth's rock layers. The patterns produced by Ana Lisa Hedstrom (also in Chapters 3 and 4) are equivalent to the ripples the wind makes on sand dunes.

Resist patterns can be found everywhere, created by sunlight or by rain—in a pale swimsuit-shape on a tanned body, a resist pattern on a ripened apple, or Andy Goldsworthy's enigmatic photos. A profoundly disturbing example of resist printing is seen in a set of steps in front of a building in Hiroshima at the time of the atomic bombing: a dark image on the steps, thought to be a human form, is an all-too-direct reminder of how closely related are art and life, and art and death.

the history of shibori

"The Dyer's Art is based on the premise that in many cultures dyeing—especially patterned resist dyeing—is considered an art form, as weaving is elsewhere. Although Europeans have tended to focus on woven cloths, the great fabric traditions of India, Japan, Indonesia, Central Asia and West Africa show as much—if not more—concern for resist dyeing than cloth making. In these cultures the cloth on which batik and plangi are executed, or the process that interlaces ikat yarns, is as important as is canvas to a painter."

—Jack Lenor Larsen, *The Dyer's Art*

There is no equivalent in English for the word shibori. The closest translation would be "shaped-resist dyeing"—when cloth is dyed, reserved areas are recorded as patterns with characteristically soft edges and crinkled textures resulting from the shaping process. No other language has a single word to encompass all shaped-resist dyeing techniques; neither is there any English terminology to describe most of the individual methods included in this broad category. Consequently, shibori methods that are quite distinct are often incorrectly lumped together as "tie-and-dye." Some textile scholars, for example, apply the term tie-dye to both ikat and shibori fabrics of various ethnic origins. This is misleading, since in the tradition of ikat, the yarns are tie-dyed before being used to weave cloth, whereas in shibori the cloth itself is tie-dyed; these are two very different processes that produce very different effects.

In this context, the word shibori seems the most useful term for the entire group of shaped-resist textiles and the numerous resist processes practiced throughout the world, and it does appear to have won acceptance in the international textile vocabulary. Nevertheless, this confusion about technical terms and design vocabulary is a good example of just how the contact and crossover of these culturally specific fiber arts practices may need further articulation in order to be fully understood and appreciated in new settings: furthering such understanding is one of the purposes of this book.

This page, top: African Nuba raffia. Center: Trine Mauritz Eriksen, "Black Pulse." Itajime shibori on wool. Photo by Hilde Maisey. Bottom: Kumo shibori from Arimatsu.

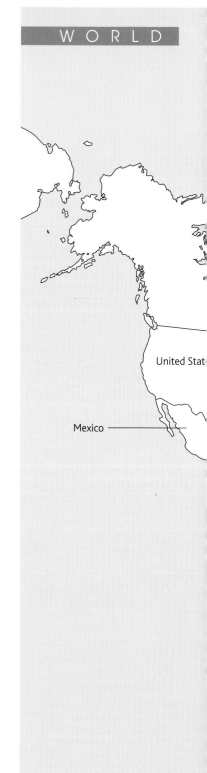

United Stat

Mexico

World map identifying various places mentioned in the text.

A wide range of techniques and resulting patterns are found historically in many parts of the world, including China, Japan, the Indonesian archipelago, the Indian subcontinent, Persia, Turkey, Mongolia, Morocco, Tunisia, western Africa, and Central and Latin America.

south america

Due to extremely arid climatic and burial conditions in most of the coastal regions of the Andes in South America, numerous fine textiles of pre-Hispanic civilization from 700 B.C. to A.D. 1500 have survived to the present day, including *amarra,* which comes from the Spanish word *amarrar* ("to tie"). *Amarras* are masterful textiles that combine esoteric and complex techniques with an outstanding aesthetic sense; they continue to inspire modern artists, designers, artisans, scholars, and the public. Studies have been done of many different kinds of weaves, gauzes, stitches, and twists, but very little research has been done on *amarra* itself—its origin, significance, and techniques.

Figure 1. Brown cotton-gauze *amarra*, ca. A.D. 1300. Chancay, from the Museo Amano. Photo by Yukari Tokumitsu.

The oldest surviving examples of *amarras* thus far are dated at approximately 700–400 B.C. They were found in the southern coastal region of Peru and belong to the Chavín and Paracas cultures. Subsequent examples were recorded in cultures such as middle to late Nasca and Wari (A.D. 400–800) and Tiwanaku (A.D. 600–800). Those early polychrome *amarras* were woven with camelid[1] fibers such as alpaca or vicuna, using the scaffold-weaving technique (Plate 1 and top of this page).[2]

Later cultures such as Chimu and Chancay (A.D. 1000–1300) yielded geometric and figurative designs in earth colors on delicate cotton in patterned or plain Peruvian gauze weave (Figure 1).

In pre-Hispanic textiles, binding was the preferred method for reserving original or previous fabric color while dyeing. The binding, applied over different fabrics and using various colors, pro-

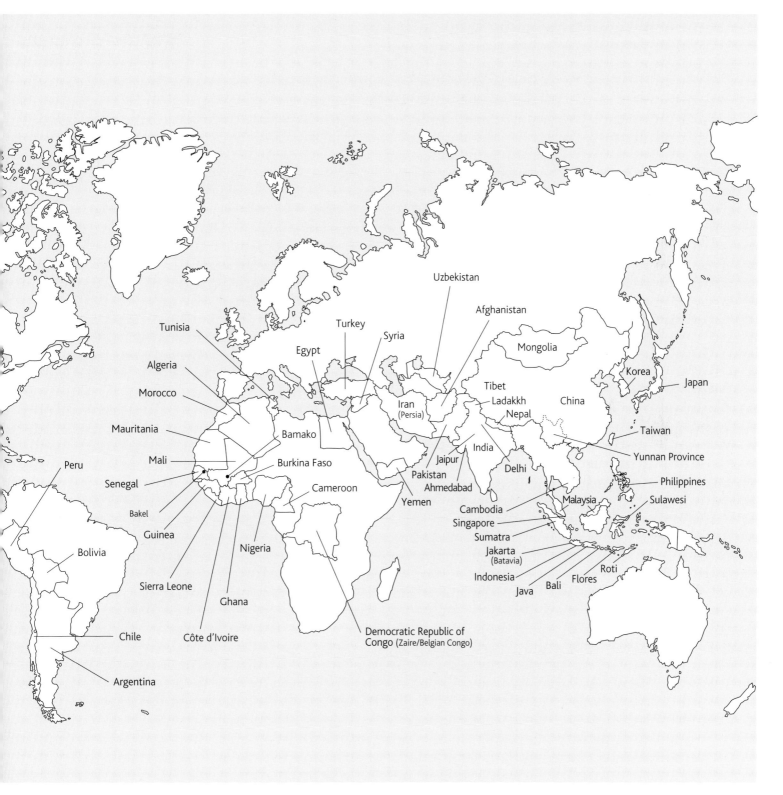

Tunisia

Algeria

Morocco

Mauritania

Peru

Mali

Senegal

Bakel

Guinea

Bolivia

Sierra Leone

Ghana

Chile

Côte d'Ivoire

Argentina

Bamako

Burkina Faso

Cameroon

Nigeria

Democratic Republic of
Congo (Zaire/Belgian Congo)

Egypt

Turkey

Syria

Uzbekistan

Afghanistan

Mongolia

Iran
(Persia)

Tibet

Ladakhh

China

Nepal

Korea

Japan

Taiwan

Yunnan Province

India

Jaipur

Pakistan

Ahmedabad

Delhi

Philippines

Yemen

Cambodia

Malaysia

Sulawesi

Singapore

Sumatra

Jakarta
(Batavia)

Indonesia

Java

Bali

Flores

Roti

duced identifiable cultural patterns. The association of certain textile articles with funeral offerings and other ritual objects suggests the central role they played in the culture. The designs were like writings, transmitting messages to those who knew their code—through color, form, and their interrelation. These once-vibrant shibori traditions declined in social importance after the Hispanic conquest, and the art of *amarra* seems to have disappeared from the central Andean region with the subsequent exploitation and repression of indigenous people. However, existing nineteenth-century *amarras* such as those of the Ranquel of the Argentine pampas and other peoples in northwestern Argentina suggest the survival of an ancient *amarra* tradition there.[3]

These *amarra* textiles present some distinctive and puzzling features to contemporary shibori artists—for example, the use of time-consuming scaffold weaving, in which each pieced module is bound-resist–dyed in red, yellow, green, blue, and maroon. Some modules on the ends of the large finished textiles have looped yarn fringes that are continuous with the rest of the scaffold weaving and tie-dyed to extend the design. The shibori patterns on each module seem to have been executed in a larger unit, with four, eight, or sixteen pieces woven together, and then separated and reassembled to make stunning compositions on large patchwork camelid fiber textiles.

Top of previous page: Colorful amarra *scaffold weaving with camelid fiber, found in Peru.* A.D. *600–800.*

A later example of shibori is created on much finer cotton fabric. These delicate bound-resist patterns resemble *kanoko* shibori (fawn dots),[4] or *hitta kanoko* shibori, small knotted and dyed squares/rings set in a dense grid. These mostly rectangular textiles come in a wide range of sizes, all of which have selvedges (finished edges) on all sides. Some of the shibori patterns among those textiles have the resist shapes appearing as solid squares or circles, without the dyed dots characteristic of all types of *kanoko* shibori (Figure 2).

Figure 2. *Above left:* Rendering of a typical *kanoko* shibori motif with dyed dots. *Above right:* unusual *amarra* motif without the dyed dots.

When I examined specimens of this type of *amarra* at the Amano Museum and the National Museum of Archeology, History and Anthropology in Lima, Peru, I found some pieces with the hint of a dot in the middle of the square where the dye had bled under the additional protective covering that must have been placed over the tip of the bound unit. The small reserved white squares on earth-colored ground were so densely placed that the ground color was registered only in the thin lines separating the shibori units; the process is precise and would have required great skill. Many of the patterns resemble the extraordinarily fine stone walls constructed by pre-Hispanic civilizations, most notably the Inka.

These specific styles of design and the uniquely complex processes in earlier *amarra* textiles as well as other awe-inspiring ancient woven or knitted textiles provide us with some clues about the aesthetics, the sense of time, and even the beliefs of the people who produced them. These examples point to but a few of the many puzzling questions identified by an *amarra* replication research group[5] that was formed in 1998 in response to the theme of the 1999 third International Shibori Symposium (ISS) in Chile. The third ISS sparked great interest and enthusiasm among the South American scholars and artists in reestablishing the lost art of the continent.[6]

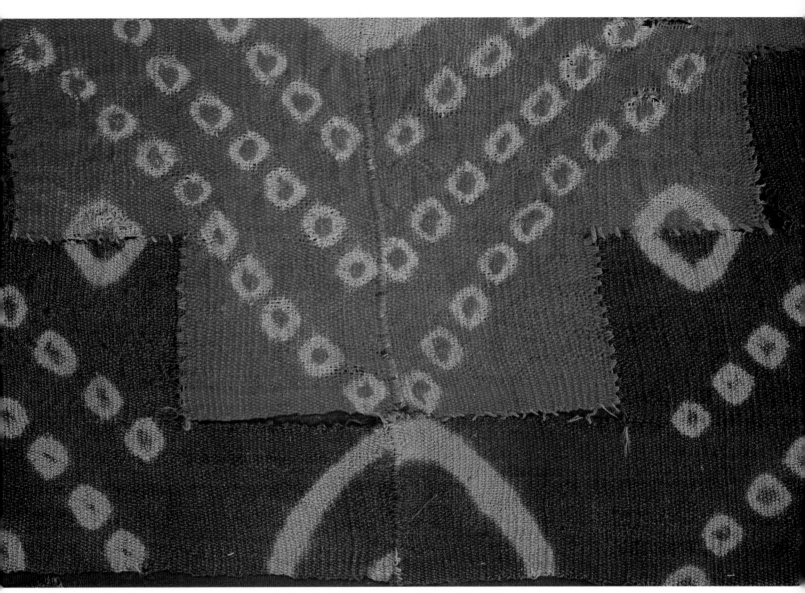

Plate 1. Colorful scaffold-weave *amarra*. Alpaca. Nasca Wari (A.D. 400–800). Museo Amano. Photo by Yukari Tokumitsu.

Plate 5. Silk *bandhani odhani* with silver embroidery, 20th c. ▶

Plate 2. *Tajírâ*, Tunisian wool shawl, Matana, south of Gabes. 20th c.

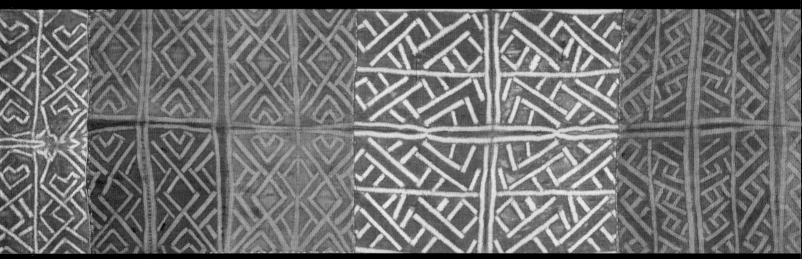

Plate 3. Kuba skirt. Stick clamp and stitch resist on raffia. 20th c.

Plate 4. Silk sash with stitch-resist lines between gold bands and solid ground, possibly from Turkey. 19th c.

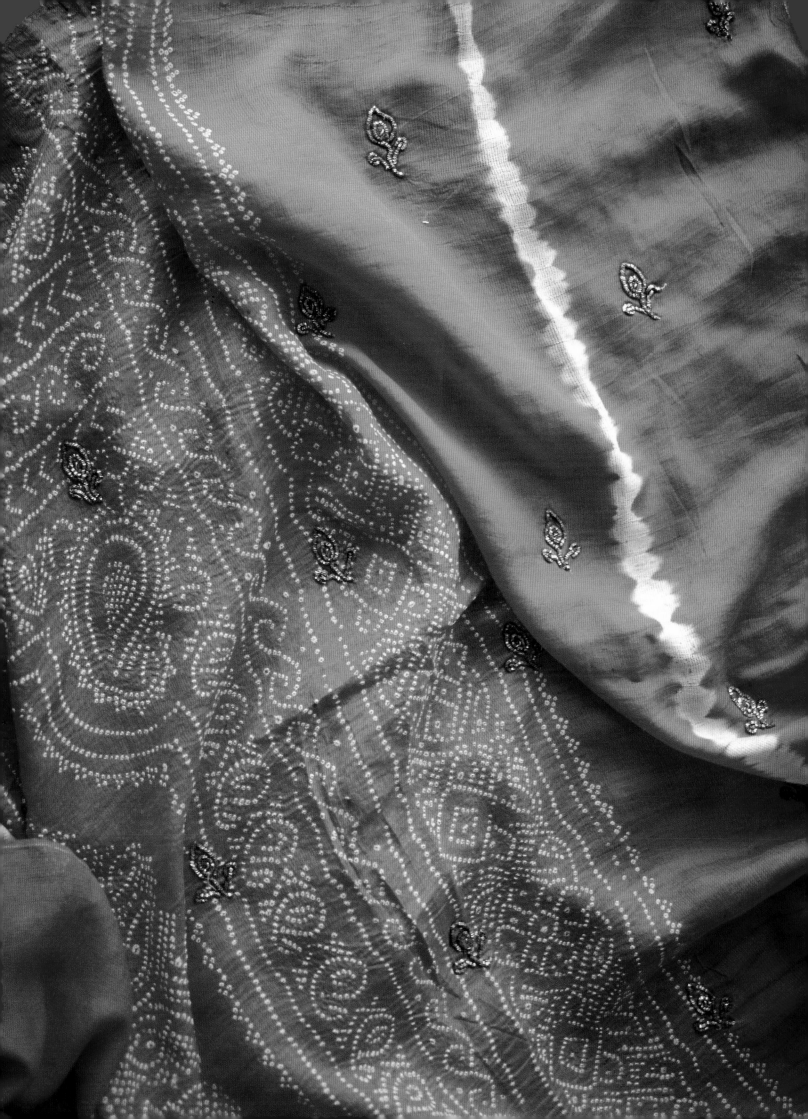

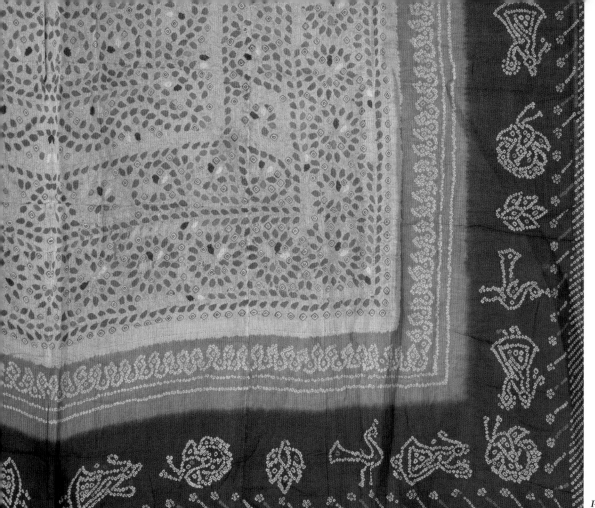

Plate 8. *Kembangan* shoulder cloth in silk. Java. 20th c. Photo by Kazuo Minato. ▶

Plate 6. Cotton *bandhani odhani* with some tied and some stitched patterns, including cowrie shell motifs. Rajasthan, India. Late 19th or early 20th c.

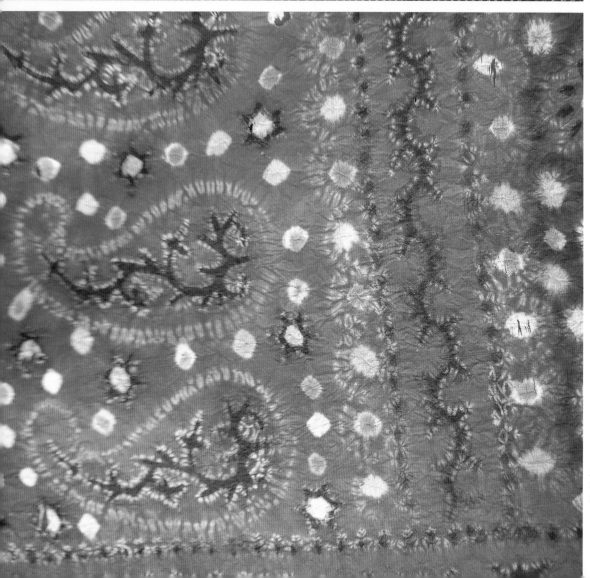

Plate 7. *Pelangi* silk sash or shoulder cloth from Palembang with attached crocheted gold metallic fringe. Early 20th c.

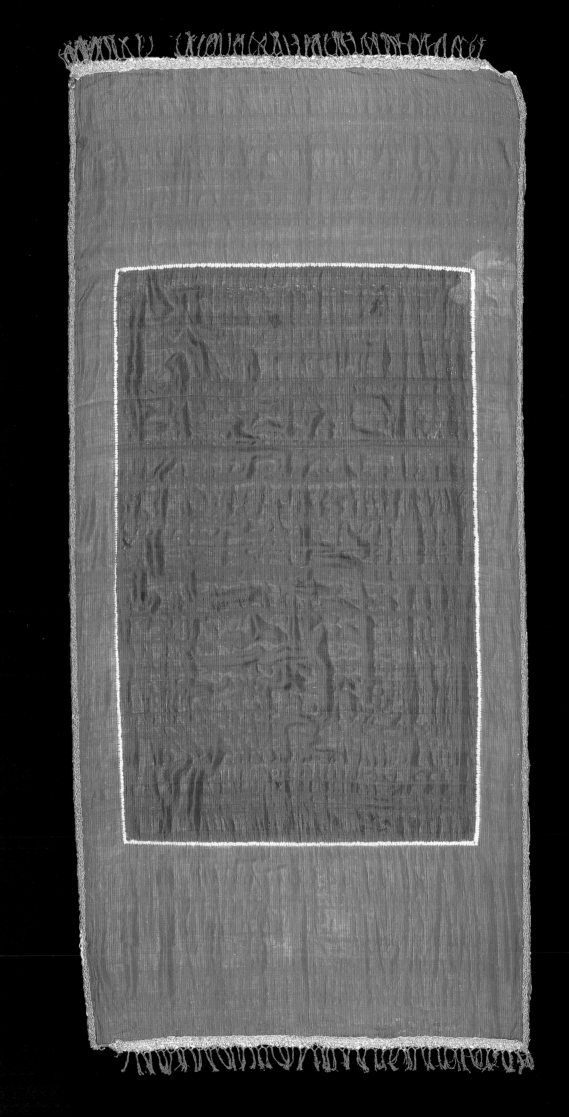

Plate 9. Stitch resist of minority Chinese. Indigo-dyed cotton. Early 20th c.

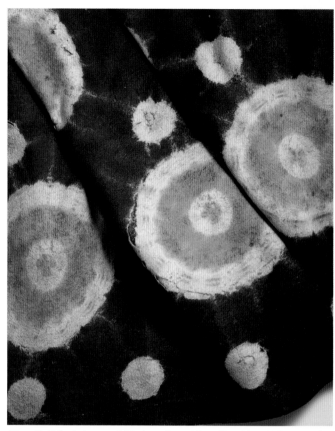

Plate 10. Shibori-decorated felted wool rug. Mongolia. 19th c. Collection of Hitoshi Fujimoto. Photo by Takumi Fujimoto.

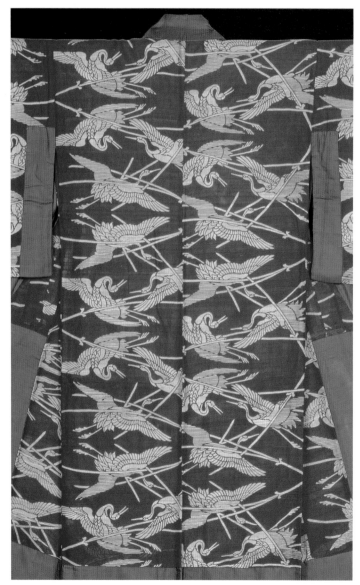

Plate 11. *Beni itajime*. A *kasane aigi*, or inner layer of a two-piece kimono set, in red-dyed board-clamp resist. Silk. Late 19th or early 20th c. Collection of Kyoto University of Art and Design (Michie Yamaguchi).

Plate 12. Battle banner with clan insignia. Silk. 16th c. Collection of Hitoshi Fujimoto. Photo by Takumi Fujimoto.

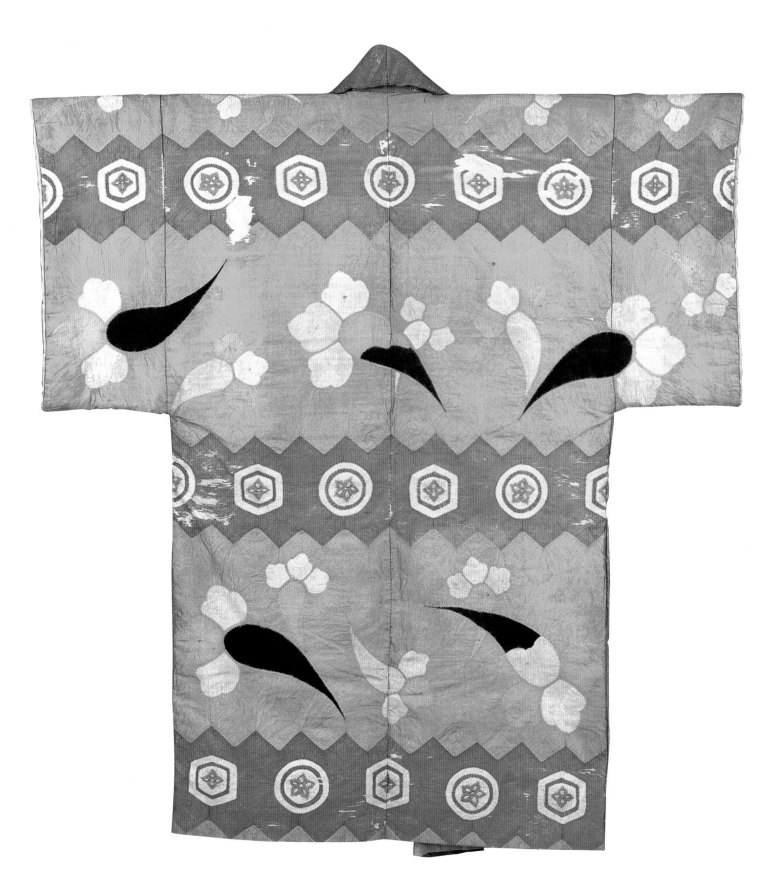

Plate 13. *Dobuku tsujigahana* with clove design, owned by shogun Tokugawa
Ieyasu. Silk. Late 16th to early 17th c. Tokyo National Museum.

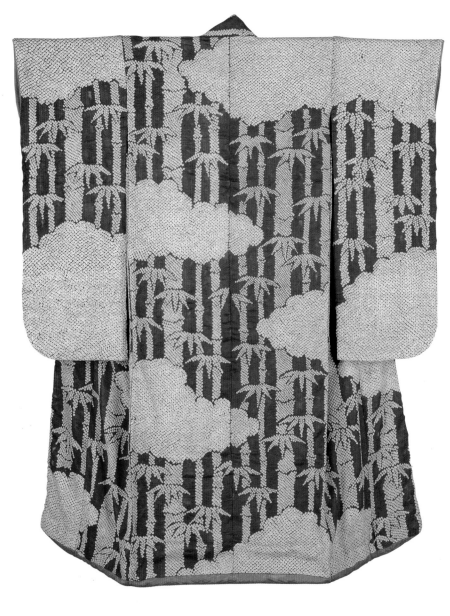

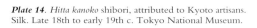
Plate 14. *Hitta kanoko* shibori, attributed to Kyoto artisans. Silk. Late 18th to early 19th c. Tokyo National Museum.

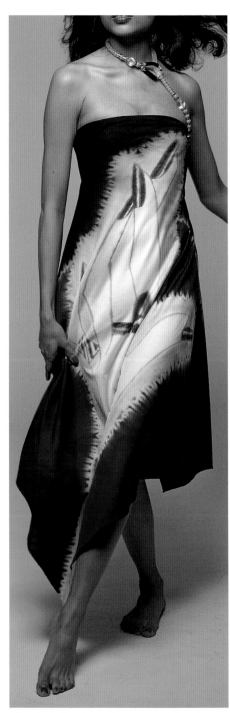
Plate 16. Fashion by Reiko Ehrman. Shibori-dyed and hand-painted silk. Late 1970s/early 1980s.

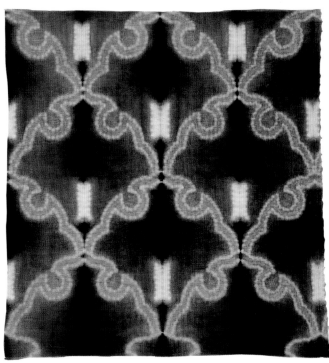
Plate 15. Motohiko Katano. Variation of the snowflake pattern in *ori nuishime* (pleat-and-stitch) shibori with indigo and peach bark dyes on cotton. 1970s. Collection of Hitoshi Fujimoto. Photo by Takumi Fujimoto.

africa

On the African continent, home of the earth's most ancient civilizations, textiles flourished, along with pottery, wood carving, metalworking, and other arts. Tie-dye techniques were developed in northern, central, and, most notably, western Africa, in Mali, Nigeria, Côte d'Ivoire (Ivory Coast), and Ghana. I am indebted to Hélène Soubeyran for the following information on African shibori, which appeared in her essay "Africa's Living Art of Tie-Dyeing." The African shibori tradition draws strength from its flexibility as an art form, its capacity to evolve with time, and its ease of transmission. Ancestral techniques kept alive over the years are sometimes transmitted from village to town and from one country to another. Climatic and economic conditions frequently drive young dyers, both male and female, from their villages to more populated areas, usually towns and cities, where their skills are in greater demand. As a result, traditional techniques from different places intermingle and give rise to innovations.

Most likely, the tradition of dyeing has always existed in Africa, owing to the easy availability of local vegetable dyes and natural plaited or woven cloth. In each of the vast areas where shibori is practiced, it has been given different names. In Maghrib, a region of northwest Africa comprising the coastlands and the Atlas Mountains of Morocco, Algeria, and Tunisia, the term *nuet* is used for simple binding, similar to *kumo* shibori and *kanoko* shibori, applied to woven wool and silk cloth. *Nuet* is a small fabric sachet of herbs used as a tea. It seems likely that those people recognized a potential embellishment technique for dyeing in the marking left on the *nuet* after it was untied.

Figure 3. Detail of indigo-dyed cotton *onikan* with a grain of coarse sand tied inside each shibori unit (actual size: 7.62 x 3.05 cm/3 x 1 1/5 in.).

This region is one of the world's great cultural crossroads and bears the influence of the Phoenicians, Romans, Byzantines, Arabs, Turks, and Spanish. In the mountainous area south of Gabes, on the coast of Tunisia, fine shawls of great beauty are woven. Shawls of different sizes—the *bakhnûg, tajîrâ,* and *ketîfiya*—may be worn together or separately for festive events and visits.[7] They are woven in wool and sometimes decorated by small bound circles achieved by tying small round objects in the fabric and dyeing it successively in yellow, orange, or red. A unique aspect of this type of shibori is that the patterns are colored in the center of each circle, on both sides of the cloth. This rare double-sided design on wool likely arose for use on cloth that was draped over the head and meant to be seen from various angles. The patterned borders are woven with white cotton weft against wool warp yarn. Only the wool takes the dye, leaving the white pattern from the weave as a decorative element (Plate 2). Shibori-decorated textiles, such as thick woolen belts (usually done in red) and turbans worn by women exist in this region, but today are seen less and less often.[8] Unfortunately, not much research has been done into the shibori traditions of this region.

In central and French West Africa, cotton and raffia[9] are woven and resist dyed *a l'attache* (with ties) and *a l'aiguille* (with a needle). English-speaking countries use the term tie-dye, but in Nigeria the Yoruba use the term *adire*[10] for a variety of resist-dyed textiles and techniques, including shibori and cassava paste-resist dyeing (*adire eleko*).[11] Specifically, *adire oniko* is a method of tying with raffia. One type of *oniko* is *onikan,* in which little peaks or puckers are formed by inserting small objects such as seeds, pebbles, shells, or corks into each tied unit and then removing them when the dyeing is completed (Figure 3).

Alabere refers to *nui* shibori, or stitch resist, done by hand-sewing or machine-sewing. *Suji* shibori, or hand pleating of the cloth before dyeing, is called *olino*. A diagonally pleated design called *sabada* was popular in Nigeria in the 1960s.

In the southwestern Sahara, along the Senegal and Niger rivers down to the Atlantic coast, shibori has evolved and diversified, with a vast array of methods and designs being developed over a long period of time. For example, in landlocked Burkina Faso, just south of Mali, rural dyers continue to use traditional shibori patterns similar to those decorating the eleventh-century cotton cap dyed in indigo that was discovered in a funerary cave in the Bandiagara cliffs in Mali, on the Niger delta. The funerary site belonged to the Tellem, an ethnic group who inhabited the area before the Dogon.[12] This rare archeological find is a striking piece of evidence that a bound-resist shibori tradition has existed in Africa for at least a thousand years.

The Dida people in Côte d'Ivoire have been plaiting tubular raffia cloth of many different sizes for centuries. Plaiting, unlike weaving with its perpendicular warp and weft, interlaces fibers diagonally. The Dida create small patterns by pinching and binding; they create larger ones by pulling and binding larger portions of fabric repeatedly to fill the ground. The larger motifs are square or rectangular rather than the typical diamond shape that occurs when woven cloth is stretched on the bias while binding. After the motifs are all gathered and tied tightly, subsequent dyeing produces the design in browns, reddish browns, yellows, and blacks (Figure 4).

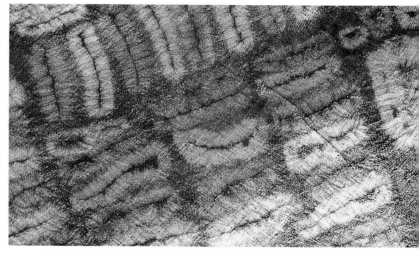

Raffia fiber has also been used extensively in central Africa, including the Democratic Republic of Congo (the former Zaire). The Kuba people of the Kasai River area make a distinctive textile with cut pile. Other areas produce appliquéd textiles as well as shibori using a combination of stick-clamp–and-stitch resist, a variation of *itajime* shibori (Plate 3).

Another unique pattern, an elongated oval, is achieved by folding the cloth, then stitching and gathering a long narrow portion along the fold (Figure 5).

Figure 4. Plaited tubular raffia cloth, bound-resist–dyed in reddish browns, yellows, and blacks. Côte d'Ivoire. 20th c.

Many of the shibori or appliquéd long cloths are used as skirts for ceremonial dance.

In Cameroon, cloth made of narrow bands of handwoven cotton is patterned extensively with intricate motifs that are created by a stitch-resist process, a type of *nui* shibori. An embroidery stitch similar to the satin stitch is tightly applied, protecting the area from indigo dye penetration and from the oxidation process.

In Bakel, Senegal, an association of women dyers is keeping alive their tradition with assistance from the government, which supports the cultivation of indigo plants. Using thick cotton fabric with black-and-white woven stripes, they stitch small rectangular, triangular, or square patterns on folds of the white stripes before dyeing, to create white motifs floating on a dark blue-black ground (Figure 6).

Today, in western African cities, in addition to natural indigo, the use of chemical dyes—which are easy to obtain and use—is helping to promote innovation and improvisation while preserving basic shibori processes. Female and male dyers, aided by Guineans, Malians, Senegalese, Burkinabes, or Nigerians, use techniques handed down through the generations, but the uniqueness of their textiles derives from the talent of the head dyer. For example, Awa Cissé in Bamako, Mali, decides on the composition of the pattern and colors, fabric, and finish. She works with one of

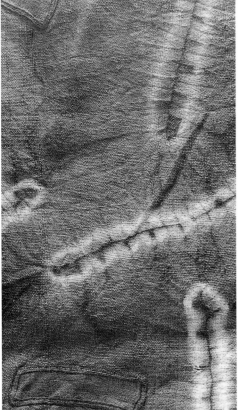

the most luxurious cotton fabrics, *bazin riche* (Figure 7), a damask cotton linen imported from Germany by Lebanese traders, which she cuts into *boubou* gowns for men and women, loincloths, and headdresses (Figure 8). She then draws designs on them and gives the cloths to the most skilled female or male stitch-tyers. After the cloths are stitched and tied, she dyes them with chemical dyes. The cloths are then starched and beaten to give a unique sheen and a crispness that are very popular in the area.

The aesthetic achievement and great diversity of technique derived from ingenious uses of shaped-resist dyeing by African artisans continue to amaze textile aficionados around the world. The strength and vitality of the shibori tradition on the African continent may be attributed to the wide range of natural habitat and rich variety of cultural tradition. This presents an interesting contrast to the Japanese shibori tradition, which has survived for over twelve hundred years in what, unlike Africa, is essentially a monoculture. It is amazing that in both areas the artisans are able to use the inherent languages of cloth and dye to produce a wealth of designs and techniques.

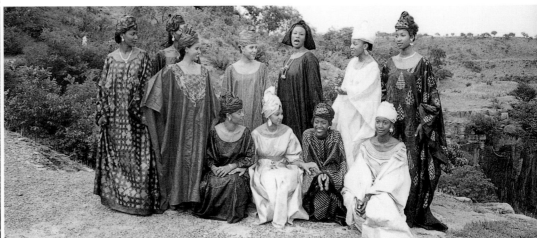

Figure 8. *Above:* Women of Mali dressed in *boubous* produced by Awa Cissé. 2001.

Figure 6. *Center of page:* Stitch resist over black-and-white stripes, indigo-dyed cotton. Senegal. 20th c. (actual size: 8.26 x 10.16 cm / 3¼ x 4 in.).

Figure 7. *At left:* Stitch resist on *bazin riche* by master dyer Awa Cissé. Mali. 1999.

the middle east

The existence in the cultures of the Middle East of a multitude of strong shibori traditions can be surmised from extant examples, such as a *nui* shibori sash of fine silk and gold threads identified as being from Turkey (Plate 4). Between gold bands and intense red ground, traces of soft white resist lines remain from stitching applied across the width of the sash, which was then gathered tightly to reserve the gold during the successive dyeing that must have been required to obtain this brilliant, striking red.

Additional evidence is provided by scores of bold and bright silk shibori head coverings from Uzbekistan and Afghanistan, as well as ongoing shibori production in Yemen and Syria. The current practice of shibori in the Middle East, however, is probably only a faint shadow of what was seen in centuries past.

the indian subcontinent

A great profusion of shibori craft is found in the northwestern part of the Indian subcontinent in the Indus River basin, one of the cradles of human civilization, where archeological finds in Mohenjodaro suggest that dyeing was done as early as 4000 B.C. The earliest examples of the most pervasive type of Indian shibori, *bandhani*, can be seen in the sixth- and seventh-century paintings depicting the life of Buddha found on the wall of Cave 1 at Ajanta. Among the courtiers and ladies in the palace of Prince Siddhartha, some wear bodices patterned with spots that seem to be *bandhani* dots, and many wear wraps with flame-striped patterns like those produced by ikat (Figure 9).[13]

Figure 9. Woman wearing a bodice patterned with scattered rings. Rendering of a painting from Ajanta Cave 1, India. 6th or 7th c.

The Sanskrit word *banda*, "to tie," is the root of *bandhani*, a group of shibori textiles decorated primarily by plucking the cloth with the fingernails into many tiny bindings that form a figurative design, a process similar to *kanoko* shibori (small plucked-and-bound resist). Primary production centers are located in Jaipur and the Shekavati region to the north, in Rajasthan, and in Ahmedabad and the Saurashtra and Kutch regions to the west, in Gujarat. The Kutch region, for example, which borders Pakistan and faces the Arabian Sea, is home to ten thousand *bandhani* artisans working with cotton, wool, and silk. For hundreds of years *bandhani* craft has enjoyed lively commerce carried out by professional artisans with local communities, including the ruling class, merchants, and shepherds. The rulers of Kutch patronized *bandhani*, which is still used for religious ceremonies, festivals, dowries, and weddings (Plate 5).

Bandhani cloth is primarily used as a shawl or head covering (*odhani* or *dupatta*) in western India, part of a woman's traditional costume of skirt, blouse, and large shawl or head covering. For example, *piliya* (yellow cloth) is a *bandhani odhani* or *orni* dyed in yellow and red and given to a woman when her first child is born, particularly in Rajasthan. Generally, stitch resist is only used in Indian *bandhani* for dyeing borders and for making the decorative cowrie shell motifs known as *kodi dana* (Plate 6). In fact, *bandhani odhani* is synonymous with *chunari*, and is so archetypical that a miniature *chunari* is one of the most important offerings made to the goddess Durga (Figure 10).

The term *laharia* derives from *lahar*, "wave." The technique is known to have originated in Rajasthan, where a few remaining *laharia* artisans still practice in Jaipur and Jodhpur. In this distinctly Indian process cloth is rolled edge to edge diagonally into a coil, bound in selected areas,

and passed through several dyebaths, creating a complex design of parallel diagonal lines or plaids. As with *arashi* ("storm") shibori, or pole-wrap resist, *laharia* patterns are diagonal in orientation, since the cloth is shaped on the bias. This typical zigzag pattern is achieved in four steps: folding a long narrow cloth lengthwise into halves or quarters, rolling the cloth from one edge to the other on the bias, binding tightly around the long ropelike cloth at varying intervals, and dyeing. The emerging wave design is a variation of basic diagonal stripes. Although no longer a commonly practiced technique, *laharia* was once favored by ladies of the court, who used yards and yards of the cloth for their marvelously flared skirts, and by maharajas for decorating the gossamar cotton used for their intricately patterned turbans (Figure 11).

In North America and the West Indies, the word *bandana* refers to a large handkerchief or head-scarf in cotton print, the typical coloration being red and white. Many variations of the word appeared in published journals in the late eighteenth and early nineteenth centuries[14] and later it

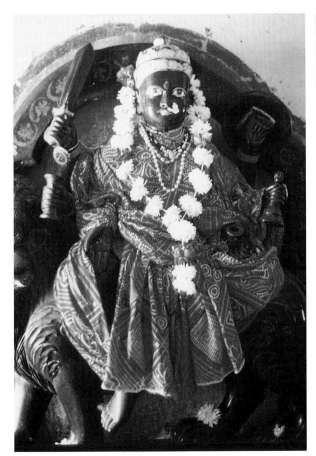

Figure 10. Statue of the Hindu goddess Durga adorned with various kinds of offerings, including a *chunari* patterned with a printed imitation of *bandhani*. Photo by Rosemary Crill.

Figure 11. *Laharia* turban. Rajasthan, India. 19th c.

became a generic English term for any scarf or head-tie. The original "bandanna" referred specifically and exclusively to silk handkerchief (scarf) piece-goods, tie-dyed or printed in Bengal for export to London under the auspices of the English East India Company, which began to order this product in the late 1720s. Prior to that date the same handkerchiefs had been brought to Europe by the Dutch East India Company under a different name.[15] Records from the early 1800s indicate that between eight hundred thousand and one million bandanas, tie-dyed or printed, were imported into England and sold annually. The immense popularity of these kerchiefs from India inspired English manufacturers to imitate them by resist-printing with wax or paste on linen batiste imported from France. Since factories in Manchester began producing these printed

bandanas by about 1750,[16] the term bandana lost its original meaning. Eventually the true hand-made *bandhani* lost ground as an important export item, replaced by the methods and materials of the new industrial age. Nevertheless, Indian *bandhani* has left an indelible mark on the lexicon of Western textile design (Figure 12).

The colonial expansionist policies of European countries driven by their appetite for tradable consumer goods had, and continues to have, a profound effect on the indigenous textile tradi-tions of both colonized nations and European countries as well as on their environmental resources and their livelihood. Indigo, as the source of the color blue and an important dye in shi-bori textile traditions on many continents, is a prime example. Since Vasco da Gama's circumnavigation of the Cape of Good Hope in 1498, indigo dye from Asia came to rank among the major commodi-ties carried on the new, powerful "East Indiamen" sailing vessels. It was often among the most valuable of all the "spices," and progressively undermined the whole European woad industry—the traditional source for blue dye in Europe. Four centuries of an immensely complex pat-tern of transcontinental trade, colonial agricultural enterprise based on slavery, revolutions in industry, rivalry between the great European shipping companies, and political relations between nations are well documented in Jenny Balfour-Paul's seminal book, *Indigo*.

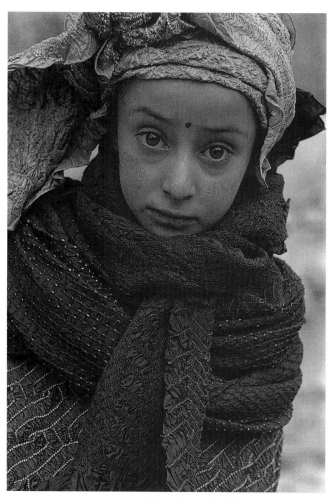

In 1520, twelve years after landing in southwest India, the Por-tuguese reached the Spice Islands of the East Indies. The Spanish, English, Dutch, and French competed to monopolize the spice trade, but the Portuguese held supremacy in the sixteenth century, with indigo occupying an important place in their trade. By the nineteenth century, Britain had gained the upper hand in the indigo trade, utilizing its position in India. However, the exploitation of the local people for growing the plants and making the dyestuff caused enough discon-tent, such as the blue mutiny,[17] to have direct political consequences for British rule in India. The global trade wars of the twenty-first cen-tury rival the political ambitions of the past in their widespread exploitation of human and environmental resources, but without the earlier age's passion for exotic spices or beautiful textiles.

Figure 12. Local girl from the village of Dah in Ladakh, India (formerly part of Tibet) modeling *bandhani* produced by Asha Sarab-hai for her Raag clothing line. 1996. Photo by Yuriko Takagi.

southeast asia

The stream of textile goods did not, of course, flow only from East to West. Since the fifteenth century, Europeans often used textiles to trade for spices such as pepper (once called black gold) and for substances such as opium with the inhabitants of China, the southeastern islands, and the Indian subcontinent. History also documents the ongoing movement from East to Far East of ideas and knowledge, including the religions of Buddhism, Hinduism, Christianity, and Islam. India's rich and varied textile trade in the East might have included articles associated with reli-gious rituals or costumes used for certain dance performances. Asian merchants in Asian vessels carried undetermined amounts of textiles in their cargoes within regional waters, but an abun-dance of surviving European records suggests the magnitude of the trade. For example, a report

by the Dutch East India Company cites an inventory of between five hundred thousand and a million cloth items in a warehouse in Batavia (now Jakarta) in the mid-eighteenth century.[18]

The export of textiles from India to Indonesia flourished well before European merchants arrived in the Eastern seas. One of the most prestigious of these textiles was *patola*, the famed silk double-ikat weaving from Patan in western India. *Patola* was exported in great quantities to the Indonesian islands and was favored by royal personages in the courts of Jogjakarta and Sukarta.[19] The popularity of *patola* inspired the islanders to make adaptations, including rare double ikat, which is still woven in the village of Tenganan in Bali, the only Indonesian island still dominated by Hindu culture and religion. Indian *patola* also influenced the designs of ikat textiles on other islands, such as Roti and Flores.[20] No scholarly attempt has yet been made to link *bandhani* from India with the shibori traditions of the Indonesian archipelago. However, the fact that the major *patola*-producing city of Patan is now situated in the state of Gujarat, which, besides Rajasthan, contains the largest concentration of *bandhani* artisans, makes it plausible that *bandhani* textiles were also exported to Indonesia and influenced shibori traditions in the archipelago and even in the Philippines.

Shibori textiles from the Indonesian archipelago show the use of stitching, capping, and binding techniques. Some fabrics are designed with large circular or diamond motifs created by simple *kumo* shibori (spiderweb binding), such as those traditionally used by the Toraja people on the island of Sulawesi. Others, such as *pelangi,* or rainbow cloth, are quite intricately patterned with motifs made by stitching, binding, and dyeing in multiple colors (Plate 7).

These silk sashes and shoulder cloths made and used in southern Sumatra, eastern Java, and Bali play an integral part in cultural rites, including weddings.

Plangi, a derivative of the Malay word *pelangi,* has sometimes been used in the West to describe the process of gathering and binding cloth. However, in Indonesia *pelangi* refers to a particular type of cloth that is decorated with multicolored shibori dyed motifs, and does not indicate a process. *Jumputan,* meaning "to tie," is a more accurate description for tie-dyeing fabric for shibori or tie-dyeing yarns in ikat weaving. Tritik is another Malay-derived word often used in conjunction with plangi. It originated in *teritik* and has been adopted by Western scholars to describe the stitch-resist technique. In Indonesia *teritik* (Figure 13) refers to a pattern of characteristic small white dots created by stitch resist.

Another type of shibori textile called *kembangan* (Plate 8) is considered older than *pelangi* or *teritik.* It usually features a single large rectangular shape in the middle that is delineated by stitching; capping is then used to dye the two areas different colors. This is similar to *oke* (tub) shibori or large *boshi* (stitched-and-capped) shibori, which demand technical precision in tying and dyeing what is seemingly a simple bold pattern. Early records mention *kembangan* cloths as being among goods shipped from the port of Tjilatjap in 1580, as well as being worn at the court of Mataram in central Java in 1654.[21]

Figure 13. Detail of *teritik, nui* shibori, cotton, Java. 20th c. (actual size: 3.18 x 16.5 cm/1 ¼ x 6 ½ in.).

china

Extensive use of *nui* shibori can be observed in the historical blue-and-white shibori textiles of the minority peoples in southwestern China (Plate 9). A number of tribal groups, including the Miao and Pei, seem to have had shibori traditions. Some Chinese minority peoples also practice embroidery extensively. One of their favorite ways of decorating is with cross-stitch (Figure 14), which is similar to the crisscross stitching used for a type of *nui* shibori applied on a fold of two layers or four layers of cloth. This stitch is commonly used in conjunction with the overcast stitch (*makinui* shibori), also on a fold, to create linear designs.

Another embroidery method, known as stem stitch, is used on the peaks of the folds in the unique technique and pattern called "butterfly-flower" or "baby-bee" shibori (Figure 15).

The young women of the mountainous regions in Yunnan Province[22] have very few opportunities for work other than in workshops developed over the past few decades by Japanese shibori manufacturers. But as a result these skilled craftswomen apply their craft to creating products for export, rather than domestic use, which threatens the continuation of their indigenous tradition. This is a delicate issue, and ongoing efforts are being made to promote and thus preserve the handicraft traditions of developing countries. There are many worthwhile programs run by nonprofit organizations, including Aid to Artisans, Global Exchange, and the Self-Employed Women's Association (SEWA).

It seems likely—although it is not certain—that technical skills pertaining to shibori traveled from Southeast Asia to southwestern China with the movement of tribal peoples. Likewise, Mongolia and the Himalayan cultures produce shibori textiles using heavy woolen materials, but the relationship between their traditions is not clear. Large shibori-decorated felt rugs from Mongolia have been favored by Japanese tea masters since the 1600s for use in winter tea ceremonies (Plate 10).

Historically Japan did not produce woolens, and the Japanese must have coveted these colorful felted rugs, with their simple, clear, and unpretentious bound-resist patterns, which brought an element of exotic gaiety to the otherwise rustic but elegant Japanese tearooms.

connecting threads

A mysterious connection yet to be researched is the appearance in a number of different cultures of technically sophisticated carved-board clamp resist resembling the more than one-thousand-year-old *kyokechi* stored in the Shosoin Repository in Nara, Japan. I once saw a *kyokechi* silk banner in a Buddhist temple in Ladakh, formerly part of Tibet, now in India. Similar Tibetan or Chinese pieces can be found in many museums and private collections.

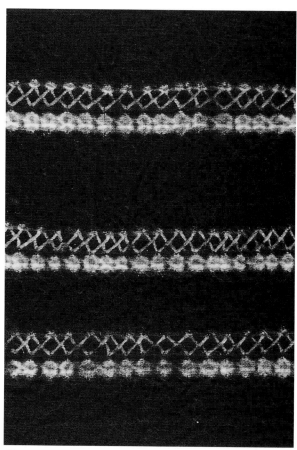

Figure 14. Crisscross stitch resist from China. 20th c. (actual size: 8.26 x 12.7 cm/3¼ x 5 in.).

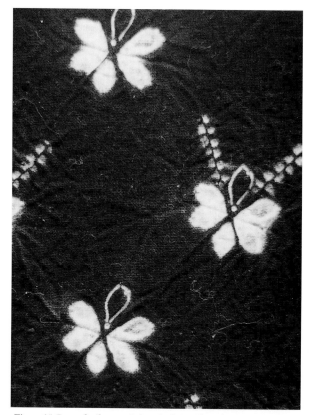

Figure 15. Butterfly-flower stitch resist from China. 20th c. (actual size: 7.62 x 10.16 cm/3 x 4 in.).

During the late eighteenth and nineteenth centuries, *bandhani* silk kerchiefs from India, which were enormously popular among the upper class, spread to the lower echelons of English society. Clamp resist with carved boards[23] was used to produce fake bandanas in factories in England and workshops in India, as were wax- and paste-resist printing.

I have studied the carved boards in the collection of the Calico Museum of Textiles in Ahmedabad, India. Most of these boards must be over a hundred years old, and they range in size from 30 centimeters wide by 50 centimeters long by 5 centimeters thick (approximately 12 x 20 x 2 in.) to about twice those dimensions. They are thicker than the carved boards used in Japan for *beni itajime* (red safflower-dyed board-clamp resist) during the late nineteenth to early twentieth centuries. At about a centimeter in thickness, the Japanese boards for *beni itajime* are well suited to the long narrow kimono cloths that were folded and clamped with multiple boards. Indian clamp resist was used to dye a much wider cloth, which required pressure to be placed evenly with a pair of large, thick boards. The perforations on the Indian boards suggest multicolor dyeing similar to that seen on textiles found among the imperial treasures in the Shosoin Repository[24] and unlike the red-and-white *beni itajime* made in more recent centuries in Japan.

The thought is awe-inspiring: it is possible that a continuous thread runs from the ninth-century clamp-resist–dyed textiles in the Shosoin imported via China, perhaps from India, to the crafting of Tibetan and Chinese Buddhist hangings, to Indian mass-produced clamp-resist printing in the nineteenth century, and to the *beni itajime* used to decorate Japanese under-kimono from the seventeenth to the early twentieth centuries. A similar thread can be traced between fragments of spotted cloth dated to the early fifth century, unearthed in the tomb of Western Liang (A.D. 418) in China near the Silk Road, the spotted bodices worn by court ladies in the Ajanta cave paintings of the sixth to seventh centuries, the seventh- and eighth-century fragments stored in the Shosoin, and the *kanoko* shibori being still produced in abundance in India and Japan.

The practice of shibori seems to be an instinctive human activity that has arisen spontaneously in many different cultures. One of the most fascinating aspects of human culture is the variety of solutions people use to address the basic challenges of life, such as economic distribution, technology, and ideology. It can be a surprising coincidence when people arrive at similar solutions at disparate times and locations. Synchronicity in the use of primary materials, techniques, design, and decoration can be readily observed in the textile arts. Diverse cultures throughout time have used similar processes and similar mineral, vegetable, and animal products to dye fibers within the context of textile traditions.

Designs created using shibori techniques clearly reflect the touch of each worker. No two people fold or bind or stitch in exactly the same way. The work of one may be very precise and even, and that of another looser and more free. Likewise, the amount of force exerted on the binding thread, or in drawing up the stitching thread, or in compressing the cloth into folds on the pole differs from one person to another. The effect of an individual's hand, and indeed temperament, on the shaping of the cloth is recorded by the dye on the finished piece. This makes for highly personal results, even within a traditional framework.

JAPAN

Japan has a long and vibrant tradition of shaped-resist dyeing, but the word shibori is relatively new. It came into use during the Edo period (1603–1867), and scholars have yet to determine exactly when and where it first appeared. Studying the history and etymology of the myriad Japanese terms that have been used to describe particular shibori techniques over the centuries sheds light not only on the technical development of shaped-resist dyeing in Japan, but also on shibori's changing aesthetic and cultural context.

In the sixth and seventh centuries great changes transpired, as disparate clans joined into a single state headed by a powerful central figure. During this period Japan transformed itself into a country fundamentally much like the one it is today. Buddhism and a system of writing were introduced from China, along with arts and technologies such as music, advanced medicine, papermaking, and calendar making. Japan emulated China's political and jurisprudence systems, and even its dress codes.

In A.D. 749 Emperor Shomu proceeded in state to Todaiji, the great Buddhist temple in the imperial capital of Nara, southeast of Kyoto. The emperor's mission was to celebrate the completion of an enormous gold-covered bronze image of Buddha, made possible by the fortuitous discovery of gold in a remote part of Japan. The same year, after a reign of twenty-five years, the emperor abdicated his throne and took religious vows.

After the emperor's death in 756, the Empress Komyo donated his household effects and personal possessions to the Great Buddha. These items, which included such diverse objects as calligraphy samples, furniture, utensils, decorative objects, and costumes, were placed in a wooden storehouse on the temple grounds known as the Shosoin. This structure was specially constructed to protect from humidity—its walls made of horizontally stacked triangular-shaped interlocking timbers tightly dovetailed at the four corners of each of the building's three sections. In the Shosoin Repository, there are over eight thousand artifacts and over ten thousand documents, among them more than eight hundred objects that were considered "official objects" and have been placed under the superintendence of the imperial court. It was customary that the emperor's messenger be dispatched with imperial permission before breaking the seal and opening its doors. Airing of the treasures took place four times between the years 756 and 856. The repository was opened infrequently after 856—to check the inventory, lend out objects for ceremonial use, and allow visiting dignitaries to view the treasures. The Shosoin suffered some theft and structural decay over the course of its long history but was always restored. After World War II, the Japanese government decided to open the treasures for viewing, and the first exhibition was organized at the Nara National Museum. Thereafter the government made a policy of organizing an annual exhibition because the treasures are now seen as belonging to the people of Japan.

The collection includes textiles from as far away as Persia. Despite Japan's humid climate and the fragility of the cloth, these ancient textiles are well preserved today. There are three types of

Above: Hitome kanoko *shibori from Arimatsu.*

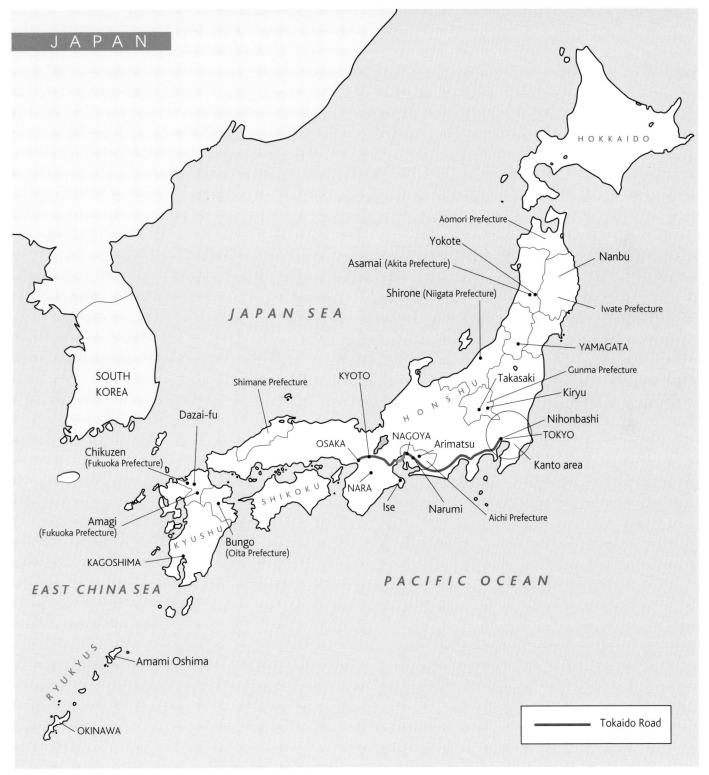

JAPAN

Map of Japan identifying various places mentioned in the text.

resist-dyed fabric—*kokechi* (tied or bound resist), *rokechi* (wax resist), and *kyokechi* (clamp resist). These are all originally Chinese terms, and it seems likely that the earliest examples of resist-dyed cloth in the Shosoin are not indigenous to Japan. Several of the *kokechi* resemble shibori found in a tomb in Astana in China along the Silk Road, which dates from about A.D. 400. Some scholars hypothesize that shibori techniques originated in India and that their influence reached China via the Silk Road.

Nevertheless etymological evidence in the form of the Japanese word *yuhata,* which refers to "knotting" cloth, suggests the prior existence of resist dyeing in Japan. *Manyoshu,* the eighth-century anthology that records poems composed by Japanese people from all walks and stations of life—from peasants to members of the imperial family—during the period between 557 and 764, contains numerous references to *yuhata* and does not include the word *kokechi.*

Another strong indication of an indigenous Japanese resist-dyeing tradition is the mention in the Chinese *Chronicles of Wei (Wei chih)* of a gift by Japanese Queen Himiko to the Wei-dynasty emperor of more than two hundred yards of "mottled cloth" in the year corresponding to A.D. 238. It seems likely that this was a type of resist-dyed cloth.

In modern Japanese, the word *kokechi* has been replaced with "shibori," *rokechi* has become *roketsuzome* or *rozome,* and *itajime* is now used instead of *kyokechi.* In his book *Shibori,* Japanese textile scholar Tetsuro Kitamura shares his investigation of the *kyokechi* textiles in the

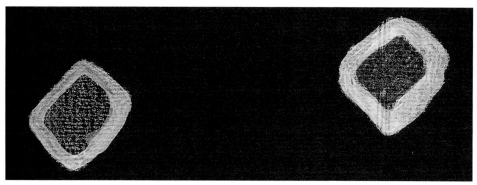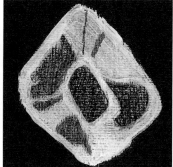

Figure 16. Renderings based on 7th and 8th-century shibori fragments from the Shosoin. *Above left:* Single rings. *Above center:* double rings. *Above right:* folded-and-bound circles.

Shosoin collection. The majority of pieces were patterned by drawing up and binding portions of the cloth.[25] Of the pieces that he examined, only two were executed with stitching. Included in the bound-resist group were single rings and double rings (two concentric rings or squares), as well as folded-and-bound squares (Figure 16).

In addition to wide variation in ways of binding, some differences in folding and clamping methods were also seen.

Rokechi textiles in the Shosoin appear to have been resisted with wax using pattern stamps, in much the same way that batik is often done in Indonesia using carved blocks. Modern *rozome* in Japan is quite different from ancient *rokechi* and warrants special recognition as a textile art form.[26]

Kyokechi textiles seem to have been dyed using a pair of large boards carved with identical motifs but in mirror images. The silk cloth was folded, sandwiched between the boards, and clamped firmly during dyeing. The boards were placed horizontally and dye was poured through perforations in the top board and allowed to drain out through openings in the bottom board. Modern Japanese are mystified by the elaborate process, sophisticated skills, and complexity of patterning evidenced in ancient *kyokechi.*

Both *rokechi* and *kyokechi* gradually disappeared, although the circumstances of their demise have not yet been clarified. Despite the fact that *kyokechi* is translated into modern Japanese as

itajime ("board clamp"), no certain direct connection has been established between the earlier pictorial examples and *itajime* shibori. What these do have in common is that both fold the cloth and maintain the folded patterns by clamping the cloth between boards.

Another form of board-clamp resist for creating patterned silk cloth was practiced in the Kyoto area from the seventeenth through the early twentieth centuries. It is sometimes called *beni itajime* (Plate 11), which means "board-clamp resist dyeing in red."[27] *Beni itajime* is similar to ancient *kyokechi* in that bolts of narrow kimono cloth are accordion-folded and clamped between boards that are carved with patterns. It differs in that a set of twelve to fifteen boards are used, resulting in a pattern that repeats over the entire length of cloth. Sometimes up to three sets of these multiple boards were stacked vertically, held together in a vise, and immersed in a dye vat. The dye would then penetrate certain parts of the cloth through perforations and grooves that were integrated into the carved design. *Beni itajime* was also practiced in the Takasaki area in Gunma Prefecture during the nineteenth and twentieth centuries. *Ai itajime*, board-clamp resist dyeing in indigo (*ai*), was produced in Shimane Prefecture. The history and extent of the use of *kyokechi* require further study.

Modern *itajime* shibori is based on the traditional folk *sekka* (folded flower) shibori, in which a long piece of cloth is accordion-folded lengthwise and repeatedly reverse-folded into a triangular,

Figure 17. Renderings of Heian attire with shibori, from a fan sutra painting. Late 12th c. *Above left:* Fine *kanoko* shibori on a formal robe worn by high-ranking women. *Above right:* simple *kumo* shibori on a servant's robe.

square, or rectangular form. This produces a bundle of folded cloth that is then fitted between two boards held in place by a vise or by heavy cords. The exposed edges of the multiple folds absorb the dye, resulting in repeated geometric patterns sometimes resembling snowflakes. The potential of this technique has been explored extensively by shibori artisans in Japan and is being expanded today by some of the artists in North America and Scandinavia who are featured in this book.

During the Heian period[28] (794–1191) shibori-patterned cloth (*yuhata* and *narabi sakume*) was considered suitable for the robes of high-ranking ladies. References in the *Engi shiki*, a fifty-volume history, indicate that by the end of the tenth century various types of shibori were being made, and that these were worn by soldiers, servants, and—provided that the quality was very fine—the highest-ranking women of the court (Figure 17). Tax records included in the *Engi shiki* show that shibori-dyed silk was accepted as tax payment by the imperial court, as were thirty pieces of shibori-dyed leather from Dazai-fu on the island of Kyushu.

The eleventh-century novel *The Tale of Genji* by Lady Murasaki, as well as a twelfth-century

diary written by a Taira clan nobleman, describe shibori-dyed robes worn by courtiers, shibori covers for votive stands, a canopy, and curtains for a Buddhist ceremonial altar. By the fourteenth century many different patterning designs and methods—most commonly binding and knotting—had evolved. Stitching was also sometimes used.

During the fifteenth to early seventeenth centuries, a group of textiles known as *tsujigahana* (literally, "flowers at crossing") became fashionable. The earliest existing examples of *tsujigahana* are not garments, but a group of banners that were placed around Buddhist temples during special religious ceremonies. Battle banners dyed boldly with clan insignia were often executed with stitched-and-capped resist—a typical *boshi* shibori process (Plate 12).

Boshi shibori processes were often used to produce pictorial designs, which were delineated with fine stitching of hemp or ramie thread and then capped (a cover placed over them as a resist) to reserve the patterns as the cloth was dyed in various colors. Another technique was the fine *kanoko* shibori, where fabric was plucked with the fingernails and bound with fine gummed silk floss. These shibori processes were often combined with *sumi* brush painting, gold or silver leaf stenciling, and embroidery. These textiles embody extreme elegance and luxury and attest to the skilled craftsmanship cultivated in the imperial capital.

Early *tsujigahana* was worn primarily by women, young men, and children. Nevertheless, a sixteenth-century portrait of Takeda Shingen, a famous warlord noted for his bellicosity, shows him wearing a subdued wraparound garment with a colorful under-kimono decorated with a *tsujigahana* pattern.

Superb *tsujigahana* examples are found among the *dobuku* (cloaks) of shoguns Toyotomi Hideyoshi (1536–98) and Tokugawa Ieyasu (1542–1616; Plate 13). Numerous *dobuku* in *tsujigahana* style still exist today, having been preserved and handed down through the generations as family treasures. Unlike the delicate designs of the *tsujigahana* worn by women, these *dobuku* had dynamic designs intended to suggest the warriors' vigor and strength.

During the brief Keicho era[29] (1596–1615), silk textiles with large areas dyed in different colors and filled with delicate embroidery and gold or silver leaf stenciling became very popular. Designs, for instance, of the *kosode*—an antecedent of the kimono—from this period tended to be bold with abstract geometric compositions, often dyed in red and black combined with white and

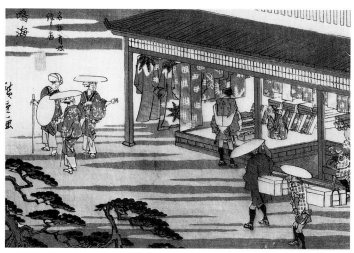

Figure 18. Woodblock print showing shops selling Arimatsu shibori to travelers. Utagawa Hiroshige, from "Fifty-three Stages of the Tokaido," *Narumi*. ca. 1843.

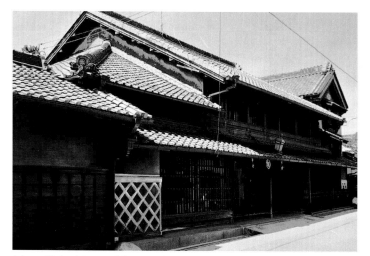

Figure 19. An Arimatsu shibori merchant's home and shop, dating from the late Edo period. The family has been manufacturing and selling shibori for fourteen generations.

gold. The process used in this type of shibori design must have been similar to that of *oke* ("tub") shibori. The large colored areas were delineated with small stitches and gathered so that the cloth could be stuffed tightly into a special wooden tub with close-fitting lids at top and bottom. The tub with lids tightly closed and cloth hanging around the edges was then immersed in dye. This process calls for accuracy and expertise that take about ten years of training to acquire.

In 1615 the shogun Tokugawa Ieyasu united Japan, establishing the shogunate in Edo (pre-

sent-day Tokyo) while keeping the emperor as a figurehead in the old capital in the west. Ieyasu commanded the assistance of twenty *daimyo* (feudal lords) to help with the planning and construction of a castle for his son in Owari (in present-day Aichi Prefecture). One of the lord's fiefdoms on the southern island of Kyushu included the shibori-producing region of Bungo. The workers he brought to help with the construction of the castle wore garments of distinctly patterned shibori cloth. Legend has it that one Mrs. Miura from Kyushu taught the villagers a number of shibori techniques, one of which became known as *miura* shibori and has been widely practiced in the Arimatsu-Narumi area. After the castle was completed, the settlement around it became the foundation for the city of Nagoya.

The *daimyo* were expected to reaffirm their fealty every other year by leaving their respective fiefdoms and journeying to Edo to reside in the shogun's capital for the entire year. This increased traffic on the Tokaido, the main highway that connected Edo and Kyo. The government established fifty-three rest stations to facilitate the needs of travelers (Figure 18). The land further east of the Owari castle beyond Narumi, the fortieth station on the Tokaido,[30] was largely uninhabited and held danger for travelers. In response to the lord of Owari's encouragement, one man by the name of Takeda and eight fellow villagers from the nearby peninsula settled together with their families on the Tokaido, near the Narumi station, in an area that would become present-day Arimatsu (Figure 19). The settlers began to cater to the needs of passing travelers with tea shops that also sold straw sandals and simple bound shibori *tenugui* (small all-purpose towels) dyed in indigo (*ai*)—the ubiquitous blue-and-white.

By the middle of the seventeenth century, peace reigned in the land. The Tokugawa period[31] fostered Japan's growing prosperity. The *daimyo* and their retainers, officials on missions for the shogunate, and people on errands for the merchant houses traveled over the Tokaido. They were joined by more and more commoners making pilgrimages to the Atsuta Shrine, just a few miles from Arimatsu, and to the more distant imperial shrine of Ise. In Arimatsu, dyed yardage set out on drying racks fluttered like colorful banners in the wind, and travelers found shibori cloth and kimonos temptingly displayed in local shops.[32]

During the Kanbun era (1661–72), the Keicho-style *kosode* gave way to yet another dramatic style of *kosode*, which used the T-shaped garment as a painter might a canvas, creating a large, sweeping pattern that continued from the shoulders to the floor. Later *kosode* developed into a whole range of showy or elaborate *uchikake* (outer kimono robes) and *furisode* (swinging-sleeved kimono) with shibori combined with *yuzen* dyeing (silk painting with paste resist) and embroidery (Figure 20).

The artisans in Kyoto perfected *hitta kanoko* shibori (a small repeated resist pattern), *boshi* or *oke* shibori, and *nui* shibori (stitch resist) using multiple colors on silk (Plate 14). These fabrics were prohibitively expensive and reserved by law for the privileged classes and entertainers. The need for extensive labor by highly skilled Kyoto artisans with many years of experience made the process very costly. The designs for these exquisite shibori kimono were created by painters and designers and often combined with other embellishment techniques.

Like indigo, safflower red (*beni*) played an important role in production of shibori textiles. This interesting dye was made from *benibana*,[33] an herb that had been known for centuries to be good for blood circulation and female reproductive health in addition to being the source of red dye for cosmetics and textiles. During the Edo period, this showy color became very popular.

Dyeing with *benibana* was extremely expensive and laborious, requiring as many as twelve pounds of petals for a single *kosode*. This gave rise to the proverb "*ikko, ichigon*" (a pound of *beni* is worth a pound of gold). Material dyed with *beni* bespoke money. Laws limiting *beni*'s use were

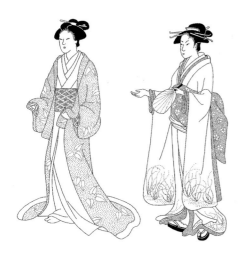

Figure 20. Above left: Uchikake (outer robe). *Above right: furisode* kimono with "swinging sleeves," worn by younger women. Renderings by Susannah Kuo.

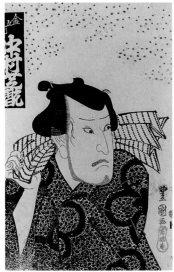

Figure 21. Woodblock print by Toyokuni. Portrait of the actor Nakamura Shinkan wearing *miura shibori* and carrying a small towel patterned with *mame shibori*. Collection of the Takeda family.

not only an attempt to keep the thriving merchant class in its place but were also aimed at regulating the economy by discouraging overspending; in fact they made the dye all the more sought-after.

During the eighteenth and nineteenth centuries it became fashionable to sport this coveted red color on an undergarment such as the under-kimono, well camouflaged by the drab greens and browns and grays worn on the outside. Ladies of the court and courtesans in the entertainment district decorated their *beni*-dyed underlayers of kimono with repeat patterns produced with labor-intensive *itajime*, while commoners often wore undergarments of solid red (see the description of *beni itajime* on page 37).

A major form of entertainment in late Edo-period Japan was the kabuki theater. Each new play demanded eye-catching costumes (Figure 21). The wealthiest leading actors worked directly with kimono makers, often paying for costumes with the help of patrons. Novel patterns and shades were created by innovative uses of embellishment techniques and mordants to set the dyes. The costumes of popular actors would sometimes set the fashion of the day, with a distinctive design or color becoming known either by the name of an actor or by the role he played while wearing it.

According to the sumptuary laws, farmers, artisans, and merchants were not allowed to wear fine *hitta kanoko*, gold embroidery, stenciling, silk material, or dyes of either red or purple. As a result, folk-type shibori clothing and other utilitarian textiles were always made from bast fibers such as hemp, ramie, and, later, cotton, and were dyed in the vernacular indigo.[34]

Most techniques and designs were developed by the shibori artisans themselves, who created highly spirited and bold motifs, as well as countless variations and innovations in processes that resulted in new and unique patterns. Artisans were inspired in their production of motifs by familiar objects and natural patterns, such as wood grain, maple leaves, or meandering mountain paths. The book *Shibori: The Inventive Art of Japanese Shaped Resist Dyeing*, which I coauthored with Mary Kellogg Rice and Jane Barton, discusses in detail an extensive collection of folk shibori techniques, the majority of which were developed in the Arimatsu-Narumi area.

The region of Arimatsu-Narumi established itself as one of the largest shibori-producing centers, with the patronage of the Owari feudal lord and a strong sense of cooperation and unity among the shibori merchant producers. There were, however, many other towns and villages that produced shibori for local needs, using indigo, which was the most effective and most colorfast dye for plant fibers. Shibori centers on the north coast of the Japan Sea include Shirone in Niigata Prefecture and Yokote and Asamai in Akita Prefecture.

In the late seventeenth and eighteenth centuries the shogunate encouraged trade along the western and northern coastal regions. Fish oil, charcoal, rice, kelp, and other products produced by these rural people were sometimes traded for worn or used cotton fabric and garments that merchant ships brought from Naniwa (present-day Osaka) and other urban areas of western Japan.[35] Textiles produced in the southern island of Kyushu, home to one of the oldest folk-shibori traditions, must have inspired dyers dwelling in coastal villages and towns. In the northeastern mountains of the Nanbu region, which corresponds roughly with Iwate and Aomori

prefectures, shibori was dyed in red and purple from locally available madder and gromwell roots, which were also used for medicinal purposes. In this out-of-the-way region where these colors had been used for centuries by the local people for their own clothing, the sumptuary laws forbidding red and purple had little relevance. The madder and gromwell dyes were often used for futon covers and baby clothes because of their medicinal benefits. Designs were created with simple folding, stitching, and binding.

Inhabitants of the Bungo region in Kyushu became well known for their production of Bungo shibori, of blue-and-white cotton, early in the Edo period. It was widely used in the area and was often acquired and brought home to other parts of the country by travelers along the sea route. Amagi and Chikuzen shibori were produced in neighboring Fukuoka Prefecture. There may be a connection between these folk-shibori traditions of Kyushu and the tenth-century shibori-dyed leather from Dazai-fu in Fukuoka Prefecture that is mentioned in the *Engi shiki*, but more research on this interesting topic is needed.

From its modest beginnings, shibori in Arimatsu and the neighboring towns of Narumi and Odaka (which has long been a source of labor for Arimatsu) grew into a thriving cottage industry that has continued unbroken to the present day. Shibori items became well known as "local products" and were popular as souvenirs among people traveling along the Tokaido, overshadowing shibori from other regions such as Bungo. The simple shibori process used by the villagers blossomed into a myriad of new techniques and a wide range of products. The primary fabric used was cotton, which had been introduced to Japan from China early in the fifteenth century and by the early seventeenth century was being grown and woven in warmer climates such as the Mikawa peninsula in Owari. The items were executed in simple yet ingenious and varied techniques (Figure 22) such as *kumo* shibori (spiderweb binding), *miura* shibori (looped binding), *makiage* shibori (crisscross binding), and *tesuji* shibori (hand pleating). The shibori industry in the Arimatsu area prospered, patronized by travelers of all classes, especially commoners, who were happy to have wonderful bold designs that were accessible because they were dyed in indigo on cloth made of plant fibers.

Figure 22. Various techniques. *Top to bottom: Miura* shibori (looped binding). *Tegumo* shibori (hand spiderweb binding). Detail of *mino* shibori (rain cape made of thatch; the entire cape is shown on page 40). *Kikaigumo* (tool-aided spiderweb binding). *Itajime* shibori (folded-and-clamped resist). *Mino* shibori is a type of *suji* shibori (pleated-and-bound resist), and a forerunner of modern shaped-resist clothing, wherein garments are first constructed, and then the cloth is shaped.

Increased sales and a greater variety of patterns led to the division of labor in the production of shibori in Arimatsu-Narumi. A strict division of labor had long been established in shibori production in Kyoto. There were those who bound or stitched or pleated the cloth, those who dyed it, and merchants who manufactured and sold it. The Owari feudal lord had given the villagers of Arimatsu the exclusive right to sell shibori and to put a stamp representing the approval of the clan on their products. The merchant producers of the village organized an association, set up quality controls, and agreed to cooperate for mutual benefit.

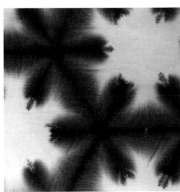

In the early seventeenth century, the Tokugawa shogunate adopted an isolationist policy. Foreigners were excluded from the country and regarded by the government as a threat to its control

of the social and moral aspects of Japanese life, as well as the economic and political stability of the country. During the two-and-a-half centuries of the Edo period, only Dutch traders, who had shown little or no interest in propagating Christianity in Japan, were allowed into the country. They were restricted to the island of Dejima at the head of Nagasaki Bay, which because it was man-made was not technically considered Japanese land. By the middle of the nineteenth century, however, the economic and technological changes taking place in the Western nations and their efforts at colonial expansion brought Japan's exclusionist policy to an end. Between 1854 and 1858, the United States succeeded in pressuring Japan into signing treaties to open more ports to trade. The British, Russians, and French followed suit, and Japan was opened to the outside world.

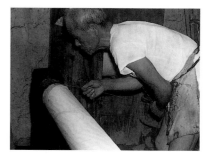

Figure 23. *Arashi* artisan Gintaro Yamaguchi working at the shibori pole.

In 1867 the shogun resigned in the wake of civil war. Demands from Europe and the United States, coupled with the deterioration of the feudal system, caused the Tokugawa family's dominance to crumble under the feet of the advancing imperial army. Significant numbers of *daimyo* and lower-ranking warriors who were dissatisfied with the Tokugawa reign and wanted the country returned to imperial rule helped propel social and political changes. Japanese imperial power, based on the religious or quasi-mystical belief in a divine lineage, had always been respected, even by the shogunate that had turned the emperor into a figurehead. The return of the emperor to real power in 1868 played a critical role in achieving national unity.

In 1868 the emperor moved from Kyoto to the eastern capital of Edo, which was renamed Tokyo. This was the beginning of a period of momentous change for the small island nation, a time of rapid industrialization and Westernization known as the Meiji period. With the change of the capital, Arimatsu lost most of the market for its shibori. The cessation of annual travel to Edo by *daimyo* and their retainers and the construction of a railway that passed through Arimatsu without stopping destroyed the advantages of its location. The villagers had to deal with competition from shibori produced elsewhere, as well as inflation and the unreliable buying power of consumers during this unstable period. In the face of this crisis, the artisans and shibori merchants of the Arimatsu-Narumi area became more inventive and a substantial number of techniques currently practiced in Nagoya were developed; these are believed to account for nearly half of the shaped-resist dyeing techniques that have been practiced in the world.

With the end of the feudal system Japan faced international competition and the challenge of ensuring the survival of Japanese sovereignty. Neighboring China, which Japan had emulated for centuries, fell prey to the British and French appetite for geographical expansion. Textile production in Japan underwent a transformation from an old-fashioned cottage industry to a modern industrial system. The most urgent concern of the new government was resistance to the Western encroachment that had already ensnared their country in a web of unequal treaties with various nations including the United States. Resistance required rapid industrialization and modern armaments. In the beginning of the new era, the government established strategic industry related to military defense, but this was soon followed by production of consumer goods, the most important of which was textiles.

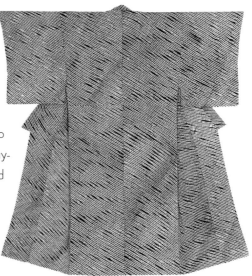

The textile industry provided the main fuel in Japan's race to catch up with the West. Textile—which encompassed sericulture, filature, and weaving—was the dominant industry in the first half of the twentieth century in Japan, just as transistor radios and automobiles were during the post–World War II era. In the 1920s Japan was the world's largest exporter of silk. As early as 1907, the country had recovered from a dark period caused by the internal turmoil of the Meiji Restoration and subsequent civil war, as well as wars against China and Russia. The economy improved and a positive Western influence permeated urban society. People felt more freedom

Figure 24. *At right, top to bottom:* Straight diagonal *arashi* pattern done by applying even, uniform pressure. *Arashi* plaid created by repeating diagonal stripes from the opposite direction. *Arashi chiri* pattern made by pushing the fabric on a pole while twisting. Detail from an *arashi* yukata, indigo-dyed cotton. Arimatsu. Early 20th c. (The entire yukata is shown on this page, above.)

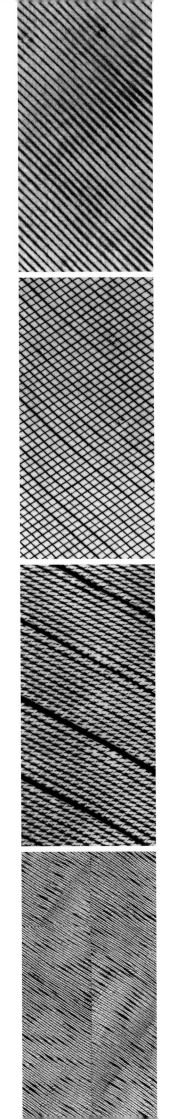

to express themselves, particularly in their taste for new styles of clothing. In provincial areas, however, far from urban influence, the traditional kimono was still worn on an everyday basis.

A typical example of the many innovations that appeared during this period of great social change in Japan is *arashi* ("storm") shibori, or pole-wrap resist, created by Kanezo Suzuki. He was born in 1837 into a shibori-producing family in Arimatsu and was just fourteen when he originated *shirokage* ("white shadow") shibori, in which fabric is stitched and pole-wrapped to produce a blue design on white ground. In 1880 he devised *arashi,* an ingenious way of creating patterns by wrapping long narrow cloth diagonally around a long pole, pushing it into tightly compressed folds, and immersing it in a long vat of dye. The resulting allover patterns with mainly diagonal orientation can be varied or combined to create myriad new designs, and became very popular for men's *yukata* (summer kimono), *juban* (under-kimono), and other articles of traditional clothing.

In early Meiji, Japan was undergoing industrialization and seeing a remarkable influx of Western designs. Suzuki responded to the social and economic changes of the day by developing his version of industrial equipment—a huge wooden pole with a marginally mechanized crank and a guide thread to regularly space the winding of the resist thread over the pole (Figure 23).

This method increased production at least tenfold over other shibori methods. At one point there were over four hundred different patterns being created and many *arashi* studios employed a large number of men, since handling the long, heavy poles required strength. The *arashi* shibori patterns created by Suzuki and his fellow artisans were quite different from traditional shibori effects (Figure 24) and reflected a new responsiveness to the changing taste of the people, who were making a transition from a feudal system to a more Western-style, open society. Eventually, however, modernization influenced the clothing worn by the Japanese—especially men, who were quick to adopt Western-style garments—causing a drastic decline in demand for *arashi* shibori cloth.

Other small manually operated machines and tools were invented to bind cloth for the spiderweb pattern and for pleating, and even to help pattern cloth using a hook, which was an efficient and effective way to simulate the famed *kyo kanoko* shibori. Between 1902 and 1921, the annual production of Arimatsu shibori reached its peak at 1,200,000 *tan* (a *tan* is a bolt of kimono cloth 35.6 centimeters wide and 11.5 meters long/14 inches wide and 12½ yards long). In the 1930s, some area producers began producing fine silk shibori, which was considered Kyoto's specialty, at a lower cost. The use of chemical dyes on silk became prevalent, but Arimatsu continued to use indigo on cotton as well.

The shibori of Kyushu had evidently remained in regional use through the Edo period and the subsequent Meiji era. Beginning in 1912, Kyushu shibori cloth made at Amagi was exported to Korea, Taiwan, Singapore, and even Africa. In 1935, Arimatsu merchants were approached by a U.S. trading company based in Kobe and asked to make shibori cloth suited to African tastes—specifically, the wide cloth commonly used for African garments. The Arimatsu producers used binding, stitching, and pleating to create boldly patterned cloth in red, yellow, green, or combinations of those colors, at times overdyed with natural indigo, which was preferred in Africa over chemical dyes. A profitable trade resulted and continued until the outbreak of the Sino-Japanese War in 1937. Trade with Africa was reestablished briefly after World War II, through the same trading company, to serve a market in the uranium-rich Belgian Congo. The influence of Japanese shibori upon African shibori processes and patterns has yet to be fully researched.

Several major typhoons hit the Nagoya area in the 1950s and early sixties, crippling many shibori dyers by destroying their indigo vats. This was an added blow to the *arashi* shibori studios, which had been struggling economically because of the rapid decline in demand for traditional kimono items, especially for everyday wear. The only remaining *arashi* artisans were Gintaro Yama-

guchi and Reiichi Suzuki. When Yamaguchi passed away in 1972, shibori manufacturing houses like Takeda and Matsuoka recognized that the kimono market had shifted to more expensive, special-occasion wear and began to apply *arashi* processes to silk for kimono and later to men's neckties in addition to the traditional *yukata* (summer cotton kimono). The Aichi prefectural government gave Reiichi Suzuki, the only remaining *arashi* artisan, a subsidy to train a successor, and his son, who was at the time an office worker, began learning this craft from Suzuki on weekends.

Since the elder man's death in 1990, the younger Suzuki and Kaei Hayakawa, another younger shibori artist/craftsman who was also trained by the elder Suzuki, are the only artisans left to continue the tradition in Japan.

In order to cope with rising labor costs, shibori producers had gone to Korea as early as the 1930s to train artisans for more complicated processes such as stitching, small knotting, and capping. After Korea achieved economic prosperity, the production base moved to China. By the end of the 1980s much of the skilled labor for shibori production was carried out in China.

Meanwhile, after World War II, Western dress was adopted almost universally by Japanese women, although the kimono is still sometimes worn on formal occasions. This development—combined with the reluctance of many young people to carry on traditional crafts and with competition from machine-printed cloth—led to a decline in production by the late 1970s. Demand remained high for expensive luxury items, including shibori silk kimono, when Japan was enjoying the so-called "bubble economy" of the 1980s. However, the wearing of formal kimono, even for special occasions, began to decline sharply in the late 1990s, to the point that the shibori producers remaining in operation today are limited to a few large establishments in Nagoya and several smaller ones in Kyoto and the Nagoya area.

Aware that the survival of their livelihood and centuries-old craft tradition is in danger, some of the younger-generation shibori producers and artisans are making efforts to preserve the tradition and to broaden its market inside and outside Japan. Since the introduction of shibori in the United States in 1975, the publication in English of a definitive book on the subject in 1983, and the start of the International Shibori Symposium in 1992, there has been a new awareness of the tradition of innovation in patterning cloth using shaped-resist methods. This awareness has spread from the small towns of Arimatsu and Narumi in Japan, and connected with the shibori traditions in North and South America, Europe, Asia, and Africa. The crossover is felt in regions that have an ongoing shibori tradition, countries without any history of shibori activity, and cultures where shibori traditions once existed but have been lost. It is as if the seeds of shibori years ago were sown in different kinds of soil and nurtured by the enthusiasm and ingenuity of all who understand the process, and now have blossomed into an array of beautiful and sometimes wild flowers.

With the knowledge of ancient skills and the respect for the innovations of their forebears, contemporary artists and artisans around the world are revitalizing their shared cultural heritage. Amid today's amazing technological developments and increasingly pervasive information network, the tactile quality of textile has become that much more essential. Like other forms of textile expression, shibori will survive and even thrive, as long as artists continue to search for the creative possibilities in combining high-tech with handwork.

A quiet revolution against unimaginative mass-produced commodities, brewing over the past few decades, has generated widespread appreciation for hand-dyed and textured fabrics. Amid the rise of bohemian artist colonies and the counterculture of the 1960s and 1970s, American youth, inspired by ethnic arts and handicrafts, adopted as their emblems tie-dye and batik. London led the European counterculture scene with Carnaby Street fashion, which included Victorian-style costume and handcrafted textiles such as crochet, batik, and tie-dye. In 1972 New York's Museum of Contemporary Crafts presented "Fabric Vibrations: Tie-and-Fold-Dye Wall Hangings and Environments."[36]

In the fine arts many painters began to move from oils to acrylics and to focus on the visceral pleasures of the medium—dripping, pouring, or spraying thinned paint onto absorbent unprimed canvas to create blurred or feathered shapes and large areas of vivid, translucent color that evoked a deep emotional response. Stain painters like Sam Gilliam created sculptural surfaces, crinkling and creasing or folding the canvas, then using pigments and paints to record the shape. Process, especially accident and serendipity, was of prime importance, reflecting the openness and spontaneity that pervaded society. The passionate interest of North American artists propelled shibori's development from a handicraft to an art form. These artists' hunger for discovery and creative experimentation was enhanced by the 1976 publication of *The Dyer's Art: Ikat, Batik, Plangi* by Jack Lenor Larsen and the publication in 1983 of *Shibori,* which I coauthored with Mary Rice and Jane Barton.[37]

Surface design in Europe evolved from batik and silk painting in the early 1970s to include shibori and *rozome,* a revival of Japanese wax-resist dyeing. The growing number of artists exploring shibori processes in Europe, Scandinavia, and Australia since the mid-1980s is largely the result of workshops and exhibitions.[38] Hélène Soubeyran organized the first contemporary shibori art exhibition in Europe in 1983.[39]

In 1989 Grethe Wellejus, who has taught widely in Europe, published a book in Danish, *Shibori: Reserveingsteknikker* (Shibori: Resist-dyeing technique), which has been used extensively in Scandinavia as an introduction to shibori. Norwegian Trine Mauritz Ericksen conducted extensive research on Japanese *itajime* (folded-and-clamped resist) shibori and incorporated this process into her own artwork, using wool. She has inspired many Scandinavian fiber artists through her teaching. Danish chemist Joy Boutrup reintroduced industrial formulas, which were welcomed enthusiastically and gradually incorporated into the curriculum of textile art education. During the early 1990s she and Jason Pollen, a driving force in the Surface Design Association (SDA),[40] taught workshops together that were attended by many leading fiber artists and teachers. Soon there was a surge of interest in North America in adopting industrial processes. Shibori is a logical choice for resist patterning and texturing a wide variety of fabric using modern techniques, as demonstrated in the last chapter of this book, "Modern Techniques."

Top of page: Trine Mauritz Eriksen. "Storbylys" (Big City Lights). Detail. 1999. Photo by Øystein Klakegg.

In Japan, industrial processes also fell into disuse and were later revived. After World War II, shibori artisans in the Arimatsu-Narumi area and printers in Tokyo and Kyoto reintroduced and actively used methods such as dye discharge and dévorée[41] in their quest to produce "new looks" in fabric design. With diminishing demand for the kimono, the economic survival of shibori crafts-people and merchants depended on reevaluating the changing needs of society and developing products that could contribute to modern Japanese life. They decided to organize the first International Shibori Symposium (ISS) in Nagoya in the fall of 1992[42]—to look outside their region and even outside their country for inspiration. Meanwhile a growing interest in surface design had inspired artists and students of textiles in the West to learn more about shibori. This timely international gathering and celebration of creative explorations in shibori was welcomed by all.

The theme of the symposium was redefining shibori as a process of manipulating two-dimensional fabric into three-dimensional shapes, an aspect of the shibori process that artists have responded to most enthusiastically. The proceedings included a wide variety of presentations—from a chemical engineer talking about a type of metal that contracts when heated and relaxes when cooled[43] to recipes for dyeing with natural materials and presentations by Chinese, Indian, and African shibori artisans of their indigenous processes. The quality of the conference was so high and the participants' experience so memorable that many organizers and members felt it important to continue the dialog by founding the World Shibori Network (WSN) in December 1992.

Figure 25. Cotton damask folded, machine-stitched, and dyed by Awa Cissé. Mali. 1999.

Many regions in western and northern Africa have unique and tremendously vibrant traditions of shibori textile production from raffia, cotton, and wool. Despite social and economic instability arising from conflict between changing political regimes, shibori artisans have continued to practice their craft; this has been possible in part because shibori requires minimal equipment, tools, or materials. During the past few decades, West African artisans have ingeniously incorporated modern sewing machines into shibori production. Using tightly woven, fine cotton cloth, they machine-stitch on layers, which results in pockets that the dye does not fully penetrate. In this way dyers are able to create a wide range of light and dark shades, sometimes almost white in areas that are not fully dyed and oxidized (Figure 25).

India and Indonesia are vibrant centers for fashion apparel and textile production in Asia. Local designers successfully translate traditional processes like shibori, ikat, appliqué, and embroidery into contemporary fashion. In addition, numerous foreign designers and manufacturers incorporate traditional craftsmanship and design into products for the international market. Allegiance to traditional clothing styles ensures a strong, steady local market largely unaffected by the fluctuations of high fashion.[44]

In countries where shibori traditions endure as a vital cottage industry, efforts have been made to apply the craft not only to Western fashions for export but also to developing products for home furnishings. Translating traditional craft processes into mainstream products, however, is not as easy as it might seem. Immersed in the relatively unchanging furnishings of their traditional culture, local artisans are not sufficiently familiar with the amenities of contemporary lifestyles to compete with designers from industrialized nations. Collaboration seems to be the key to success. For example, innovative Western designers like Jack Lenor Larsen and Jurgen Lehl work with local producers to incorporate ancient processes like shibori and ikat in the creation of contemporary fabrics for home furnishings, a field that awaits more creative input from dyers.

Since the International Shibori Symposium in Nagoya in 1992, Japanese fashion designers

have been collaborating with shibori manufacturers. They cope with the constant demand for a new look by exploring an endless flow of possibilities in yarn, cloth, and fabric treatment processes.

In the fiber arts field in Japan many artists have been greatly affected by the achievements of Motohiko Katano (1899–1975), a painter-turned-dyer who created a body of sublime shibori work during the last twenty years of his life using indigo and other natural dyes. Guided by Soetsu Yanagi, leader of the *mingei* ("folk craft") movement,[45] Katano recognized the beauty of the humble art of Arimatsu-Narumi shibori. Many of his techniques were inspired by shibori craft traditions from the area where he lived, in Nagoya. One such process, now popularly called *katano* shibori, produces a repeating pattern across the width of the cloth in variegated colors, white lines, and areas resembling soft airbrushed tinting (Plate 15). His work leaves an indelible mark on contemporary shibori art, and his legacy is being continued by his daughter, Kaori Katano.[46]

The second International Shibori Symposium was held in 1996–97 in Ahmedabad, India.[47] Three exhibitions were held at India's National Institute of Design,[48] and several Indian designers, most notably Asha Sarabhai, showed superb examples of clothing, seamlessly combining their understanding of the centuries-old techniques of *bandhani* with a sophisticated sense of contemporary fashion.

The workshops on high-tech shibori processes taught by Japanese designers and artisans were enthusiastically received by all participants, including traditional Indian craftspeople. The workshops on Indian *bandhani* (bound-resist rings) and *laharia* (coiled-and-bound resist) were received with equal enthusiasm and attended by many non-Indian participants. Despite many constraints, the symposium was a remarkable success. Devoted students, faculty, and volunteers broke down barriers and forged alliances between the traditional artisan and contemporary artist, craft and art, personal exploration and industrial commercial work, scholarship and science, student and teacher, developed and developing country, and textile maker and textile enthusiast.

Although tie-dye of the hippie era symbolized a nonconformist lifestyle, high-fashion houses purveyed the same look to the wealthy. The Fashion Institute of Technology in New York owns actress Lauren Bacall's evening dresses by Halston and a few more Halston pieces dyed by Reiko Ehrman (Plate 16), whose hand-dyed fashions also appeared in ads in numerous major magazines.

Out of the 1970s milieu, with its concern for expressing individuality and demonstrating appreciation of quality craftsmanship and design, emerged a desire for adornment in unique, creative, and vociferous body wear. Many celebrities, such as Sonny and Cher and Elton John, patronized wearable art businesses. Most of the artists included in this book owe a good part of their career success to two visionary women. In 1973 Julie Dale established Julie: Artisans Gallery in Manhattan and Sandra Sakata opened Obiko in San Francisco. Julie and Sandra handled a wide variety of clothing and accessories from over two hundred artists, at first mainly North American, and later international; Sandra's work is now being carried on by Monique Zhang.

Shibori has gradually become an important part of the development of high fashion in Japan and wearable art in North America. The rich sensuous colors and pliability of the material respond well to the movement and flow of the body. The three-dimensionality of the clothing adds complex visual effects. Works of wearable art have been shown in galleries patronized by socialites, celebrities, and others who appreciate fine art and craft. Some of the pioneers in the early tie-dye phenomenon in North America, such as Marian Clayden and Carter Smith, have continued their work into the new millennium.

Costumes in the theater have also found shibori expressions—in Japan, Australia, Italy, and the United States. In the late 1960s the Broadway musical *Hair* commissioned Marian Clayden to create

hundreds of yards of tie-dyed fabrics for the stage. More recently, in the early 1990s, Joan Morris, a dyer for the Dartmouth College Theater Department, used laborious traditional stitch-resist and bound-resist shibori processes in vibrant colors to create innovative fabrics for costumes in the "Can You Feel the Love Tonight?" scene of the Broadway musical Disney's *The Lion King*. The scene evokes the delight of the jungle with fantastical flora and fauna created by the shibori textures (see page 71).

In the United States and Canada, the folk tradition of quiltmaking and patchwork has gradually gained the status of a legitimate form of creative statement, and many quilt artists, most notably Jan Myers-Newbury and Judith Content, have been exploring the potential of shibori to produce effects quite different from the sharp edges seen in solid color or printed cloth. Shibori has an inherent dimensional quality, due to its enormous range of dark and light. Slight changes in the placement or orientation of the shibori pattern as the patterned pieces are joined create subtle shifts in the dynamic of each plane. Adding an element of shibori can greatly increase the creative range of artists in a variety of fields. Katherine Westphal, who was a leading artist in surface design before the field was even defined, took an early shibori workshop that I led. For years she has been incorporating images of her shibori-dyed fabric in her paper kimonos and collaged gourd vessels (Figure 26).

The third International Shibori Symposium was held in the fall of 1999 at the Museo Nacional de Bellas Artes (MNBA) in Santiago, Chile, on the theme "Tie-and-Dye or Shaped-Resist Dyeing in Pre-Columbian Textiles." The presence of major wearable art and surface-design artists at this gathering attests to the important role that the art of shibori has played in establishing the dyer's art as a serious and legitimate creative expression in the world.

Figure 26. Katherine Westphal. "Midsummer." Gourd. Collage with shibori images transferred on paper. 1989.

The imaginative works in the three exhibitions held concurrently at the MNBA,[49] and presented at the remarkable fashion show, evolved out of the individual shibori experimentation and interpretations of contemporary artists. These eye-opening creations left strong impressions on the viewers, and especially on the Chilean audience, who had had little exposure until then to fiber art, not to mention shibori.

A group of Chilean researchers presented a study on "Color Images of the Andean Dyer," which was enhanced by the seminal exhibition of pre-Columbian shibori, "La Amarra en los Textiles Precolombinos," at the Museo Chileno de Arte Precolombino (MChAP) in Santiago.[50] This was the first time in the study of pre-Hispanic textiles that an exhibition had focused on *amarra* and addressed the origins and applications of this previously neglected textile art. Scholars and artists alike were stimulated to study, preserve, and promote the renewed growth of the *amarra* tradition. A group in North America aims to study the shibori process by replicating the ancient textiles.[51]

Fascination with the roots of shibori and the potential inherent in its modern technological application is shared by a very diverse community of practitioners—from artists working in sculptural forms or installations to designers creating costumes or wearable art. Many of them collaborate, empower, and inspire one another despite their different languages and different cultural roots. Viewing each other's work and exploring their differences sparks innovation and strengthens the vitality of their separate traditions. Some of the artists and artisans whose works are presented in this book are from countries with living shibori traditions, while others are from countries where the absence of tradition has generated a passion for the exploration of new craft media. It is my hope that *Memory on Cloth* will bring to public attention the depth and beauty of contemporary shibori and contribute to the dialog that is already taking place.

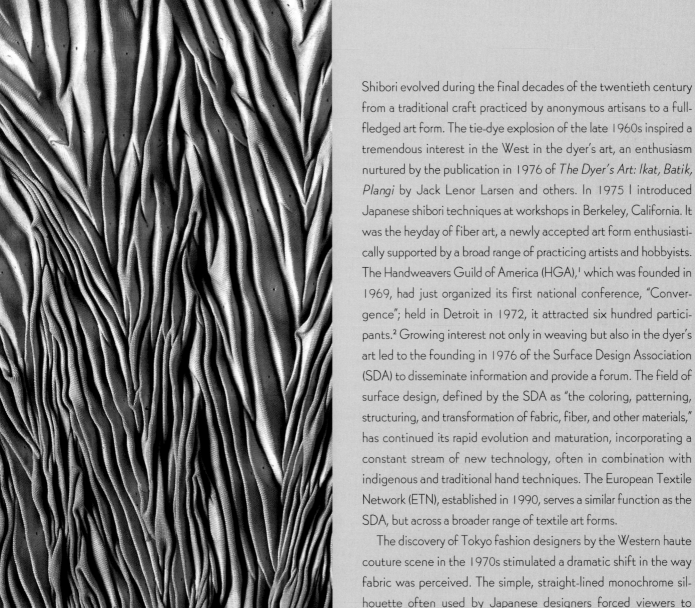

Shibori evolved during the final decades of the twentieth century from a traditional craft practiced by anonymous artisans to a full-fledged art form. The tie-dye explosion of the late 1960s inspired a tremendous interest in the West in the dyer's art, an enthusiasm nurtured by the publication in 1976 of *The Dyer's Art: Ikat, Batik, Plangi* by Jack Lenor Larsen and others. In 1975 I introduced Japanese shibori techniques at workshops in Berkeley, California. It was the heyday of fiber art, a newly accepted art form enthusiastically supported by a broad range of practicing artists and hobbyists. The Handweavers Guild of America (HGA),[1] which was founded in 1969, had just organized its first national conference, "Convergence"; held in Detroit in 1972, it attracted six hundred participants.[2] Growing interest not only in weaving but also in the dyer's art led to the founding in 1976 of the Surface Design Association (SDA) to disseminate information and provide a forum. The field of surface design, defined by the SDA as "the coloring, patterning, structuring, and transformation of fabric, fiber, and other materials," has continued its rapid evolution and maturation, incorporating a constant stream of new technology, often in combination with indigenous and traditional hand techniques. The European Textile Network (ETN), established in 1990, serves a similar function as the SDA, but across a broader range of textile art forms.

The discovery of Tokyo fashion designers by the Western haute couture scene in the 1970s stimulated a dramatic shift in the way fabric was perceived. The simple, straight-lined monochrome silhouette often used by Japanese designers forced viewers to notice the subtle details in the materials. The extraordinarily dynamic qualities of the fabric used—heavily textured, matted, torn, frayed—sparked a new appreciation for the expressive power

Hiroshi Murase. Gangi mokume shibori on polyester.

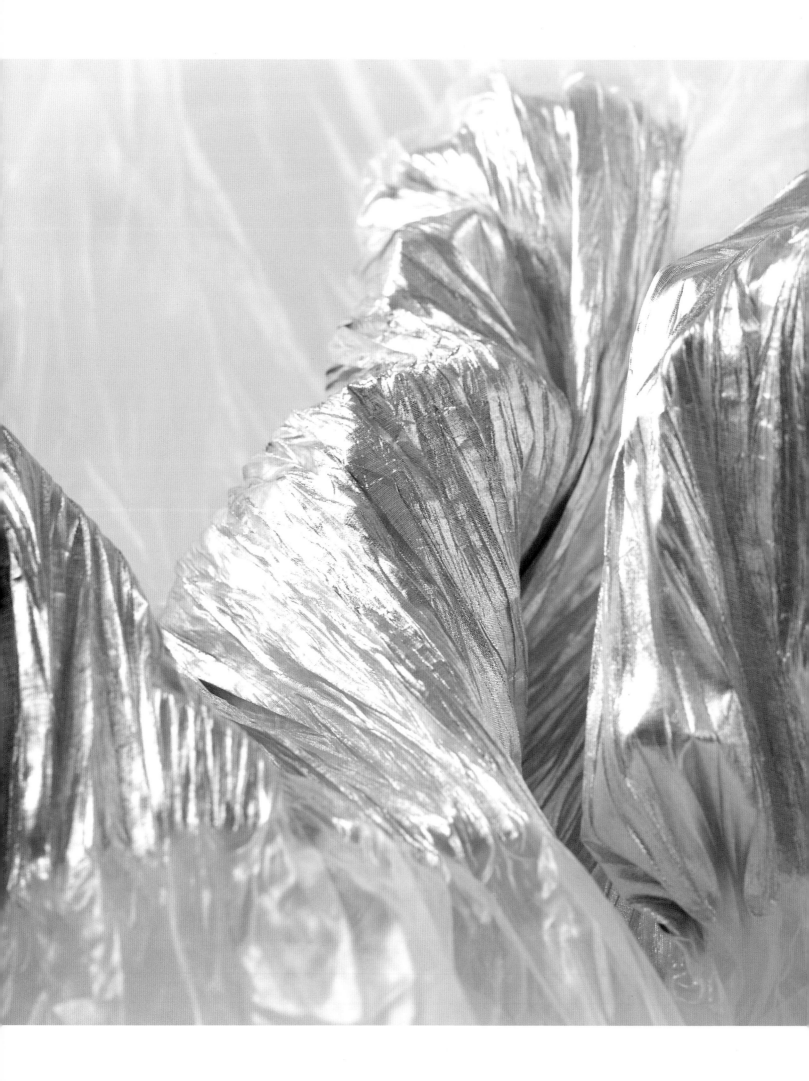

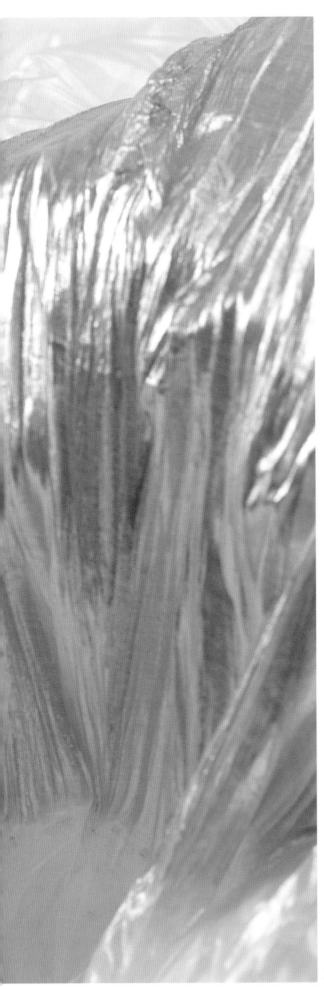

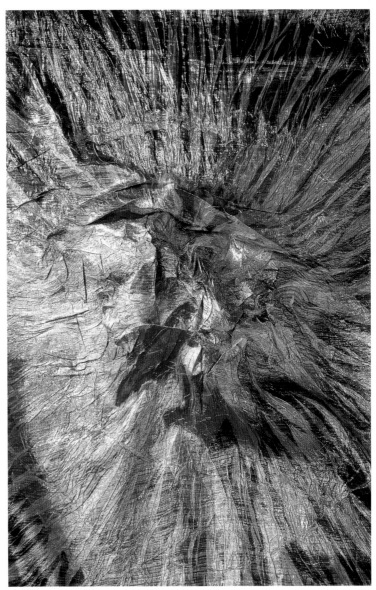

Plate 18. Jun'ichi Arai. Bound resist, melt-off, and repeated heat-transfer using different colors. 1997.

Plate 17. Jun'ichi Arai. Silver patterns on a transparent ground created with bound resist and melt-off on 100% polyester. 2000.

inherent in fabric and a new respect for the artistry of the textile designer, who has traditionally been overshadowed by the fashion designer.

The primary function of Japan's centuries-old shibori tradition was to embellish silk garments, often multicolored, worn by the privileged classes. Simple, bold folk garments of cotton or hemp patterned in indigo blue-and-white became popular in the last three or four hundred years. Japan's adaptation and emulation of Western models, however, led to a serious decline in demand for traditional Japanese clothing. The collapse of the kimono industry combined with the shrinking of Japan's "bubble economy" during the late 1980s and early 1990s motivated textile makers and designers to reach beyond their habitual practices—to explore and experiment with new materials and processes and to network and collaborate with experts in other fields (some of the most striking examples are seen in the textile and fashion designs covered in this and the next chapter). The first International Shibori Symposium in Nagoya in 1992 attracted artisans and artists from around the world. Presentations of high technology alongside demonstrations of indigenous techniques contributed to the shift in thinking and practice from traditional craft for embellishment to using the shibori process to transform fabric and reveal its expressive potential.

Since the late 1980s the proliferation of new routes of information, including e-mail and the Internet, has enabled people to learn about and network with one another more easily. Access to a showplace in cyberspace gives individual artists and groups the opportunity to express their vision and fosters collaboration among artists from different countries. This democratization of the worlds of commerce and art helps artists, artisans, and designers transcend political and geographical barriers. A good example is the Centre de Recherche et de Design en Impression Textile de Montreal (CRDITM) (Center for Textile Printing Research and Design), commonly known as Centre de Design & Impression Textile. It was founded in 1985 by Canadian silkscreen print designers Robert Lamarre and Monique Beauregard. In 1997, the center established a heat-transfer printing studio, Editextil, which gives artists and designers access to a large dye sublimation installation comprising an electrostatic paper printer, a heat press, and technical assistance including help with computers. Some of the U.S. artists featured in this book are listed on the bilingual web sites of Editextil and CRDITM, where they have worked, taught, or exhibited. The World Shibori Network (WSN), a grassroots organization of shibori artists, artisans, and scholars around the world, is using its Web site not only to disseminate information about shibori but also as a platform for shibori practitioners to show their work, share research projects, and confer on techniques, materials, and supplies.

"The appeal of shibori is that the process is immediate, expressive, honest, and unpredictable each time."
—Jun'ichi Arai

The fabrics created by the artists featured in this chapter demonstrate the diverse approaches to the resist-dyeing process and the great variety in its tactile expression. That half the artists in this chapter are working in Japan is not due simply to the fact that shibori originated there. Japan, where textile is considered one of the oldest and most essential art forms, continues to offer artists and designers many opportunities for innovation and creative work.

JUN'ICHI ARAI, one of the most technologically innovative textile designers anywhere, was born the oldest son of a weaving factory owner in the traditional textile town of Kiryu. He worked in his father's kimono textile factory while auditing textile engineering courses and reading widely. In the mid-1950s, Arai became intrigued by the synthetic gold yarns introduced in Kiryu for weaving lamé and gold brocade. He eventually received thirty-six patents related to metallic yarns, which took him to Mexico to train workers and consult on manufacturing at the textile factories there. His travel throughout that country whetted his appetite for colorful pat-

terns and traditional ritual objects and cultural practices; in Arai's case this appetite is combined with an equal hunger for the latest advances in technology and engineering. These two seemingly divergent impulses merge seamlessly in his work.

In the 1970s, Kiryu was one of the first traditional weaving centers to embrace the computer technology integrated into jacquard looms. Arai again became absorbed in the new technology and found ways to incorporate it into traditional textile processes such as filature and finishing to create surprisingly unconventional textiles. In the 1980s fiber engineering, including improvements to polyester and other synthetic filaments, provided a new forum for the textile industry, scientists, and designers to spur each other on with creative impulse and innovation. Arai designed textiles that had not existed before, combining complex weave structures created on computer with the latest filaments, such as ultrafine film yarn vacuum-coated with aluminum or titanium, as well as new finishing treatment processes, such as holographic coating or polyamide coating on metallic yarn that enabled it to take acid dye.

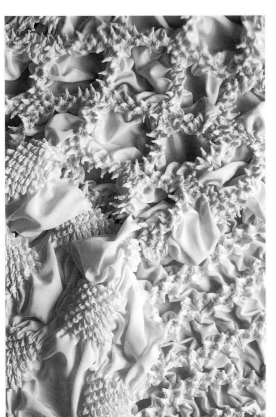

Plate 19. Hiroshi Murase. *Miura* and *kikaigumo* shibori and heat-setting on poly crepe de chine.

Arai has pioneered the unexpected use of traditional shibori process, using metallic polyester fabric of his own design where, instead of dyeing shibori-resisted cloth, he uses a mild lye solution to melt off the aluminum coating on the polyester film yarn, creating a silver pattern against a transparent ground (Plate 17). The fabric shown on page 162 is another interesting example: woven with thirty-five percent nylon film yarn with aluminum coating and sixty-five percent wool, it is bound resisted but, unlike conventional shibori, it is first treated with lye solution to melt off the metallic coating, and then dyed and fulled by being thrown in a washing machine with hot water and tumbled. The resulting shibori cloth has shiny reserved areas against textured and matted areas that sparkle slightly with nylon yarns. The contrast between the wilder matted woolen surface and the sleek cold metallic cloth is surprising.

Such unconventional combinations of shibori and modern technology have been explored since the 1980s by shibori artisans in Japan.

HIROSHI MURASE, an artisan in Arimatsu, a town that grew up since the early 1600s around the cottage industry of shibori, is well versed in traditional shibori techniques. He uses *gangi mokume* (chevron-, or zigzag-, patterned) shibori (page 49), simply applying parallel running stitches in continuous V-shaped lines on polyester fabric, which is then dyed and heat-set. The cloth retains the fine pleats created by the stitching; the pleats interact with and enhance the dark and light of the resist pattern, translating a traditional pattern into completely modern material.

TSUYOSHI KUNO, another artisan from the shibori center of Arimatsu, has been avidly seeking information and materials to transform the age-old craft and adapt it to the contemporary paradigm. He modernized his family dyeworks with industrial machines and equipment, including a high-pressure and high-temperature chamber that allows him to process polyester. When he collaborated successfully with the fashion house Nicole in the early 1990s, his studio produced 8,000 meters (approximately 8,800 yards) of shibori-dyed fabric for the collection in the span of just a few weeks. Kuno's fabric in Plate 26 is resisted using the straightforward bound-resist process of *kumo* shibori; however, the choice of material—fifty-six percent wool, thirty-one percent mohair, and thirteen percent nylon leno weave—and the treatment process of fulling produce a fabric with an unusual combination of lightness and density. Again in Plate 27, Kuno exhibits his virtuosity in dyeing and in combining unusual and complex fabrics, using a lightweight challis woven with polyester filament core yarns wrapped with wool filament,

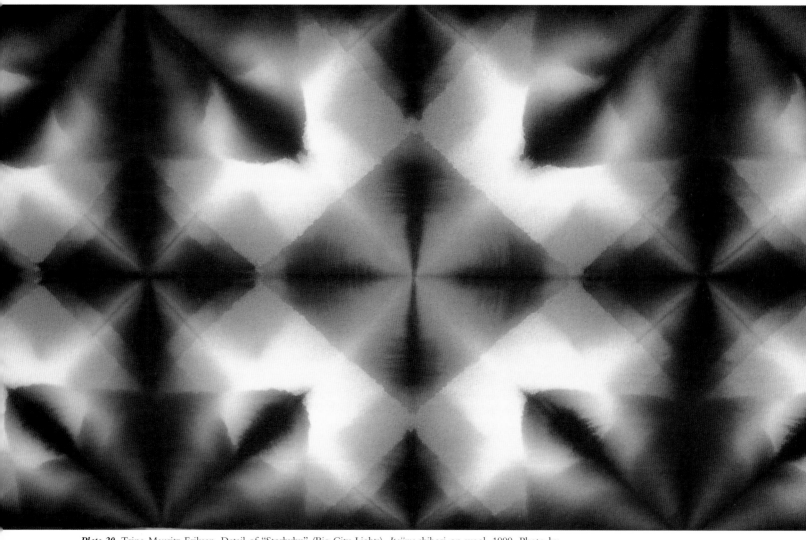

Plate 20. Trine Mauritz Eriksen. Detail of "Storbylys" (Big City Lights). *Itajime* shibori on wool. 1999. Photo by Øystein Klakegg.

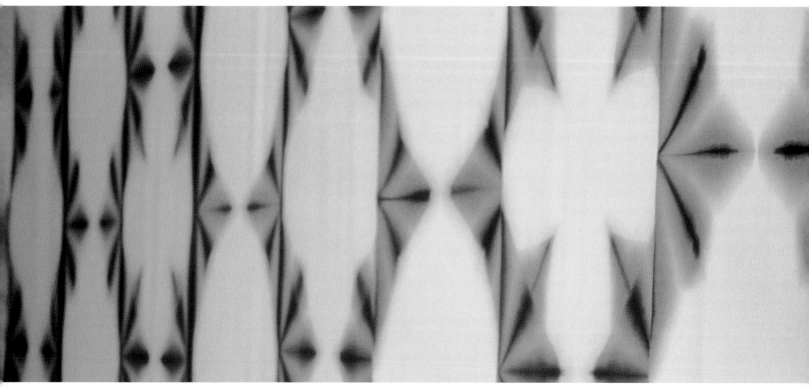

Plate 21. Trine Mauritz Eriksen. Detail (from an oblique angle) of stage curtain "Sentrum og Periferi" (Center and Periphery; for complete view, see Plate 23.) *Itajime* shibori on wool. 2000. Photo by Morten Løberg.

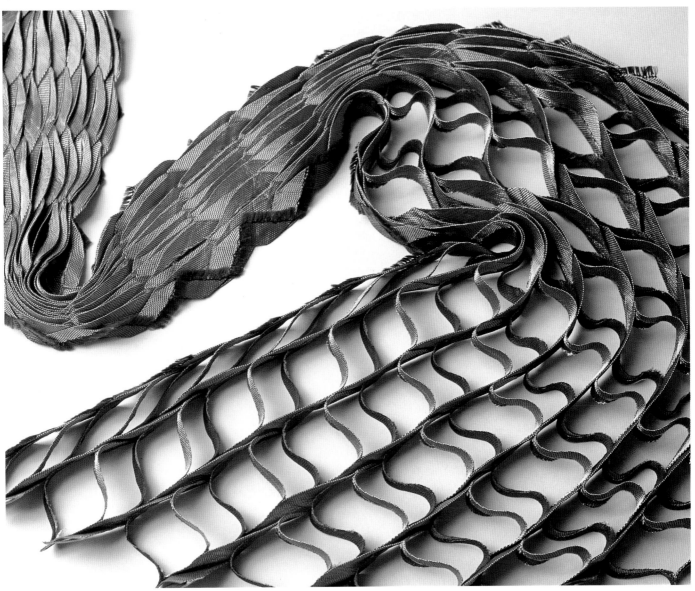

Plate 22. Elisa Ligon. "Pleat and Slit." Scarf. Pleated, heat-set, and slit silver polyester. 2000. Photo by Elaine F. Keenan.

and doing one shibori process over a different one. Younger artisans like Murase and Kuno are reaching out for alternative creative venues—collaborating with fashion designers, theater costume designers, and makers of home furnishings—all of which lead to worlds outside their own tradition.

Application of shibori to larger-scale interior furnishings is not as simple as just enlarging the scale of patterns, because traditional shibori techniques are based on handwork and depend upon the proportions of the human hand and body. Therefore, the successful translation of traditional *itajime* shibori by TRINE MAURITZ ERIKSEN in Norway into large-scale wall panels and stage curtains commissioned for public spaces is quite noteworthy (Plates 21 and 23). In Norway, commissioning artwork for public spaces is a relatively recent phenomenon, and the inclusion of craft art alongside pictorial fine art is an important development. While creating her artwork she has continued to teach and to pursue her study of ancient Japanese craft; in all these ways she has made an indelible mark on Norway's cultural and educational scene.

In the early 1990s, Mauritz Eriksen began her extensive study and experimentation in *itajime* shibori; she originally used silk georgette, which readily absorbed the liquid dye, making it easy to manipulate shapes and achieve consistent patterns. Eventually she discovered a type of wool felt that suited her artistic intentions. Its thickness and density were the opposite of what she was accustomed to, and at times shaping and resist dyeing it seemed almost impossible. Nevertheless she took advantage of this limitation, carefully planning and building colors and geometric patterns into the material. Typical *itajime* shibori patterns are based on folding a length of cloth to yield hexagonal and octagonal images, which are called *sekka*, meaning "folded flower," or *asa no ha*, meaning "hemp leaf." Norwegians see in them motifs that are akin to the traditional Norwegian pattern of an eight-petal rose found in old woven coverlets and hand-knitted articles.

"I keep the evidence of my contribution to the material to a minimum. I do not work in or on the textile, but *with* it. Inventiveness and planning become important elements in the working process all the way through to the final result."

—Trine Mauritz Eriksen

The wool felt, which is appropriate for the Norwegian climate, is clamp resisted using pairs of large wooden forms. Mauritz Eriksen then expertly guides the permeating dyes—creating depth and breadth in the monochrome by layering several different colors, sometimes achieving a black as seen in "Storbylys," which was awarded the Applied Arts Prize in 1998 (Plate 20).

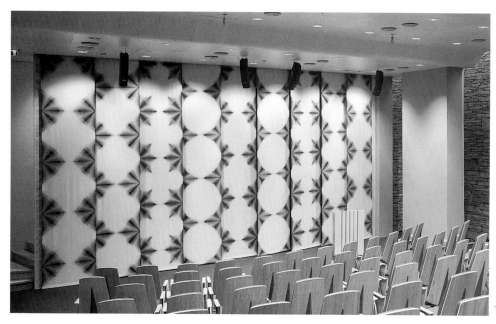

Plate 23. Trine Mauritz Eriksen. Stage curtain, "Sentrum og Periferi" (Center and Periphery). *Itajime* shibori on wool. 9 x 4.5 m. (30 x 15 ft.) Photo by Øystein Klakegg.

Plate 24. For her large-scale works, Trine Mauritz Eriksen often makes life-sized cartoons by drawing replications of *itajime* shibori images on paper with a charcoal.

Her patterns pulsate and draw the viewer into the depth of each design module, into a world of intense monochromatic subtlety. Mauritz Eriksen takes no chances in enlarging her visual elements for a large-scale architectural commissioned work. She prepares her design in full scale in her studio, drawing with a charcoal stick, which is an unusual practice for a dyer (Plate 24). As Mauritz Eriksen explains, "The laws of geometry and color chemistry are decisive; the entire process is thought out in advance. When the proper technique has been found and I am satisfied with the quality of the water, the color, and the material itself, then the degree of penetration of textile by the dye, for instance, can be controlled automatically, almost mechanically. The process must of course be stopped exactly at the crucial moment, the moment when the beauty, complexity, and depth of the work emerge at their peak."

The geometry explored in the *itajime* shibori work by Trine Mauritz Eriksen finds a counterpart in the work of ELISA LIGON, who approaches *nui* shibori (stitch resist) using a grid.

However, unlike classical stitch resist, which is dyed, Ligon shapes the cloth into various pleats by stitching and heat-setting the shapes (Plate 22), which are sometimes machine-stitched after the hand-stitching is removed. This results in cloth that can be folded flat or opened to reveal an accordion-like three-dimensional form or a kinetic, stretchable textile (see also Chapter 4, Plate 127). In "Salsa Series #1" (Plate 25), a piece of red polyester chiffon is layered, around the outer edge, with black polyester organza. Because of the high heat used to set the pleats, the black of the organza sublimates onto the red chiffon, leaving an impression that is revealed by cutting away some of the organza fabric. Ligon notes, "I start from a grid structure. But like jazz, the structure allows me the freedom to improvise new variations of form."

This process of sublimation dyeing with disperse dyes became commercially viable in the late 1960s and has been gaining popularity in printed textile production, particularly in recent work by artists who use dye-transfer images generated by computers. The ingenious use of sublimation dyeing with unique shibori processes is exemplified in "Tsumami" (see page 157), produced by NUNO Corporation under the direction of REIKO SUDO, as well as in Jun'ichi Arai's work in Plate 18. In "Tsumami," a paper stencil with slits is used to push and pull polyester chiffon selectively through the slits, creating a kind of quick shibori process without laborious plucking and binding; this is ideal for multiple production. The paper form used for shaping the fabric provides a resist that keeps the dye from coloring the cloth beneath it. Arai's sublimation piece, on the other hand, is constructed more intuitively. Like a painter, Arai applies successive layers of shaping and coloring to produce a rich, complex surface pattern. The polyester metallic fabric is plucked and shaped and colored

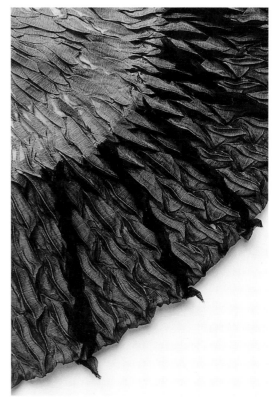

Plate 25. Elisa Ligon. "Salsa Series #1." Scarf of red polyester chiffon and black polyester organza. Hand-stitching, heat-transfer, sublimation, and cutting away the black organza. 2001. Photo by Elaine F. Keenan.

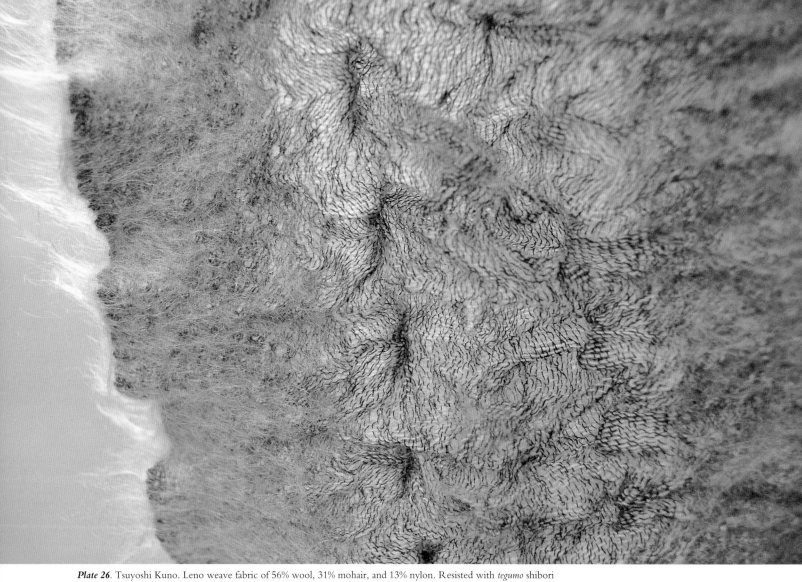

Plate 26. Tsuyoshi Kuno. Leno weave fabric of 56% wool, 31% mohair, and 13% nylon. Resisted with *tegumo* shibori and fulled by washing. 2000.

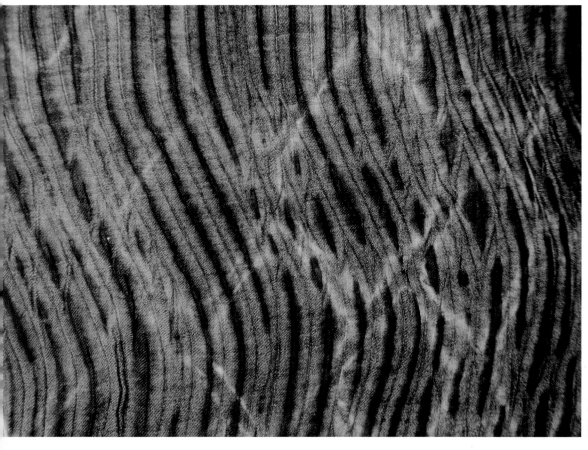

Plate 28. "Origami." 100% polyester organza. Directed by Reiko Sudo. Paper form developed by Mizue Okada. Production carried out by Hiroaki Takekura and Hiroko Suwa. Manufactured by NUNO Corporation. 1997. (Technical information on the process is given on page 155.) ▶

Plate 27. Tsuyoshi Kuno. Lightweight challis woven with 65% wool and 35% polyester. *Nemaki* shibori and *arashi* shibori with acid dyes. 1999.

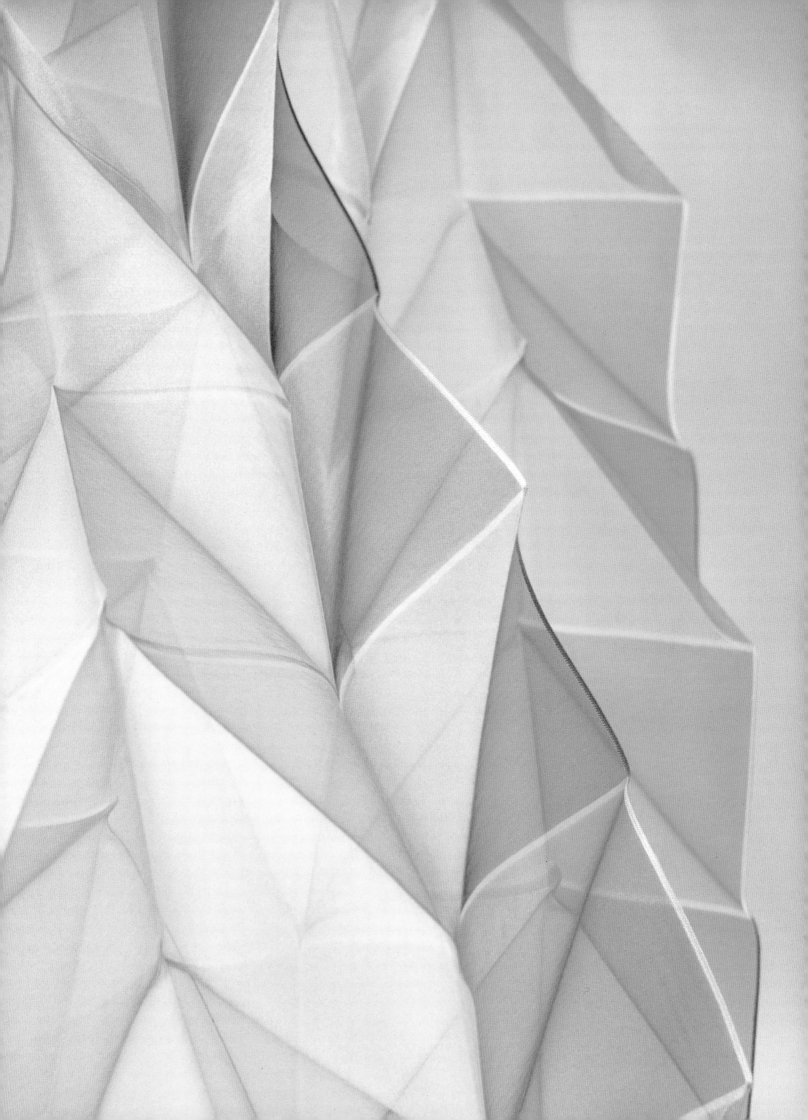

several times on both sides in the heat-transfer machine, using a different color each time on each side; Arai feels that it is important that the use of heat-transfer allows him to make double-sided pieces. This particular creation evokes an active volcano on one side and an expanse of virgin forest on the other.

Another sublime example of heat-transfer on shaped cloth is "Origami," an elegant sculptural scarf in sheer polyester organza, produced by NUNO Corporation under the direction of Reiko Sudo (Plate 28; technical information on the process is given on page 155). Here the dye sublimates through the colored material, giving the piece depth and translucency. There are huge possibilities for combining different weights, textures, and weaves of polyester and for controlling sublimation with shibori processes. Reiko Sudo has been spearheading these innovations in textile design for the new millennium with unrivaled expressions of sensibility, adventure, and sometimes playfulness.

"I take fabrics that, in the past, could only be produced by hand and reinvent them in contemporary ways. I am always exploring industrial means to create things that are seen as traditional, in order to give them a new lease on life in the present."

—Reiko Sudo

At the opposite end of the spectrum from these postmodern technological twists on handwork is the work of JURGEN LEHL (Plates 30 and 31). Lehl embraces his work as part of living; he designs and creates products that come out of his environment and reflect his cultural interests, using predominately natural materials. He travels widely in diverse cultural and social spheres, frequenting frontiers and esoteric spaces. He respects the characteristics and limitations of the materials, tools, and skills that allow him to gain new visions. Details are as important as the overall statement made by the finished object, as can be seen in his choice of buttons made of shells, pebbles, wood, and cloth (no plastic). He recently introduced an enormously well-received collection of bed linens in cotton, patterned with shibori and dyed with natural dye. The collection is laboriously produced in China. His creative work usually derives first from the materials, as in his first textile venture in Tokyo in 1972, which was a collection of linen, towels, and textiles for the home. At that time, as a newly landed Western designer, he introduced colors, patterns, and products that were perceived as refreshingly new and Western in their sensibility. Lehl has been living and designing in Japan and other Asian countries for decades, and over this time his work has evolved to be neither Asian nor Western, but his own unique expression—from gold or lacquered jewelry to ceramic bowls to carved wooden stools and beds to a huge array of clothing, bags, and shoes for women and men. Over the years Lehl has succeeded in sensitively orchestrating the production of textiles developed for the Japanese market using indigenous crafts traditions in Asia.

Plate 29. Awa Cissé. Cotton fabrics produced in Mali with various shibori patterns under the direction of Awa Cissé. 2001.

AWA CISSÉ in Mali, Africa, is a traditional dyer who initially learned her skills from her mother and proceeded to create a business that supports a large family as well as a community of artisans in her native country, producing mainly for their own regional market (Plate 29).[3]

As dissimilar as their situations may seem, Lehl and Cissé, like artists ANDREA SERRAHN and YOSHIKO JINZENJI, share a deep respect for traditional handwork, natural materials, and the joy of interaction with cloth and dye. Each of them explores the pliancy of the textile and its potential for creating a multitude of shaped and resisted designs that carry the tactile memory of the cloth's journey through the artistic process. Cissé's repertoire of shibori techniques is vast, as is the talent that exists in traditional communities in Africa for producing textiles that reflect their

Plate 30. Jurgen Lehl. Tie-dyed woven ▶
silk. Photo by Yuriko Takagi.

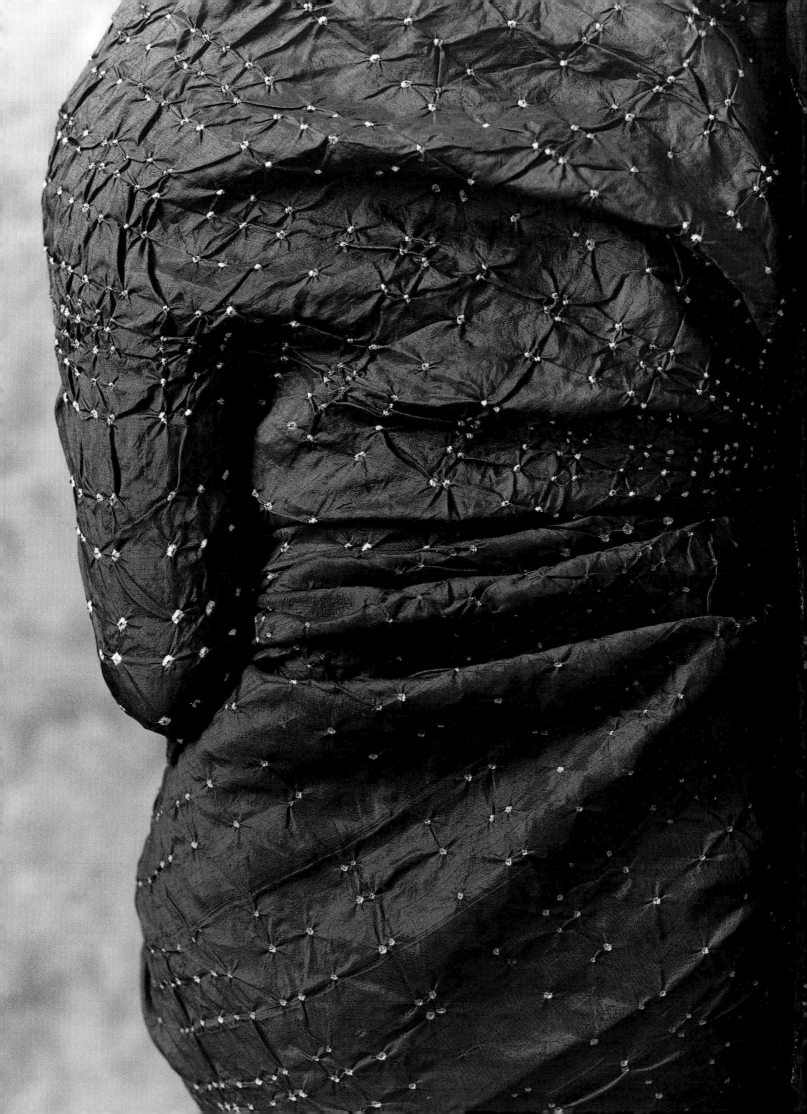

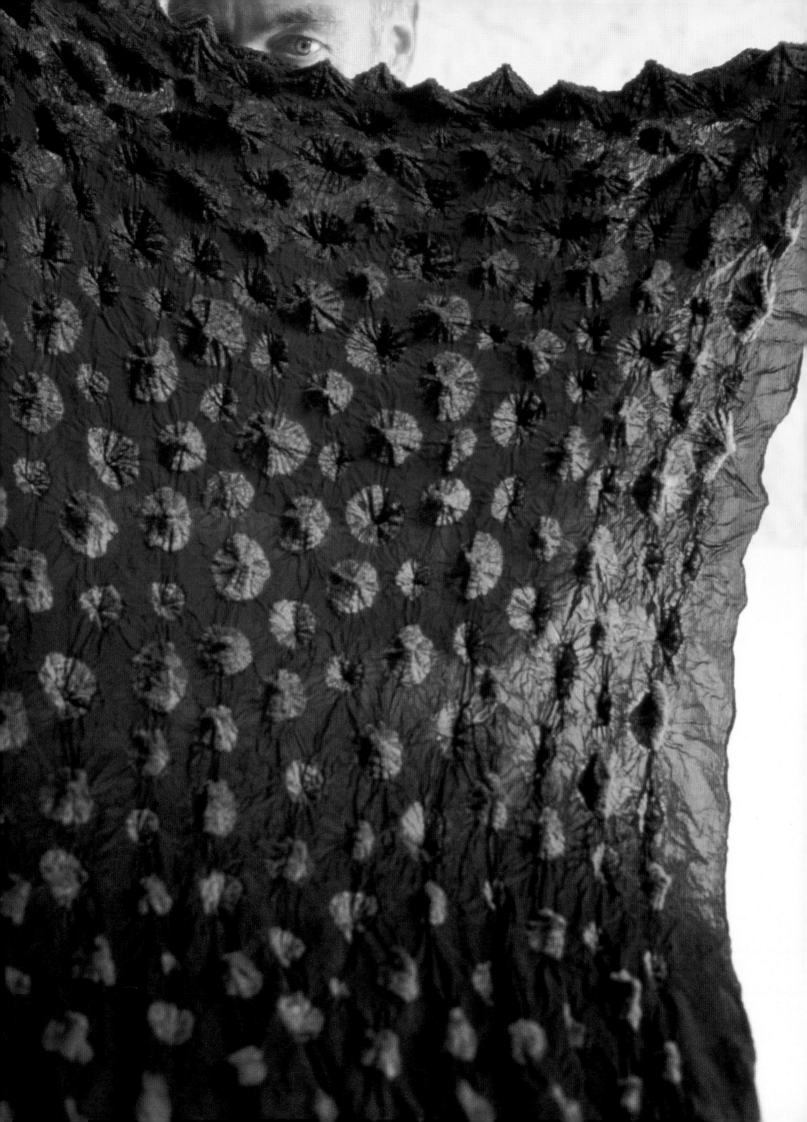

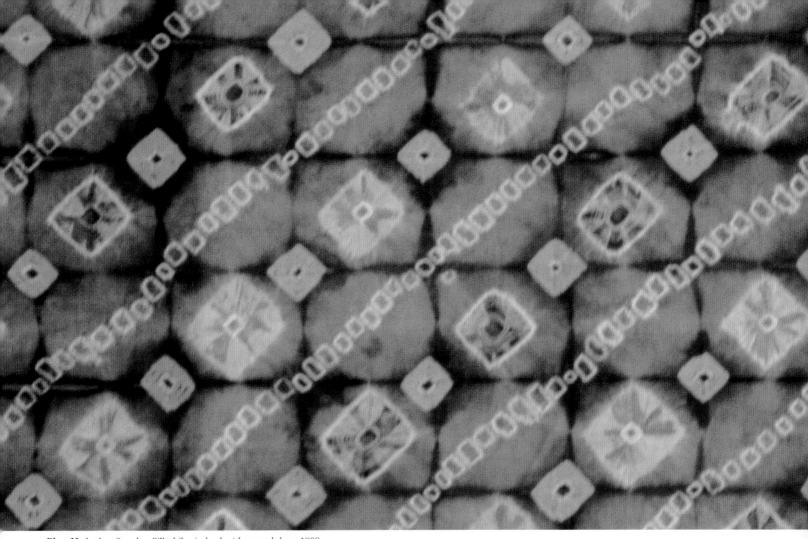

Plate 32. Andrea Serrahn. Silk shibori, dyed with natural dyes. 1999.

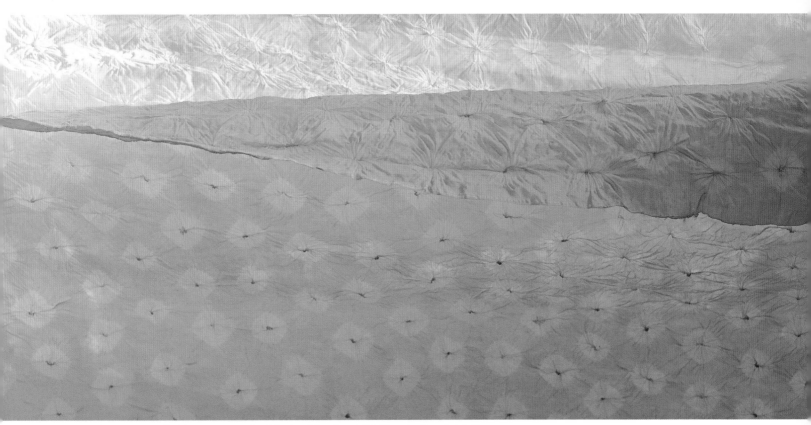

Plate 33. Yoshiko Jinzenji. Silk shibori, degummed and dyed with bamboo. 1998. Photo by Bunsaku Tsuji.

◀ *Plate 31*. Jurgen Lehl holding one of his shibori-patterned fabrics. 2001. Photo by Yuriko Takagi.

own changing trends and new designs. Serrahn, on the other hand, an American artist who learned the traditional shibori process of *bandhani* in western India, developed her work in collaboration with local artisans (Plate 32). She makes a moving statement with her expressive use of natural dyes and a palette all her own. The challenge of developing a collection with large quantity and wide distribution using laborious indigenous processes, however, is a whole other dimension that both traditional artisans and foreign designers must contend with.

Yoshiko Jinzenji came to shibori gradually, through quilting. While living for a time in Canada in the early seventies, she came upon quilts made by the Mennonite People and was deeply moved by their resonant, sacred quality. She began to make quilts from material that she dyed herself with natural dye, but she was dissatisfied with the existing palate, and wanted to find a natural dye that would turn fabric white. After long experimentation, she discovered that this could be done with bamboo. Although she also works often with amazing natural-dyed colors and with high-tech fabrics produced for instance by Jun'ichi Arai, a constant in her career has been the use of this very subtle white, which she achieves by cooking degummed silks in fresh bamboo (Plate 33). She also often uses shibori to create delicate patterns and to draw out the shadowy quality in the cloth, from which she then makes her lushly minimalist quilts. Her designs resonate with a sacrality akin to that of Mennonite quilts, but are rooted in an Asian, even Buddhist sensibility. Jinzenji lives in Kyoto but maintains a studio in Bali (Plate 34), since airing cloth in the sunlight there is an essential step in the process of achieving this elegant white. She works with local Indonesian workers to produce a small collection of handmade, one-of-a-kind textiles for the Japanese market, but her focus remains very clearly on her art and her research.

In the European arena, Italy, with its long textile tradition, remains a leading manufacturer and exporter of fine woven and printed materials. Perhaps because of the powerful Italian textile industry's proprietary control over technology and design, individual Italian fiber artists have had little noticeable impact on the international art scene, except in fashion design. In the last few decades, however, small-scale studio artists and individuals in textile design have formed groups for creative collaboration and promotion of their innovative designs and handwork. SARA CHIARUGI is one of the artists who has emerged as part of recent movements to expand the Italian cultural vocabulary. Chiarugi's work in textile encompasses weaving, shibori, painting, embroidery, and fashion for men and women. Her forms include wall hangings and fabric for clothing and home furnishings. A representative example of her work is "Panel 1995" (Plate 37). To silk patterned with shibori, she adds painting for a reflective accent and embroidery to create another dimension on the surface.

Plate 34. Yoshiko Jinzenji gathering materials for bamboo dyeing at her studio in Bali. Photo by Michiko Matsumoto.

"Shibori allows me to bring out the differences between transparent and white areas of the cloth."

—Yoshiko Jinzenji

Plate 35. Jun'ichi Arai examines a metallic polyester fabric that he has patterned with a large shibori design, using melt-off.

Plate 36. Hideko Takahashi. "Horse's Mane." ▶ Complex double-weave design, shibori, and fulling on wool. 1994.

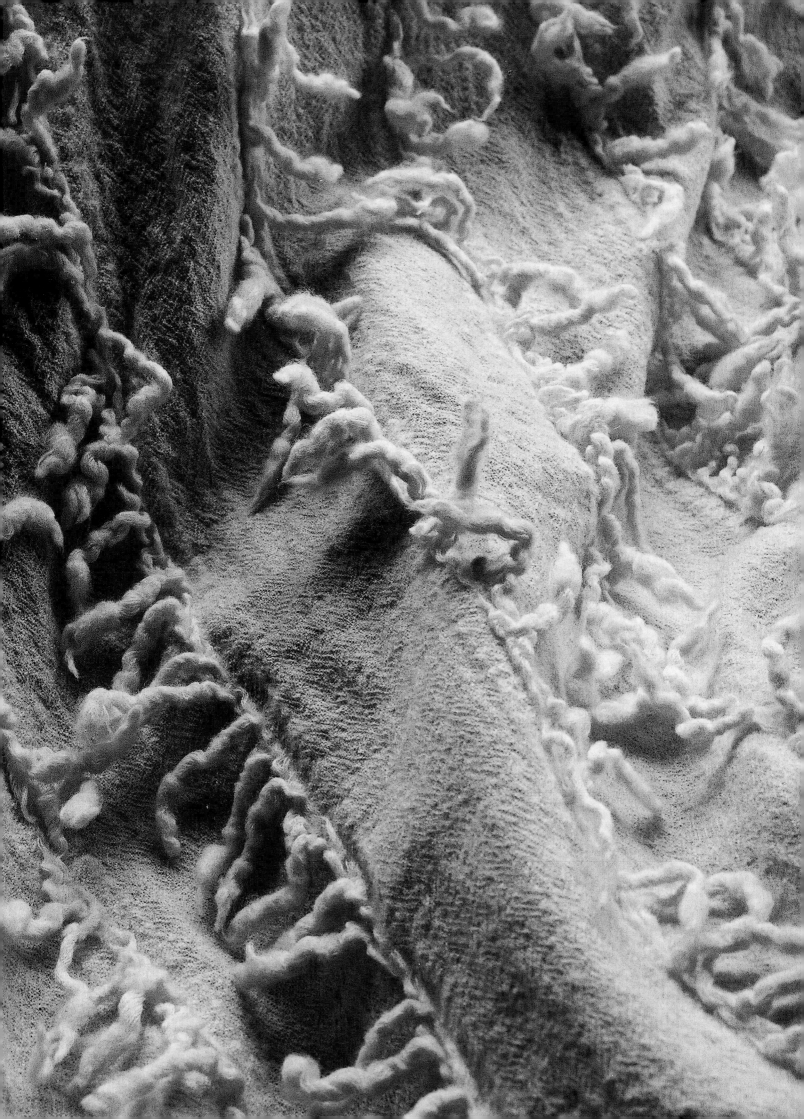

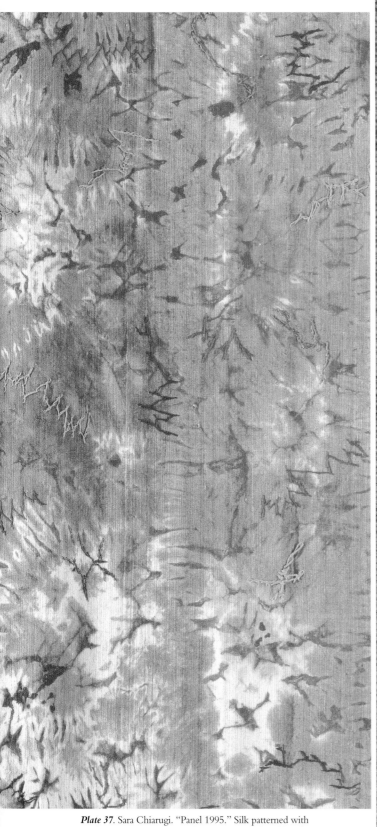

Plate 37. Sara Chiarugi. "Panel 1995." Silk patterned with stitch resist, dyed in three colors, painted with gold and bronze, and embroidered. 1995.

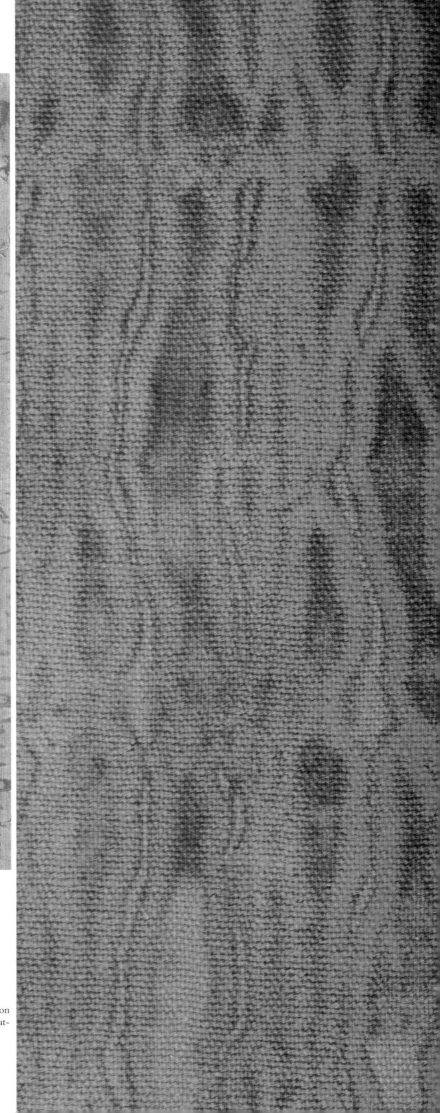

Plate 38. Catharine Ellis Muerdter. "Golden River." Cotton tabby weave with supplementary pattern wefts, dyed, and heat-transferred. 1999. Photo by A. Hawthorne.

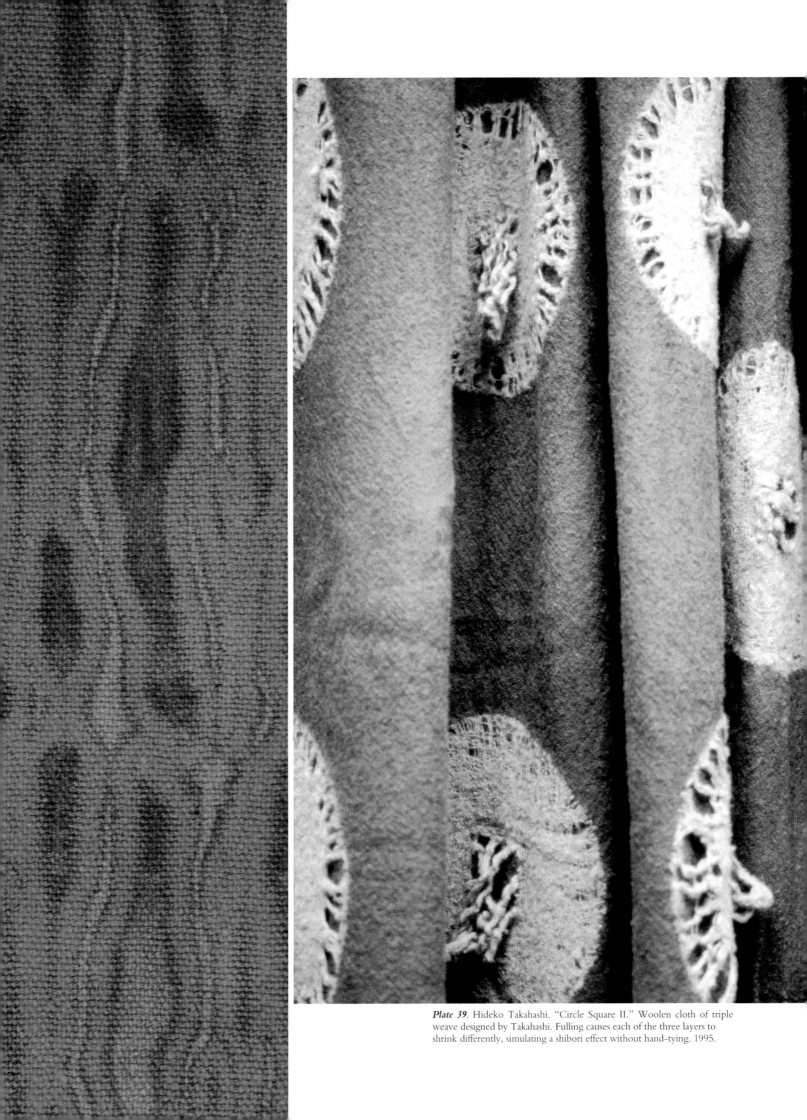

Plate 39. Hideko Takahashi. "Circle Square II." Woolen cloth of triple weave designed by Takahashi. Fulling causes each of the three layers to shrink differently, simulating a shibori effect without hand-tying. 1995.

The application of traditional mixed-media techniques to surface embellishment is taken further by CATHARINE ELLIS MUERDTER, who has been a weaver for three decades, with training in technical fabric construction and very controlled dye processes. In recent years her work has changed completely, focusing on developing and perfecting a process of "woven shibori." Unlike traditional stitched shibori, where the gathering threads are put into the fabric with a needle, she gathers fabric with the threads that are woven as supplementary pattern wefts into a tabby cloth on the loom.

I introduced traditional shibori techniques in a Japanese textile history class that Muerdter attended at the Penland School in North Carolina in 1992, and included an obscure technique called *taiten* shibori.[4] As a skilled weaver, Muerdter must have recognized this as an antecedent of "woven shibori." Ever since she became aware of the possibilities of using a woven pattern to make resist images, the exploration of structural and predictable woven elements combined with unexpected liquid penetration and resist patterns has been the driving force for Muerdter's multifaceted creative work (Plate 38). Her supplementary weft threads do not retain the hint of stress from gathering like the holes in traditional *taiten* shibori, but they do record the peaks and valleys, and dark and light patterns created by the permeating force of the dyes. She now ventures into combining polyester with natural yarns to broaden her patterning to include heat-transfer printing and heat-setting texture into cloth.

Another virtuoso weaver who combines the shaping and resisting inherent in shibori processes with complex weave structures created with woolen yarn is HIDEKO TAKAHASHI. Her first success in this arena in 1984 won her an award at the International Textile Design Contest organized by the Fashion Foundation in Tokyo. Until recently, however, she was not convinced that there was any connection between her work and the concept of shibori,

"I am forced to accept the unknown when I work. The control that a weaver usually has over her cloth on the loom is now entrusted to the dye pot in much the same way that a potter offers her work to the kiln. Perhaps this is the most appealing part of the process. After the weaving, the drawing up of threads, and the application of dyes is complete, anticipation hangs heavily until the fabric is opened."

—Catharine Ellis Muerdter

which she had thought of predominantly as a traditional patterning method for kimono. This perception of shibori is widely held. Unfortunately, many Japanese fashion designers and fiber artists do not tap the tremendous possibilities that shibori offers in creative expression, because they consider it merely an established craft tradition.

Sometimes artists or designers, like Takahashi, have used the concept of shibori without setting out to do so. Takahashi designs complex weave structures, manipulating loose weft or warp yarns to form double-layered surfaces, as in "Horse's Mane" (Plate 36). She often makes sample cloth on her floor loom and has it produced on an automated jacquard loom at a mill. This multilayered jacquard fabric can sometimes be split into separate cloths, each with many potential variations for patterning with bound resist and fulling. Takahashi chooses wool because of the way this material shrinks and mats when it is washed and agitated. Fulling transforms the flat, open-weave cloth into a different, almost unrecognizable texture and surface pattern, as in "Circle Square II" (Plate 39). In the end, the cloth becomes denser and the bound areas are transformed into a sculptural surface. Additional yarns are sometimes transformed into matted tassels like dreadlocks by being either pulled or cut, then bunched up and bound, and finally fulled by washing.

Takahashi's heavily textured textiles sometimes resemble wild animal hide or feathers. Her large pieces with a bas-relief effect created by protruding thick fibers have tremendous visual

impact. She also works with a clothing designer to turn her fabric into jackets and coats that have a playful animated quality. Her work was recently included in the exhibit "Structure and Surface: Contemporary Japanese Textile" at New York's MoMA and the Saint Louis Museum of Art.

YUH OKANO also creates lighthearted and expressive surfaces with shibori on polyester made into sculptural objects (see Chapter 4, Plate 120). For the "Palmira Dress" (Plate 41), Okano collaborated with Academy Award–winning costume designer Emi Wada, creating the material for the costume used in the movie *8½ Women* by Peter Greenaway. For this costume, Okano applied her methods for texturing polyester to silk fabric, creating three-dimensional patterns by resisting with shibori and treating with a cloque process. Here the calcium nitrate solution used in cloque causes exposed silk areas to shrink while reserved areas remain transparent and unaffected, resulting in an ethereal fabric.

Another example of successful collaboration using shibori for the theater is JOAN MORRIS (Plate 40), who was commissioned to make fabric for costumes by Julie Taymor, award-winning director of the Broadway musical produc-

> "I have thought of shibori as a vivid depictor of natural form in space. My natural inclination with this set of textile techniques has been to use the marks generated by shibori in layers, working dark to light as I go; to work deeply layered compositions into the cloth."
>
> —Joan Morris

tion Disney's *The Lion King*. Instead of using conventional mass-production costume companies, Taymor asked many individual artists to produce costumes and props. Morris was first given a group of renderings of costumes for the scene "Can You Feel the Love Tonight?" in which Taymor envisioned colorful and vibrant flora and fauna integrated into dancers' costumes, evoking the delight of the jungle (Plate 42). Instead of literally translating the plants and flowers, Morris succeeded in creating innovative textiles to meet Taymor's challenge, using laborious stitch-resist and bound-resist shibori processes in rich colors and fantastical three-dimensional shapes (Plate 43).

Taymor demonstrated great vision in her awareness of the undiminished dramatic and visual power, even today, of traditional forms of artistry and craftsmanship such as puppetry, shadow theater, mask making, fabric painting, and

Plate 40. Joan Morris putting stitches into a cloth.

dyeing. Morris showed that decorating cloth with the ancient method of shibori can create an impression that is both contemporary and traditional. Morris's creations became part of the superbly magical experience on the stage, which left a lasting impression on the minds of young and old (Plate 44).

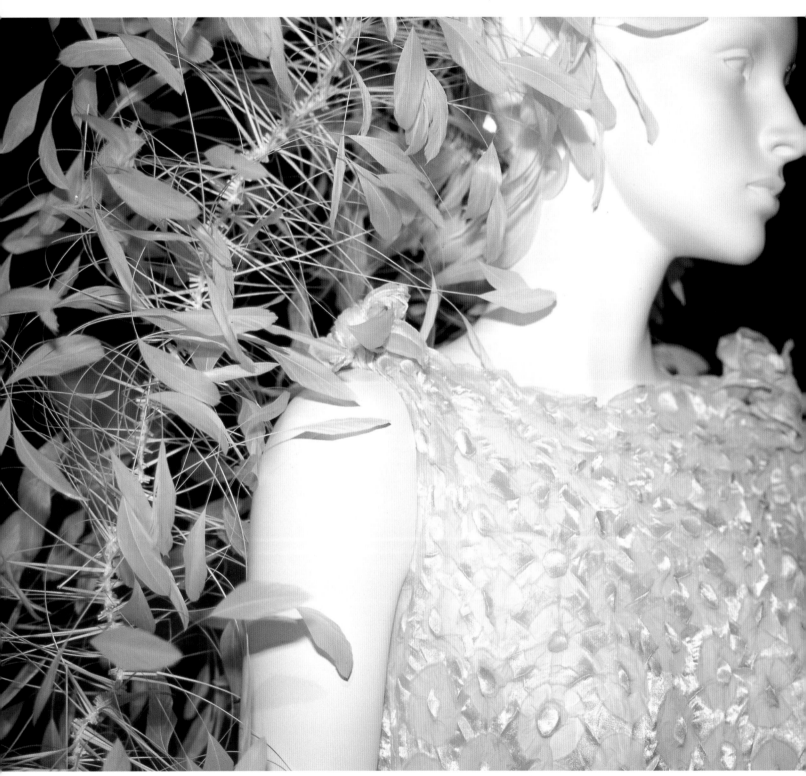

Plate 41. Yuh Okano. Fabric made by Okano for the "Palmira Dress" created by costume designer Emi Wada for the film *8½ Women*, directed by Peter Greenaway. *Kumo* shibori and cloque on silk. 1998.

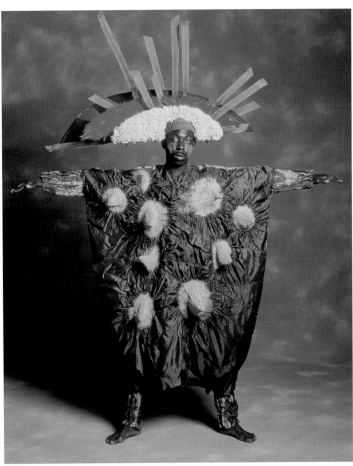

Plate 42. Costume design and rendering thereof by director Julie Taymor, from the Broadway musical production of Disney's *The Lion King*. (© Disney Enterprises, Inc. Used by permission of Disney Enterprises, Inc.)

Plate 44. Sam McKelton from the original Broadway cast of Disney's *The Lion King* in a "jungle costume" designed by Julie Taymor and made with textiles created by Joan Morris. Photo by Per Breiehagen. (© Disney Enterprises, Inc. Used by permission of Disney Enterprises, Inc.)

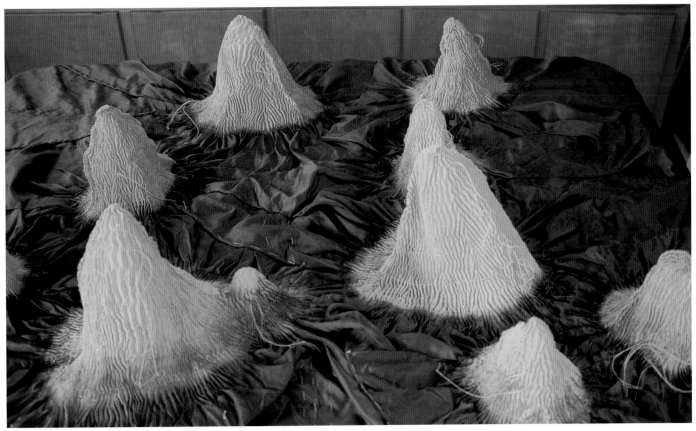

Plate 43. Joan Morris. Detail of a shibori textile created for a costume for Disney's *The Lion King*. (© Disney Enterprises, Inc. Used by permission of Disney Enterprises, Inc.)

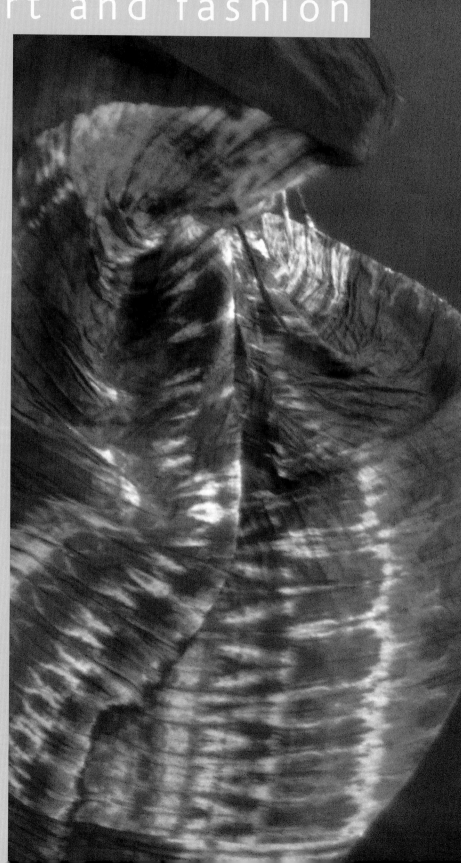

art for the body: wearable art and fashion

Australian artist PATRICIA BLACK cherishes memories of her mother and her great-aunts doing textile handwork and tailoring, and of her own gradual apprenticeship with them in the tactile exploration of fabric texture and drape. After studying art, arts education, and design in the 1970s and early 1980s, Black finally found her own voice in the Designers' Collective in Adelaide, a group of artists that promoted unique and limited-edition wearable pieces. During the mid-1980s she moved to Sydney, with the intention of finding work in theatrical costume design and gaining recognition within a broader artistic community. She began professional costume work with the dance company Darc Swan in the late 1980s and later collaborated with American choreographer Annetta Luce on many productions that were staged at unconventional or outdoor sites.

Her three-dimensional costumes, which she calls "body sculptures," echo the motion of the body; the pleats bounce and the spikes stretch and extend the dancer's contortions (Plate 45). Dancers have told her that wearing the sculptures enhances their perceptions of their own movements. Black thinks of her costumes as a second skin and speculates that the energy of the physical manipulation of the cloth may somehow be imparted to the wearer. In addition to costumes, Black also constructs large textile sculptures that serve as easily transportable set designs.

In the mid-1990s she began a series of collaborative works with glass artist Alan Prowd using internal light sources, exploiting the translucent, shimmering effects of passing light through the silk organza she had dyed. In 1996 she was awarded a grant from the Australia Council for residency in Besozzo, in northern Italy, which brought opportunities to teach in Venice and Tuscany and a commission to create costumes for a modern dance performance on the Feast of the Befana (Epiphany) at the Palazzo Moncenigo, a costume museum in Venice.

In the nineties she also began exploring the shibori tradition. Back in Australia, Black participated in a touring exhibit of work by the students of shibori and indigo artist Hiroyuki Shindo, with whom she had taken a master class. In 1997 she returned to Italy, where she mounted a shibori installation along the Grand Canal in Venice as part of an environmental art group project. Links with Japanese organizations continue with a recent commission to dye specially woven silk and then create a fashion garment with it for the permanent collection of the Gunma Prefectural Society for Sericulture Promotion.

An exuberant delight in working with color, texture, and form is also clearly evident in the work of Swiss artist MASCHA MIONI. She studied art in Switzerland, France, England, and Italy and established a reputation for her naturalistic oil paintings and her representational art on textile. While touring North America in the early 1980s, she was captivated by the traditional art of the Amish and began to collect and restore quilts dating from the 1880s through the 1940s. As a result, her art began to shift toward more abstract forms, guided by the power of color.

"It is the element of uncertainty in the process of shibori that fascinates me. I always enjoy that moment of sweet anticipation when an unpredictable soggy piece of fabric is opened up to reveal a wonderful pattern or texture."
—Patricia Black

By the end of the 1980s her work in textile had become increasingly important within the overall scope of her work and had been shown throughout Europe and in the United States. In 1989 she founded the Art to Wear Team, and has participated in many Team exhibits, including one at UNESCO in Paris in 1998. In addition to producing wearable art she does polychrome paintings. In the mid-1990s she founded Greina Verlag, a publishing house for books on textile art. Her first book, *Art to Wear*, came out in 1996, with a second volume by the same title appearing in 2001.

In Mioni's wearable art, the form and design are subordinated to the painting of the fabric; she says that they "evolve almost on their own." She uses French colors from DuPont or natural dyes on different types of pure silk, using all washable materials. She superimposes up to five layers of color and fixes them with steam, then folds the fabric by hand and crumples it before finally fixing it again with steam. In her finished work, the color and texture of the fabric is supported by an armature—namely, the wearer's body. The movements of the body activate the fiber work, transforming it into a kind of moving canvas where textures imprinted by shibori processes move and shift in patterns of ever-changing visual delight (Plate 46 and page 72). About her transition to clothing design she says, "It has become my inner vocation to establish art-to-wear as a legitimate art form—to bring it not only to museums, but to the people, on their bodies."

ANGELINA DEANTONIS, eager to explore her artistic vision amid a large community of progressive artists and performers, moved to the San Francisco Bay area in 1990, after completing a bachelor's in fine arts at the University of Oregon. Her study had spanned textile, sculpture, and performance art, and this became the basis for her collaboration with troupes of dancers and performers searching for ways to incorporate into their work new forms of expression in a wide range of media. DeAntonis quickly began to become known as an innovative designer.

◀ *Mascha Mioni. "Blue Bird." Painting (with resist paste), binding, folding and crumpling, and fixing with steam on silk. 2000. Photo by Asy Asendorf.*

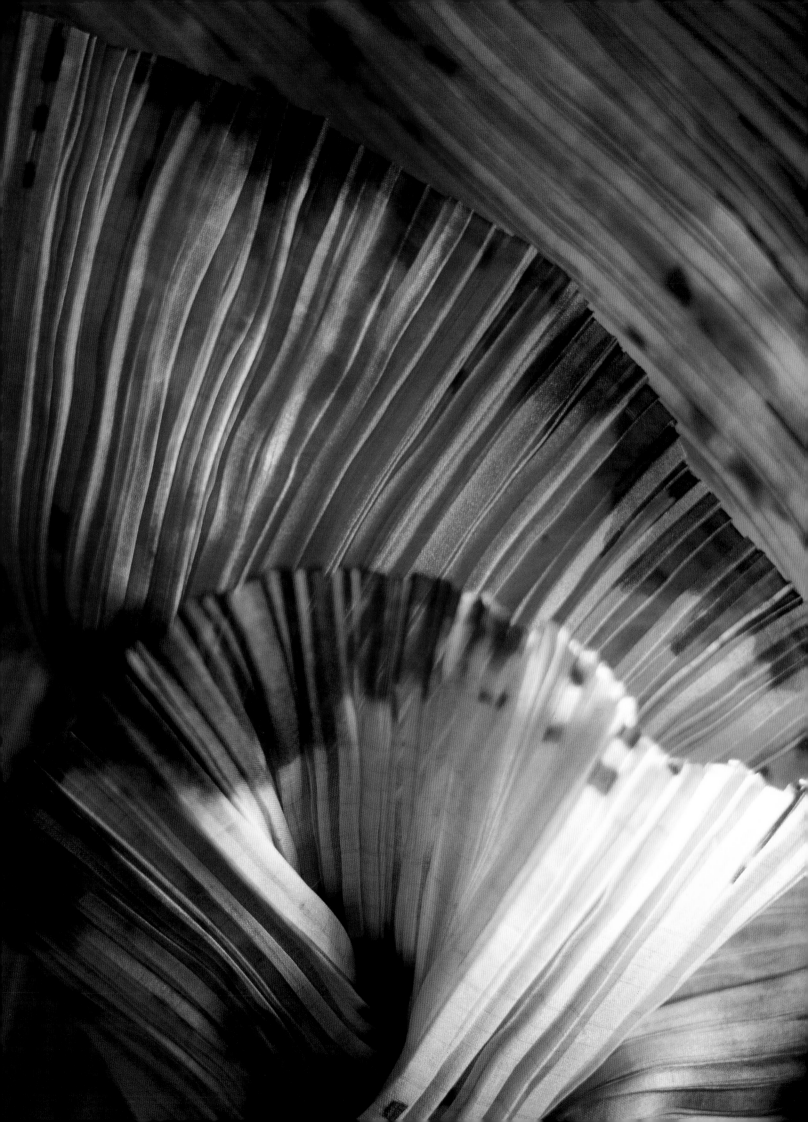

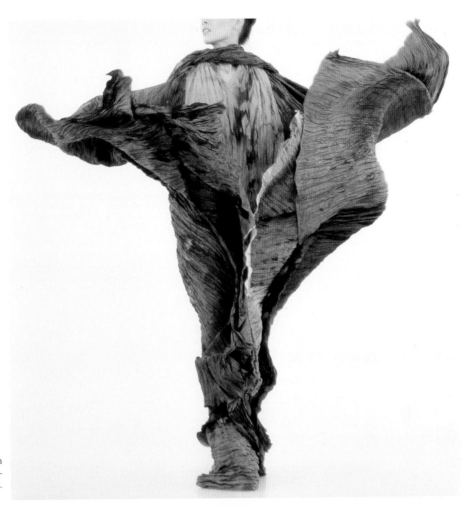

Plate 45. Patricia Black. Detail, "View from the Antipodes." Photo by Early Lancaster.

Plate 46. Mascha Mioni. "Geburt aus der Asche" (Birth from the Ashes). Painting (with resist paste), binding, folding and crumpling, and fixing with steam on silk. 2000. Photo by Asy Asendorf.

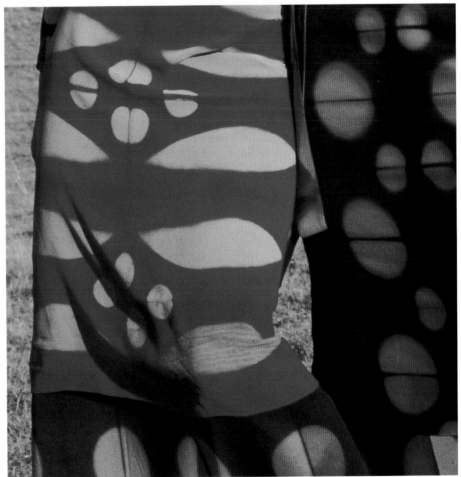

Plate 47. Angelina DeAntonis. Skirt and wrap skirt. *Itajime* shibori with natural and chemical dyes on silk and rayon jersey. 2001.

She is particularly drawn to *itajime* ("board-clamp resist"), a traditional Japanese shibori process where cloth is folded and sandwiched between boards and then bound or clamped. Traditional *itajime* produces repeat designs of bold, straightforward geometric patterns. DeAntonis capitalizes on this quality in her choices of scale, motif, and color palette to create sublime compositions (Plate 47). A desire to share these creative expressions with a wider audience led her in 1998 to establish a clothing line in Oakland, California, which she called Ocelot. Exhibiting the same kind of ingenuity often seen among traditional Japanese shibori artisans, she set up a studio, using old equipment adapted to suit her needs, where professional dyeworks of considerable volume can be output (Plate 48). The organization of work areas and equipment contributes to the shaping of the finished fabric; for DeAntonis an organized and aesthetically pleasing work space is essential for comfort, efficiency, and peace of mind. She experiences her creative process as a journey of discovery, a dialog with all the elements that present possibilities (Plate 49).

In her clothing line, the *itajime* dye pattern dictates the rest of the design and is the essential voice of the garment. DeAntonis begins by dyeing silk with natural dyes, establishing both the color of the resisted shapes and the base color that will subsequently be overdyed with acid dyes. She believes that natural dyes evoke a particular response in viewers that chemical dyes do not—the reflected light frequency is different, even if the colors appear the same. She prepares her own extracts from plant materials, with primary colors coming from osage, madder, myrobalan, catechu, and indigo. After dyeing

"Wearing *itajime*-dyed clothing allows the body to transcend its human architecture just as the patterning of a plant or animal might."

—Angelina DeAntonis

silk fabric in a solid color, she cuts the garment pieces, such as sleeves or neckbands, folds them and arranges the fabric bundles between pairs of wood shapes, fastens these with "quick-grip" spring-tension woodworker's clamps, and then overdyes the clamped fabric with acid dyes; use of these dyes allows her to achieve the desired depth of color and contrast. The definition of

Plate 48. Angelina DeAntonis in her studio. Photo by April Gertler.

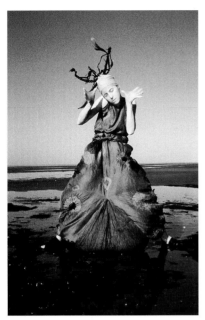

Plate 49. Angelina DeAntonis. Costume.

shapes, which varies with the way dye penetrates through layers of folds, can create a beautiful outlining halo effect. Dye remaining on the wooden molds from previous dyebaths also leaves an imprint on the fabric, introducing another variation into the repetition of resist patterns.

ISSEY MIYAKE became known as a creator of innovative fashion in the United States and France in the 1970s. Miyake's clothing was based on a series of flat cloths that the wearer's body supports and shapes. This comes from the notion of clothing as an extension of the skin, which stretches and contracts as the body moves. This fundamental concept is conveyed most dramatically in Tsurumoto's *Issey Miyake: Bodyworks* by a pair of images—one the naked torso of a young woman, and the other that of a quite aged woman. The seamless and taut skin surface of the young body contrasts with the wrinkled and textured surface of the aged. Skin is portrayed as a two-dimensional plane that records the process of aging, imprinting the creases made by the force of time. This "memory on skin" is possibly the most intimate form of shibori. Naturally the concept of a second skin implies that clothing should be a good fit with a woman's day-to-day movements, feelings, and activities. Miyake's ingenious designs leave room for the active participation of the wearer, who in fact actually completes the designer's artistic vision.

The traditional approach of Western tailoring involves draping a piece of cloth on a body and sculpting it by means of cutting, sewing, and darting into a dimensional covering that presents in some form an idealized woman's figure. In Japanese kimonos, on the other hand, the excess of each rectangular piece of fabric becomes part of the clothing, by being not trimmed off, but allowed to hang so that the wearer negotiates the excess. This tradition and the notion of clothing as second skin led Miyake to explore pleating in 1988, which gave birth in 1993 to the revolutionary clothing line "Pleats Please," wherein a straight-cut garment is constructed larger than normal size and then machine-pleated and heat-set. Shaping a series of two-dimensional planes of a garment with three-dimensional folds gives the garment structural support as well as flexibility and creates a new kind of clothing in which shape and function are dictated by the material. This concept has also been played out in other Miyake creations using shaping processes such as twist-and-crumple (Plates 50 and 52), which involves using shibori to add not patterning, but texture alone, to a piece. These techniques are made possible by working with advanced textile industry technology that is providing designers with exciting new materials and processes.

MAKIKO MINAGAWA has been working alongside Miyake since the early seventies, designing and developing textiles for Miyake Design Studio (MDS). Describing her collaboration with him she observed that, "Working with Miyake is like a Zen dialogue. One day he says, 'White in winter.' That's all he says. I wonder, the white of ice? The white of a salt field? The white celadon of the Korean Li dynasty? Or simply the white of snow? In ordinary Zen dialogue there is an immediate response. In this case, my responses take at least a year, starting with the selection of materials for yarn."[1] The entire process, from creating initial sample fabrics to making final bolts of cloth for the collections of any of the various lines of clothing that MDS now produces might take two to three years, with Miyake, Minagawa, and the staff refining their ideas along the way.

Minagawa has a unique talent for challenging the skills and expertise of Japan's weaving mills and dye studios. She is responsive to the strengths and limitations of these establishments, many of which had centuries-long traditions of producing kimono fabrics before converting to production of Western-style fabrics in the twentieth century. Although it is now common practice for Japan's large fashion houses to develop their own fabrics and control the entire process from beginning to end, this was not the case three decades ago when Minagawa traveled to numerous textile centers where looms had not yet been completely converted to high-tech automation and

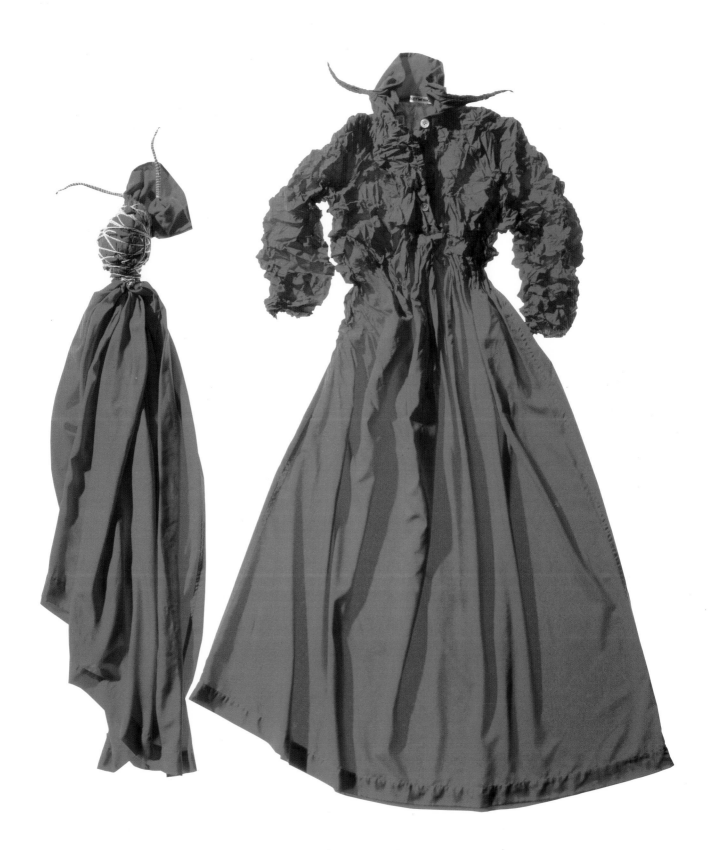

Plate 50. Issey Miyake. Partially Crushed & Tied. Polyester. Autumn/Winter 1993/94. Photo by Tetsuo Yuasa.

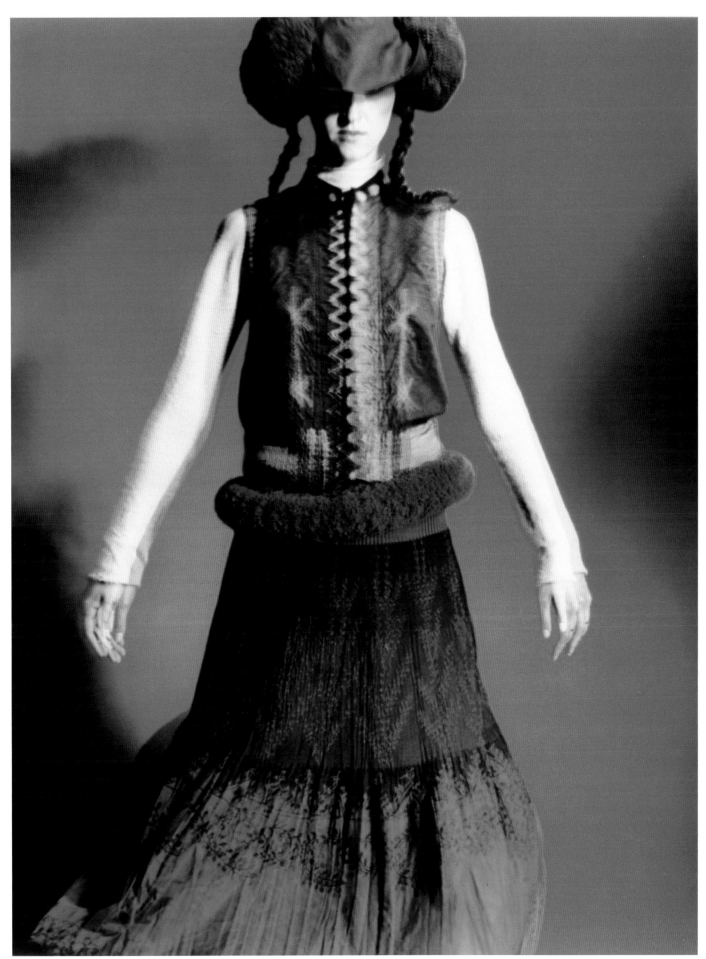

Plate 51. Makiko Minagawa. Stitch and dye. Haat by Miyake Design Studio, 2000 Autumn/Winter collection. Photo by Yoshie Tominaga.

Plate 52. Issey Miyake. Heat-set crinkled polyester shirts in an Arimatsu workshop.

where dyers were willing to experiment beyond traditional applications. With these makers she could engage in dialog as a fabric was developed specifically to accommodate ideas generated by Issey. In these settings Minagawa began to create fabric with patterns made by a process of folding, machine-stitching, and dyeing layered cloth. The stitching controls the dye liquid penetration and the ease of sewing on a machine makes it possible to create lines that have the gestural feeling of brush painting. The fabric with its warm and lively patterns, as seen in the vest in the outfit in Plate 51, has a distinctive "contemporary ethnic" look. This clothing is part of the Haat line: the Hindi word "haat" means "hand," and the line is based on the concept of a Japanese-Indian collaboration that values making things by hand, and that also effortlessly combines various traditional and modern elements.

Traditional Japanese clothing is inseparable from the material that gives it shape, design, function, status, and meaning. The kimono is basically unisex, oversized, and layered. Kenzo and Miyake introduced designs based on this same idea, of clothing that is layered and oversized, or one-size-fits-all. This fashion concept, which was then uncommon in Western apparel, was introduced by Japanese designers and became widespread during the 1970s in Europe and the early 1980s in North America.

In the 1981–82 fall-winter Paris collections, when Rei Kawakubo of Comme des Garçons and YOHJI YAMAMOTO introduced their collections, characterized by traditional materials and con-

struction in severely simple designs, a headline in the *International Herald Tribune* proclaimed that the Japanese had "gained a foothold in Paris." Their clothing was primarily black and cut asymmetrically, and it was shown on pale mannequins who were not even wearing lipstick. The style was dubbed "Japan shock" in Europe and North America. Far from the Western idea of structural beauty connected to the body, these garments were simply "baggy," bearing little relation to the physical form. The unfinished look, deliberate defects, and acceptance of roughness are familiar aesthetic criteria in fundamental Japanese concepts of beauty such as *wabi* (simplicity and quietitude) and *sabi* (elegant rusticity). In the decades since, Yamamoto has demonstrated a highly sophisticated capacity for draping, shaping, tailoring, and layering remarkable materials—thin and thick, shiny and matte, smooth and rough—with woven and dyed colors and patterns. For the 1995 Spring/Summer Paris collection, he presented a large number of elegant outfits incorporating traditional shibori processes (Plates 53 and 54). His use of this centuries-old handcraft is well integrated into the overall shape of his garments and the texture inherent in the shibori patterns is often maintained for additional visual interest.

Historically in Japan no clear distinction has ever been made between art and craft. Design begins with the choice of material, and the emphasis is often on the process more than on the end result. This approach is demonstrated in fashion design by the notion that material takes precedence over shape (for example, Miyake's early experiments based on the idea of making a garment from a single piece of cloth). The object is clothing that acquires its true shape only by being worn, and whose character is dictated by the cloth—its material, texture, color, and pattern.

"The beauty of a few hanks of vegetable-dyed cotton can inspire me to show the endless possibilities of combining yarns of different colors. Even the combination of colors like indigo and madder lying on the table next to each other can inspire many different designs."

—Jurgen Lehl

In this fertile ground for material exploration, German designer JURGEN LEHL found an ideal environment for creative expression through the fashion and home furnishing markets in Japan. Lehl trained as a textile designer from 1962 to 1966 in Paris, where he worked before moving to New York in 1969 and Tokyo in 1971. In Tokyo in 1973 he founded the Jurgen Lehl Company—designing and selling women's and men's clothing, accessories, and jewelry. The company has subsequently expanded into forty-five individual Jurgen Lehl shops throughout Japan.

His work has been documented in a number of books and widely exhibited, including large solo exhibits in Germany and the Netherlands. The company is known for its use of natural materials, high standards of hand craftsmanship, and subtle color schemes. Amidst this basic continuity, products change with the seasons and the years—like people—and are designed to serve the needs of everyday life. Harmonious expression is a result of Lehl's sensitivity to the characteristics and limitations of the materials, tools, and skills that all contribute to creating his products. Shibori as an embellishment process for his textiles is a natural choice for Lehl. Along with handweaving, shibori is one of only a few hand processes for decorating fabric that is still a commercially viable cottage industry in countries like India, China, and Japan. Unlike batik or block printing where the finished images, although beautiful, are static, the shibori process invites the participation of wearers and viewers and reveals the touch and feel of the process through texture and soft-edged patterns. The texture can be semipermanently imprinted to add flexibility to the shape and size of the garment. For example in Red Blouse (Plate 55)—tied superbly in China and dyed in Japan—Lehl applies fine shibori lines in a diagonal orientation, which enhances the fluidity of line and shape activated by the movement of the wearer.

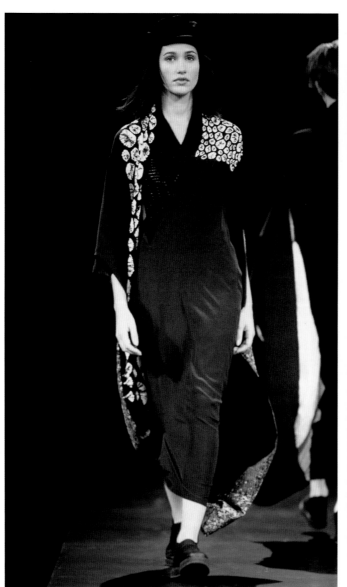

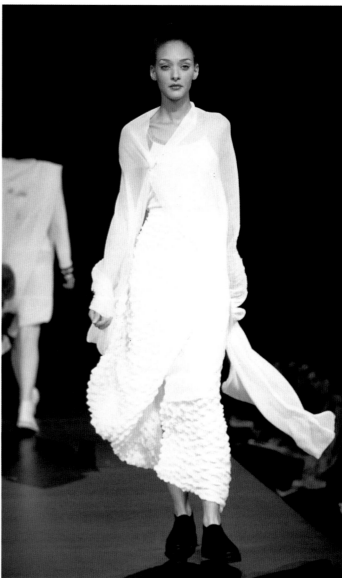

Plate 53. Yohji Yamamoto. Paris collection, 1995 Spring/Summer. Photo by J. L. Coulombel.

Plate 54. Yohji Yamamoto. Paris collection, 1995 Spring/Summer. Photo by J. L. Coulombel.

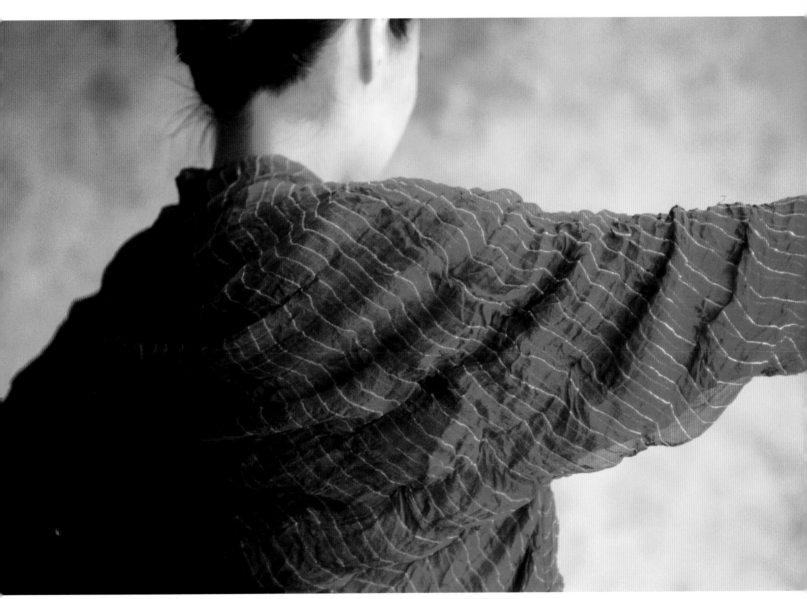

Plate 55. Jurgen Lehl. "Red Blouse." Shibori on silk. 2001. Photo by Yuriko Takagi.

RYOKO HARAGUCHI studied textile art at the Otsuka Institute of Textile Design after discovering her love of fabric while majoring in home economics at a women's junior college. In 1981 she joined the Fashion Planning department of Toyo Rayon Company, a major textile manufacturer in Tokyo. From 1988 to 1996, as an independent textile designer, she worked for Seiyu and its newly launched line of clothing, housewares, stationery, and food intended to offer customers products that were simple, beautifully designed, and reasonably priced. Their shop Mujirushi Ryohin (No Brand, Good Products) has been a great success with younger and middle-aged customers. One of the most successful retail ventures in the 1980s and early 1990s, Muji, as it is also known, soon spread across Japan and now into the United Kingdom and France.

Meanwhile, Haraguchi was increasingly eager to create her own brand of clothing to capitalize on the enormous potential in an orchestrated combination of Indian and Chinese artisanship, Japanese design and sewing, and dyeing in India and Japan. She founded the design studio and gallery Sind in Tokyo in 1992, and a retail outlet, Sind Shop, in 1996. Her experience planning and designing textile products for Muji while working with artisans and factories in Japan, India, and Thailand provided fertile ground for producing her own creations. The wealth of materials,

Plate 56. Ryoko Haraguchi at work.

skills, and culturally specific textile and clothing designs she encountered fueled her experiments and enabled her to draw conventional fashion and product designs into her own realm. She began guest teaching at universities, and holding Sind exhibit sales at galleries and department stores across Japan as well as at Cicada, a wearable art gallery in San Francisco.

"I place the highest importance on beauty that arises from function. Human hands weaving history and culture, like a weft against the warp of time, transform a fabric into a garment."

—Ryoko Haraguchi

She now spends a few months twice a year in India, developing and producing materials and products. Her small company is run by dedicated staff who collaborate with her. Their limited scale of production enables them to produce high-quality, labor-intensive products (Plates 56 and 57). Haraguchi is particularly interested in finding fabric that sparks her imagination, fabric that begs to be manipulated by shibori, dyed and overdyed with persimmon tannin and sumi ink, torn and woven or knitted, pieced, or embroidered (Plate 58). Many of her garments are constructed to fit a range of body shapes and are great to layer and to mix and match. Her uncomplicated approach to garment style and the subtle coloration and tactile quality of the material provide a vehicle for the wearer's expression of mood and spirit.

Italian artist ELENA BOCCINI graduated cum laude in architecture at the Polytechnic University of Milan in 1993 and received grants to study architecture and sculpture in Holland. She had a revelation while visiting the studio of her roommate's mother, who was creating textiles and clothes using a combination of batik, shibori, and silkscreen. Seeing that workplace, full of tex-

tiles, colors, sketches, and photos, Boccini realized that she too wanted to work in such a place, and decided to move from architecture to the world of textile.

Returning to Italy she opened a studio for the production of batik, a technique she had learned during her student years in Milan. In 1996 she contacted shibori artist Inge Dusi and became her assistant in shibori production. She credits Inge with opening up for her the realm of shibori and showing her what being a professional textile artist requires. She continued to explore shibori on her own, and to make art-to-wear clothing and accessories for several shops in Verona and Milan.

She traveled to India in 1997, where she learned the traditional Indian shibori traditions of *laharia* and *bandhani*, which she has since been incorporating in her textile and clothing (Plate 59). She also went to Senegal and Mali that year, to study local textile design and production.

Boccini notes that she takes inspiration from observing combinations of color in everyday life, from the natural world and from more artificial and industrial contexts, and that she is equally interested in combinations that agree and those that jar.

Her fascination with the three-dimensional aspects of shibori (absent in textile printing) probably stem from her studies of architecture and sculpture. She observes that clothing is the closest and most immediate form of architecture. She continues to work, teach, experiment, and exhibit regularly at a showroom in Milan. Her ongoing exploration in process, pattern, and material is evident in her experimental work using old mechanical bars, gears, and engine parts for clamp resist (Plate 61).

Plate 57. Ryoko Haraguchi's process being done by a worker in India.

ASHA SARABHAI's aesthetic was nurtured by her childhood in India surrounded by the tactile pleasures of her mother's collection of saris and other textiles and by her explorations as a young adult of the treasures of the Calico Textile Museum in Ahmedabad. With no structured professional training in the field of craft or any intention of becoming a designer, she entered the field of textures and shapes motivated and guided by her delight in the feel of things, the comforting interaction of cloth and gesture, and the amazing array of possibilities for fabric and clothing design. As a student of social and political science at Cambridge University she was angered and distressed at the way insensitive market forces were diminishing, if not crippling, traditional small-scale methods of producing commodities and relegating centuries-old craft traditions to the care of grandmothers and museums. Sarabhai's response was to work on developing connections and continuities in traditional Indian textile craft, exploring what might be most relevant to contemporary contexts. She set up the Raag workshops of artisans to produce her designs, choosing the name (the equivalent English word is spelled "raga") for its connotations of harmony, structure, and improvisation (it also refers to the act of coloring or dyeing, especially with red).

I met Sarabhai in 1983 while researching *bandhani* under a fellowship from the Indo-U.S. Subcommission on Education and Culture. I was delighted to observe the creative sparks that flew among her and Japanese fashion design titan Issey Miyake and his colleague Makiko Minagawa, who joined me in India that year for a textile research trip. The collaboration that grew out of that meeting of the minds took the form of the clothing line Asha by MDS (Miyake Design Studio). Established in 1984 and gradually expanded over the years, this line of clothing incorporating tra-

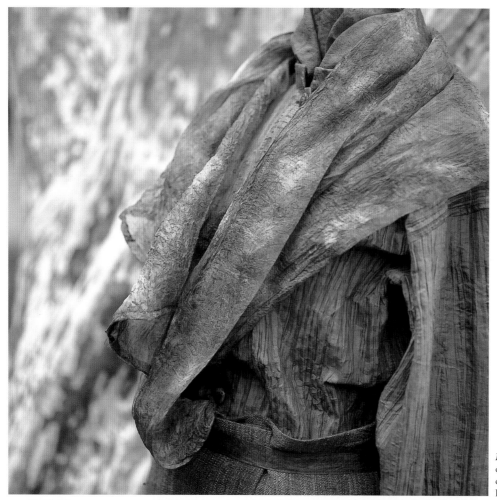

Plate 58. Ryoko Haraguchi. Scarf, bound shibori on silk. Blouse, crinkled shibori and pole-wrap on muga silk, finished with persimmon tannin. Photo by Shigeharu Matsuo.

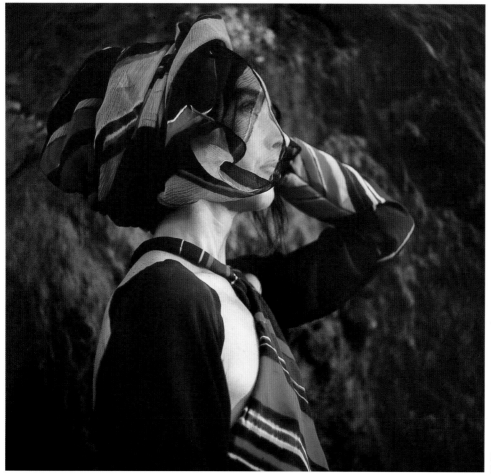

Plate 59. Elena Boccini. Scarf, blouse. *Laharia* (Indian shibori) on silk with chemical dyes. 1998.

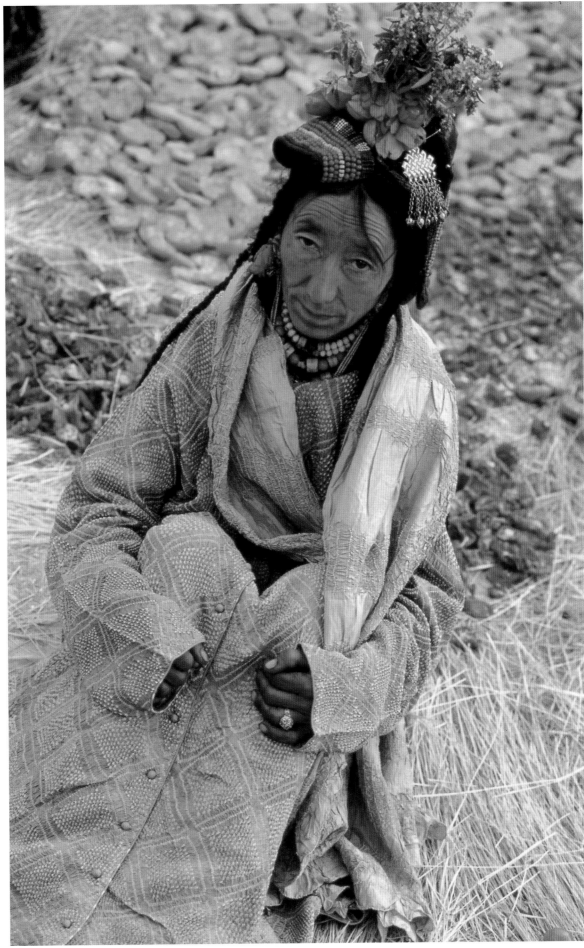

Plate 60. Asha Sarabhai. Local woman from the village of Dah in Ladakh, India (formerly part of Tibet) wearing a silk *bandhani* coat and scarf produced by Asha Sarabhai for her Raag clothing line, 1996. Photo by Yuriko Takagi.

ditional Indian handwork and costume styles, was designed by Sarabhai and MDS designers under Miyake's direction and produced in India for the Japanese market (Plate 60). In the mid-1990s Sarabhai and her friend Maureen Doherty started Egg, an outlet in the United Kingdom for simple but elegant things to wear and live among—products designed by Sarabhai and her associates and made lovingly by hand in India. Sarabhai points to linguistic confirmation of the centrality of the tactile in art and in human experience when we say that we are *touched* by what we most love and cherish.

Plate 61. Elena Boccini at work.

With the rise of the counterculture in the 1960s, clothing became a vehicle for personal expression and political belief. The fashion of antifashion was popularized by youth idols like musicians Janis Joplin, the Grateful Dead, and the Beatles, as well as by the Broadway musical *Hair*. MARIAN CLAYDEN worked with fellow artist K. Lee Manuel to create hundreds of yards of tie-dyed fabric for this legendary production. Flower children and hippies of the sixties generated an enthusiastic revival of handicraft and appreciation for ancient cultural traditions. The liberation of art from the confines of gallery and museum led artists to "perform" and to involve the public in "happenings." So it was logical that artists would begin using the body or clothing as an art form, which turned out to be the ultimate fusion of art and everyday life.

As a painter in the 1960s Marian Clayden had been concerned with exploring the luminosity of colors. Her increasing awareness of the limitations of paint on canvas led her to experiment with textile, to which she was attracted for its flexibility, tactile qualities, and fluidity (Plates 62 and 63). The enormous satisfaction she experienced in working with fabric fueled her interest in dyeing and eventually in resist techniques. The search for what she termed "new visual electricity" drew her to the techniques of tie-and-dye and led her to create huge hangings, or *environs*, that were included in "Fabric Vibration," an exhibit held at the American Craft Museum in New York in 1972. By tying and dyeing selected areas, Clayden produced irregular patterns that reflect the processes of gathering the fabric and dyeing and discharging. Her colors on silk are audacious, extravagant, and captivating. Her linear images neither float nor define the plane but rather vibrate at the heart of the composition. From simple binding she began to shift to *itajime* shibori (board-clamp resist), producing fluid and spontaneous colors defined and accentuated by repeated shapes. This exploration resulted in a series of silk panels that have an emotional resonance that is at once subtle and dramatic.

Clayden was intrigued by the possibility of extending viewers' perceptions into large spatial installations. She became well known for innovative fiber art such as hangings composed of huge space-dyed ropes, and sculptural objects constructed with variegated dyed cotton webbing.

Plate 62. Marian Clayden (at left) working with a dyer at her studio.

Intrigued by fabric's potential for sheerness and fluidity and realizing that those qualities are better expressed in clothing than exhibition art, Clayden began to create a line of clothes during the early 1980s, capitalizing on her artistry in patterning with dyes. Her choice of materials is always astute, taking into account the opacity, reflectivity, and transparency of various fabric surfaces affected by the colors and light. She continued to explore *itajime* shibori processes, ombré (shading), spray dyeing, overdyeing, and discharging (removal of color) over solid color fabrics as well as previously printed fabrics. The sophisticated and luxurious clothing Clayden created became so well accepted by celebrities and women with a taste for unique elegance that her line

Plate 63. Marian Clayden at her company.

became specialized in evening wear, despite her interest in working with a broader range of materials, including the cut-out felt that she commissioned Hungarian artisans to produce. She continues to be intrigued by the possibilities of breaking up the familiar two-dimensional surface of fabric by folding some areas irregularly and then using a pair of cut-out shapes to leave resist patterns on the cloth that reflect these irregularities (Plate 64). Her art-to-wear takes into account the unpredictable elements a wearer's body might have and their potential interactions with the surface layer of clothing, whether in terms of texture, color, pattern, or design composition. The result is a piece of wearable art that never goes out of fashion (Plate 65).

CARTER SMITH started learning shibori from his mother in Santa Cruz, California, in the 1960s, back when it was called tie-dye. As he played with the hands-on process of dyeing fabric, something took hold. He was at first excited about the process and then, as he perfected various techniques, amazed at the results. In addition to his fascination with the mechanics, he was mesmerized by the brilliant, electrifying colors he was able to achieve, especially with silks, even while still a beginner. The brilliant colors and almost psychedelic images fit the spirit of the sixties perfectly and Smith rapidly found commercial success and became a tie-dye production expert.

Today Smith is a prolific technical innovator. When he began serious shibori production in the 1980s, he sidestepped laborious traditional techniques of pleating and folding, inventing Rube Goldbergian machinery to speed the process and to "automate" production of his patterns. Like the traditional shibori artisans of Arimatsu, he uses materials at hand to improvise ingenious methods for creating his own patterns (Plate 66). Smith himself dyes more than eighteen thousand meters (twenty thousand yards) of cloth each year (Plate 68). His goal of quantity production is not about mass production in the industrialized sense but simply a desire to work efficiently enough to have time to create.

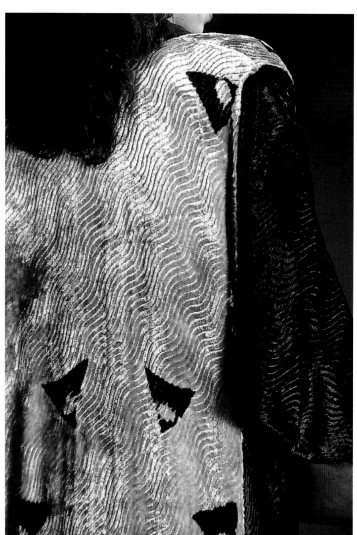

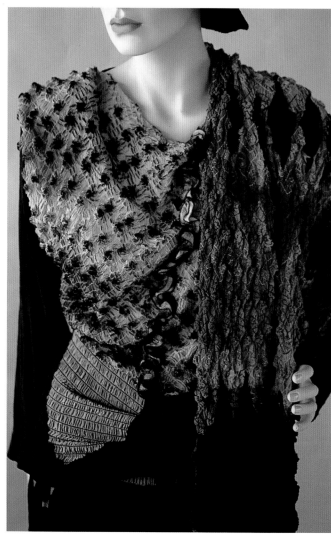

Plate 64. Marian Clayden. Triangular-pattern coat. *Itajime* shibori and dye discharge on silk.

Plate 65. Marian Clayden. *Itajime* shibori and dyed silk scarf. Discharged top. Printed skirt. 1993.

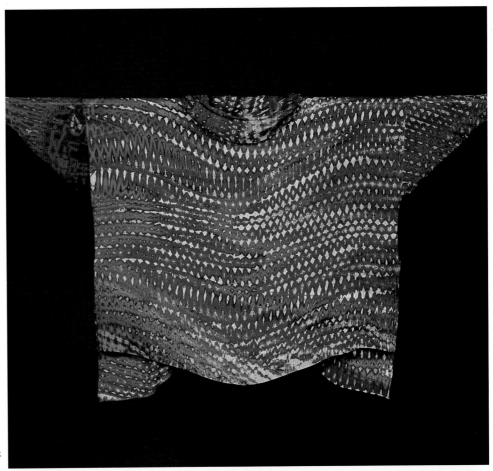

Plate 66. Carter Smith. Top. Shibori on silk chiffon.

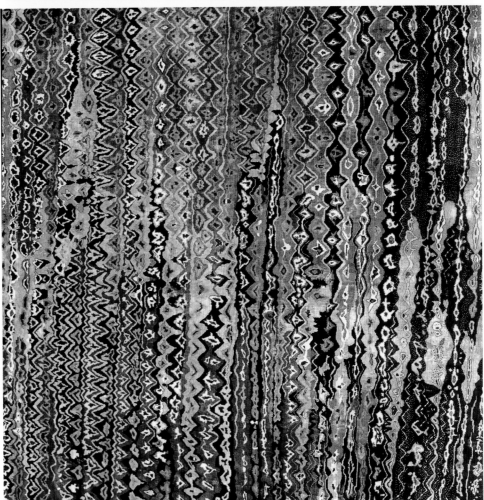

Plate 67. Carter Smith. Rug. Hand-woven with 400 knots per square inch, on silk. (Design based on the artist's shibori silk.)

Eventually Smith realized that as a textile artist his expression was subordinate to the fashion designer and that his personal voice could only be fully expressed if he went to work for himself. In the 1980s he started making silk scarves and simple kimono-shaped garments for Bergdorf-Goodman's and Julie's in New York City. Some of these garments became nearly transparent tattoos that envelop the body over one of the new base layers of choice: a Spandex unitard, a Tactel slip, an undershirt with jeans. His unitards and leggings have been featured and discussed in the press together with work of Armani, Galliano, and Kawakubo. He has had exhibits at numerous museums in the United States and in Europe and Japan, and has been commissioned by a gallery in Japan to create eleven formal kimonos.

For Smith the greatest joy occurs at the moment of discovery, when the cloth is unwrapped. Certain actions on certain materials have predictable results, but any new element introduces another element of chance. Shibori "mimics the semi-regulated, semi-random process in which genetics endlessly bequeaths its markings on animal skins." Not surprisingly, Smith's trademark patterns resemble snakeskins and animal spots and stripes. The semi-sheer silk gauze and chiffon on which they are dyed is cut on the bias and sewn into flattering dresses, vest-coats, and tunics that are unlined and unencumbered by buttons or zippers.

Plate 68. Carter Smith tying a bundle of fabric in his studio.

He continues to collaborate with his wife Teri Jo in creating not only silk dresses and tops, but also hand-knotted silk rugs in shibori patterns (Plate 67), as well as printed textiles, coats with shibori-inspired woven materials, and even tents covered with his shibori fabric and ingeniously stretched over a metal armature.

ANA LISA HEDSTROM's love of textile is grounded in her childhood play with the luxurious fabrics kept in a box that were the evidence of her mother's earlier career in design. She moved to the San Francisco Bay area in the early 1960s to attend college and was particularly inspired by her classes in ceramics and the history of Asian art. Unwilling to settle into an office job after graduation, she saved her money, bought a one-way ticket, and embarked on two years of work, study, and exploration in Japan, Southeast Asia, India, and beyond. This exposure to rich Asian textile traditions reinvigorated her childhood fascination with cloth.

Upon her return she began to weave, spin yarn, and experiment with natural dyes. In 1975 she enrolled in the first shibori class that I taught with Donna Larsen at the Fiberworks Center for Textile Arts in Berkeley. As her interest deepened, more and more students discovered shibori and became eager to learn the varied techniques of the process. Hedstrom gravitated toward *arashi* shibori—a vigorous method with only a few practitioners left in Japan. She began to experiment with the technique in her studio, producing scarves, most of which were sold at Sandra Sakata's Obiko in San Francisco. "Making scarves," she reflects, "supported my 'silk habit.'" In other words, this work financed her apprenticeship as a textile art professional. In 1976 she joined me, Mary Rice, Jane Barton, Junco Sato Pollack, Virginia Davis, and other fiber artists in founding the Shibori Society in North America, which established a network for shibori artists and scholars, to be later absorbed into the World Shibori Network, formed in 1992.

The traditional *arashi* process involves wrapping fabric around a pole, securing it with string, then compressing it into minute folds before dyeing (Plate 69). Hedstrom began to create innovative pleats and textures using *shibori* and incorporating Western ideas of shaping such as smocking, ruching, and shirring. Her repertory includes a dozen different pleats whose textures have been compared with ripples, feathers, mushroom gills, seashells, and reptile skin. One par-

Plate 69. Ana Lisa Hedstrom outside her studio with *arashi* poles.

ticular pattern creates ripples reminiscent of the famous pleats of Mariano Fortuny, the Spanish painter who also designed stage sets and fashionable clothing from a studio in Venice in the early twentieth century; the secrets of Fortuny's pleating techniques were never passed on.

Hedstrom likes to explore a pattern and its variations thoroughly, sometimes wrapping the fabric on the pole as many as four times, dyeing or discharging at each step. The sensory experience of color is a major source of her inspiration. Since the mid-1980s, her palette has expanded, as she added bold clear colors to the more subtly muted hues she had been using. Cutting the *arashi*-dyed fabric into various sizes and shapes, she then pieces them together or uses them as insets—juxtaposing pattern and color to create striking designs that have been compared to the work of Modernist painters like Mondrian and Klee.

Bored with the repetitive production of finely detailed limited-edition clothing for wealthy clientele and wanting to create something fast, simple, and cheap, she developed a series of designs she calls "videowave patterns" since they resemble the fine zigzag lines on a television screen. She also began to experiment with a line of T-shirts imprinted with images based on her *arashi* designs; she calls these creations Head Storm, a play on her name, the idea of brainstorming, and the literal translation of *arashi*, storm.

Hedstrom's work is an ongoing dialog among Western fabrics, tools, dye techniques, and traditional shibori concepts. Recognizing the potential in using combinations of disparate fibers for shibori, she has become adventurous in her exploration of chemical reactions, for example using cloque (lye shrink) on silk and cotton cheesecloth stitched with colored polyester threads or dévorée on wool and acrylic. She has begun to experiment with digital technology for dye-sublimation transfer printing at Editextil in Montreal, Canada (Plate 70). Her studio is a laboratory where ideas are generated not only for clothing but for interior wall pieces, industrial use, and her own pleasure and amusement. Though she has focused more in recent years on fine art than art-to-wear, her involvement with the Gunma silk project has renewed her enthusiasm for making clothing with the special silk. She has been exploring the possibilities presented by degumming and creping this silk, using *arashi* and *itajime* shibori processes to shape the fabric and using combinations such as acid or fiber-reactive dyes with vat dyes to achieve subtle and mysterious effects, producing halos of another color around the dye color (Plate 71).

CAROL LEE SHANKS, who studied textile and costume design at the University of California at Davis, has a great reverence for cloth and strives to make beautifully simple, unstructured garments that feel good on the body, suit an active lifestyle, and are easy to wear and care for. In her signature collection she applies a variety of shaping processes to silk fabric of different weights and textures. Since silk is a protein fiber, heating the shaped fabric and then drying it in that shape creates semipermanent textural memory that defines the shape of her oversized garments without compromising the wearer's ease of movement. She then layers these textured garments to achieve a balanced silhouette that is activated by body movement and transformed into a dynamic yet delicate three-dimensional moving sculpture. She was one of twenty artists that I chose to work on the silk project funded by the Gunma Prefectural Society for Sericulture Promotion. Because of her keen interest in texture and monochromatic expression, Shanks is in her element with the special silk fabric, which she can manipulate three-dimensionally and degum so that the shrinking, twisting crepe yarns cause the shapes to be recorded and transparency is maintained by the sericin reserved in the fabric (Plate 72).

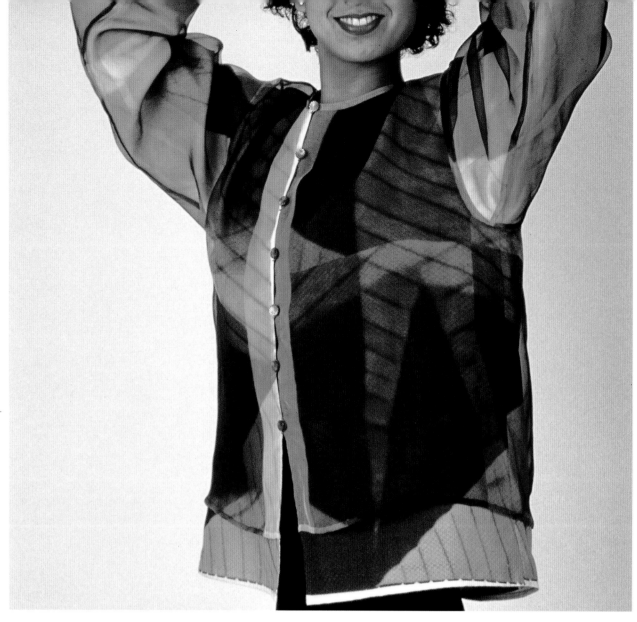

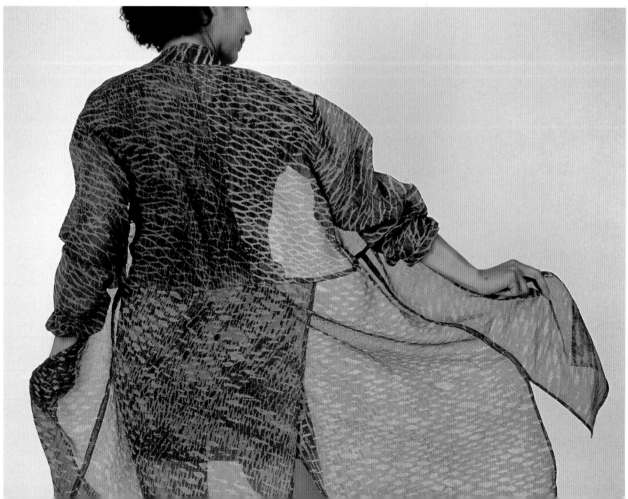

Plate 70. Ana Lisa Hedstrom. Jacket. Heat-transfer prints of digitally altered *arashi* shibori pattern on polyester. 1999. Photo by Elaine F. Keenan.

Plate 71. Ana Lisa Hedstrom. *Arashi* shibori on scoured and dyed Gunma silk. (Coat design by Ariel Bloom.) 1999. Photo by Elaine F. Keenan.

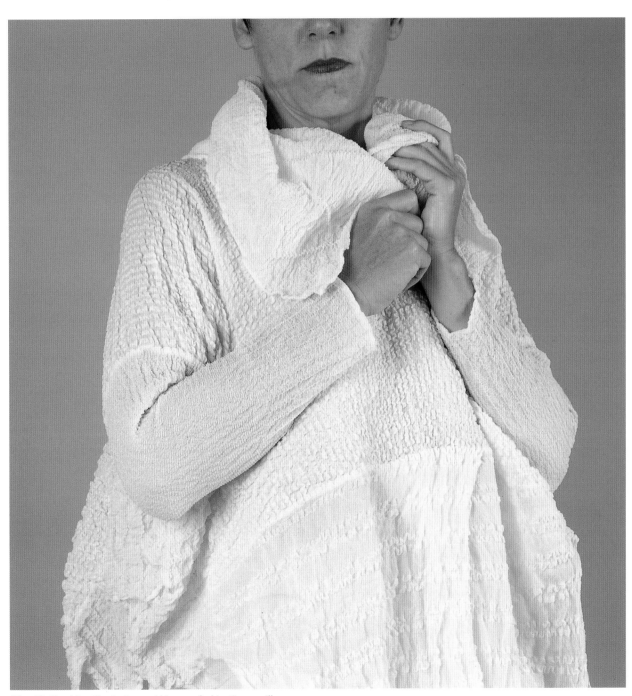

Plate 72. Carol Lee Shanks. Layered blouses of white Gunma silk.

The layers of garments can be interchanged to give wearers options that reflect their needs. Since the silk is lightweight, a layer can be added for warmth without burdening the body or making the outfit too bulky. Texture is perhaps the must crucial element in her work. As she explains it, "Since I do not use printed cloth, my surfaces are purely textural. I manipulate cloth using various techniques that add depth to my designs."

Her method for manipulating her lightweight clothing makes it possible to change the pattern and the shape of the garment easily. When quickly hand-washed, towel-dried, and pleated or twisted into coils, the garments dry into new temporary textures and shapes. A vertical pleat will produce a more streamlined fit, whereas a horizontal pleat creates a boxy geometric look. These separates pack easily, take up little space, and weigh next to nothing.

Shanks works and exhibits her clothing from her studio in Berkeley, where she has established a loyal following (Plate 73). Her work is also shown and sold in art-to-wear galleries throughout the United States. She has been collaborating with textile artist Kathryn Alexander, who produces unique handspun and handwoven cloth, allowing Shanks to layer different kinds of textures physically and metaphorically in her work.

Plate 73. Carol Lee Shanks stitches into Gunma silk.

After completing a bachelor's degree in ceramic and fiber sculpture in 1976 at a college in Seattle, D'ARCIE BEYTEBIERE received an artist-in-residence award from the Washington State Arts Commission from 1976 to 1986, which enabled her to pursue creative studio work while teaching young people and seeking information on new processes, materials, and artistic interpretations. In 1985 she received a master of fine arts in textile design from the University of Washington, Seattle, where she accumulated a great deal of technical knowledge in spinning, weaving, off-loom construction, a wide range of surface design processes, and clothing construction. During this period she also began to study shibori.

Beytebiere particularly likes the way cloth looks while it is all bound up into an intriguing object, sometimes preferring that to flattened finished pieces (Plate 74). She attributes this preference for sculptural texture to her ceramic and fiber sculpture background. In her shibori work some parts of the bound units are kept tied up while others are opened to reveal the dimensional shapes, but without being flattened. In 1986 Virginia Blakelock, a bead artist in a class Beytebiere was teaching at the Oregon School of Arts and Crafts, introduced her to the sparkly and luminous quality of beads. This was the beginning of an opulent shawl series in which Beytebiere incorporated bead embroidery with highly sculptural shibori processes such as *kumo* shibori (Plate 75). Another group of related shibori textiles was produced by spinning and twisting wool yarn before weaving it. Excited by the more permanent dimensional expression made possible by the high twist of the wool yarn and subsequent fulling, she was inspired to explore dyeing in depth. In 1985, she studied with Ana Lisa Hedstrom, who is well versed in *arashi* shibori and various silk dyeing techniques, and in Deer Isle, Maine with Frass and Slade, who do fabric painting with dyes on cotton. Beytebiere became very skilled in piece dyeing and multicolor dyeing.

Beytebiere places the highest value on personal exploration; wearable art is the canvas for her vision, rather than something she makes to sell or to appeal to a certain audience. In addition to teaching art in high school, she is now fascinated by glass and is working with glass fusing.

MIKE KANE and STEVE SELLS were originally painters, and each was motivated by a desire for greater movement and fluidity in his art. Their collaboration, which began in the early 1980s, continues to evolve and produce fresh new work. The fact that their personalities are very differ-

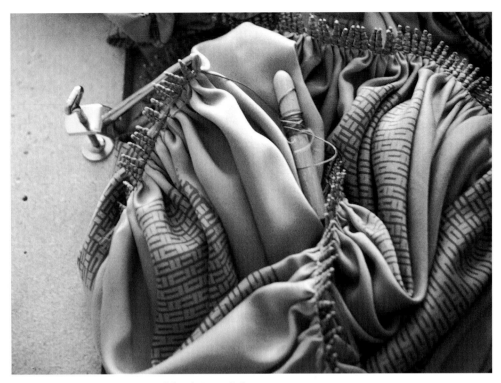

Plate 74. D'Arcie Beytebiere. *Kumo* shibori being applied to hand-painted and silkscreened silk.

ent—Kane is an impetuous risk-taker and Sells is more cautious and painstaking—strengthens their partnership (Plate 78). Each comes up with ideas that he could never have had in isolation.

Moving away from paint on canvas into an exploration of textile art, they gradually acquired expertise in techniques such as color discharge, graduated dyeing, dévorée, and application of textile paints by airbrush. They were excited to discover the book on shibori that I coauthored. Enthusiastically testing the procedures described in the text, Kane and Sells learned the board-clamping technique of *ita-jime* shibori, which they still practice occasionally. They connected most deeply with *arashi* shibori, the technique that has come to be most characteristic of their work (Plate 76).

"We are passionate about shibori and make it a golden rule to always keep our work fresh and alive—to play, to learn something from everything we do, and to use the information we have acquired for the next piece. We keep it very intuitive. 'There are no mistakes!'"

—Kane and Sells

Their interpretation of *arashi* is closer to the traditional Japanese than that of most American practitioners. Although they replace the traditional wooden pole with a PVC pipe, they use relatively thick (eight to ten centimeters in diameter, or three to four inches) and long (seventy-six–centimeter/thirty-inch) pieces. They produce a huge number of different patterns by shifting the angle at which the cloth is wrapped on the pole, varying the interval between the folds, twisting the fabric as it is bunched together, or repeating the process on a second pipe of a different diameter to create two sets of lines that cross. Further variations are possible when these techniques are combined with discharge dyeing or airbrushing with textile paints.

In the year 2000 Kane and Sells decided that a shift from limited-edition production to one-of-a-kind handmade fabrics and garments would allow them more creative freedom. Their designs are inspired by rhythmic patterns in nature—ripples on water, striations on rock, grooves in the bark of trees. "Our work is about animation," Kane explains. "Silk isn't heavy; it moves, adapting perfectly to the human form."

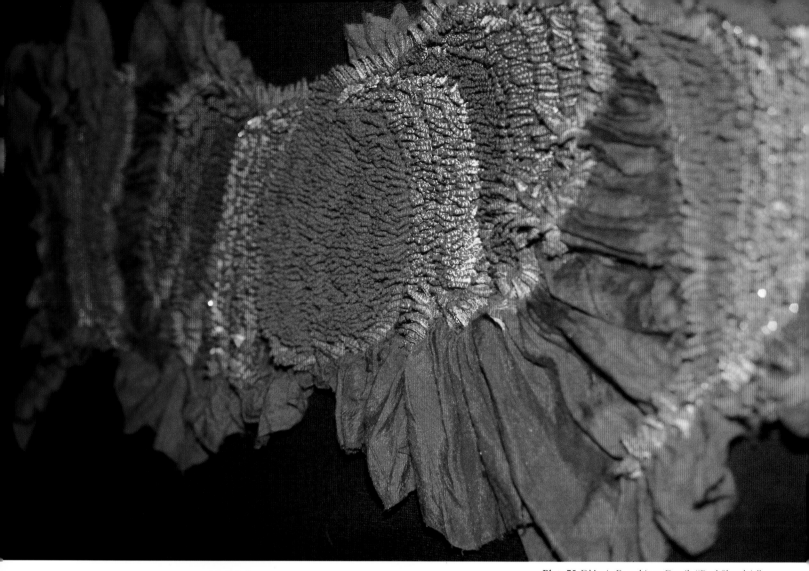

Plate 75. D'Arcie Beytebiere. Detail, "Red Shawl 1." Silk dyed and shaped with shibori and embellished with glass beads. 1990.

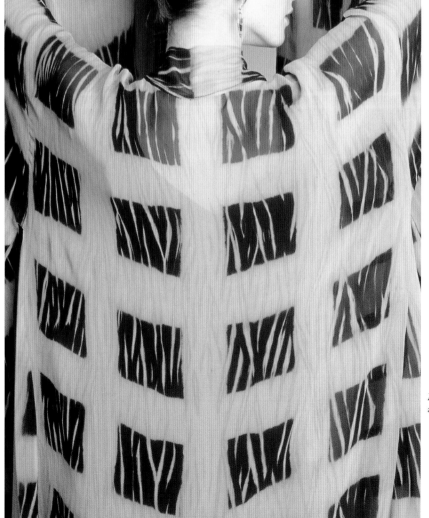

Plate 76. Kane and Sells. Silk kimono. *Itajime* shibori and dye discharge on *arashi*-shibori–dyed silk.

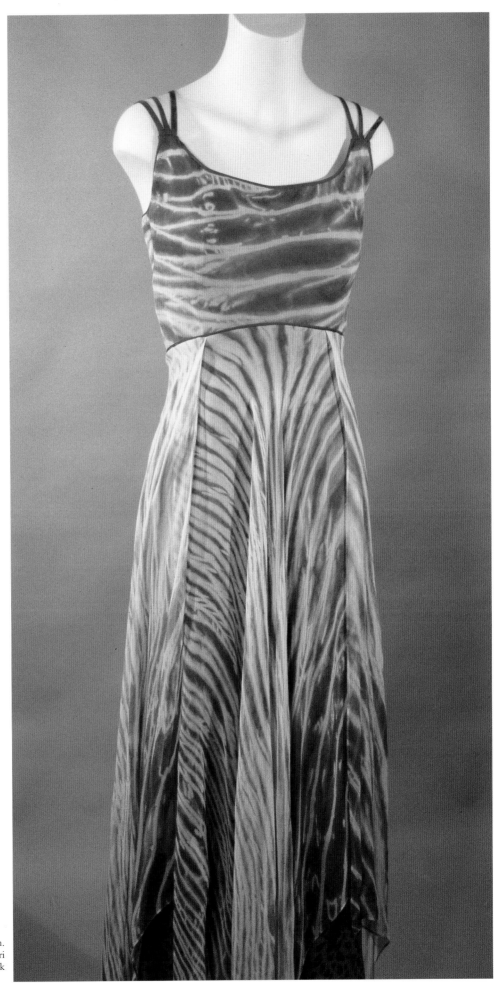

Plate 77. Mariana Carreño and Dorita Gomien. "Blue/Lemon." Evening gown. *Arashi* shibori and reactive dyes on layered silk chiffon and silk charmusse.

In the late 1990s in Santiago, Chile, fashion designer MARIANA CARREÑO teamed up with textile artist DORITA GOMIEN to create garments with a uniquely Latin American style. The two women met through their mutual connection with artist Inge Dusi, who brought attention to surface-design techniques including shibori and exhibited and taught in the early 1970s in Chile and later in Italy. Each of Dusi's students in Santiago who was actively working with shibori was invited to create a fabric design using a favorite technique. Carreño, impressed by Gomien's work, invited her to collaborate; the two have been working together ever since.

After earning a degree in textile design Gomien pursued her interest in dyeing by participating in courses and workshops. Applying shibori and other techniques and principles learned during a 1989 course on patchwork with Ingrid Schaub, she began to work independently, participated in two group shows, and continued developing her style. In 1997 she took two courses with Inge Dusi, the first on reviving the ancient Andean art of *amarra* and the second on discharge dyeing on cotton and silk. Subsequently she learned traditional and experimental shibori with indigo in a workshop I taught in Santiago while I was helping prepare for the third ISS, to be held there the following year.

Plate 78. Kane and Sells with some of their shibori fabrics.

Carreño earned her degree in fashion design in 1989 and began working as personal and design assistant to fashion designer Rubén Campos, participating in the creation and production of his national and international collections. In 1995 she began to work independently and ran the Annis Couture boutique for a time during the late nineties.

One of the first pieces that Carreño and Gomien created was inspired by the sea—a prominent natural element in Chile, with its more than thirty-two hundred kilometers (two thousand miles) of coastline (Plate 77). Gomien envisioned the expressions of the sea—sometimes turbulent with big waves and other times quiet with a sparkling surface. The basic dress was made with subtle woven silk dyed in plain blue, and worn over it were layers of silk gauze dyed in yellow and blue patterned by *arashi* shibori that reflected the rhythmic patterns of the sea and a fresh spring atmosphere. With the movement of the wearer, the colors on the dress shift from blue to blue green to yellow in a motion like that of water.

KARREN BRITO, who earned a Ph.D. in chemistry in 1976, founded Entwinements, a wearable art and textile studio, in Ohio in 1983. There she focused on her lifelong avocation of creating beautiful textiles—primarily handwoven accessories and one-of-a-kind garments—while at the same time she taught chemistry at a college until 1989.

Brito has always loved working with fabric. Her mother used to give her a bag of scraps instead of buying her more toys, because the child was happiest when making clothes for her Barbie dolls. When she got a little older she began to make clothes for "anyone who would stand still long enough for her to design something," as well as for herself.

While she was teaching chemistry in Venezuela between 1965 and 1979, she became totally enamored by the exquisitely woven textiles of South America, and had a simple loom built so that she could start weaving herself.

In 1989 she took a three-week workshop on shibori at the Penland School from D'Arcie Beytebiere, who was incorporating multiple folds and *arashi* pleats on silk dyed in rich shades with Cibacron F and discharged with thiourea dioxide and Ciba vat dyes. These dyes and chemicals came from the two important textile institutions that had emerged at about that time in Seattle, where Beytebiere lived. One was Cerulean Blue (a textile supplier and information source) and

another Color Trends (natural and chemical dye supplier and resource organization led by Michelle Whipplinger). Brito was quite exhilarated by the textures and colors imprinted on silk and the kinetic nature of shibori textiles. These experiences played a pivotal role in her decision to begin to concentrate solely on textile.

Brito began experimenting with folding broad silk cloth lengthwise and applying *arashi* shibori and dyeing and heat-setting the pleats in the finished piece. The signature of her highly colored and textural work—including a recent series of feather-pleated boas—is that the top of the pleats are one color and the valley another, so that when worn her pleated shibori appears to change color as it moves.

She dyes the silk, then pleats and ties it, frequently discharging the original color and overdyeing in many colors. Brito's scarves range tremendously in size and intricacy of their folds, but share in common a resemblance to exotic flowers, tropical sea creatures, and dramatic autumn clouds in sunset hues (Plate 79). Their construction requires great care, especially in the placement of heavily pleated areas, since the texture in silk, while semipermanent, is not as indestructible as in polyester.

In recent years Brito's work has been shown and has won awards at galleries, exhibitions, and craft shows throughout the United States.

LORI BACIGALUPI and her husband MARSHALL began a multifaceted cottage industry in 1974. They lived in a rural setting in Oklahoma, where they conducted weddings, baked and designed cakes, made wedding clothes, and raised their two children. Marshall wove strips of cloth from an inkle loom of his own making, and Lori applied them to clothing that she designed and sewed. One day someone brought along some Procion dyes and asked them to make a set of colorful wedding clothes. That was their introduction to hand-dyeing, which would eventually evolve into a line of hand-painted and quilted garments now known as Kiss of the Wolf. Since Marshall's death in 1996, Lori has expanded the business while continuing the legacy of comfort, quality, and excellence that she and her husband developed.

Lori Bacigalupi studied education and art at college. Over the years the business provided her and her husband a wide range of opportunities to develop their unique style, a fortuitous combination of quilting with the dyer's art. The Bacigalupis had been experimenting with tie-dye since the 1970s; someone who saw their work at a show during the eighties recognized its resemblance to Japanese shibori and gave them a copy of the book that I had coauthored on shibori. Since then, *arashi* shibori has been incorporated into their clothing designs. The allover pattern and subtle texture created by *arashi* shibori is enhanced by quilting stitches placed in circles or diagonal lines. First the shibori fabric is backed with a thin layer of cotton batting. Then gauze or another lightweight airy material is placed in back of the batting and stitches are made around the shibori design, which is then applied to the jacket.

In the early eighties the Bacigalupis spent months traveling in Asia, observing local traditions, studying batik and weaving, and developing their aesthetic.

Kiss of the Wolf has now been on the craft show circuit for years, and its designs, color, clothing style, and choice of materials have become increasingly sophisticated and distinctive. Its warmth and unpretentious elegance (Plate 80) has brought the clothing line a following. Work from the collection has been exhibited widely and has received various awards, including the prestigious Saks Fifth Avenue Design Award in Fiber Wearables in 1994 in Philadelphia.

JOAN MCGEE's driving interest since childhood has been in creating her own cloth. At an early age, she discovered fabric dye at the variety store and began to make her own fabric for clothing.

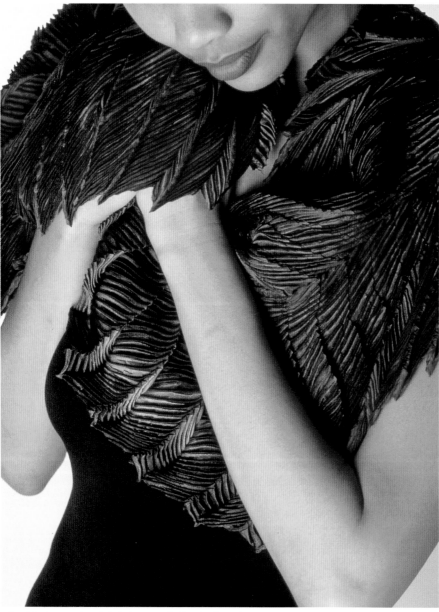

Plate 79. Karren Brito. "Black Spectrum." Pleated silk scarf.

Plate 80. Designed by Lori Bacigalupi, for Kiss of the Wolf. Quilted jacket. *Arashi* shibori.

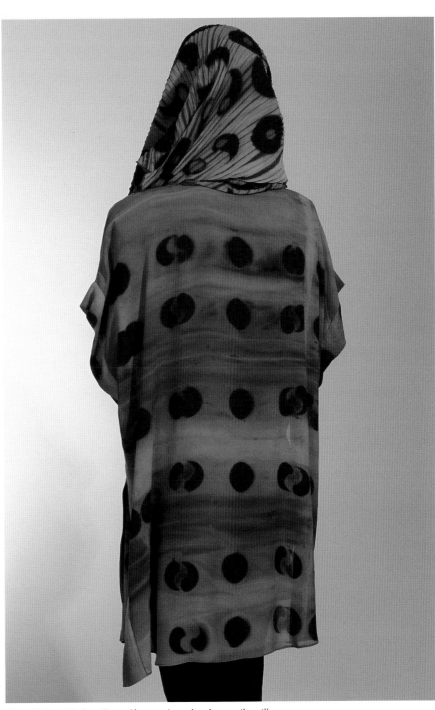

Plate 81. Joan McGee. Coat. Clamp resist on handwoven ikat silk.

This early artistic effort led her to explore dyeing as well. She experimented with dyeing not only cloth but also yarn to weave fabric, which she then made into garments of her own design. Many of these were silk hand-dyed and handwoven jackets and coats made using a weft ikat technique. To this day handwovens are the mainstay of her business. In the early 1990s, McGee began to work with shibori techniques on cloth, inspired by the book *Shibori: The Inventive Art of Japanese Shaped Resist Dyeing*. In the early 1990s she began going to Italy to purchase some of the finest cloth available. She and her husband then devised an arashi pole with an ingenious dyeing setup incorporating a recycled bathtub (Plate 82). She shapes the cloth on the pole, and dyes and discharges it. Next she adds bound resist to the *arashi* shibori by using rubber bands while the cloth is on the pole, or by using various board-clamp techniques, which she sometimes follows with *arashi* shibori (Plate 83).

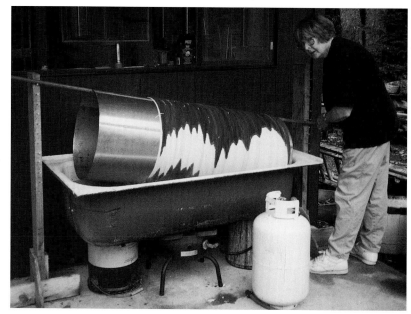

Plate 82. Joan McGee with her ingenious *arashi* shibori equipment.

Assisted by her husband in pattern-making and sometimes her son in *arashi* pole-wrap processes, she has explored a remarkable range of techniques, including *arashi* shibori, combinations of board clamping with other decorative elements, smocking, and application of various shibori techniques to handwoven silk (Plate 81). The yarns she uses are specially spun in Switzerland and hand-dyed by McGee in unique color combinations. Her husband does all the weaving, as well as most of the labor involved in the *arashi* pole work; she employs a seamstress to help with sewing. Lately they have begun to experiment with heat-transfer on polyester, allowing them to use many of the shibori techniques they had been doing on Italian silk to produce fabric that is permanently pleated. McGee often uses silk shibori as a lining to complement the handwoven fabric that they make into elegant coats and ensembles. Sometimes airbrushing is used on the silk in colors compatible with or the same as the handwoven. Another process involves screen-printing the fabric and then repeatedly pole-wrapping and dyeing or discharging it.

McGee's collection is built around the basic combination of a beautiful silk handwoven made into a coat or jacket with an equally beautiful lining, accompanied by a matching shibori silk outfit to be worn underneath. Her collection is supported by teamwork and is an example of a willingness to experiment with materials and processes resulting in a line of elegant and friendly clothing.

MARK THOMAS is a self-taught textile designer who discovered tie-dyeing at the age of twelve and quickly became an addict, searching constantly for anything that he could dye. After high school he moved to California and took a job at a small apparel factory while saving money to attend the Fashion Institute of Design and Merchandising in Los Angeles. This experience inside the fashion industry turned him completely away from mass production. After a few years of study he became an assistant to Oscar-winning costume designer Jean-Pierre Dorleac. Working in that fascinating environment and observing the construction of all sorts of costumes encouraged him to think of apparel as an art form.

His life changed when, during a visit to San Francisco in 1982, he was introduced to Sandra Sakata and her art-to-wear boutique and gallery, Obiko. He moved to San Francisco and began a successful business hand-dyeing and hand-painting silk for Obiko, Bergdorf Goodman, and private clients. By the late 1980s Thomas found he was spending a great deal of time dealing with

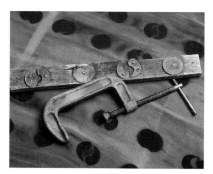

Plate 83. Joan McGee. Silk patterned with clamp resist and dye discharge, shown together with a board and a C-clamp.

the myriad practical issues that needed to be considered when creating art-to-wear, such as sizing, complexion, and season. At about that time he took on a small independent job dyeing and color-matching velvets for a fashion designer and was able to expand this kind of work rather quickly into a large free-lance contracting business (Plate 84). He spent the next nine years producing hand-crafted textiles for designers Catherine Bacon and Ariel Bloom and for his own clients, exploring processes including hand-dyeing, shibori, block printing, silkscreen, mono printing, guava resist, batik, block-resist immersion dyeing, low-immersion dyeing, discharge printing and overdyeing, and dip-dye discharge gradation, while devising his own tools and techniques.

In 1999 Thomas felt the need to create his own statements, incorporating experiences and ideas he had accumulated over years as a dyer, and he began to produce hand-painted coats and separates from silk rayon velvet. He hand-dyes and paints the velvet with fiber-reactive dyes suspended in a seaweed paste to give the dye a paintlike consistency so that it can be applied with a brush. Using techniques for three-dimensional manipulation of the fabric surface such as "finger pleating" (plucking and pleating furrows into the fabric by hand) as a starting point he creates a zoomorphic abstractionist fusion with the addition of patterned spots and brushwork gradations (Plate 85).

GENEVIÈVE DION credits her grandmother with teaching her to sew and to

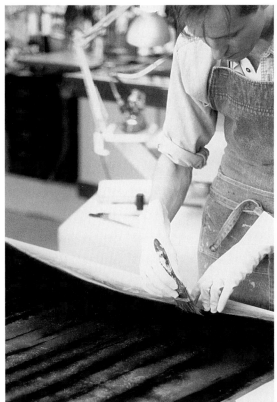

Plate 84. Mark Thomas applying dye on velvet.

enjoy hand textile work. As far back as she can remember, she wanted to make beautiful things to wear, including shoes. By the time she was eleven years old she had figured out, on her own, how to make shoes and bags out of leather. During her high school years she made hundreds of pairs of sandals and bags to order, which earned her spending money. Her own creations, however, were a bit "clanky" for her tastes, and she dreamed of going to Italy to learn fine shoemaking. Dion moved from her native Quebec to the San Francisco Bay area in 1983 after receiving an associate degree in fine arts. In 1985 she enrolled in San Francisco State University, in industrial design. She succeeded in finding an artist and master shoemaker, Gaza Bowen, to instruct her in the art of shoemaking.

"I use the shibori process to sculpt, dye, and form couture garments and accessories that are derived from a single piece of fabric. This is in stark contrast to traditional design, where garments are most often cut and then pieced together. The aim is to create highly textured works within which certain characteristics coexist: vitality through light, color, texture, and fluidity."
—Geneviève Dion

After achieving her longtime dream, however, she needed something else to pursue. Fascinated with fabric, she found her way to a shibori class I was teaching at San Francisco State University. She was delighted to discover that with shibori she could achieve a three-dimensional surface with velvet, molding it so that the colors seemed to jump off the fabric. She combined strips of colored velvet with lacelike areas made of cotton threads. She devised her own technique for creating these lacy intervals. She then manipulated the fabric using shibori and overdyed or discharged it to create rich and unusual cloth that she then transformed into shawls or capes. One of her first pieces in the series won a prize in the International Textile Design Contest in Tokyo in 1990. Her work is characterized by the use of fine materials, capacity for successful use of traditional techniques, and undivided attention to detail. She loves to explore and experiment with novel materials and is determined to find appropriate tools to express the results she imagines. When they are not available, she will alter or translate traditional processes.

Dion uses shibori as a way of allowing the fabric to become self-determining and assume a life

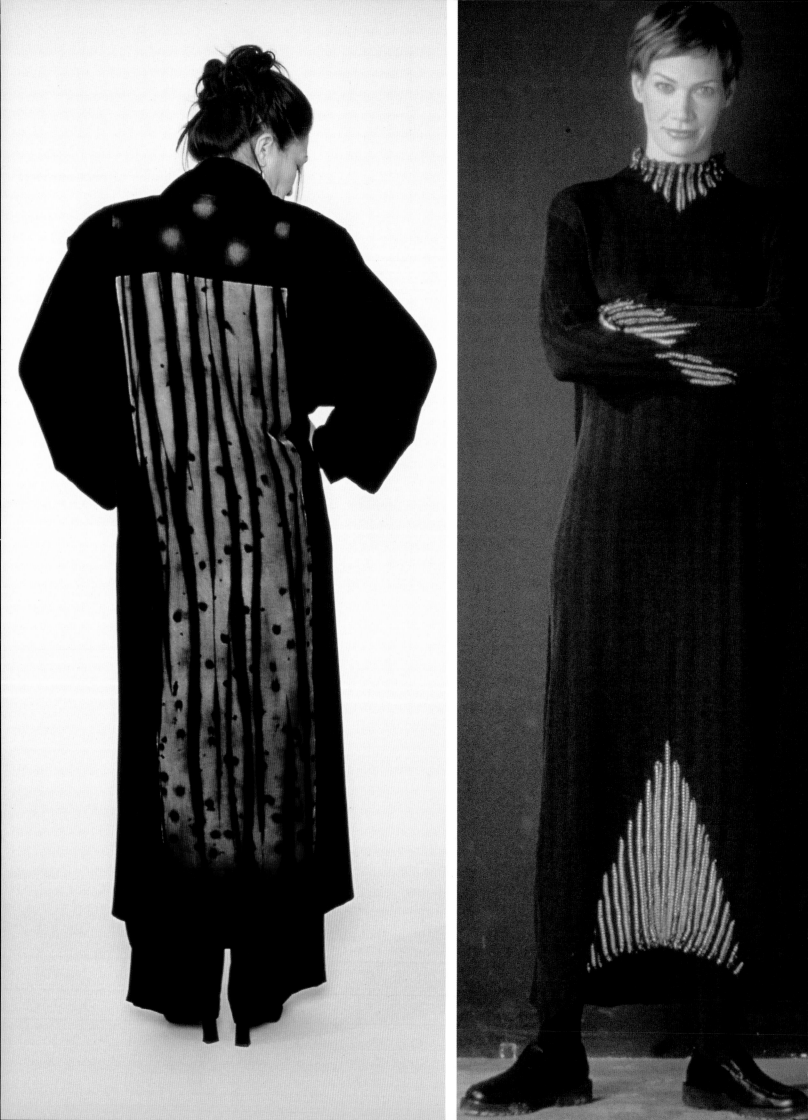

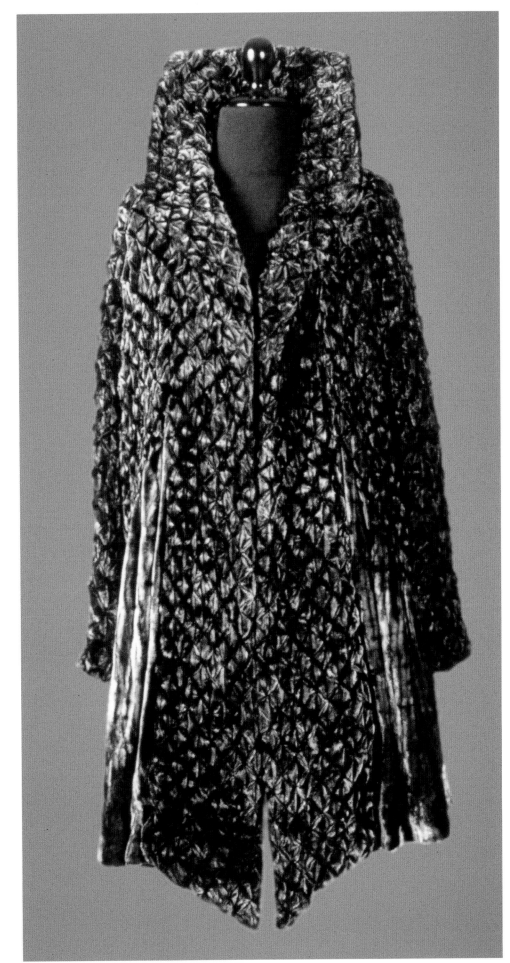

Plate 85. Mark Thomas. Velvet coat with hand-plucked pleats.

Plate 86. Geneviève Dion. "Deco Dress." *Nui* shibori on scoured and dyed Gunma silk. 2000. Photo by Kim Cook.

Plate 87. Geneviève Dion. "Knotted Coat." Shibori-dyed 100% rayon velvet. 1996. Photo by Donna Miller.

of its own. For her it is an integral part of the final three-dimensional design. In "Deco Dress" (Plate 86), she wanted to accentuate the neckline, cuffs, and hemline by contrasting them with a simple garment design. This required that she first apply stitch resist to the raw fabric in those areas of the garment, and treat the whole piece by degumming or dyeing, thus creating a permanently textured surface on silk.

She has been exploring permanent texture and the construction of a finished product with her scarves and purses as well as in clothing construction. For the "Knotted Coat" (Plate 87), Dion bound and pleated individual pieces of velvet by hand with the overall design already in mind. In essence, each of her designs is created with the final piece envisioned (Plate 88).

Plate 88. Geneviève Dion in her studio.

She uses multiple processes and stages to produce the highly textured organic fabrics that are incorporated into her luxury garments, accessories, and interior textiles. Her work is centered around the concept of fusing shibori surface design with new applications in textile construction. For example, certain traditional shibori processes, such as clamping and *arashi,* tend to limit the width of the final fabric and consequently limit the ultimate design. To overcome this, she uses her own "knitting" technique that allows smaller dyed textiles to be joined in a concerted fashion and made into a larger, integrated piece.

Dion's clothing and handbag lines are shown at New York's Bergdorf Goodman store; her pillows have been at Barneys New York, and her home accessories are found at Fifty-One Antiques in Toronto. Her creations are so labor-intensive that only ten one-of-a-kind Opera Purses are completed each year. Her coats, which take five hundred hours, or about two months, to make, are even more exclusive. Lined with fleece to provide softness and shape, the exquisite pieces give the impression of fur, as do her plush tassel-trimmed stoles and wraps.

After receiving a certificate in dress design from a technical college in Sydney, BARBARA ROGERS began work as a designer in 1975 for a large knitwear company, gaining valuable experience in "the trade." In 1978, she left the company to produce her own fashion collection with a friend, using a range of printed fabric, some of her own design. After six years of running the business, she left the field completely for several years, because she did not feel suited to the more cut-and-dried business aspects of the work. But the allure of tactile and flexible materials remained strong, and she returned to her art, this time beginning to work with leather. Loving the supple texture and even the smell of leather, she plaited whips and made belts, bags, and of course some coats. Encouraged by the reception her leatherwork received at the Australian Craft Show (ACS) in 1988, she gradually became excited about textiles again, and decided to enroll in a workshop on shibori taught by Inga Hunter in 1989. Rogers had not previously been familiar with shibori, but her admiration for Hunter's work inspired her to try the process, and she was enthralled by the creative possibilities it presented. She immersed herself in experiments with dyes and shibori, and then actively began to incorporate these elements into clothing design in 1990. Rogers asserted her artistic interpretation in the realm of wearable artwork, gaining honors such as the prestigious Dame Mary Durack Award, for the leather coat Xathorrhoea, at an exhibit in 1990. Her shibori-dyed kangaroo skin and silk kimono received an Award of Excellence in Craftsmanship and the Special Exhibit Prize at the ACS in 1993, and was subsequently purchased by the Queensland Art Gallery.

In her creation of art-to-wear Rogers was inspired by African textiles and by the traditional and contemporary textiles of Japan. Her study of these traditions also provided her with a technical basis to develop her own methods of dyeing and surface design on skins or leathers from fishes, reptiles, kangaroos, pigs, sheep, and cows; many of the materials she uses are readily available in Australia (Plate 89). She teaches widely in Australia while continuing to broaden her technical and aesthetic vocabulary by participating in workshops and conferences. According to Rogers, "The risk, the irreversibility, and the decision-making processes in shibori are quite exciting. Creating individual pieces—going from fabric lengths or hide to scarves and complex items of clothing that I cut and sew myself, I've come a long way from my 'ragtrade' days."

JEUNG-HWA PARK studied clothing and textiles in her native Korea, earning a bachelor's degree from Kyung Hee University in 1983 and a master's in fashion design from Ewha Women's University in 1988. She also worked as a designer for a sportswear company for six years while a graduate student. Before moving to the United States in 1992, she taught at colleges, continued free-lance design, and worked as a fashion journalist. She kept her ties with Korea as a fashion reporter, sending her forecast on trends from the United States while taking continuing education classes in textiles at the Rhode Island School of Design to enhance and broaden her knowledge of apparel design, eventually obtaining a master of fine arts in textiles in 2000.

Park's studies extended to include many aspects of textile design, such as pattern, repeat, layout techniques of surface design, knitting, shibori, as well as the potential of reinterpreting historical designs in contemporary ways. Park became involved with the application of shibori to knitted blends, taking advantage for example of the differing reactions of wool and silk to the process of fulling. She began dyeing her fulled pieces, encouraged by fellow student Liz Collins, who told her, "If you like cooking, then dyeing is easy." Dyeing added another dimension to her hand-manipulated construction of wearable pieces that reflect the changing seasons in New England. Besides stitch resist, Park uses natural objects such as chick-peas and fava beans in the shibori units in her bound-resist process instead of more widely used objects like buttons and marbles. After dyeing, the shaped fabric is dried and the shriveled beans are removed—leaving marks from the path that each natural shape took as it became no longer dry and hard, but moist and expanded. The resulting fabric is an object full of life, composed of unpredictable, distorted protrusions of softer, more open knit against the heavier, rigid fulled ground (Plate 90).

Living now in North America, Park experiences the conflict as well as the harmonizing of opposing elements in her life, such as fashion and textile, commerce and art, handwork and machine, tradition and innovation, nature and science, and the personal and communal. Finding a subtle balance between content, context, and technique, she transforms the humble art of knitting into an unorthodox and cultivated material and visual luxury.

MIE IWATSUBO entered the Musashino Fine Art University in Tokyo in 1996. She had become interested in textiles when she had happened to visit Arimatsu, the small town in Nagoya that has been a center of shibori production since the 1600s. In addition to an annual shibori festival, there is also a Shibori Museum in Arimatsu, and it was there that Iwatsubo encountered old women demonstrating the centuries-old techniques of *kumo* and *miura* shibori. The artisans' hands magically transformed pieces of flat fabric into unrecognizable, dimensional, creaturelike shapes by plucking and binding or hooking, pushing, and loop-tying across the surface of cloth. Iwatsubo was mesmerized by the deliberate, measured movements of their fingers, and by the subsequent processes of dyeing the shaped and bound fabric that recorded their actions. When she learned that shibori textile production was losing ground as a viable cottage industry in Japan, she

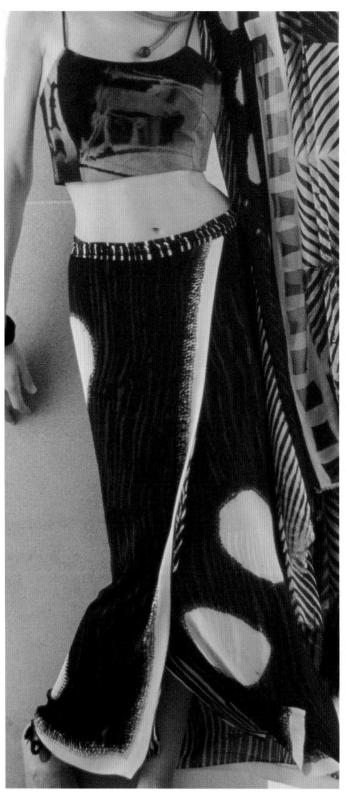

Plate 89. Barbara Rogers. "African Notions." Kangaroo leather and silk, both shibori–dyed. 1999. Photo by Gilbert Rossi.

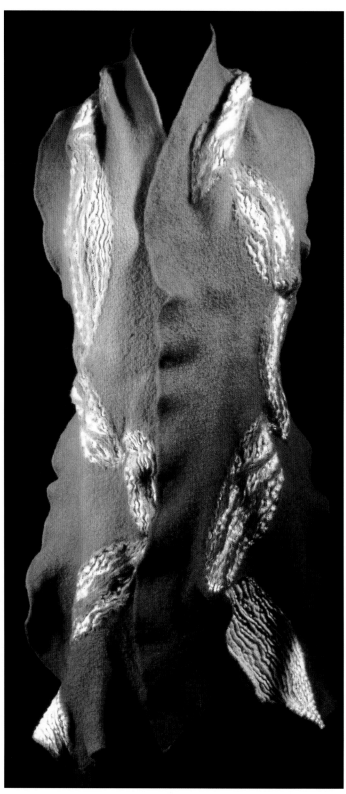

Plate 90. Jeung-Hwa Park. Shawl. "Falling Leaves IV." Wool, machine-knitted, stitched, felted, and dyed. 2001. Photo by Karen Philippi.

Plate 91. Mie Iwatsubo. Cape. *Nui* shibori and felting on knitted (racked ripple knit) lambswool and cotton. 2001. ▶

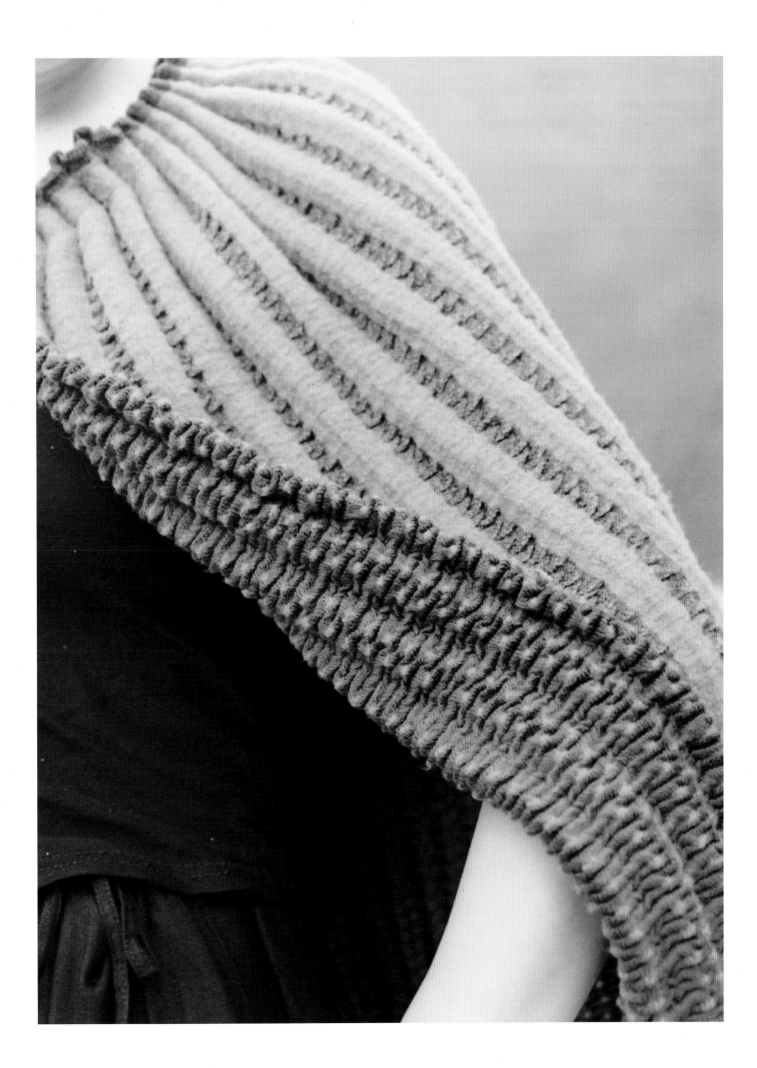

decided to learn and try to carry on the tradition. She began creating fiber art pieces, mainly for the wall, using shibori processes on wool.

During her college days, she discovered the book *Shibori* that I coauthored, and was inspired to learn that shibori has existed around the world and that there are no fixed boundaries or hierarchies among its expressions—no sense of opposition between the traditional and the contemporary, or the functional and the conceptual.

Working for two years at Jurgen Lehl's studio while still in school made her realize that products that are created by a tremendous number of "hands hours" can still find a commercially viable route to consumers who appreciate artistry and handwork. Her interest shifted from art pieces to fashion textiles and under Lehl's direction she created felted accessories, including bracelets, that subtly incorporate shibori processes (Plate 92).

After earning a bachelor's degree in textile design in 2000, Iwatsubo began working toward a master's in fashion and textiles at Nottingham Trent University in England. She is particularly interested in combining shibori processes with other textile techniques such as felting or knitting, in balancing hand techniques with machine production, and in integrating tradition into the contemporary. Iwatsubo recently developed an innovative technique of using shibori on a racked ripple stitch knit, which is first felted to make the material denser; stitching is then done with thick threads, and finally the piece is overdyed. It is easy to insert the threads into the loosely knitted surface and apply compression to it. The right side, which is mostly cotton with tiny woolen spots, appears to be dyed as a stripe. The reverse side shows mostly heavier wool yarns. Since both surfaces exhibit a beautiful shibori pattern, the fabric is reversible (Plate 91). The thick fabric makes it ideal as a winter cape.

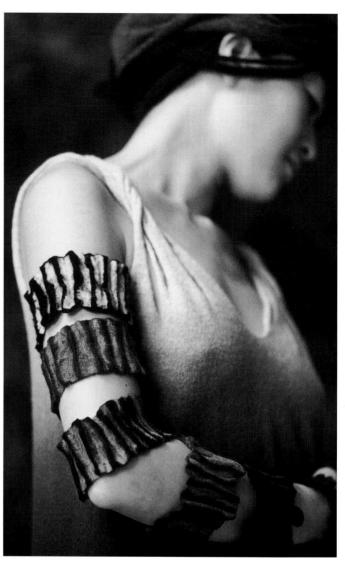

Plate 92. Jurgen Lehl. Felted bracelets. Photo by Yuriko Takagi.

Iwatsubo is now interested in expanding the application of her textiles to home furnishings.

In addition to Japanese fashion designers, haute couturiers such as Paco Rabanne and Ted Lapidus in Paris have been inspired to use shibori textiles. Rabanne commissioned textile artist HÉLÈNE SOUBEYRAN to create shibori fabric for his evening dresses when he saw her sculptural objects, especially the folded and dyed precious silk satin "book" series "Books of the Sky" (Plate 96; see also Chapter 4, Plate 130). Soubeyran has been actively pursuing creative work in shibori on fabric and paper since the 1960s.

Well-known and innovative designer YOSHIKI HISHINUMA has been fascinated from the start by technology and the materials developed for it because in it he can always find new ways of creating clothing—for example, recycling discarded audio tapes by heat-cutting and entwining them into a rustling dress shown in Paris in 1992. This experience made him realize that making clothes does not have to involve painstaking meticulous handwork but can be more like "whipping up instant noodle soup." Hishinuma's boundless inquisitiveness leads him to explore how materials react to different processes. This can be seen in his collection of hand-fulled and felted woolen garments. He worked and worked on woolen knit and woolen yarns—layering, washing, beating, shaping, and boiling them, and in the end produced a line of clothing with a wonderfully wild

look, full of flattering lines and expressive textures. Not surprisingly, his favorite pastime is cooking, but his approach to this too is unorthodox, more like a Chinese herbalist concocting a potion or a lab technician searching for a new vaccine.

One of his first impressive creations, for his 1995 Spring/Summer collection, is based on the potential of vinyl polychloride yarn for heat-shrinkage of up to fifty percent of its original length. The yarn is machine-stitched all over the already constructed oversized polyester garment. High heat is then applied to shrink the yarn and at the same time to heat-set the puckered surface created by the shrinkage. The heat eventually disintegrates the thread, leaving a permanently textured, flexible, stretchy surface. This "3-D clothing" does not require the usual complex cutting and darting to fit the shape of the wearer; it simply stretches and hugs the body. This process relates to *nui* shibori where stitching is applied in a certain pattern and the thread is drawn up tightly through dyeing to record the resisted pattern. With modern material like polyester, high heat is used in place of dye to set the shaped pattern. This concept created a revolution in the fashion industry. He obtained a process patent and licensed the concept, now marketed as a clothing line called Peplum.

"No one can imagine how fabulous it feels when you open the crumpled and bunched-up shibori parts of the material and see them unfold and reveal their 'secrets.' I enjoy manipulating the risks."
—Mie Iwatsubo

Plate 93. Yoshiki Hishinuma. Propeller mold for his "Dresses with Extensions" (Plate 97).

Plate 94. Yoshiki Hishinuma. Fish-scale mold for his "Fish Dress" (Plate 98).

Plate 95. Yoshiki Hishinuma working with his designer.

Extending the idea of three-dimensional clothing, Hishinuma attempted to "sculpt" with polyester fabric—creating a wooden mold to permanently imprint three-dimensional shapes with heat by laying the piece of clothing over the mold and tying it down tightly and securely before the whole thing is boiled to activate the shrinking of the exposed parts. Hishinuma has also worked with an engineer and a yarn twister to come up with a fabric that stretches and pulls under high heat. He then made dresses with this fabric and placed them over wooden molds that look like propellers and securely tied the whole thing before boiling it (Plate 93). The result is futuristic evening dresses with extensions that are inspired by eighteenth-century French clothes (Plate 97). He also used wooden molds (Plate 94) to create a collection of clothing with remarkable embossed patterns for 1996 Spring/Summer, and in 1997 for the fantastical, elegant "Fish Dress," covered with a dimensional texture like that of fish scales (Plate 98). The dimensionality and colors are obtained by his interpretation of the concept of shibori—focusing on the shaping of fabric of already constructed garments, thus giving them a flexible, elastic quality. He asserts that he wants each of his creations to be individual and slightly different since they are made with technology but also with the artist's hands (Plate 95).

No technique or material is a trade secret to Hishinuma. He claims that it is only natural that he is generous with his ideas and findings because he has enjoyed trusting relationships with people who have helped him. The fact is that by the time someone else is trying out what he developed Hishinuma is already onto totally new territory. He now uses computers to manipulate the garment's traditional body size and form, varying them at his will. And since the 1999 collections, his garments have been constructed without using conventional sewing thread, but by melting the polyester fabric to cut it and then fusing it. "It's important for the first concept to grow and change freely," he says.[2] "I am not a conceptual artist; the concept is only the starting point ... The emotional side is more important. Sometimes I create a garment directly onto the body, using my hands freely. In this way I free myself from the original concept. The garment then evolves emotionally ... My collection is created like this every season."

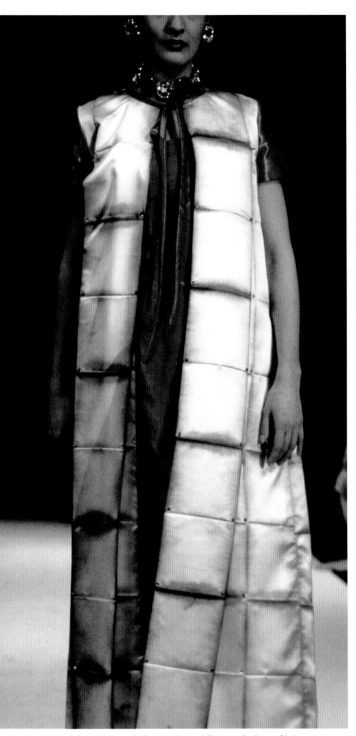

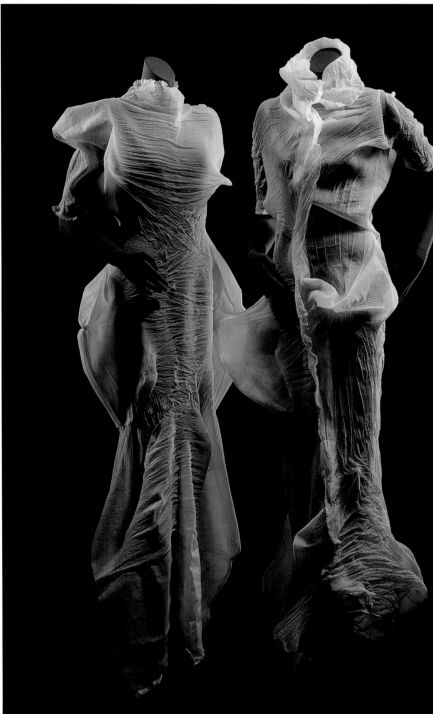

Plate 96. Paco Rabanne. Dress. Silk satin duchesse fabric commissioned from Hélène Soubeyran and inspired by her series of textile sculptures, "Books of the Sky." 1992.

Plate 97. Yoshiki Hishinuma. "Dresses with Extensions." Polyester. Spring/Summer 1998. Photo by Erik and Petra Hesmerg. Gemeentemuseum, Den Haag 2001 c/o Beeldrecht Hoofddorp.

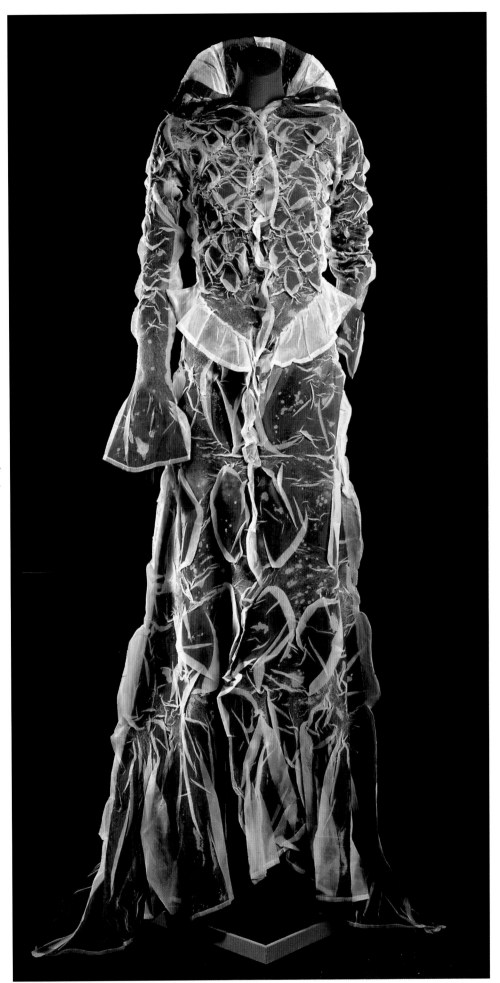

Plate 98. Yoshiki Hishinuma. "Fish Dress."
Heat-transfer on polyester. Spring 1997.
Photo by Erik and Petra Hesmerg.
Gemeentemuseum, Den Haag 2001
c/o Beeldrecht Hoofddorp.

inner journey: fabric and beyond

At the end of the twentieth century, a group of textile artists from many different countries who had learned the language of shibori began deciphering and communicating with the marks left by the force of dye liquid on hand-manipulated and compressed pliable planes such as fabric. This focus on the memory of the process recorded on cloth was marked by directness of expression, spontaneous light-hearted humor, risk-taking, and a welcoming attitude toward the fluid transformation of events and natural phenomena. Realizing that parallels of shibori processes exist throughout our environment and everyday lives, these artists have undertaken their own personal journeys into the creative realm, finding shibori to be a perfect medium for recording ideas and emotions, since it can never be seriously threatened by industrial imitation nor made into a purely cerebral exercise.

Indigo has of course been used for centuries around the world, but the subtle variations achieved in Japanese indigo dyeing—from pale blue to the deepest black-blue—are a sublime revelation. Artists have an almost spiritual devotion to transforming yarn or cloth through color into expressive poetry that reflects the glory of the living environment—earth, plants, water, and sky. No other color has left such an indelible mark on Japanese textile—from the deep indigo-dyed pages of the Nara-period Buddhist sutras inscribed with gold or silver calligraphy to shibori-dyed cotton kimonos or the humble work clothes of ordinary people woven from strips of recycled blue cotton rags.

In the 1960s, while studying at Kyoto City University of

Arts, HIROYUKI SHINDO became enraptured by the magical colors and mystery of the fermentation vat-dyeing process achieved with natural substances. Knowledge of the time-consuming and demanding classic process of natural indigo dyeing was then rapidly disappearing. Fortunately Shindo met Motohiko Katano, a shibori artist in Nagoya who was willing to share his knowledge of the tradition. Since that time Shindo has established himself as one of the most innovative contemporary fiber artists to use natural indigo, preserving this once ubiquitous craft and translating it into contemporary visual language. In his "Indigo Space" series he incorporates shibori subtly, by placing a group of large rocks on a tray and laying the fabric over, then pushing some parts of the fabric down between the rocks before pouring in the dye. This records the shapes and ambiguous edges created by dye seepage as well as the reserved areas where the cloth was supported by the rocks. This process relates to the classic folk shibori technique *okkochi*, where a large ground area is reserved in white by holding back a portion of the fabric during dyeing. Shindo's large-scale indigo-dyed textile installation truly transcends the conventional boundaries between art and craft. Its composition—with large indigo dye marks floating like moving clouds on the hemp ground—is deeply calming (Plate 100). In it he translates ancient indigo and gold sutras into his own idioms.

Plate 99. Michie Yamaguchi. "Galaxy 930327." Stitched and pleated resist. Blueprint process on cotton. 250 x 524 cm (8¼ x 17¼ ft.). Collection of Seiryukai.

Another artist involved in this area is YUKIKO ECHIGO (page 116), who has been studying shibori using natural indigo with Kaei Hayakawa. Echigo has explored the *katano* shibori process and adapted it to her work. Instead of using the traditional narrow kimono cloth and folding it vertically to obtain a conventional pattern that repeats along the width and length, she folds a large square cloth at oblique angles similar to origami folds, reducing the large cloth to a much smaller square before stitching a design through the layers. After dyeing, the stitching threads are removed and the cloth is opened to reveal a light and dark design that repeats in all directions. The resulting piece conveys dynamic movement within a superb composition of indigo gradations.

MICHIE YAMAGUCHI, on the other hand, works with chemical blue, using a blueprint process applied directly to the fabric. She gathers the cloth with a large stitched line in the center and applies emulsion before exposing it to sunlight. After the chemical is neutralized, the cloth is ironed flat; it then carries the record of the creases imprinted by light (Plate 99).

KAEI HAYAKAWA was born in a family of dyers in Arimatsu. His interest in becoming an artist,

◄ Yukiko Echigo. "What's in the Box?" Folded and stitched resist. Natural indigo on cotton. 2001.

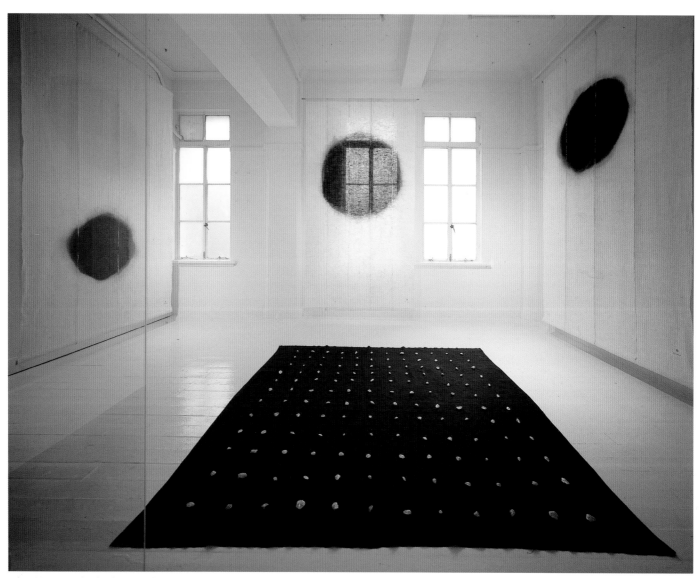

Plate 100. Hiroyuki Shindo. From the "Indigo Space" series. Installation at Gallery Gallery, Kyoto. On walls: "Clouds."
Okkochi shibori panels on hemp, dyed in natural indigo. 2001. On floor: "Sutra." Pebbles collected from the artist's
environs and wrapped in gold thread resting on antique French linen dyed in natural indigo. 2001.

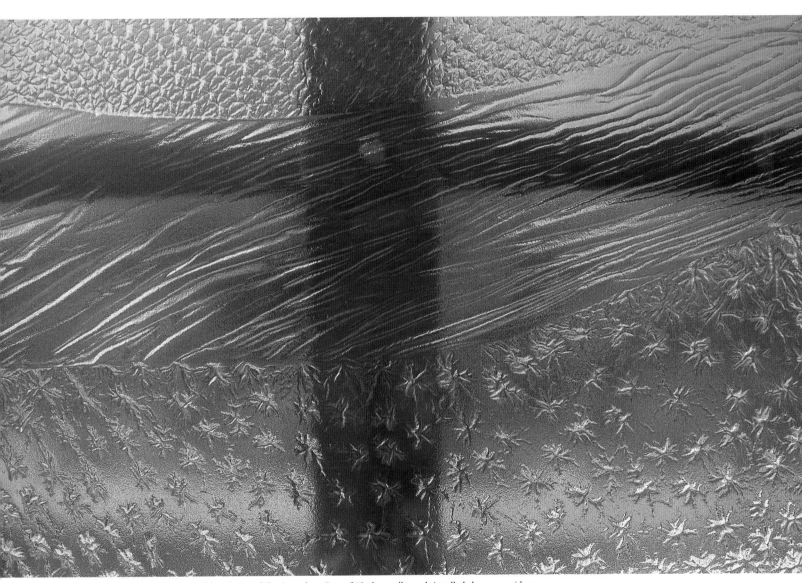

Plate 101. Kaei Hayakawa. *Kumo, arashi*, and *miura* shibori on glass. One of 63 glass wall panels installed along a corridor in the new train station in Arimatsu, each 80 x 70 cm (32 x 28 in.). 2001.

rather than a traditional shibori dyer, made him a black sheep in that small community of shibori artisans. While dwindling consumer demand for traditional textile and the rising cost of labor-intensive handcraft forced many younger shibori producers and artisans to reevaluate their work and search for new products and new markets, Hayakawa's natural instinct was to create something different, something all his own. He maintains a studio with natural indigo vats as well as *arashi* shibori equipment and other dye equipment (Plate 102). Having learned *arashi* shibori from Reiichi Suzuki, the last traditional *arashi* artisan, Hayakawa now utilizes the process in a wide range of variations. His introduction of a shorter pole and minor electric motorization has made it possible for him to operate the equipment alone. The short pole acts as a core onto which a PVC pipe 91 to 122 centimeters long (three to four feet) can be fitted tightly. The PVC is much lighter and easier to handle than the traditional solid wooden pole, and its hollow core makes dyeing or discharging easier and more efficient. By controlling the rotation and speed of the pole, Hayakawa can shape a dozen or more fabrics or garments on individual PVC pipes in one session and dye them all in another session (Plate 103). The ease and control that his system allows makes it possible for him to focus on each piece and vary the patterns as he likes. He has done many commissioned works for fashion designers including Yohji Yamamoto and Hiroko Koshino.

His most recent explorations involve translating shibori from fabric to aluminum or to glass (Plate 101). A piece textured with *arashi* shibori is hardened and made into a mold, which is then cast in glass or metal. These non-fabric pieces are being commissioned for use in architectural projects—one a central monument in the newly developed station plaza, and others to be installed on the walls of the station building, in Arimatsu. Glass *arashi* shibori can also be used for lighting fixtures, and adds a new dimension of beauty and practicality to the contemporary shibori scene.

Plate 102. Hayakawa at work with his innovative *arashi* shibori equipment.

KEIKO AMENOMORI-SCHMEISSER taught herself *katazome* in the early seventies. She received a master's degree in 1978 in industrial textile design from the Academy of Fine Art in Hamburg, Germany. During this time she also interned with a commercial printer where large panels were produced; there she learned screen printing and also began to incorporate, first, painting into the printed images (Plate 107) and, later, shibori-dyed elements, to balance the hard edges of the printed images.

After moving to Australia in the late 1970s she continued to explore textile, and received her first major commission in 1988, for a series of screen partitions to create space of different sizes in the reception hall of Australia's new Parliament House. She started working with shibori in 1995, when she assisted Hiroyuki Shindo at a workshop he gave in Australia on natural indigo dyeing and shibori. From the beginning she favored natural fibers like linen, with its crispness and weight and rather coarse weave. She started to draw freely by hand on white linen, using the cloth as a canvas. She then expressed the energy of these lines when she stitched over them with *nui* shibori. Her concern is the fluidity of the lines being stitched, not the neatness of the stitching. When the cloth is stitched and gathered and tied, the bundle epitomizes the cumulative energy of all those processes.

Amenomori-Schmeisser combines shibori and painting to create works that have both the crispness of a screen print and the soft blur of shibori. She changes the stitching direction, uses different thicknesses of thread, and varies the stitch according to the color and texture she wants. Sometimes she paints all over the shibori-tied surface rather than dyeing it; this enables her to shape the textured cloth, which becomes an object in its own right. Her use of fabric

paints, which cover the surface without dyeing it, adds to the structure and color range of the work and gives the cloth rigidity that allows three-dimensional forming (Plate 104).

JUNCO SATO POLLACK completed an apprenticeship in the 1970s under Tsuguo Odani, a master weaver in the *mingei* circle, from whom I also learned ikat weaving and indigo dyeing. Her focus since 1974 has been on spinning, natural dyeing, and ikat weaving with silk on a back-strap loom—all practices that were on their way to becoming esoteric. Since the late seventies Sato Pollack has added shibori to the range of traditional Japanese textile crafts that she uses in her work and includes in her teaching.

While living on the west coast of the United States in the latter half of the 1970s, Sato Pollack began searching for ways to create three-dimensional works using cloth. She needed material with a certain stiffness, so she began weaving with untreated gummed silk yarn that she reeled from her own cocoons. In the 1980s she created a large body of exquisite shell shapes dyed in natural dyes and shaped with shibori processes. She pushed the notion of dimensionality and lustrous surface further by beginning to weave with traditional gold thread, thus moving into quite a different realm in textile art. In 1991, she had access to silver and silk gossamer broadcloth produced by French manufacturer Dorures Louis Mathieu Industry, which enabled her to work more efficiently and on a larger scale. Sato Pollack applies surface texture in an intuitive, almost symbolic manner, adding drawing-like lines rendered through finger-pleating in a manner similar to classic *suji* shibori, then machine-stitching or ironing the cloth. The creased layers of fabric cast shadows and patterns that float on the wall when lit, accentuated by the reflective surfaces of gold leaf, thermofused aluminum, and colors applied with heat-transfer dyes (Plate 106).

Plate 103. Hayakawa's shorter *arashi* poles, fitted with PVC pipes that make it possible to shape and dye cloth with greater ease and precision.

As the daughter of an accomplished dressmaker, JOAN MORRIS was encouraged to design and sew at the age of seven. Drawing and painting have also always been an important part of her life. In the early 1970s, she abandoned her formal education, moved to rural Vermont, and became involved in communal living and organic farming. She began working for a production ikat weaver, who showed her some indigo-dyed shibori swatches. This first encounter with shibori was a revelation. She set about learning as much as she could about shibori and about dye and discharge dye processes. The aim of her shibori experiments was to create textiles that she originally conceived of as drawings or paintings.

The discharge process figured prominently in her self-education, since she likes to use colors in combinations that allow a dark figure to float on a light ground. These color combinations are often complementary, so color and pattern removal became an important part of her process. She found herself most attracted to stitch-resist patterns, which are labor-intensive but exquisite in their intricacy and aliveness. Her process involves stitching and subsequently erasing and replacing patterns, or layering with other patterns and colors.

Since 1984 Morris has been the master dyer for the Drama Department of Dartmouth College in New Hampshire; she has dyed the textiles for over sixty productions there. She began teaching shibori in 1989—to adults as well as to children in schools of the northeastern United States.

In 1992 she was commissioned by award-winning director Julie Taymor to design and create textiles for costumes for the Broadway musical Disney's *The Lion King* (see Chapter 2, Plates 42–44).

In 1996 Morris completed a highly innovative shibori project for the Remote Sensing/

Plate 104. Keiko Amenomori-Schmeisser. "Ripples, Red and Gold." Shibori, dye, and paint on linen. 70 x 125 x 20 cm (28 x 49 x 8 in.). 1998.

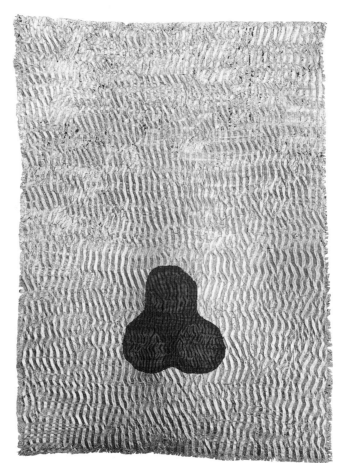

Plate 105. Joan Morris. "Replication." *Nui* shibori on mechanical-resist–dyed silk and gilding with 23-karat gold. 38 x 48 cm (15 x 19 in.). 2000. Photo by Debbie Kates.

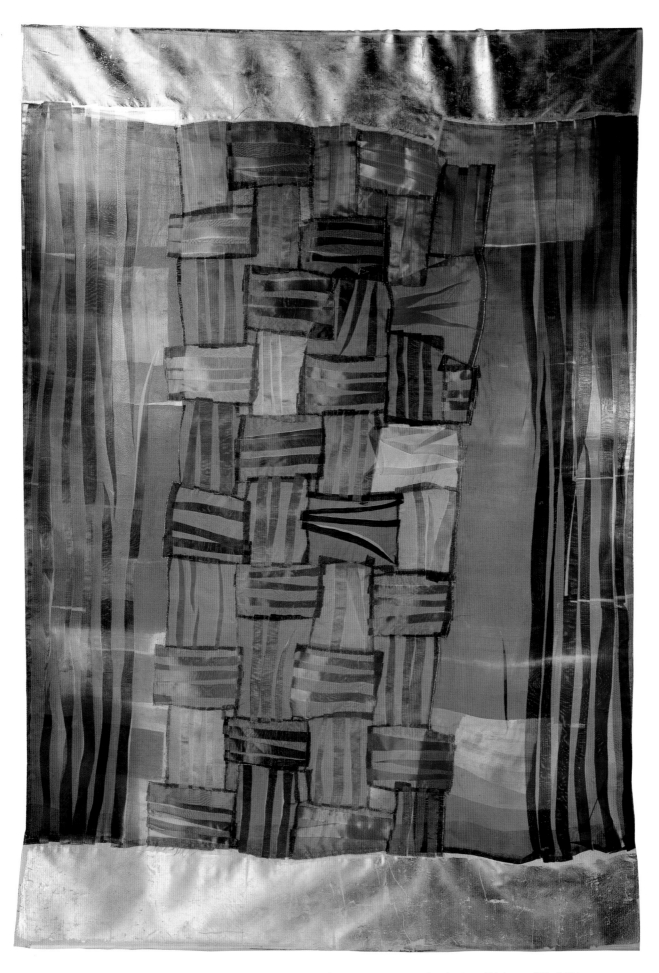

Plate 106. Junco Sato Pollack. "*Kesa* 4: Folds." Shibori, heat-transfer, dyeing, piecing, and application of 23-karat gold leaf. 114 x 165 cm (45 x 65 in.). 1999. (The Japanese word "*kesa*" refers to the patchwork stole traditionally worn by Buddhist monks.)

Geographic Information Systems Center in Hanover, New Hampshire. She was amazed by the similarity between shibori and the process of capturing digitalized images of the earth's surface using remote-sensing satellites, and wanted to share this observation with the scientists at the GIS. They were excited by the similarities, and the director of the center saw the possibility of a commission, recognizing that displaying art that expressed the beauty of the center's images could make their work more interesting to the thousands of nonscientists who visit the facility each year. Morris was granted the commission after spending a grueling two months analyzing the correlation fully and preparing a succinct but highly technical proposal.

The five-year project, funded by the U.S. Army Corps of Engineers, involved translating four environmentally significant remote-sensed satellite photographs into shibori, using stitched, pole-wrapped and capped shaped resist (see front jacket). Morris deconstructed the satellite images visually layer by layer and translated them into cloth, using dye discharge to create deeply layered compositions—working from dark to light to depict the range from the most distant plane to the closest.[1] This work led to her collaboration in 1996 with a Dartmouth mathematics professor who received a grant to produce *Wind-Driven Rain,* a short video about her shibori work. Subsequently Morris developed a geometry curriculum based on the *itajime* shibori process.

These projects triggered a perceptual shift for Morris in regard to the layering of images, which she has incorporated into her most recent textile work using gold embellishment, in which a layer of 23-karat gold leaf is affixed to the cloth (Plate 105). In 1995 she began to use mechanical resist in conjunction with shibori, to enrich the surface of the cloth and add other gestural marks to her compositions. She sees the possibilities for pairing shibori with other methods of surface design as limitless.

From the beginning ANA LISA HEDSTROM has gravitated toward *arashi* ("storm") shibori—a unique Japanese process that traditionally involves wrapping fabric around a long pole, securing and carefully patterning string around it, compressing it into minute folds, and then dyeing it. In this technique, the side that is flush against the pole resists the dye and only the surface of the minute folds takes the color. The tiny folds created on the surface of the shaped fabric and the tension exerted upon it cause patterns that are subtle in color and texture to emerge. Hedstrom is in a league of her own, demonstrating the rigor seen in classic *arashi* shibori work and skill equal to that of traditional artisans. She has achieved an essential balance between spontaneity and control in the creative process. As a leading creator of wearable art since the 1970s, Hedstrom has expanded her repertoire to include exquisite shibori-dyed and pieced compositions using Gunma silk fabric, juxtaposing colors with a wide range of opaque and transparent textures (see Chapter 3, Plates 70 and 71).

In addition to experimenting with heat-transfer processes and technology such as video and digital imaging to create cutting-edge visual statements, Hedstrom continues to explore the juxtaposition of pattern and color. "Lexicon," one of her many wall panels, demonstrates her interest in "vocabulary" as an essential element in communication (Plate 111). The dominant pattern repeated on the panel alludes to a book shape. Hedstrom challenges the viewer to peruse the visual clues and marks imprinted on the cloth and to read there the language of shibori.

Born in Germany and raised in Chile except for three years of study in Munich in the mid-1950s, INGE DUSI has divided her life and work between South America and her husband's native Italy since 1973. Her work and teaching in Chile and Italy have made her the leading textile artist working in surface design in either country. She also co-chaired the third ISS in Santiago in 1999.

Apparent in her work "Huella Precolombina" (Pre-Columbian Footprint; Plate 109) are all of

Plate 107. Keiko Amenomori-Schmeisser painting on shibori-textured cloth.

Dusi's pivotal experiences—her first exposure to the works of such painters as Paul Klee and Wassily Kandinsky in Europe, witnessing firsthand the fiber art movement and the contemporary art of the 1960s and 1970s while in the United States on a Fulbright fellowship in 1971, and finally her study of Pre-Columbian art, especially the *amarra* (tie-dyed) textiles of the Andes. In 1969, at the Amano Museum in Lima, Peru, Dusi encountered these enigmatic and completely unique textiles and was captivated. She began studying these fabrics and undertook the replication of some of the processes, using her own skills in dyeing together with artistic license. Dusi uses methods similar to classic *suji* shibori, *nui* shibori, and *itajime* shibori to create works in silk and linen that range in size from small to enormous.

LYNN KLEIN is well known for her mixed media work, using primarily printmaking processes such as mono-print, photogram (a shadowlike photograph made by placing objects between light-sensitive paper or fabric and a light source), and photographic lithography. For Klein, the process of making marks on fine silk by resist dyeing is a very natural extension of her print-making activity. The sheerness of the silk and the art of chine collé (layering silk and paper) enable Klein to juxtapose images on a single plane. These superimposed images seem to draw patterns and objects near us and then, with a subtle shift of perspective and a change of focus, push them away. Klein often includes photograms of everyday objects or cut-out shapes into her work that seem to float, ghostlike, above and below the surface of the picture plane (Plate 110). Only the trained and knowing eye can discern from her luminous and transparent colors and soft edges that she is using shibori processes.

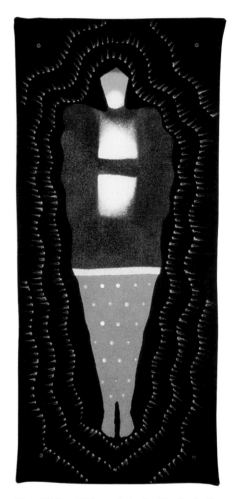

Plate 108. Jean Williams Cacicedo. "For Sandra." *Itajime* shibori and fulled wool. 61 x 137 cm (24 x 54 in.). 2000.

While studying in the late 1960s at the Pratt Institute of Art in New York, JEAN WILLIAMS CACICEDO was one of the pioneering artists to create body sculptures using yarn and cro-chet. She and classmate Janet Lipkin became leaders in the wearable art movement of the 1970s. From constructing a garment solely with crochet, Cacicedo began combining crochet, fulled knit, and fabric in a garment, eventually going on to create dynamic graphic compositions with felting, fulling, and piecing; some of these works became garments, and others wall hangings. During the nineties Cacicedo began to incorporate shibori into her work. "For Sandra" (Plate 108) is in homage to Sandra Sakata, who ran the boutique Obiko in San Francisco and played an important role in the wearable art movement.

MARIE-HÉLÈNE GUELTON studied graphic art in college and completed a bachelor's degree in visual art from the Sorbonne in Paris in the late 1970s. She had been fascinated with weaving

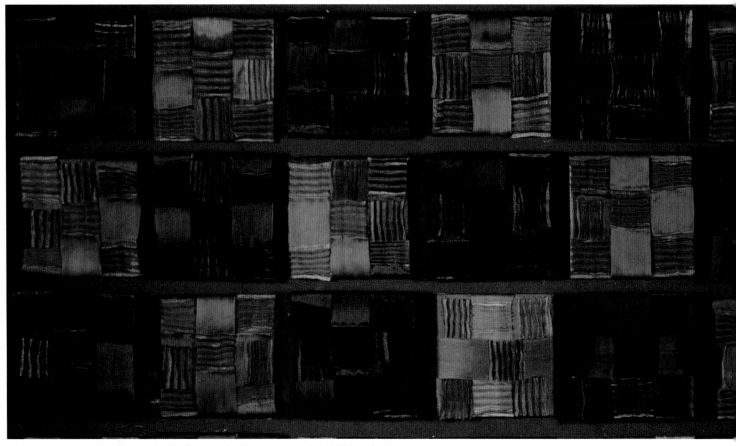

Plate 109. Inge Dusi. "Huella Precolombina" (Pre-Columbian Footprint). Detail. Shibori-dyed silk, assembled. 5.2 x 1.85 m (17 x 6 ft.). 1999.

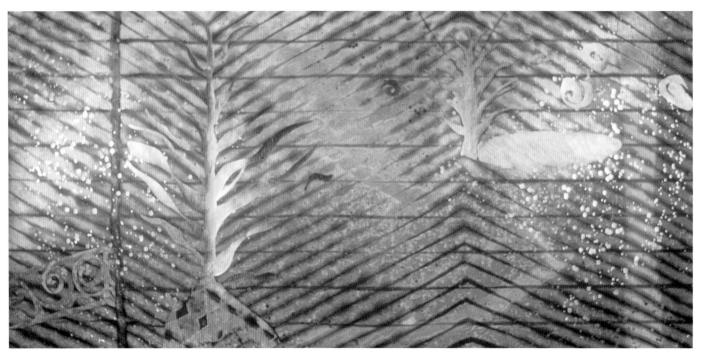

Plate 110. Lynn Klein. "Winter's Light." Resist-dyed silk, photogram, gold foil, pastel drawing, and chine collé. 188 x 91 cm (74 x 36 in.). 1988.

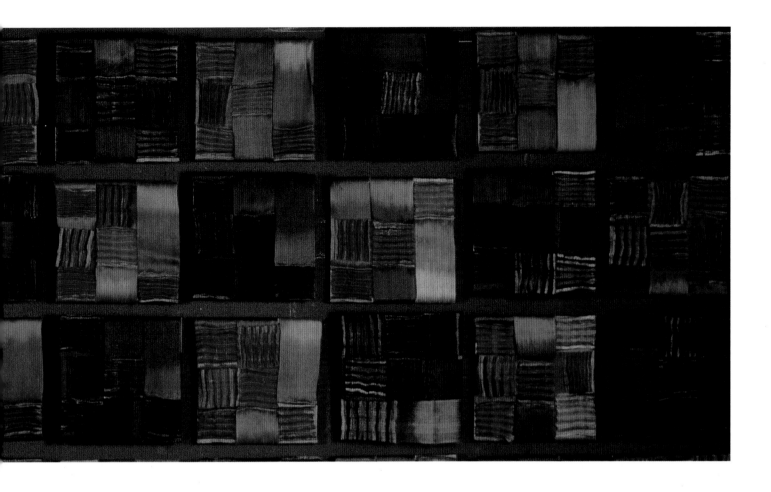

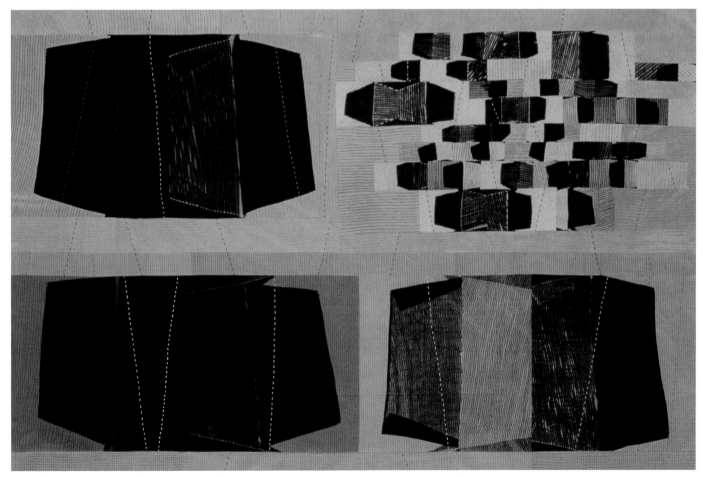

Plate 111. Ana Lisa Hedstrom. "Lexicon." Shibori–dyed, discharged, and pieced silk pique. 208 x 137 cm (82 x 54 in.). 2000.

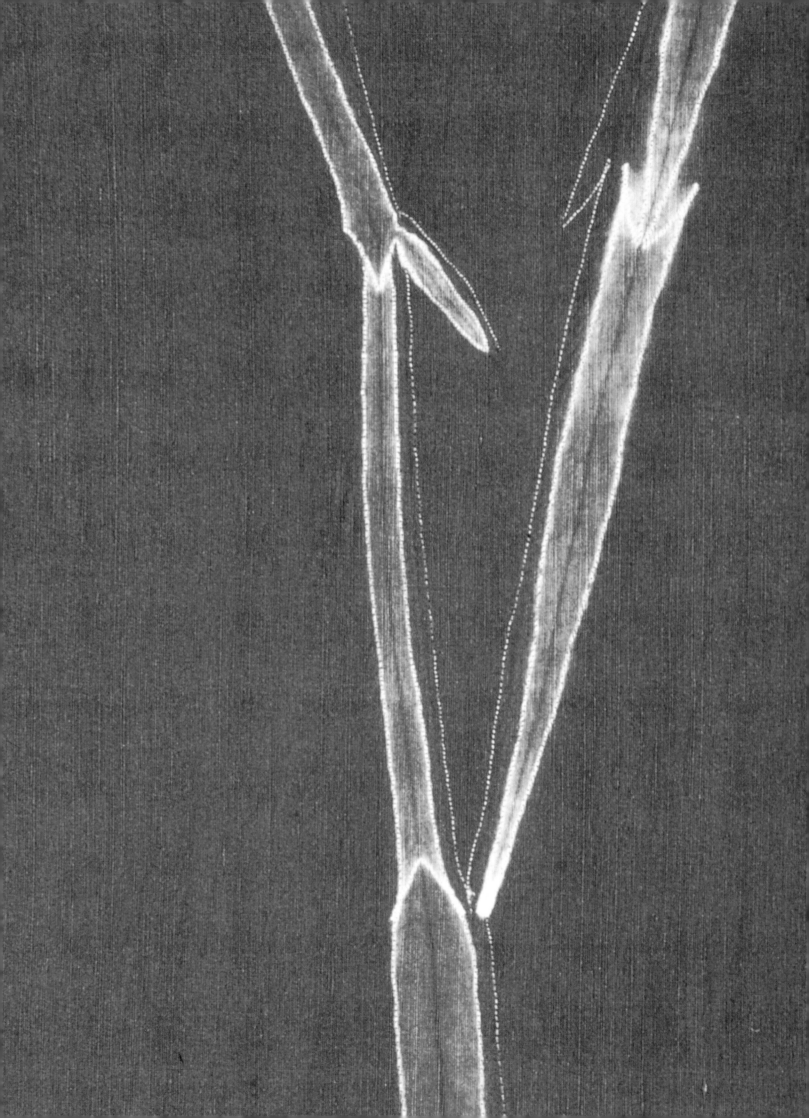

since the early seventies and continued to pursue the study of this art while completing her formal education in Paris, spending much time in the Maghreb region of North Africa. Although she worked briefly as a textile designer in the mid-1980s, her passion to know more about the structure, material, and ethnology of textile led her to take courses at the International Center for the Study of Ancient Textiles in Lyon and the Social Sciences College in Paris. Her capacity to analyze and recreate ethnographical textiles drew the attention of Monique Drosson, curator of the 1987 exhibition "Pliages, Plissages, Plangi" (Pleats, Folds, Tie-dye) at the Musée de l'Impression sur Etoffes (Museum of Printed Textiles) in Mulhouse, France. Guelton collaborated with Drosson to create forty-five textile samples for the exhibit and write an essay on shibori and its origins. The project stimulated her creative interpretation of resist, including the stitch-resist prevalent in African shibori textiles, within her own body of work. Her familiarity with the regional weaving of Maghreb gave Guelton a basis upon which to expand her visual and technical vocabularies, influenced by Moroccan embroidery traditions as well as by women's mantles of the Beni Quarain tribe. "My knowledge of weave structure informs my process of shaping and manipulating—in the weft direction, or using pleating, stitching, or wrapping," she says.

In the mid-1980s Guelton met Indian textile scholar Krishna Riboud, who invited her to work for the Association for Study and Documentation of Asian Textiles (AEDTA) in Paris as associate curator and director of technical research, which she did until the closing of the center in 2001. At AEDTA Guelton conducted many research projects that generated exhibits and important publications on topics such as Indian textiles of Samit and Lampas, the floral motif in Moghul textiles, Tunisian women's costumes, Japanese *kesa* (Buddhist monks' robes), and ceremonial uses of textiles in Sumatra. During this period, she taught surface design at the École Nationale Supérieure des Arts Decoratifs (National College of Decorative Arts) and other venues and focused on the creation of her art textiles using *arashi* shibori and laborious *nui* shibori on a wide variety of fabrics (Plate 112). "Guelton's work, always superbly restrained, demonstrates her innate understanding of the materiality of textile."[2]

The mostly feminine home craft of quilting underwent transformation with the rise of the counterculture in the early 1970s, as did the traditions of weaving, dyeing, and sewing. Quilting came to be defined as the creative medium of layered and stitched fabric. A handful of artists such as Nancy Crow and Michael James saw the quilt as an essential medium for artistic statements that could not be expressed with any other materials or process. One of the first regular art quilt exhibitions, Quilt National—which continues to be the most influential—began in 1979 to show works that did not fit into the conventional classic categories. The early Quilt National exhibitions made it clear to viewers that quilts can be other than functional objects. Since then the art quilt field has become crowded with artists doing bold and inspired work.

Through extensive formal and informal studies of historical and traditional textiles, including a master of fine arts from Cranbrook Academy of Art and a master of science in textile history from the University of Wisconsin, CHAD ALICE HAGEN has actively engaged in an inquiry about fiber and its viability as a source for meaningful communication in contemporary society. She brings these same concerns to her teaching and her creative work. As her chosen medium she uses felt, which can be made into a flat sheet like a rug, or formed into sculptural shapes such as a hat, shoes, or even a movable house like the yurt, a type of tent used by nomads of Central Asia. During the 1970s Hagen became attracted to hand-weaving, and this inspired her to pursue textile seriously. In the 1970s and early 1980s felting was still a novel process in North America, and it evolved as a creative medium in tandem with the rising popularity of hand-spinning and weaving.

◄ *Plate 112*. Marie-Hélène Guelton. "Anthracite 1." Detail. Partially pleated, machine-stitched, and dyed silk. 120 x 140 cm (4 x 4½ ft.). 1996.

Plate 114. Jan Myers–Newbury. "The Three Graces." 48 x 140 cm (19 x 55 in.). 1997.

Hagen selects the fleece, makes the felt, and dyes and hand-stitches the pieces into larger works for the wall, as well as crafting whimsical hats. Her technique of patterning by layering small units of hand-felted pieces emerged naturally from her approach to constructing textile pieces ranging from small to huge. She has been interested in the concept of movable walls as they relate to the traditions of tapestries or temple hangings as well as cave dwellings and yurts. Dyeing fleece and felted pieces helped her to refine her visual language and develop her own distinctive color palette and textural quality. She uses shibori as one of her prominent patterning processes.

Plate 115. A commissioned piece being worked on in Judith Content's studio. On the floor a small rendering lies next to a silk piece.

The colors, edges, and lines of her resist-dyed images on thick felt are saturated, vibrant, and evocative. In addition to *arashi* shibori, Hagen uses a simple bound-resist process often combined with a small object inserted into each bound unit, as practiced in western Africa in the making of *onikan* (see Chapter 1, Figure 3). In her "Driveway Collection" series, she incorporates in the shibori process stones that she herself has collected from various driveways, including her own in North Carolina. After dyeing, each stone is tacked with stitching onto its own "shadow" as a record of the resist (Plate 113).

JUDITH CONTENT's love of color is evident in all her creative work, including quilts, paper beads, fans, collaged bowls, mosaic tiles, painting, and even her collection of artifacts. Content is best known for her quilt work, which can be found not only in the homes of collectors but in such corporate office complexes in California as Varian World Headquarters, Chevron, and Kaiser Permanente. Her hand-dyed, pieced, quilted, and appliquéd silk wall pieces are patterned using a contemporary adaptation of traditional *bomaki* shibori (see page 190). Normally the *bomaki* process calls for the use of large and unwieldy poles, but Content came up with the innovative idea of dyeing or discharging relatively small pieces of different kinds of black silk on wine bottles. The dyed silks are then split up and reassembled into pieced, quilted, and appliquéd wall pieces that often make allusion to such Japanese forms as the scroll or kimono. Her work explores the colors, textures, and patterns of stone, sky, fire, and water. A great source of inspiration has been the play of light and shadow observed along the northern California coast (Plate 122 and pages 5–6). Content likens her quilt construction process to a painter mixing a palette of paints. When she has enough silks to work with, she scatters them over her studio floor (Plate 115) and tears and cuts them into smaller pieces, looking for just the right combination of color, design, and imagery.

"I wish to explore the idea that a movable textile wall can create a place of stillness, meditation, and reflection."
—Chad Alice Hagen

In her quiltmaking LIZ AXFORD finds herself addressing many of the same spatial, geometric, and textural concerns that she did while studying architecture at university and then while practicing as an architect from 1978 to 1986. Sharing her mother's interest in quilts and cherishing fond memories of an old quilt she grew up with, made by her great-grandmother, she was drawn into quiltmaking. When Axford began making quilts in the mid-1980s (she had been sewing clothes "constantly" since childhood, "more for personal satisfaction than need"), she was dissatisfied with the limited choice available in fabric stores. She began hand-dyeing fabric for her quilts with fellow artist Connie Scheele, and this developed into a business of custom hand-dyed fabric for other quiltmakers, called Fabrics to Dye For, that continued from 1993 to 1997.

Shibori dyeing has added greater complexity and transparency to Axford's fabric construc-

tions, giving her work a delicate tension. In "Emotions and Abstractions 5" (Plate 116), Axford was inspired by a series of black-and-white photographs of impressions and debris left in the sand by retreating waves at low tide. For her these images were a metaphor for the time surrounding the death of her mother—the memory of many conversations and fleeting moments, some meaningful and others ordinary, and of the events that remain etched in memory and the many more that are washed away. In this work she uses patterning evocative of waves in both the piecing and *bomaki* shibori.

JAN MYERS-NEWBURY uses shibori-dyed fabrics together with custom-dyed solid color fabric in her art quilts. She has pursued quiltmaking for twenty-five years as a medium to express personal visions of color relationships and the illusion of light and depth within a flat plane. Having studied painting and color theory at university, she sees the op art and abstract paintings of Victor Vasarely and Hans Hofmann as being close to her "paintings" in fabric. Her earlier work was generally based on preliminary drawings and incorporated architectural elements translated into fabric pieces whose colors, patterns, and shapes emphasize space and movement. She began a gradual shift to patterning fabric by dyeing it with mottled dye or by scrunching the fabric during dyeing, thereby producing pieces with unpredictable, fluid patterns—a kind of rudimentary shibori. When Myers-Newbury tried to incorporate these newer elements into planned quilts, the shibori fabrics lent her work a whole new dynamic. They introduced a lively element of impressionistic marks as against the more controlled gradation and depth she planned for with solid colors. Since each shibori piece is different, its texture and color communicating visual activity in a particular organic rhythm, she stopped relying on sketches. The small fabric pieces in her quilts were replaced by larger shibori components with intricate organic patterns achieved mainly by *arashi* shibori. In "The Three Graces," Myers-Newbury achieves an almost painterly quality, using the marks left by repeated shaping and dyeing (Plate 114).

"Shibori has allowed me to create color relationships and the illusion of light and depth within a single piece of fabric."

—Jan Myers-Newbury

Like many people growing up in rural Ireland, MARY LITTLE wore handmade clothes from her mother's knitting and her grandmother's sewing. This exposure to textile handwork caused Little to love all the school assignments that required sewing. She began to create functional home furnishings using fabric—cushions, rugs, quilts, and sculptural objects. She failed her final art exam-

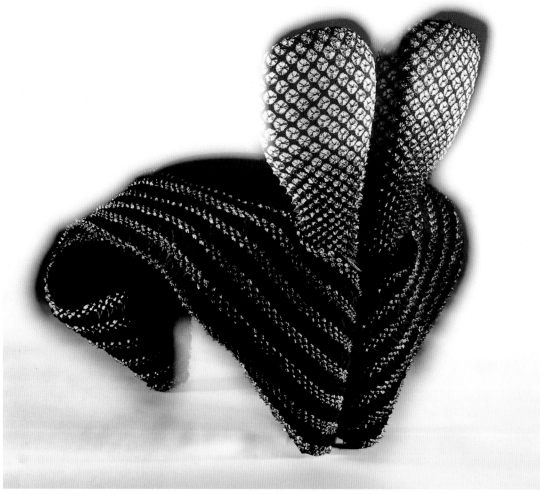

Plate 117. "Nancy." Chair created by Mary Little and Peter Wheeler. Shibori on cotton/linen produced by Hiroshi Murase. 1995. Photo by Steve Speller.

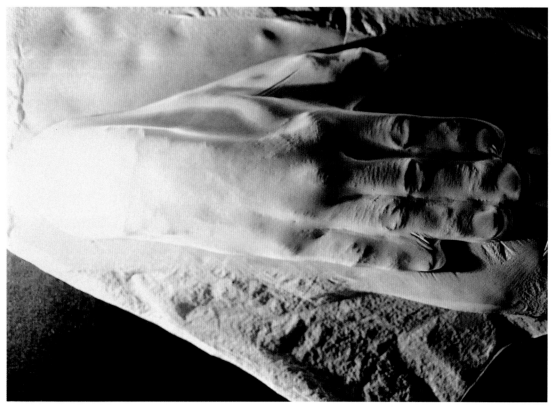

Plate 118. Sharon Baurley. Untitled. Polyester with stainless-steel spattered finish. 30 x 20 cm (12 x 8 in.). 1998.

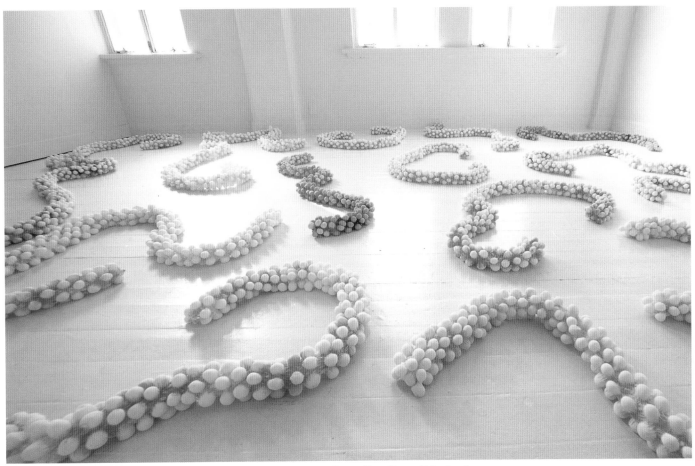

Plate 119. Masae Bamba. "Like Touching with Your Eyes." Installation at Gallery Gallery, Kyoto. Shibori and heat-setting on silk. Each piece 200 cm (6½ ft.) long. 2001. Photo by Makoto Yano.

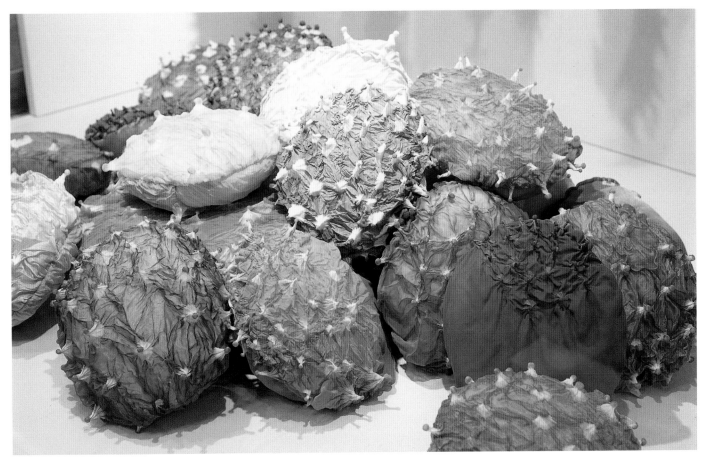

Plate 120. Yuh Okano. "Epidermis: Ocean." Shibori and heat-setting on polyester. Each piece about 10 cm (4 in.) in diameter. 1998.

ination in high school, since she was expected to submit paintings and drawings in keeping with the hierarchical conventions of art.

Little studied design at the New University of Ulster in Belfast in the late 1970s and received a master of design degree from the Royal College of Art in London in the mid-1980s with an emphasis in furniture-making incorporating textile. Since she had had no woodworking experience until she went to art school, working with upholstery in furniture felt more natural than working with wood. She lived and free-lanced in Milan from 1986 to 1988 and then established a studio in London to design furniture for private clients. In London in 1997 she formed a design partnership called Bius with PETER WHEELER to work on artistic projects for private and public commissions. The Bius partnership allows Little to focus on creative ideas and Wheeler to concentrate on design aspects of the furniture. They love to create furniture as an artistic statement with clear functionality built into innovative forms and materials. When Little had an opportunity to work with shibori fabric, she immediately responded to its stretchability and textured surfaces—minute sculpture upon sculpture (Plate 117).

Textile designer SHARON BAURLEY is an industry consultant specializing in developing products that integrate innovative technologies and materials. In 1997, she received a Ph.D. from the Royal College of Art in London, based on research that explored methods of creating three-dimensional form in textiles using compression molding, electroplating, and shearing techniques. A variety of high-tech textiles developed for highly specialized needs became the raw material for Baurley's exploration of functional design and aesthetics.

One of the most important synthetic fibers in use today is polyester. It offers designers and artists the opportunity to work with a two-dimensional pliable plane that can be molded into shapes and permanently set by heat. Among the processes Baurley has developed are thermoforming three-dimensional shapes in fabric, relief embossing, and technical finishes and treatments such as heat-setting, spot welding, laminating, coating, bonding, and use of nonwoven construction as well as print processes. One of her artistic endeavors involves casting three-dimensional objects, including parts of the body such as the face or a hand, and molding sheer polyester fabric over them. Baurley pushed fabric to its limit to create an object with an illusionary quality. For "Untitled" (Plate 118), she heat-welded the polyester fabric, which is metallic but transparent, shaping it into an impression of a hand. The hand seems hard but is made of soft light fabric, and the whole object is curiously airy.

She is currently looking into microwave treatments, ultrasonic bonding, and laser cutting.

MASAE BAMBA studied textile at Kyoto City University of Arts, receiving a master of fine arts in 1992. While working as an undergraduate in the medium of paste-resist stencil dyeing, Bamba was inspired to create three-dimensional fiber art objects by dyeing on cloth. She was not satisfied simply to construct stiffened fabrics over an armature to make three-dimensional forms, but wanted to find ways to transform the flat plane of a piece of fabric into a 3-D sculpture by making essential structural changes. Bamba first used extensive stitching on a piece of cloth and gathered and tightened the thread so much that the whole piece became compact, hard, and heavy, like a small stone. When she dyed the piece and removed the stitching thread, the cloth retained much of the shaping and simultaneously

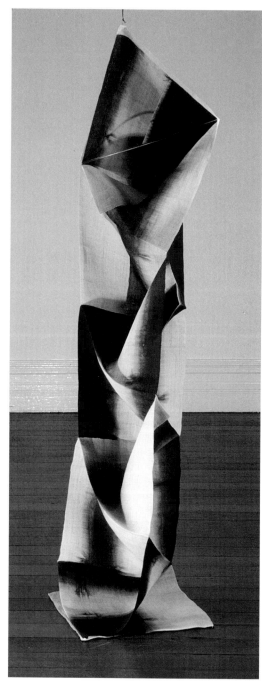

Plate 121. Moira Doropoulos. "Sentinel: Kozo 36." Paper mulberry bark, shibori, indigo, linen thread, etched steel. 36 x 165 x 36 cm (14 x 65 x 14 in.). 2000. Photo by Bill Ahaylor.

recorded the process of dye penetration. This discovery was a revelation that shibori was the means she had been seeking to create three-dimensional objects using a dyeing process (Plate 119 and page 153). She creates these objects in multiples of ten or even of a hundred.

Transparent and seemingly fragile synthetic fibers can be very strong and durable. Some are extremely lightweight and elastic, adapting to the shape of the object the artist uses to mold the material. YUH OKANO works with polyester or silk fabric and shibori to create three-dimensional forms or highly textured expressive surfaces, sometimes using metal disks or glass beads. Her polyester textile sculpture installation "Epidermis: Ocean" incorporates whimsical shibori fabric made into objects resembling corals and sea animals in a fantasy underwater environment (Plate 120). Okano studied basic design at schools in Tokyo and continued her study at the Rhode Island School of Design, receiving a bachelor of fine arts in textile design in 1991. While at RISD Okano encountered visiting instructor Jun'ichi Arai, who made a great impact on her development. Subsequently Okano was invited to assist Arai in his teaching in various countries and at the Otsuka Textile Design Institute in Tokyo as a full-time faculty member. Exposure through

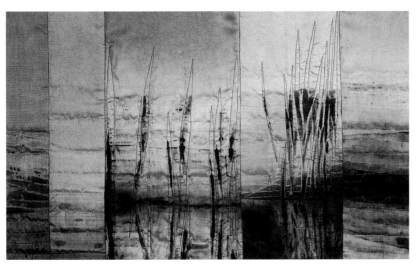

Plate 122. Judith Content. "Perfectly Transparent Midwinter Water Hole." *Bomaki* shibori. Black silk, discharged and dyed. 183 x 112 cm (72 x 44 in.). 1999.

Arai's work to new, technologically oriented materials and processes helped Okano to see the wide range of possibilities polyester offers.

Okano began active studio work in 1998, which has included the creation of fabric for costume designer Emi Wada for the Peter Greenaway film *8½ Women* (see Chapter 2, Plate 41). She established a textile design company, Textiles Yuh, in 2000, and has been exhibiting extensively in Japan as well as in the United States, including in "Structure and Surface: Contemporary Japanese Textile" at New York's MoMA and the Saint Louis Museum of Art.

MOIRA DOROPOULOS grew up in a close extended family where everyone sewed or knitted as a matter of course and where domestic artistry, in textile handwork or in the kitchen, was handed down through generations of women in the family. This communal sharing and exchange of knowledge was carried out with love and passion by Doropoulos's grandmother, who was born on a remote Greek island and died in Australia, with her life spanning almost the entire twentieth century. Doropoulos's creative work in textile is firmly connected to this tradition.

Doropoulos's work is often related to issues of history, tradition, ritual, and genealogy. Shibori is her primary method for making marks on cloth. She searches for and finds an appropriate method or combination of methods for the particular types of resist marks that she wants, using stitching, clamping, pole-wrap resist, and *okkochi* shibori (large-area resist), which she learned in a workshop with Hiroyuki Shindo. Her works are often installed in an environment where their arrangement calls attention to the relationship between them and encourages visitors to interact with, rather than just view the art (Plate 121).

TERRI FLETCHER uses blocks and clamps, as in *itajime* shibori, to make marks on paper, specifically vellum, and fabrics. The dye seeps under the clamps and softens the edges of the shapes, transforming them. Shapes are repeated but are not exactly the same, each taking on a rhythm and reflecting the cyclic patterns she observes in living things (Plate 123 and pages 2–3).

A studio artist and teacher, EMILY DUBOIS is inspired by feelings of love to translate perceived

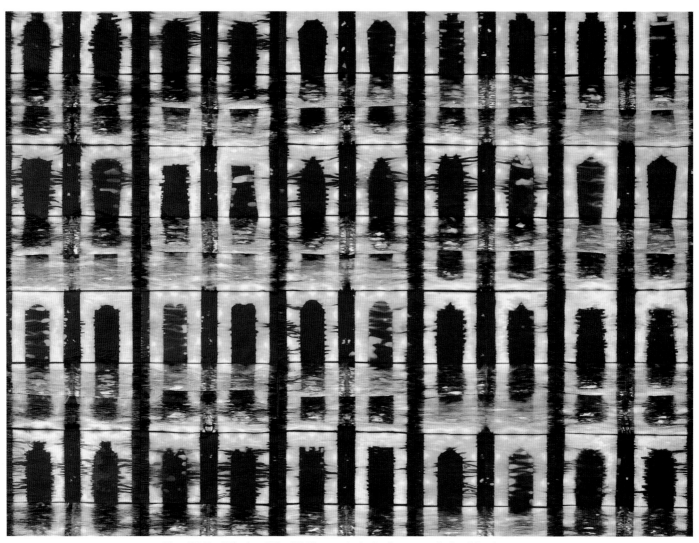

Plate 123. Terri Fletcher. "Flood." Clamp-resist dyed vellum, scrunched and fused to canvas. 145 x 119 cm (57 x 47 in.). 1996.

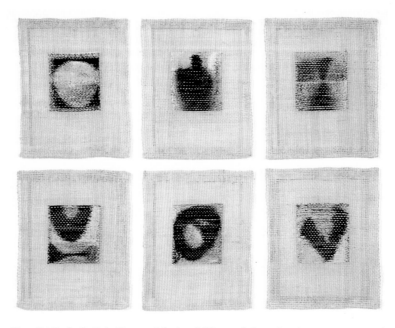

Plate 124. Emily DuBois. "Rematerializations." Woven, discharged, and rewoven cotton and bast fiber. 86 x 76 cm (34 x 30 in.). 1993.

Plate 125. Linda Lee Kerr. "Reverence." Mixed-media installation. ▶

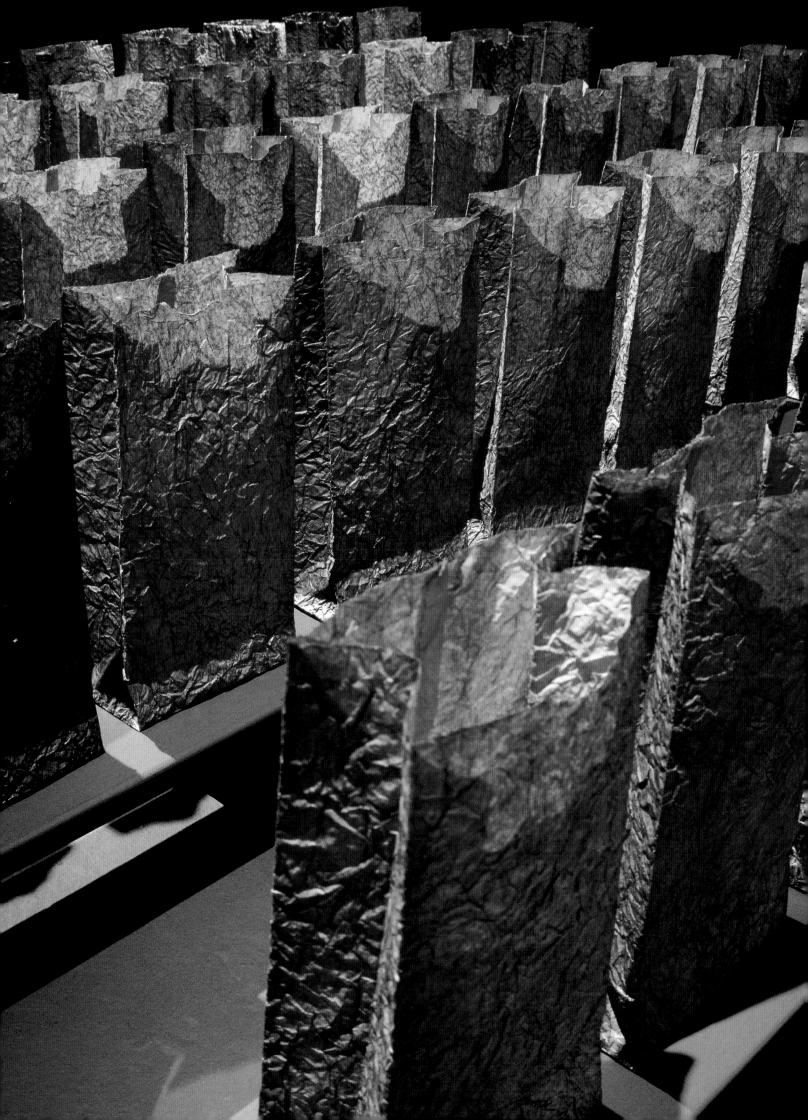

signs of transcendence into material form. She enjoys lessening her direct control of the outcome of the artistic process, and leaving more room for chance to enter in. Her love of painting and drawing makes it enormously satisfying to create a canvas to paint on by weaving it (Plate 126) and at the same time creating images within its surface by resist-dyeing the yarns. She often does clamp-resist-dyeing and a weaving process similar to ikat.

DuBois weaves a temporary weft-faced fabric in black mercerized cotton thread and creates images on one or both of its sides by either clamp-resist dyeing or stencil printing with discharge chemicals (see page 191). "When the images first appear in the temporary fabrics, they are surprising—so many variations from so few basic clamped shapes. They suggest a range of themes, which then influence the reweaving." After thoroughly rinsing and drying the temporary cloth, she unravels the resist-dyed weft yarn from it. Using the patterned yarn as a supplementary weft, she weaves a cloth with strips of bark cloth, paper, silk noil, or bast fibers. In the reweaving process, the original images are transformed in unexpected ways (Plate 124).

ELISA LIGON starts each of her works by laying the same grid structure out on fabric. Using the grid as a foundation, she builds each piece by relying on basic elements such as the inherent quality of the cloth and specific characteristics of the material, needle, and thread. She creates different forms by varying these materials, the interval or length of her stitches, the scale of sewing, how much cutting she does, whether she stitches on one side or both sides, and whether she leaves the thread in the cloth. Her process involves a unique balance between geometrical planning and improvisation. Often she articulates pleats and slits with stitching and kinetic patterns that appear with movement and light (see Chapter 2, Plates 22 and 25, and page 1). Although her works start from the same point, they all take on completely unique shapes and dimensional designs.

Like pieces of origami, many of her two-dimensional fabrics can take on a three-dimensional form in the end. Her discovery early on that she did not necessarily need to dye her work freed her to concentrate on the geometric and sculptural qualities of shibori. In "Beehive" she varies the spacing of the parallel stitches, and after stitching, she shapes the entire cloth by pulling the threads and heat-setting the polyester to fix the pleated pattern (Plate 127). After heat-setting, the threads are relaxed, to retain the highly dimensional surface. She makes the beehive shape by stitching the sides together.

Plate 126. Emily DuBois at work on a weaving loom.

"The most difficult part of my work is letting go of preconceptions. My first big hurdle was the idea that shibori was about dyeing fabric. The next was that it was necessary to remove threads."

—Elisa Ligon

LINDA LEE KERR's artful transformation of 101 paper bags into an ambitious and moving installation called "Reverence" took more than a year to complete (Plate 125). Paradoxically, by spending time to transform "time-saving, throw-away" materials, she redefines their value, converting them into precious art objects.

For this work, Kerr chose a pack of brown sandwich bags as material; there were 101 bags in the pack. Ten bags are installed on each of ten wooden benches, and the odd bag became the one to be seen at eye level and scrutinized as an individual object. Kerr soaked the bags in warm water, took them apart, and dyed the flattened papers one by one in a single bath of black dye. The colors vary from jet black, in the bags dyed first, to faint traces of color at the end of the dyeing when the dye was exhausted. She carefully manipulated each bag in the dye vat, crumpling it gently, and then balling it up and letting it dry. The dried bags were flattened by ironing, but the paper recorded all the wrinkles and no two bags were alike. She then rubbed both sides of the paper surface twice with a stick of graphite, to obtain the desired darkness and give an elegant patina to the slightly textured surface. Finally she folded each paper and reassembled it as a bag.

LESLEY NISHIGAWARA's latest body of work transforms silk. Her choice of tools are a needle and thread, and her processes include compression done to reserve areas from burning and from dyeing. In the series "Mokume" (referring to *mokume* shibori) she started by envisioning the three aspects of the silk—inside, outside, and center. She used *nui* shibori to delineate a circle on each of many square pieces of silk and resist-dyed them with tea. Using a wood or leather scorching tool and tracing the outer edges of her stitched "doodles," she burned and separated the silk into three groups of patterns. The rings that were cut out and stitched together in an overlapping pattern constituted "Mokume-positive" (Plate 128), and the areas outside those circles became "Mokume-negative." The small interior circle cutouts were folded and stitched in various shapes and hung by threads in vertical rows, becoming "Internal Mokume." In the installation of this piece, lighting enhances the delicate sepia layers of the cloth and creates textural shadows. This work is a sub-lime example of the transformation of plain silk into a provocative and memorable piece of art.

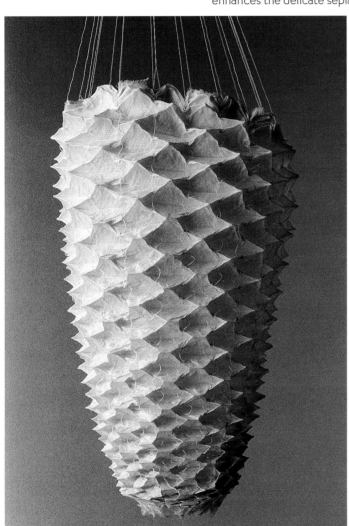

Plate 127. Elisa Ligon. "Beehive." Hand-stitching, folding, and heat-setting on polyester.

HÉLÈNE SOUBEYRAN began tie-dyeing in the sixties and by the seventies her work had grown into a serious artistic exploration of the properties of shibori. She was fascinated by the act of opening cloth in the air and sun and witnessing the record of dye penetration inside and outside each pleat and fold. Inspired by the movement of cloth in the air, she created shapes from tie-dyed nylon that she called "Flying Textiles" and that were intended to interact with wind. In the late 1980s she began using pastes of colored earth to stiffen cotton textiles and papers and shape them into geological formations. Her large-scale outdoor fabric installations mimicked earth strata (Plate 131). During the 1980s and early 1990s, Soubeyran made several trips to western Africa to research local shibori traditions in Mali, Ghana, and Cameroon. The early 1990s saw the production of several series of unfolded heavy silk satin and pleated paper, including "Sky, Earth, and Moon" and "Books of the Sky" (Plate 130). Subsequently, those "books" made of shibori on silk satin inspired haute couturier Paco Rabanne in Paris to commission Soubeyran to make a similar fabric that he used to create evening dresses (see Chapter 3, Plate 96).

In the mid-1990s, Soubeyran was faced with a catastrophe in her life and had to fight to regain the will and energy to create art. She began folding all her dyed silks and tying them into parcels wrapped in black plastic, symbolically closing and burying her vibrant and active past. After filling an old stone-walled carriage house with these morose parcels, she began to slice them in half, an apparent act of destruction that became a path to rebirth. The pressed and sliced fabric mass, given new three-dimensional form, was patterned with layers and swirls unrecognizable from the material's two-dimensional dyed patterns, and shone with a new life of its own. Soubeyran's artistic process of devastation and rebirth was a metaphor for her emotional and psychological state.

In 1994 she began her pursuit of the materials and processes that would express her sense that the earth is one huge work of shibori. Her masterwork, the sculptural series "Du Souffle de la Terre" (Earth Wind), was born. Borrowing scientific techniques used by archaeologists, she

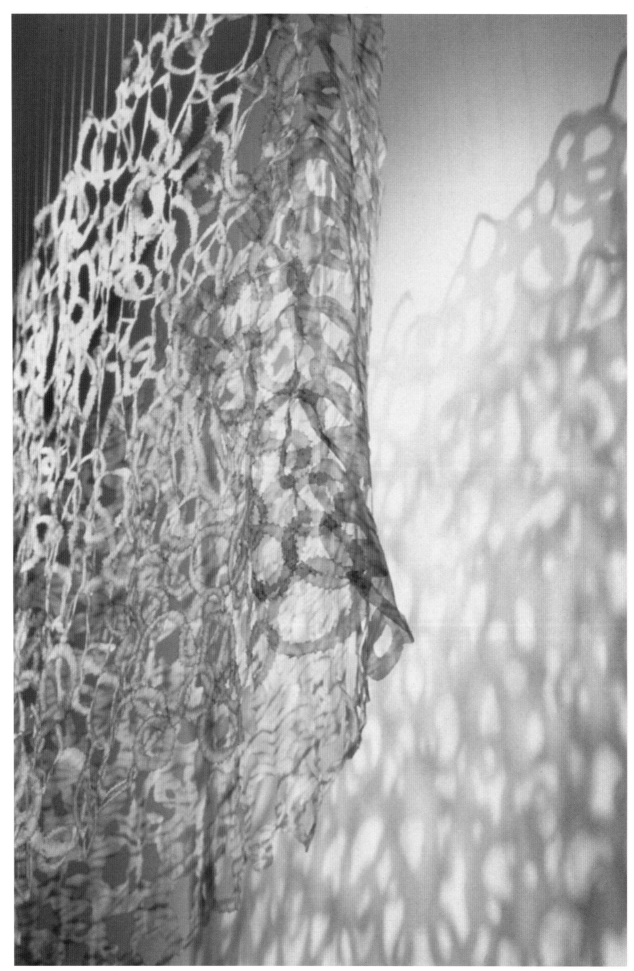

Plate 128. Lesley Nishigawara. "Mokume-positive." Tea staining, *nui* shibori, and burning on silk organza. 2001.

Plate 129. Hélène Soubeyran. "Du Souffle de la Terre" (Earth Wind). Installation at Jardin des Plantes,
Paris. 2001. Each column 21 x 122 x 21 cm (8¼ x 48 x 8¼ in.).

impregnated with resin the folded, crumpled, and pressed pieces of shibori work that she had made over the two decades since 1974 and cast them into 122-centimeter (four-foot) columns (Plate 129). Then she cut and polished the hardened material.

The rigid columns, which resemble intricately patterned agate and marble, sometimes stand collectively in a shallow pool of water, reflecting their own images. To Soubeyran they represent the darkness and hidden energy and beauty of a subterranean world. In another series, she has sliced some of these columns into thin cross-sections; these transparent alabaster-like slices represent life—fluid and fragile, yet solid.

Soubeyran's work is rooted in her understanding of earth's natural behavior. Formation, compression, peaks, valleys, rivulets of dye—these mechanisms of shibori parallel and mimic what happens to rock and earth over the ages.

Plate 130. Hélène Soubeyran. "Books of the Sky: Tome V, vols. 1, 2, 3." Silk satin duchesse, folded, hand-held, and dipped in dye. 15 x 15 x 15 cm (6 x 6 x 6 in.). 1992.

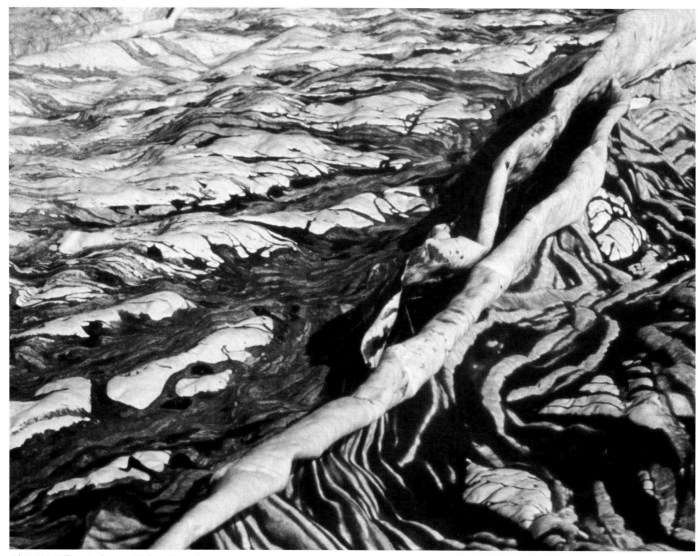

Plate 131. Hélène Soubeyran. "Solvesc." Outdoor installation. Cotton shaped and coated with mud and flour. 70 sq. m (77 sq. yd.). 1986.

modern techniques

Textile production has expanded into the manufacture of an increasing variety of highly specialized, highly engineered "techno-textiles."[1] In a search for solutions to a variety of specialized needs, scientists and engineers continue to develop textiles with new qualities and characteristics. These new textiles become the raw material for artists and designers, who explore their functional and aesthetic possibilities. Using technological advances that make it possible to manipulate the molecular structure of materials, textile professionals have applied the results of intensive observation of microstructures in nature to the development of microfibers.[2] These tough, highly durable fabrics were developed for heavy-use applications in such diverse fields as medicine, space, sports, technology, and architecture. Recently they have also made their way into the world of fashion, where their distinctive aesthetic qualities are valued as much as their outstanding performance features.

The final look and characteristics of microfibers can be altered at many different points in the manufacturing process, starting with the production of the yarn. Building on the knowledge base embedded in existing craft traditions, modern technology is being used to create a variety of advanced yarns. Microfibers are often combined successfully with regenerated yarns[3] or with cotton, linen, or silk. Microfibers are used in the warp for lightweight fabrics and in the weft for heavier ones. A wide range of finishing treatments can be applied to the woven microfiber fabric that will completely transform its texture, color, and shape.

The development of microfibers has enhanced the appeal of synthetic fibers, such as polyamide polyester, polyprolene, acetate, acrylic, viscose, and elastane, many of which are derived from coal- and oil-based raw materials. Textile companies have been concentrating on developing polyamide 6.6 and polyester filament yarns, which are well suited to the dense structure of microfiber fabric.

Polyamide was the first successful fully synthetic fiber, originally developed by DuPont in 1938 in the United States and subsequently produced in the United Kingdom by British Nylon. Introduced during World War II for the manufacture of tents and parachutes, it has come to be used in hosiery and lingerie as well as fashion and interior textiles. Polyamide resists wear and tear and absorbs dye and other finishes well. It blends well with both synthetic and natural fibers and improves their performance. There is a growing trend in the textile industry to combine two or more materials that differ in form or composition to produce a new and better performing material.

Synthetic fibers can be molded into many different forms during the liquid stage of their manufacture, and filaments can be constructed to exact specifications for individual needs.[4] Transparent, seemingly fragile synthetics can be very strong and durable. Some are extremely lightweight and elastic, and adapt to the shape of the wearer. Others reflect light or retain heat. Intriguing new blends have been developed—wool with copper, for example, or silk with stainless steel—some of which will be covered in this section.

Experimentation by artists and designers unearths the aesthetic possibilities of such new materials. For example, a lightweight hybrid material, combining textile with glass, metal, carbon, or ceramic, offers an intriguing range of potential qualities and effects. Similarly there is much to explore in the variety of processes used to produce nonwoven cloth in which the fibers are oriented directionally or randomly.

Shibori techniques are a natural fit for creating pattern, texture, and shape in contemporary synthetic or mixed-fiber textiles. For example, shibori patterns are created by dissolving the stainless steel in silk metallic cloth. The silk resists the alkali, retaining its properties. Another mixed-fiber yarn has a fine stainless-steel wire core that is wrapped or twisted with fine woolen filaments. A dévorée process uses an alkali to dissolve the wool, thus exposing the fine metal core filaments. This creates opaque wool motifs suspended on sheer woven stainless-steel metal cloth. Cloth woven with polyester and rayon fibers is selectively treated with fiber-reactive dyes that affect only the rayon. The design takes advantage of the fact that the polyester areas remain uncolored.

Some of the most exciting technological advances in textile manufacturing and manipulation are taking place in Japan, where craftsmanship has traditionally been valued and respected as highly as art. New technologies encourage new ways of thinking and working, and the application to them of traditional Japanese shibori techniques provides a fertile ground for innovation. Forward-thinking manufacturers have invested heavily in research and development, establishing research centers for textile technologies. Collaboration by Japanese shibori artisans with those who make synthetic fibers or cloth and create new fabric-treatment processes has made it possible to respond creatively to the demand for each season's new look in the high-fashion industry.

Synthetic textiles have come a long way since the early days, when they were perceived as a cheap substitute for luxury fabrics including silk. Technological advances have eliminated problems such as excess static and the tendency to retain oil-based stains. Most of Issey Miyake's polyester fabrics, for example, are woven with a minute amount of metal in the fiber to protect against static cling. Natural fibers are often blended with the new synthetics to change the look and texture of the cloth or to increase strength, crease resistance, or ease of care. Textile laboratories and research centers are conducting extensive experiments with different combinations and percentages of fibers. Artists and artisans have only just begun to explore and experiment with the enormous range of new possibilities.

New discoveries and new techniques are propagated among artists and artisans in collaborative projects and at gatherings such as the International Shibori Symposia and Surface Design Conferences. The Textile Research Institutes of local governments in Japan, educational institutions such as the Danish Design School, and private experimental textile studios such as Editextil in Montreal, Canada are a few of the many places where artists and designers can work with scientists and engineers. In the beginning of the third millenium, when information technology is available to bridge high industrial technology and ecological and cultural concerns, shibori artists and artisans are also embracing two opposites—hand and technology.

heat-set on polyester or silk

The most important synthetic fiber today is polyester.[5] The fact that it can be manufactured in many different forms opens up a wide range of creative possibilities for artists and designers. Polyester was invented in the 1940s. It is derived from oil and made of ethylene glycol and terephthalic acid. It is composed of long linear molecules of carbon, hydrogen, and oxygen held together with different kinds of bonds, the most important being the hydrogen bond. Polyester is thermoplastic, which means that its bonds can be broken by heat; in other words, it can be shaped in response to heat. It can also be melted and thus recycled. After cycles of reuse, it can be incinerated into water and carbon dioxide if done at the appropriate temperature. This makes it one of the most environmentally friendly synthetic fibers.

Heat is an essential factor in the manufacture of polyester filament. Melted polyester is extruded through tiny holes and stretched to many times its original length, a process that induces changes in the inner structure of the material that give it strength and stability. The stretched filament is heat-set at a temperature just under the melting point. When this degree of heat is applied to polyester fabric, it reverts to its unstretched state, shrinking drastically. This quality can be used to advantage by artists and designers who wish to texture the fabric or to create three-dimensional effects. This is why many fashion designers in Japan—most notably Issey Miyake and Yoshiki Hishinuma—create artistic clothing in polyester. Polyester's softening point is between 238° and 240°C (460° and 464°F), and its melting point is 260°C (500°F). Ideally, bound polyester fabric should be wrapped or otherwise held in its form and heated to around 200° to 220°C (392° to 428°F) for twenty to thirty minutes to set the three-dimensional texture in the fabric, as in the scarf by Yuh Okano shown on this page. Higher temperatures would drastically shrink the filaments (see also the heat-setting instructions in recipe 1, page 192).

Heat-setting of silk is achieved by boiling or steaming cloth that has been bound or otherwise shaped. The temperature should not exceed 140°C (284°F). The resulting three-dimensional effect, or texturing, is quite effective, but the shape is not as permanent as it would be with polyester. A classic example of this process can be seen in a traditional *obi-age*,[6] an article often decorated with *hitta kanoko* shibori (allover bound dots in a grid), where dyeing in hot dye liquid or steaming followed by drying in a shaped form causes the silk to retain the three-dimensional shape of the bound dots. The now dyed and textured *obi-age* takes on a new elasticity. Heat-set silk shibori articles, however, should be kept away from steam or high temperature. Dry cleaning is advised to retain the texture.

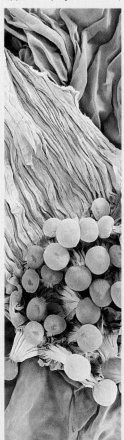

Details of a polyester scarf with three-dimensional dyed and heat-set shapes, by Yuh Okano.

Polyester organza blouse with stitching.

jellyfish

Polyester organza, a light and semitransparent material, is appropriate for this textured ethereal fabric called Jellyfish, created by NUNO Corporation.

The garment is constructed prior to the shaping process, and the pattern is designed with some allowance for shrinking. A sheet of polyvinyl chloride (PVC), which was developed recently for use as a "shrinking material" (originally used in the brewing of beer), is marked with linear patterns and then inserted between two layers of the garment's fabric. Using water-soluble vinylon thread or adhesive, the three layers of fabric are bonded together according to the linear pattern; the whole garment is then heated to approximately 200°C (392°F). The high temperature causes the shrinking material to shrink as much as fifty percent, creating a puckered texture that is permanently heat-set on the polyester organza. The deterioration of the PVC fabric caused by high heat will later make it easier to separate the sheet from the garment. When the treated garment is immersed in hot water (60° to 90°C/140° to 194°F, depending on the type of water-soluble thread or adhesive used), it is washed free of any extra materials used during the shaping and heat-setting processes.

This process is akin to the traditional *nui* shibori (stitch resist) where the stitching thread is pulled tightly to gather the fabric, thereby creating texture on the surface. Even without the high-tech materials commonly used in Japanese industry, one can simulate the effect with polyester organza by stitching the pattern and pulling the thread tightly, then heat-setting it in a pressure cooker (according to the heat-setting instructions in recipe 1, page 192). The stitching thread is removed with a seam ripper or simply by cutting the knot at the end to reveal a permanently shaped garment. In this modern version, the shrinking material is used to create a surface texture while water-soluble thread or adhesive eases the removal of extraneous material.

Before and after heat-shrinking.

Detail of finished Jellyfish blouse directed by Reiko Sudo, produced by NUNO Corporation.

Polyester chiffon fabric. 7.6 x 7.6 cm (3 x 3 in.).

gangi mokume shibori

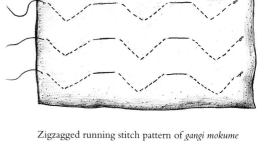

Zigzagged running stitch pattern of *gangi mokume* shibori.

Medium-weight crepe de chine polyester fabric retains the shaping design well and drapes elegantly. It is important to select a stitching thread of appropriate weight and a needle the right size to accommodate the weaving density and fabric thickness in all *nui* shibori processes, including this variation of *gangi mokume* (zigzag pattern) shibori created by Hiroshi Murase.

A row of running stitches in a broken zigzag pattern from selvedge to selvedge is repeated lengthwise (see illustrations at right). After the entire cloth is stitched, each thread is drawn tight and knotted securely. Following the steaming process (recipe 1, page 192), the cloth is dried and the stitches are removed.

In the related and quite classic process of *mokume* ("wood-grain") shibori, the alternating dark and light dyed areas look like wood grain. In this example, contrary to conventional shibori where the cloth is always dyed, the cloth was intentionally left undyed in order to emphasize the light and dark patterns cast by light and shadow on the surface of fabric as it moves. When worn or hung, a length of cloth that drapes well and is dyed with *gangi mokume* evokes the movement of a waterfall. Monochrome fabric is conducive to yielding subtle yet rich texture. A fabric that is heavy and crisp can also be used, and the resulting pattern will resemble broken frost columns.

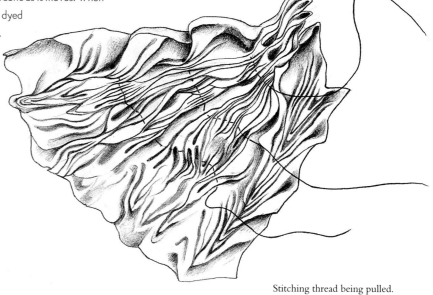

Stitching thread being pulled.

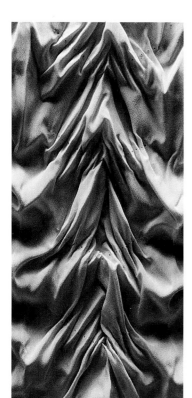

Finished heat-set shibori by Hiroshi Murase.

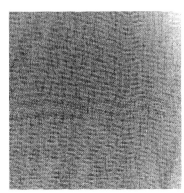

Polyester chiffon fabric. 7.6 x 7.6 cm (3 x 3 in.).

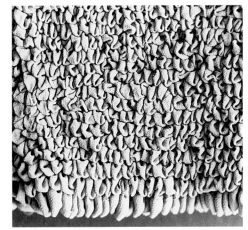

PockeTee tied with *miura* shibori.

stretchable garment / *miura* shibori (looped binding)

A lightweight polyester georgette retains shibori puckers that allow the fabric to expand and contract, making it ideal for garments. The weight and weave of the material must be appropriate for minimal retention of body heat, maintenance of the garment's shape, and comfort against the skin. If a fine knit is used, its weight and weave must ensure that the degree and direction of stretch will be right for the design of a particular garment.

In the process of *miura* shibori, cloth is pushed up from underneath by the left index finger (which holds a small looped binding unit) while the right hand lays the thread around the cloth. A hook held in the right hand catches the tip of the cloth on the left index finger, which then pulls the fabric away from the hook. The left index finger is slid out of the cloth and the looped thread is pulled taut. This movement is repeated across the width of the cloth; care must be taken to keep the binding thread tight, as the tension that is applied to all units is what holds the shapes in place. This tying is easy and can be undone quickly after dyeing or steaming. This cost-effective process is now being done in China. The original idea, presented by Yoshiko I. Wada and executed by K. Takeda & Co. in the early 1990s, has been duplicated many million times over.

Constructing stretchable garments such as pockeTee by K. Takeda & Co. requires a straight-cut pattern that is three times larger in scale than an ordinary garment would be. All tying must be done on assembled garments that are then steamed to set the puckers. As shown at bottom right, a tied garment is miniscule compared to the wide range of body sizes (U.S. sizes 0 to 16) that the finished garment can accommodate. *Miura* shibori creates gentle, tiny hills covering the surface of a garment. The texture shifts in light and the shape changes as the body moves.

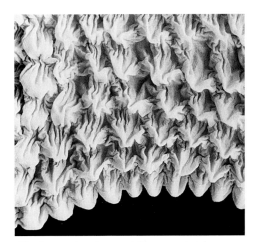

After heat-setting, the material becomes stretchy.

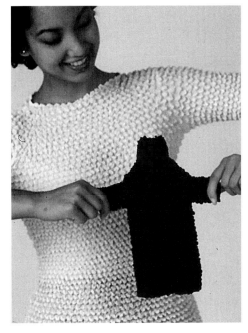

A model wearing a pockeTee and holding one that has been heat-set and is still bound. By K. Takeda & Co. and designed by Yoshiko I. Wada.

Polyester organza fabric. 7.6 x 7.6 cm
(3 x 3 in.).

kikaigumo (tool-aided spiderweb) shibori

A sheer polyester organza fabric holds shibori textures extremely efficiently. The
light weight and crispness of the organza allows small spires to remain tight, creat-
ing a field of spiky points that feels alive.

Kikaigumo is a variation on hand-pleated classical *tegumo* shibori (for
another type of *kumo* shibori, see page 165). In *kikaigumo*, a tip of the cloth is
held out in both hands toward a hook that juts from a simple motorized tool.
The tool catches the cloth and gradually gathers it into a horn shape, while
quickly winding threads around it. Because the size of the binding units
that can be produced by the mechanical tool is limited (from 1.5 to 6 cm/
¹⁰⁄₁₆ to 2 ³⁄₁₆ in.), *kikaigumo* is efficient at producing fields of small spires of
spiderweb designs (for heat-setting instructions, see recipe 1, page 192).

The paperlike organza material is covered with protruding short tenta-
cles created by *kikaigumo*. The three-dimensional shapes inherent in the shibori
process are permanently captured by heat-setting the piece while it is bound. In this
shaped finished piece produced by Hiroshi Murase, the open weave and lightness of the
fabric allow for the extreme elasticity of the curvature.

Bound fabric is opened after being heat-set.

Detail of sculptural *kikaigumo* shibori.

Finished spiky elastic shibori fabric by Hiroshi Murase.

Polyester chiffon fabric. 7.6 x 7.6 cm
(3 x 3 in.).

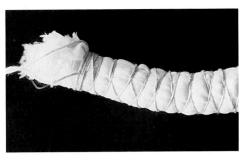

Tesuji shibori piece on a core.

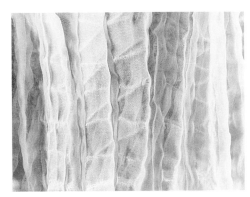

Finished fabric showing pastel-colored dye and the texture set by heat.

dyeing polyester: *suji* shibori

Medium-weight polyester fabrics such as chiffon takes dye effectively and so are well suited to use in a studio environment where fabric is to be heated in an ordinary pressure cooker.

Binding and dyeing lengths of pleated cloth is a classical method of *suji* shibori. Vertical stripes are created by a simple process of pleating cloth along the warp, then binding the pleated cloth either by itself or around a core. The size and shape of pleats will vary with the desired design effect. When the cloth is bound tightly, only the peaks of the pleats are exposed to dye. The result is a pattern of stripes with fine, intersecting resist lines.

The fabric is accordian-pleated lengthwise in a knife-edge style where the peak of each pleat shows only a little. Then the narrow pleated cloth is lain over a rope core, and a thread is knotted around one end of both the fabric and the rope core and wound along their length, binding them together. A resist thread is then wound tightly over the entire piece at 8-millimeter (1/4-in.) intervals, to reserve the areas that are hidden by the pleats from the dye. The entire piece is immersed in the dye pot (see recipe 4, pages 192–93). Afterward, the fabric is removed from the rope core and opened.

Due to the high heat used in this process, the resist pattern of *tesuji* shibori is recorded as a dyed design as well as a texture. Small thread-resist paths wind through the pleats, appearing and reappearing in the dyed and undyed spaces along the pleats. Executed by Lindsay Robinson and Ryoko Kohbata.

dyeing polyester: *osage* (braided and bled) shibori

Three lengths of polyester fabric are dyed with disperse immersion dye but are not fixed with a carrier. The fabrics of three different colors are braided tightly and returned to the high-pressure, high-temperature dye vat with the carrier. This results in bleeding of colors where the fabrics have been pressed together, creating soft shadows in serendipitous shapes on the permanently textured surface.

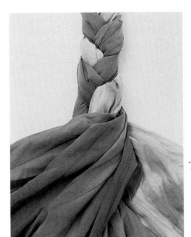

The strips are braided before heating.

Finished braided and bled shibori piece directed by Reiko Sudo and executed by Mariko Hiranuma for NUNO Corporation. The braided piece is placed in a high-temperature, high-pressure dyeing machine. The colors bleed into a mottled, almost batik-like pattern.

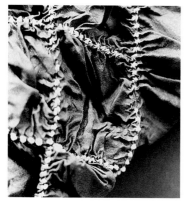

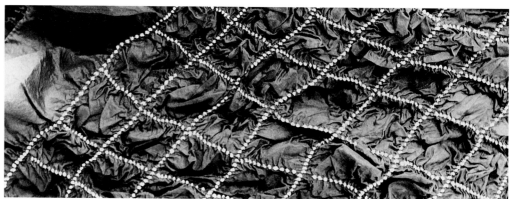

Detail of silk *bandhani* dots.

Heat-set shibori silk scarf by Asha by MDS.

silk *bandhani* scarf

A medium-weight, fine *habutae*-type Indian silk is used here to create an elegantly patterned scarf from the collection Asha by MDS—a collaboration between an Indian designer and Miyake Design Studio.

This deep blue scarf has a grid of tiny white bound *bandhani* (shibori) units. These exquisite small knotted units are continuously tied by pushing the fabric from the back, plucking the tip with the fingernails, then winding the tip with soft cotton thread. When the silk is dyed in a hot acid dye vat, *bandhani* resists the dye while simultaneously recording the shape of the tiny plucked fabric bits. The design evokes white pearls. Silk, being a protein fiber, reacts to heat in a way that allows the shape to remain semipermanent. When used for scarves and jackets, the heat-set shapes retain the original shaping process surprisingly well. Ideally the piece should be dry cleaned. Ironing is not possible; if the piece is hand-washed in cold water, it should be dried flat to regain most of the texture.

silk gauze knit *kikaigumo* shibori scarf

This open-weave silk gauze knit works well with *kikaigumo* shibori tied on a vertical grain along the length of the scarf. *Kikaigumo* shibori (see page 150) is used here to create rows of white scalloped shapes along the warp, rather than along the conventional bias-oriented binding. In Hiroshi Murase's scarf, both the nature of the weave of this silk and the vertical orientation of the tying allow the *kikaigumo* shibori units to remain triangular, creating an unusual effect.

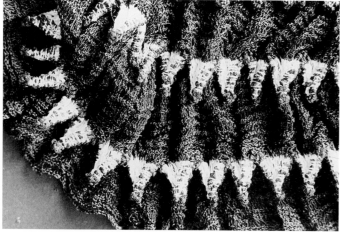

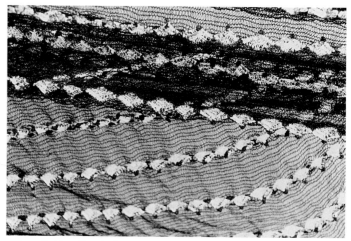

Detail of silk knit gauze *kikaigumo* shibori.

Silk scarf with scalloped effect by Hiroshi Murase.

A drawing by artist Masae Bamba showing the process of manipulating the cloth into a three-dimensional sculpture.

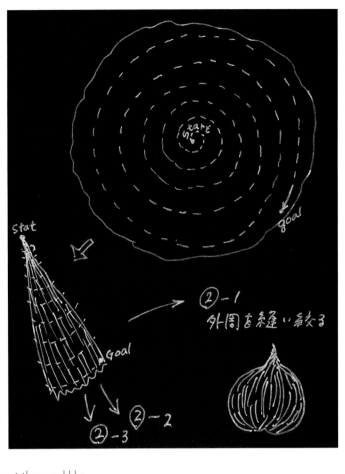

sculptural forms in cotton

Semipermanent three-dimensional forms in cotton can be created by using shibori to shape the cloth, securing the shape, dyeing the cloth, and drying it completely before unbinding it. Additionally, stiffening the shaped surface will help make the three-dimensional form more permanent. This can be done using a clear starch such as rice flour, diluted craft glue, a clear polymer, Scotchgard, or hair spray. Alternatively, certain shibori techniques applied on light openweave cotton or linen in conjunction with cloque (page 173) will produce sculptural effects.

Masae Bamba arranges her stitching in a circular spiral pattern to create pleated folds that support a sphere. Once the shape is formed and stiffened, the three-dimensional shape in cotton fabric is semipermanent (but less permanent than would be possible with polyester).

Each shibori process changes a two-dimensional fabric plane to a three-dimensional object in a particular manner. When an artist gains a rapport with a material and with particular processes in shibori and subsequent finishing treatment, fabric can be molded into sculptures that are light, airy, and tactile. For one ambitious installation, Bamba made three pieces each day for three months to complete the thousand pieces that comprised the work (photo at bottom right).

Bamba makes a record of her new pieces in a small notebook that itself becomes a work of art. Documenting the processes used to make each piece reveals her thought processes, and lines on sheets of paper give clues to how she achieves her many layers of dimensional change.

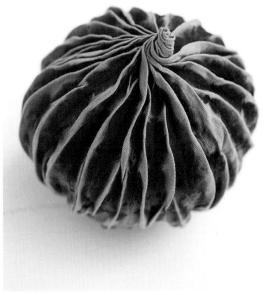

Bamba's finished cotton piece. 10 cm (4 in.) in diameter. One of 1,000 pieces from "One/A Lot." 1995.

heat-transfer on polyester

The only dyes that polyester can absorb are disperse dyes, which dissolve in polyester fiber but are not soluble in water. Fiber must be dyed at high temperatures under pressure or by atmospheric pressure with a carrier.[7] It has been difficult in the past for textile artists to dye or print polyester, since this has required either expensive equipment for achieving the necessary high pressure and high temperatures or risking exposure to the toxic carriers.

The development of transfer brands of disperse dyes by the French firm Filatures Prouvost-Masurel has opened up new realms of possibility. When heated, these dyes are able to sublimate; they evaporate from a solid state and move directly from one material to another. These special brands of disperse dyes are printed onto paper, which is placed in contact with the fabric. The sublimation and transfer process takes place in the presence of heat. The method was patented in 1960 and the first commercial production began in 1968. By 1995, five percent of the world production of printed textiles was achieved by transfer printing.

Transfer printing is fast, easy, and relatively safe. Thus it is well suited to studio use by individual artists. Since the dyes used are metal-free and most are free of organic solvents as well, the process is considered to be environmentally friendly. In addition there is no wastewater and no washing out of surplus dye. Thickeners too that are solvent- and preservative-free can be chosen.

Smaller heat-transfer presses are being developed for experimental work in art schools and for individual studios. These machines are equipped with temperature control and vacuum suction to ensure better contact between dye paper and fabric. One shortcoming of the small presses is that it is difficult to register a repeat pattern for a continuous print, but these presses are well suited to collage printing and to grouping and superimposing patterns and images. Transfers are easy to resist since fabric penetration is very low. Special effects can be achieved when folds, pleats, threads, or textures resist the dye transfer, leaving halos around the transfer image when the paper is lifted from the ground fabric. Pastes can also be used to resist the transfer dye, and fabrics that have absorbed dye can be used again for printing with less intense color on yet another fabric surface.

A limitation of transfer printing is that fabrics dyed with this process retain their ability to sublimate. Thus transfer prints must be marked with a "No ironing" label. The sublimation tendency can also create problems when transfer-printed fabric is to be used in additional processes such as shibori or heat-setting. Heat may cause dye that is already bound to the fabric to sublimate, causing further color dispersion or alteration. This shortcoming, however, can also be used to creative advantage if properly planned for, as in the braided and bled shibori process described on page 151. In the United States, printed dye paper once used for heat-transfer in the textile industry has been recycled into gift bags and sold at stationery stores. These once-used prints retain a certain amount of disperse dye and are perfectly usable for heat-transfer of images onto polyester fabric; they are currently being enjoyed by studio artists as a great source of material.

Small-scale transfer printing can also be done on a mangle, a dry-mount press, or simply with an iron in a home studio. The emerging technology of digital printing offers many new possibilities, since disperse transfer dyes can be used in many digital printers to create dye-transfer paper that can then be used directly on fabric. The textile departments of many art and design schools are in the process of acquiring transfer-printing machines or digital textile printing equipment, and it will be interesting to see what innovative developments emerge. For shibori artists, heat-transfer on polyester fabrics offers a new dimension in the shaping of two-dimensional planes, by flattening and simultaneously coloring three-dimensional shapes.

"Mineral" by Jun'ichi Arai. *At left*: Metallic polyester fabric crumpled and pressed and heat-transferred. *Above right*: "Mineral" is opened to reveal printed and resisted areas on the crumpled fabric.

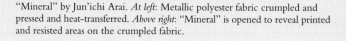

Folded fabric, clamped with clothespins, ready to be printed.

origami

Polyester organza is carefully origami-folded into a long, flat reverse-pleated shape. Practicing the folding on paper is advised. All folds are accordion- or reverse-folded; in other word, the peaks and valleys of the folds alternate. The folded piece must be ironed at a high setting, to keep the folds flat. Two different colors of dye-transfer paper are chosen. Paper of one color is placed on the bottom, facing up; folded fabric is placed in the middle; and paper of the other color is placed on top, facing down. Heat is applied to all the layers of folded fabric in a vacuum transfer machine, which helps to create the optimal conditions for the sublimation of dye. The heating of the fabric also sets the pleats (for transfer-printing instructions, see recipe 3, page 192).

The sheer organza allows a small amount of sublimating dye to pass through the top layer as well as the second and sometimes the third layer of fabric, depositing dye at each layer. There are some intriguingly beautiful color combinations produced by NUNO, including medium bright purple fabric with dark blue on one side and dark reddish purple on the other; as well as light yellow-green fabric with burgundy on one side and darker green on the other. The color gradation on each layer of folded fabric adds depth and visual interest when this scarf is opened. As the wearer moves, the shapes of the folds shift and change, giving movement and depth to this sculptural work.

A pair of paper origami pleat forms. Cloth is folded by being sandwiched between them. This allows for efficient heat-setting of pleats.

Following heat-transfer, the dye paper is peeled back, exposing the dyed folded piece.

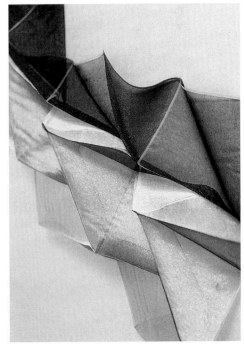

Colored finished scarf by Hiroaki Takekura and Reiko Sudo for NUNO Corporation.

Polyester sateen fabric. 7.6 x
7.6 cm (3 x 3 in.).

The way the fabric is folded.

pleat and print

Medium/heavy-weight polyester sateen, available at most local fabric stores in North America, is very thermoplastic and firmly retains heat-set pleats, including pleats that have been set into fabric using a home iron at a high synthetic fabric temperature setting. The unforgiving quality of polyester sateen can be used to advantage when designing subtle images on a two-dimensional surface without the application of dye, creating embossed lines.

This modern interpretation of the classical *suji* shibori that is shown at the top of page 151 moves away from the prescribed design constructs of kimono cloth—that is, vertical pleating on fabric 36 centimeters by 11.43 meters (14 in. by 12 1/2 yd.) long. A square sateen fabric piece was randomly pleated diagonally and patterned with disperse dye using a heat-transfer process (see recipe 3, page 192). The heat also serves to permanently set the pleats.

This example differs from classical *suji* shibori in that it is square in shape and allows for diagonal pleating. The crisp pleats and sharp edges of the colors achieved on this type of sateen are striking when the fabric is presented as an angular sculptural object, much like the garments created by designer Issey Miyake for his Pleats Please collection. Miyake ingeniously capitalizes on the need to flatten garments during the heat-transfer process by constructing the garment with straight cuts, folding it like an origami piece, and then simultaneously pleating and heat-transfer printing the garment. In this example by Ryoko Kohbata, the kinetic movement of the pleats reveals white ground hidden beneath the dyed patterns, so that as the folds move, the painted stripes running across the pleats and the white ground seem to visually interrupt each other.

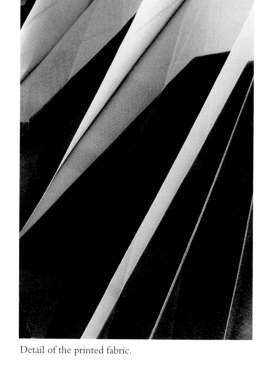

Detail of the printed fabric.

Finished pleated and printed fabric by Ryoko Kohbata.

tsumami A

This slightly textured ultrafine polyester chiffon scarf has a hand of very fine silk crepe, which makes it easy to manipulate through slits on the paper form. With heavier fabrics, heavier paper forms that provide more support should be used. Sheer and lightweight fabrics easily bind with disperse dye, leaving "shadows" (light color shading) where the fabric is creased and so lifts the paper forms, allowing small amounts of dye to sublimate.

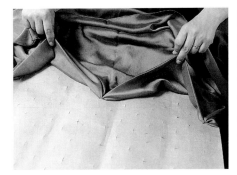

Fabric and paper form with slits.

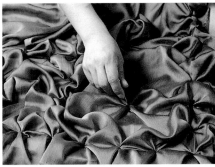

Pushing and pulling fabric through the slits.

The first step in this process is creating a paper form with slits (the paper should be construction or bond paper weight). Here, simple X-shaped slits are arranged evenly. (When constructing paper forms, it is important to consider the harmony of the design in terms of scale, repetition, and spacing.) Fabric is then pushed and pulled through the slits to expose as much fabric as desired (the word "*tsumami*" refers to this action of picking or pinching). Dye-transfer paper should be prepared according to the instructions in recipe 3, page 192. After the entire scarf has been put through the slits in the paper form, it is placed under a solid dark dye paper, and set with the transfer machine at 180°C (356°F) for forty seconds. This prints the shaped piece and simultaneously sets the puffed bits into flat shapes.

The effect of the finished piece is similar to the pattern created by shaping and looped binding in classical *miura* shibori (see page 149), but instead of tying the cloth with thread, the effect is achieved by shaping the cloth with the paper forms.

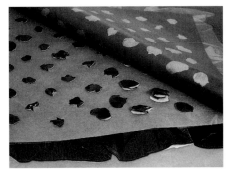

Following the heat-transfer, dye paper is lifted off the pressed shaped fabric. The dye that is sublimated and bound onto the polyester fabric is much darker than the paper. Technique developed by Hiroko Suwa; hand-pleating by Hiroaki Takekura. Manufactured by NUNO Corporation.

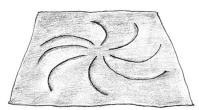

Paper form.

tsumami B

Polyester chiffon is easily available and remarkably receptive to heat-transfer printing with paper forms. In contrast to Tsumami A above, where the overall design fills the field with smaller motifs, this example by Lindsay Robinson shows a single large motif on a square fabric piece. Again the fabric is pushed and pulled through slits to expose as much fabric as desired. In this example, two different dye colors were used to paint with one solid color first and decorate with a second color on the same transfer sheet. Dye-transfer paper is then applied to the fabric for forty seconds in a heat-transfer press at 180°C (356°F). Transfer printing can be repeated on the reverse side (the side where the fabric has not been pulled through the slits) to fill in negative areas where the ground fabric is left white.

Polyester chiffon. 7.6 x 7.6 cm (3 x 3 in.).

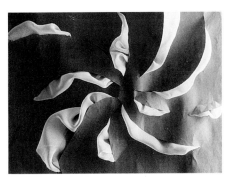

The fabric is pulled through slits in the paper form before transferring dye color onto it.

A free-spirited, fluid design translates well with a large singular slit pattern. The puckered fabric is dyed in deep rose, and light pink shadows float above a sea of green. Gestural brushstrokes in brown add to the movement of the overall pattern. When more than one dye color is transferred, certain dyes will maintain the original color, while others result in a new mixed color. Here, purple paint brushed on green dye paper was transferred onto rose-colored fabric, appearing brown in the final piece.

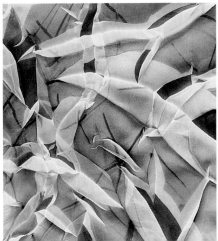

The finished piece by Lindsay Robinson shows unexpected fold patterns and transferred colors and lines.

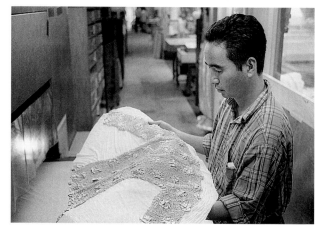

Yoshiki Hishinuma at a commercial heat-transfer machine.

crimp and print

Yoshiki Hishinuma uses a specially developed lightweight polyester that shrinks with the application of heat to create this dramatic orange blouse, which clings gently to the wearer's body. The fabric is woven with a warp of high-twist crepe polyester yarn. The weft yarn is made of polyester filament and polyurethane that is stretched out taut; the two filaments are then twisted and wrapped tightly with water-soluble vinylon yarn (which dissolves at about 90°C/194°F) to keep the finished yarn from shrinking. When the fabric is woven, it is flat and very sheer. The shaping is started with a white bound blouse almost twice the size that the finished garment will be. Garments are boiled in hot water for forty minutes to an hour, which causes the fabric to shrink. During the boiling, the water-soluble yarn dissolves and the high twist in the warp yarn and the elastic polyurethane yarn causes the fabric to ripple and move.

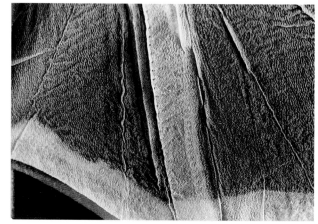

Detail of crimped and printed blouse.

The dry shaped blouse is laid on a piece of brown paper with red dye paper inside and yellow paper outside it (on the front of the blouse). It is then placed in a heat-transfer machine with another piece of brown paper on top. The crimped surface of the fabric results in random creases and small pleats when the garment is pressed. The weight of the fabric is sheer enough for dye to disperse easily and penetrate through, but dense enough to capture most of the dye. Therefore the intense bright red color mixes with yellow on the other side of the garment. The heat-transfer printing process is repeated once again for the back of the garment, again with red paper inside and yellow outside.

Polyester crepe blouse showing creases in resisted yellow, and some areas with original white where dye paper did not cover.

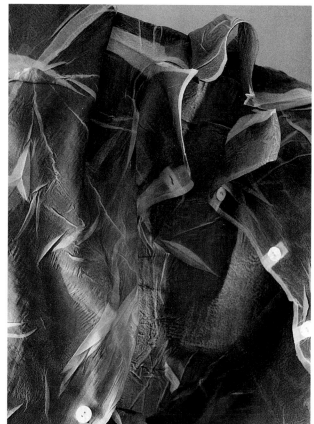

Detail of expandable garment pockeTee discussed on page 149, showing *miura* shibori puckers pressed down and matte black polyurethane film laminated onto the surface of a white polyester chiffon fabric blouse that was initially three times the size of an ordinary garment. When worn, the distribution of black dots changes according to the curvature of the body, presenting an optically enhanced three-dimensional surface.

laminate and print

There has been a wide range of heat-transfer laminate sheets of polyurethane film and binder available in the Japanese textile industry. Polyurethane melts at around 240°C (464°F) but the binder melts at 150°C (302°F). Heating this specially developed laminating film (trade name, DIMA) onto polyester fabric at 150°C completes the laminating of the thin polyurethane film permanently.

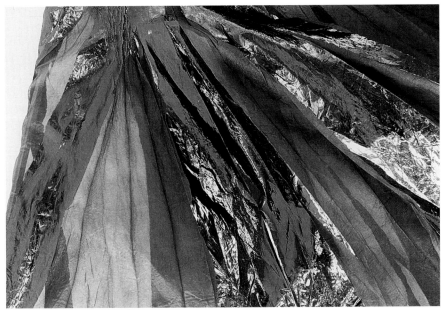

Detail of a skirt by Yoshiki Hishinuma. Sheer black polyester organza is first made into a skirt. Hand pleats are put in roughly along the length, and the garment is laminated with glossy black polyurethane film. The transparency and lightness of the skirt are toned down by using opaque laminated shiny film for a slightly drapy effect, which makes this revealing skirt visually tantalizing, yet easily worn. The pressed and laminated pleats are kept tight from the waist to the lower hip, while the rest of the pleats are pulled open to show the transparent organza. This manipulation of laminated pleats defines the shape of the entire skirt.

This paisley print laminate pockeTee is tied with the much finer technique *hitta miura* shibori (looped binding in a fine grid), which takes three times longer to tie than regular *miura* shibori. First the garment is sewn and tied. The tied garment is heat-set to keep the puckers permanent. The tying thread is then removed, and dye-transfer paper with a paisley print is placed on either side of the textured garment, which is again put in the heat-set machine to laminate the fabric with clear film. The resulting glossy surface resembles snakeskin. When worn, the chiffon is soft against the skin and the printed puckers, flattened like fish scales, move with the body. The overall effect is of a slightly shiny, mesmerizing garment.

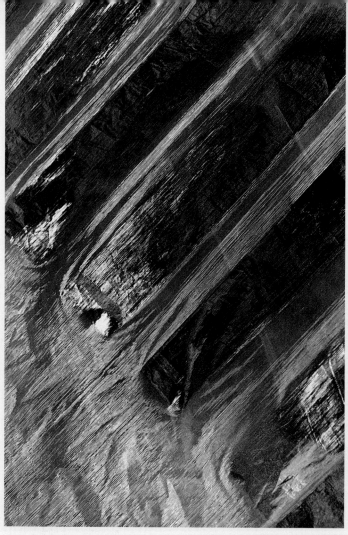

melt-off on metallic fabric

Historically, in Japan, metallic textiles are woven with yarn made by using natural lacquer to attach gold or silver foil to a sheet of strong thin paper. The gilded paper is then cut into thin, filamentlike paper yarn. This metallic paper yarn, invented in China, may be woven into fabric as weft, or wound around a thread core to form more durable yarn. Modern metallic fabric is normally woven with polyester or nylon metallic yarn, often combined with other fibers. Metallic yarn is made from polyester or nylon film coated with a minute amount of metal and then cut into fine strips and wrapped around a polyester core yarn. Another type of metallic yarn comes from similarly made polyester or nylon film cut into fine strips (film-slit yarn) without a core yarn, and used as the weft in the same way that ancient gold paper yarn was.

Melt-off is akin to dévorée in that metal is dissolved or "melted off" selectively from metallic fabric or lamé. Similarly, cellulose fiber is "burned out" of the cellulose blend. Melt-off is usually most effective with the film-slit yarn type because of its greater transparency when the metal is dissolved.

The examples in this section feature three kinds of unconventional metallic fabric produced in Japan by innovative textile designer Jun'ichi Arai. Arai resides in Kiryu, a weaving town in Gunma that is famous for silk and metallic brocade for *obi* (a wide stiff sash worn around the waist over a kimono) and other items produced using a jacquard loom. This kind of loom was also used to manufacture modern broadcloth, including lamé, for post–World War II export to Middle East and Asian countries, taking advantage of the newly developed sparkling metallic film-slit yarn that was still cost-effective.

Arai was active as one of the designers and manufacturers who popularized lamé in the 1950s and 1960s, and he serves as an advisor to the Gunma Prefectural Society for Sericulture Promotion. He made great improvements to broadcloth lamé, which has typically been woven with synthetic film and yarns. Arai's lamé is woven with sixty-five to ninety-five percent silk fibers and is therefore more elegant. The texture, hand, and appearance of the cloth all shifted toward those of silk. The Gunma silk yarn is combined with experimental metallic filaments, such as ultrafine-gauge polyester film-slit yarn, which increases the proportion of the weight of silk in the fabric; titanium-coated polyester film-slit yarn, which produces a lacquerlike surface; aluminum-coated polyester film-slit yarn with a holographic finish; and aluminum-coated nylon film-slit yarn, which can easily be dyed with acid dye. Arai has also produced a body of dazzling work using shibori processes on fabric woven with polyester-film metallic yarn, patterned with a heat-transfer sublimation-dye method, and shaped and permanently heat-set.

Itajime shibori and melt–off on silk and polyester metallic cloth effect a striking contrast between the original shiny metal fabric and the transparent polyester ground. (The process is described on page 161).

Metallic cloth woven with 65% silk and 35% polyester film-slit yarn with aluminum coating, designed by Jun'ichi Arai for the Gunma Prefectural Society for Sericulture Promotion. 7.6 x 7.6 cm (3 x 3 in.).

itajime shibori on metallic silk fabric

Material made of a single-ply nylon filament (one layer of filament coated with metal) is necessary for melt-off applications. Two-ply metallic yarn (two filaments sandwiched around a metallic coating) will not be affected by the chemical. Locally available lamé should be tested for suitability for this process. Some jacquard lamé also yields interesting effects, due to its woven pattern.

The material is accordion-folded along the weft. The folded bundle of fabric is sandwiched between boards and clamped securely. The whole thing is immersed in a mild alkaline solution and heated (see recipe 5, page 193). Both the shape of the folded fabric and that of the clamping boards can vary greatly according to the design. For the melt-off process, larger design elements tend to be more effective.

Bands of semitransparent polyester hover like floating ladders on a shiny metallic ground (for larger view, see page 160). There are many design possibilities in combining heat-transfer printing images on a base fabric of polyester. Acid dye can be used with fabric woven with nylon film-slit yarn.

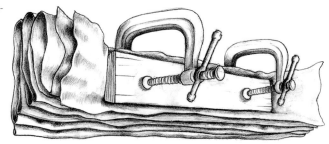

Folded and clamped contemporary adaptation of *itajime* shibori.

Detail of finished fabric showing the original metallic portion against the transparent polyester portion where the metal has been dissolved. Directed by Jun'ichi Arai and executed by Yoshiko I. Wada.

Metallic nylon-slit yarn woven with wool, designed by Jun'ichi Arai. 7.6 x 7.6 cm (3 x 3 in.).

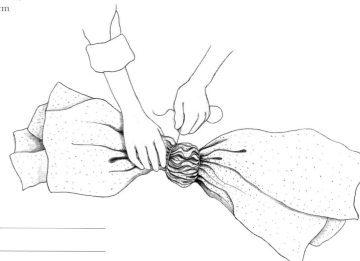

large binding on wool and metallic fabric

Jun'ichi Arai designed this fabric of twill weave using wool and metallic nylon film-slit yarn. The middle of a piece of medium-heavy large fabric is gathered with the fingers and bunched up. The section to be reserved is tied with a strong twine, then covered and bound with a strip of rubber from the inner tube of an automobile tire (a very useful material for resist binding, commonly used by shibori artisans). This keeps the design in the middle safe from penetration by dye. The bound cloth is then immersed in an alkaline solution and heated to melt off the metallic coating from the nylon slit yarn. Here acid dye is used to dye one side of the cloth green and the other blue; both the wool and the nylon yarn are colored at the same time. The dyed bundle of cloth, still bound in the middle, is then machine-washed (this is necessary to rinse off excess dyes, and it also contributes to the finishing of the fabric by shrinking the wool yarn in the exposed area). The dyed portion of the cloth sparkles with the nylon-slit yarn without the metallic glitter. Of course, the shibori design in the middle of the cloth still retains the metallic coating. Like a stream of bright light in the night sky, the white line shows off the original weave of the cloth with aluminum against a dark shiny ground.

The process of tying.

Finished fabric, showing the bound white resisted design against dyed ground where metal has been removed from the nylon film-slit yarn, exposing sparkly dyed slit yarn and fulled wool, by Jun'ichi Arai.

Silk metallic fabric designed by Jun'ichi Arai. 95% silk and 5% polyester film-slit yarn with aluminum coating. 7.6 x 7.6 cm (3 x 3 in.).

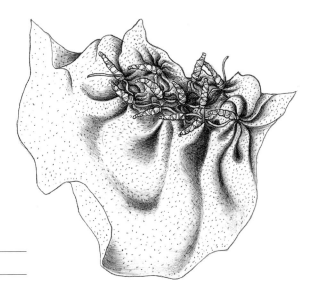

Kikaigumo shibori process.

kikaigumo on silk and metallic fabric

Jun'ichi Arai designed this special silk lamé woven with ninety-five percent silk and five percent metallic film-slit yarn for the Gunma Prefectural Society for Sericulture Promotion. The yarn is "reeled silk," which is reeled off cocoons and is not degummed. As a result, this fabric presents multi-fold possibilities with mechanical resist processes, especially with shibori, several of which are outlined here. (1) The shibori may be applied on the original greige good (untreated fabric) before degumming. The degumming process, which involves cooking the cloth in an alkaline solution, can also melt off the metal coating on the polyester filament. If undyed, the fabric retains the three-dimensional shibori shapes with the metallic pattern in the areas that were reserved. The degummed ground is not shiny, due to the melt-off (see photograph at right). (2) Fabric treated with this process may then be dyed in an acid dyebath. The hot bath turns the textured fabric into a flat cloth, but the colored ground highlights the melt-off shibori design where the metallic coating is still intact (see photograph below). (3) The process outlined in (1) is followed, except that natural enzymes may be used for degumming. The enzymes break down the protein sericin on the outer layer of silk yarn without melting the metallic coating. After degumming, the bound cloth may be dyed. This produces metallic silk fabric with spiky shibori shapes reserved in white against the dyed ground, which is softer without the sericin.

Kikaigumo shibori (see page 150) is used here together with melt-off to create a resist pattern. At the same time, the spiky three-dimensional forms in the cloth may be enjoyed as part of the effect.

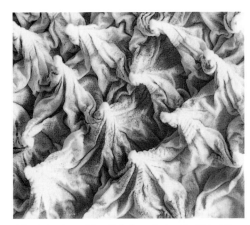

After being heated in a light lye solution for 20 to 30 minutes, the fabric is opened. Note the melt-off of metallic yarns and the spiky heat-set shapes.

After melt-off, the silk fabric is dyed in acid dye, bringing out the light-reflective quality of the shibori pattern.

fulling

The fibers in sheep's wool have microscopic scales on their surface that retain heat, keeping the animal warm. When these fibers are agitated by washing or rough handling, the scales "catch" on each other, causing matting and shrinking.

The process of felting takes advantage of this characteristic by placing raw fibers called fleece in the form of a sheet on a screen or cloth, rolling it, then washing and beating the fibers. The agitated fleece begins to matte and to form a tighter, cohesive structure, resulting in what we call "felted fabric"; this is used to create a wide variety of products, including rugs, hats, shoes, and coats.

Fulling starts from the constructed cloth; a loosely woven or knitted fabric is agitated through washing, causing shrinkage from matting of fibers. The original fabric is transformed to a denser, heavier woolen cloth sometimes called "boiled wool." Soft open fabrics can be selectively patterned by combining this shrinking process with shibori techniques; certain areas can be fulled tightly while others are reserved from shrinkage and matting. Fulling and felting make it possible to record textures and three-dimensional shapes into all-natural fabrics.

Textile designer Jun'ichi Arai suggests using simple, woolen, open-weave tubular cloth from a four-harness loom to construct a garment by fulling. Changing the density of the cloth in different areas while weaving or knitting can have the effect, after fulling, of giving varied textures to different

parts of the same garment. This idea can be expanded by adding shibori processes to manipulate the cloth and by fulling the cloth to shape the finished garment. Artist Jay Rich suggests combining knitting or crochet technique with shibori to create sculptural pieces.

Woolen stole with spiky creatures shaped by *tegumo* shibori and fulling, by Hiroshi Murase. (The process is described on page 165.)

Open-weave wool, specially designed
for fulling. 7.6 x 7.6 cm (3 x 3 in.).

kumo shibori

A one hundred percent woolen cloth with an open-weave structure, specially designed for fulling, is used to create a highly sculptural, intriguing stole. Fabric is held by a hook and then pulled, while both hands are free to pleat and gather the cloth into a horn shape. Using a strong thread, the conical shape is tightly bound, base to tip and back to base, as seen in the photograph at right.

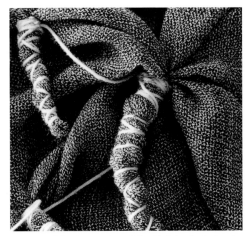

In *tegumo* shibori, a portion of the fabric is plucked and gathered and bound.

Kumo shibori consists of two variations—*tegumo* (hand spiderweb) shibori, which is the original, classical process, done by hand, and *kikaigumo* (tool-aided spiderweb) shibori. The two variations differ only slightly (for information on tool-aided spiderweb shibori, see page 150). The word *kumo* (spider) refers to the binding process as well as the resulting design, which resembles a spiderweb pattern. In this example, Hiroshi Murase repeats the *kumo* shibori in various sizes over the fabric randomly—a modern interpretation. Once binding is complete for the entire design, the fabric is machine washed. The length of time and the temperature of the water will vary with the amount of shrinking desired. After the cloth is allowed to dry, the fabric is untied to reveal heavily sculpted horn shapes. The great textural contrast between the raw fabric and fulled ground enhances the sculptural aesthetic of the final piece.

When worn, the shawl appears animated, with conical *kumo* shapes floating on a bed of soft, dense wool. (For detailed information on fulling, see recipe 6, page 193.)

Detail of finished *tegumo* shibori after fulling. By Hiroshi Murase.

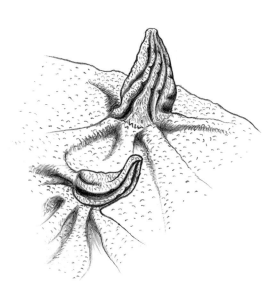

Shibori shape sculpted in the fabric after fulling.

Fine light wool jersey slightly fulled. 7.6 x
7.6 cm (3 x 3 in.).

makinui shibori

A lightweight, soft, one hundred percent woolen cloth is used to create a subtly sculpted fabric using *makinui* shibori (overcast stitch). Simple overcast stitching is applied in parallel rows. Once the stitching for the entire design is complete, the thread is pulled to gather the fabric tightly, and knotted securely. The tied cloth is agitated through washing in a conventional washing machine to achieve the desired density of fabric. (Details on fulling are given in recipe 6, page 193.) After the cloth is dried, the threads are removed to expose the permanently textured pattern on a denser ground.

Makinui shibori is executed with a long needle whose length can accommodate the portion of fabric being stitched and lightly gathered. As stitching progresses, gathered cloth falls off the needle until the continuous linear pattern is finished—from selvedge to selvedge or the beginning of a line to the end. The artist must be sensitive to the stitching size, spacing of the linear design, and weight and density of the cloth, so that all work harmoniously.

Makinui shibori in process, showing stitches of different sizes.

Finished fulled piece by Hiroshi Murase, executed by Ryoko Kohbata.

Knitted woolen fabric. 7.6 x 7.6 cm (3 x 3 in.).
By Jay Rich.

marble shibori on knitted wool

Loosely knitted mohair/wool blend cloth is sculpturally shaped using a variation on an ingenious process of shibori resist over marbles or ping-pong balls and fulling with the bound objects tied firmly inside. The ground area of this cloth was shrunk quite readily by twenty to thirty percent, whereas the areas reserved by the marbles and ping-pong balls retain their spherical shape and the original loosely woven texture.

The tight binding at the neck of the object here is strong enough to resist shrinkage, due to the tension maintained on the original cloth knitted by Jay Rich. Knitting and crocheting offer the freedom to quite easily create irregular shapes and varying density, and allow artists to explore great possibilities in sculpting three-dimensional objects, including garments.

Detail of fulled piece.

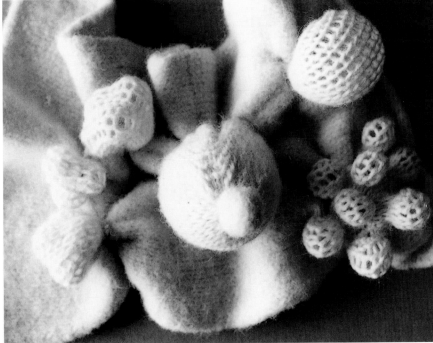

Finished fulled object by Jay Rich, executed by Ryoko Kohbata.

dévorée

In recent years, amid continual technological advances, experimentation by artists and designers has unearthed aesthetic possibilities in new materials, including lightweight hybrid materials that combine textile with glass, metal, carbon, or ceramic. These fibers offer an intriguing range of potential qualities and effects. Shibori techniques offer flexibility and tremendous possibilities for creating pattern, texture, and shape in contemporary synthetic or mixed-fiber textiles.

Mixed fiber is essential for the process of dévorée (a technical term derived from the French word for "devoured"), in which one type of fiber is dissolved by a certain chemical that does not affect the other fibers. Typically in dévorée, cellulose fiber is burned out with acid, and when protein is to be removed, alkali is used. Thus the effect is usually an opaque pattern suspended over sheer ground fabric.

The dévorée process first appeared in the textile industry in Europe around the late nineteenth century. The chemical paste was applied to a long yardage and heated to activate the chemical reaction. The dissolved fibers were washed away. The process has gone in and out of fashion since then and was most recently reintroduced to the artists' and designers' community in the West by Joy Boutrup, a Danish chemist and teacher. In Japan, it has been used off and on since the mid-1900s. During the past two decades, Japanese fashion designers have used numerous interesting dévorée fabrics, due to the close collaboration they enjoy with textile designers and manufacturers.

The shaping-and-binding resist processes of shibori were not fully explored by the textile industry in the West until recently. For that matter, the concept of shibori was not understood or appreciated in the West until the 1970s. The shibori process requires exerting tension on three-dimensionally manipulated fabric. The fabric is shaped and bound to prevent liquid dye penetration; however, it can also serve to resist penetration by any liquid, including chemicals such as alkali that affect fibers. Alternately the exposed surface of the compressed fabric can be painted with chemical paste, which reduces the amount of hazardous material being used.

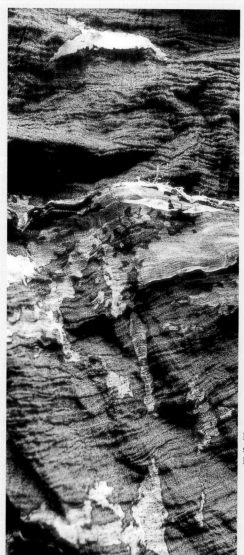

Dévorée with shibori on a unique fabric woven with stainless-steel filament wrapped with wool fiber. By Hiroshi Murase.

Rayon velvet with a polyester ground.
7.6 x 7.6 cm (3 x 3 in.).

nui shibori on rayon and polyester velvet

Dévorée yields a striking effect on polyester and rayon velvet, because of the way the two contrasting fibers react to one chemical. Acid (sodium bisulfate or sodium acid sulfate) is used to remove the shiny rayon pile while exposing the semi-sheer polyester backing material. When acid paste is mixed with disperse dye, the heat required to activate the acid will also help sublimate the dye and the polyester ground can be colored at the same time. In the United States, rayon and silk velvet is more readily available for dévorée than the polyester and rayon combination, and it can be colored by an even wider range of dyes.

Nui shibori (hand-stitched resist) creates slightly undulating vertical pleats due to the natural irregularity of hand-sewing. The resulting pattern evokes tree bark or the grain of wood and is called *mokume* ("wood-grain") shibori, as seen in the example in the photograph below. A wide variety of stitch resist should be considered for dévorée, including the stitching created by a smocking machine. Parallel running stitches are applied along the weft of the entire length of the cloth, from selvedge to selvedge. After stitching the entire design, the threads are drawn up and secured tightly with knots. The acid-salt paste is applied from the polyester side of the cloth; this burns the bottom of the rayon pile to release the fiber in the cloth more efficiently. After the dévorée process is complete, the knots at the end of each row of stitching are cut to remove the resist thread. The cloth is washed thoroughly to remove the burned-out (carbonized) fibers and neutralize the cloth. Always wear a cartridge respirator to avoid inhaling the small fibers. Here the white patterned cloth has been dyed to bring out the *nui* shibori design, especially the reserved rayon pile area, now dyed in blue.

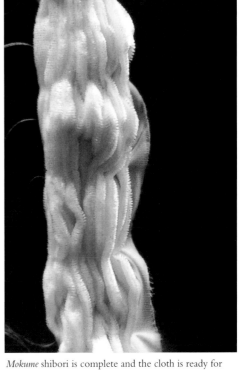

Mokume shibori is complete and the cloth is ready for the next chemical treatment.

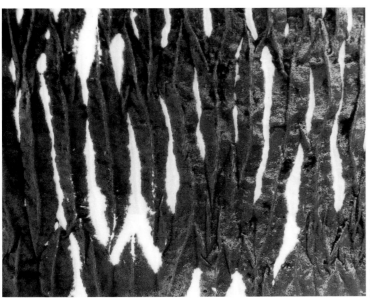

Finished fabric after dévorée. It is colored with fiber-reactive dye to enhance the shiny velvet against the white semitransparent polyester. By Hiroshi Murase.

Rayon and silk charmeuse fabric.
7.6 x 7.6 cm (3 x 3 in.).

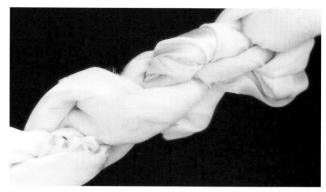

Twisted into a rope to resist areas from dévorée.

rope resist on silk and rayon charmeuse

The dévorée process only works on materials that consist of specific combinations of two opposing fibers. This silk and rayon charmeuse fabric is ideal since rayon is easily decomposed by acid while silk remains unaffected.

There are several different approaches to the production of handcrafted pieces. One is one-of-a kind production, which affords labor-intensive and a hard-to-duplicate effect; another is multiple- or limited-edition production, which requires that results are predictable enough to be duplicated; and yet another is mass production, which demands great speed in process and a consistent result. The example illustrated here offers a few possibilities for studio artists in the way fabric is manipulated into shapes, and resisted and dyed. However, for mass production of material of 2,000 meters (2,190 yd.) or more, the prototype can be made in a studio and duplicated in an industrial facility by making a screen from the shibori fabric. For mass production a silkscreen is used to apply dévorée paste to material of long yardage, which is then heated and washed in a properly equipped factory. In this example, the artist used white fabric and a dévorée stencil based on his own shibori fabric to further expound on the embellishment possibilities afforded by layering colors and designs.

A couple of shibori processes are suggested to simulate the image in this example, on large fabrics. Fabric can be pleated lengthwise and heated to set the pleats before it is folded into a smaller bundle and held in the shape during the dyeing and discharging processes. Another suggestion is to use a simple ropemaking machine; in this case, two lengths of fabric are tightly twisted and coiled in opposing directions, then the two coils are brought together and twisted into a rope. This can be achieved without the tool by securing the tops of the two lengths of fabric to the edge of a table with a C-clamp. After the fabric is tightly twisted, it is stretched taut to brush on the acid-salt paste (see recipe 7, page 193). After the dévorée process is completed, there are a number of ways of dyeing the silk as well as the rayon to create a more complex and intriguing statement, as accomplished by Carter Smith; resembling cheetah spots or camouflage print, the design pattern both reveals and disguises.

Detail of dévorée and dyed fabric, showing shiny dyed rayon against a silk ground.

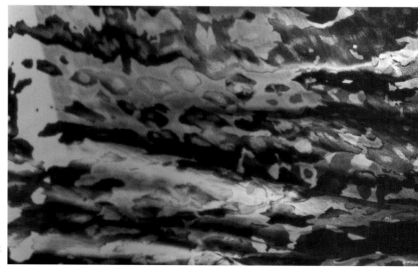

Overview of the complex dyeing patterns that can be achieved with dévorée. A signature look by Carter Smith.

Wool fabric in light gray. 7.6 x 7.6 cm
(3 x 3 in.).

Acrylic fabric in darker gray. 7.6 x 7.6 cm
(3 x 3 in.).

mokume shibori on wool and acrylic

Combinations of disparate fibers and fabrics are a perfect foil for a shibori and dévorée combination.
Ana Lisa Hedstrom combined acrylic and wool to create an unusually interesting material, which was
eventually made into a vest and a cap for winter. The high relief and pattern evoke the natural
patterns seen in stone and at the same time incorporate a distressed and
edgy urban look.

Mokume ("wood-grain") shibori is created by hand-sewing parallel
rows of running stitch, which creates slightly undulating vertical
pleats due to the natural irregularity of hand-sewing. In this example,
the running stitch is used to "laminate" the two fabrics. Because of the
thickness of the fabrics, the stitches are made larger. Polyester embroi-
dery thread is chosen for its strength, color, and impermeability to the
lye. The color of polyester thread contributes to this intriguing surface
embellishment.

The running stitch is gathered tightly, but not tied off as is done in
traditional *mokume* shibori. This leaves the artist free to shift the amount
and areas of tight folds, as well as to revert back to the flat fabric after treat-
ment without losing the lamination created by the sewing. For dévorée of wool,
lye paste is brushed onto the surface and left on for several hours, until the wool
fiber is decomposed enough to become loose. The fabric is washed carefully and
rinsed thoroughly, and then neutralized in a mild vinegar bath.

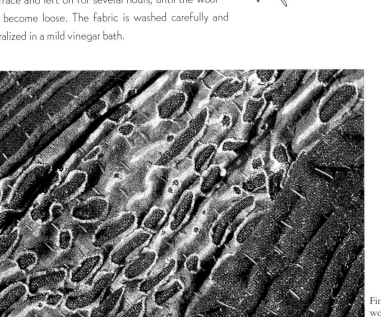

Acrylic and wool fabrics are layered
together and stitched with *mokume* shibori.

Finished fabric, showing the burned-out
wool portion and the acrylic below. By
Ana Lisa Hedstrom.

Wool over a polyester core yarn woven
into a fine blend fabric specially suited for
dévorée. 7.6 x 7.6 cm (3 x 3 in.).

gangi mokume, *tatsumaki*, *itajime* shibori on wool and polyester fabric

This fabric was developed specially for dévorée. The lightweight wool twill is woven with a fine poly-
ester core yarn wrapped with woolen filament. Thus, after the wool is removed, the integral fine poly-
ester fabric is exposed, to create a partially sheer material. The heating step, which changes the
acid-salt (sodium hydrogen sulfate or sodium bisulfate) to acid so that it can dissolve the cellulose
fiber, also helps the polyester retain the three-dimensional shape created by the shibori process.

The complexity of shibori processes and dyeing techniques for various fibers are almost second
nature for Tsuyoshi Kuno, a dyer in Arimatsu. This cloth is first executed with the stitch-resist
process *gangi mokume* shibori (see page 148 for more information) and dyed with acid dye. Then the
gathered cloth is placed on a rope core for the *tatsumaki* shibori process described on page 175, and
subjected to a dévorée process to remove the wool. Finally, the cloth is treated with a variation of
itajime shibori, using a set of boards with the areas to be affected cut out. Rather than conventional
boards that resist the shape of the board, these "reversed" boards resist the ground. In this final step
the wool is dissolved again in selected areas, creating larger sheer shapes.

Detail of final piece showing the areas of remaining dyed
wool next to the dévorée portion of the polyester ground,
which has also been dyed.

In the final piece, holes from the stitching pattern of *gangi mokume* shibori are visible due to the fineness
of the fabric; they add another interesting element to the design. The polyester and wool are both first
dyed black; brown dye is then applied, affecting only the wool. By Tsuyoshi Kuno.

cloque

Throughout Japan's textile industry, there has been a revived interest in cloque since the early 1980s. Many shibori artisans have been enjoying the effect derived from combining shibori technique and cloque. In fact setting shibori texture on cellulose fiber fabric with lye became so popular during the 1990s that one dye studio in Hamamatsu got the idea of applying for a patent for the process of setting texture permanently on fabric using shibori and cloque. Much to the surprise of the rest of the shibori dyers, the patent was granted to this studio in 1996.[8]

John Mercer, who capitalized on the tendency of cellulose fiber to shrink when treated with lye, originally developed the technique for lye shrinkage of cotton. In 1844, he developed a resist medium that would protect selected areas from lye shrinkage, creating fabric with an embossed surface. Since then, the process has been in and out of fashion in the textile industry, and also there have been many new developments based on Mercer's cloque method. For example, in the *chakubatsu* (dye discharge) method, cotton or linen that has already been dyed with fiber-reactive dye is then printed with vat-dye paste that contains lye. The effect of steaming the printed areas of

the cloth is twofold: the reactive color is removed (via a discharging process) and the cellulose fiber shrinks.

Joy Boutrup first reintroduced traditional methods in which lightweight, open-weave cotton fabric is printed with a resist medium before being treated with a strong lye solution. This causes exposed areas to shrink, creating textured fabric composed of a tightly textured ground with puckered transparent areas of design.

The combination of shaped-resist and the basic cloque process offers a unique opportunity for artists and designers who seek to produce effects with textured surfaces and to explore the contrast between opacity and transparency in cloth without using a rigid woven structure.

Cotton cloque with *yokobiki* shibori by Ryoko Kohbata. (The process is described on page 174.)

Fine open-weave cotton. 7.6 x 7.6 cm
(3 x 3 in.).

yokobiki shibori on cotton

A light open-weave cloth is best. The design to be tied is marked with a
fugitive pen or soft lead pencil on the bias of the cloth. *Yokobiki* shibori is
usually executed by using a tool to pluck a tiny bit of cloth and then bind-
ing that area with cotton thread (thread should not be twisted too tightly),
making several half-hitch knots on each unit (see Resources, page 195, for
information on shibori tool kits). The tying is done on the bias of the cloth,
starting at one end and continuing to the other, then going back to the
same side to begin the next row. After the entire design has been tied, the
cloth is treated with a lye bath (see recipe 8, page 193).

This process makes the fiber elastic and the sculpted texture perma-
nent. There are areas with varying degrees of opacity, which add subtle
elegance to the finished piece.

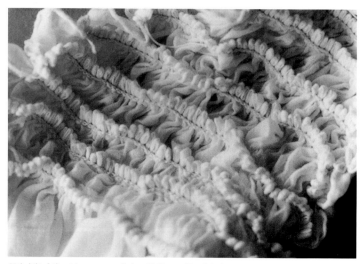

Yokobiki shibori in process. 7.6 x 12.7 cm. (3 x 5 in.).

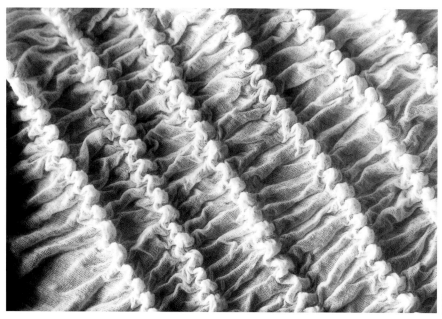

Finished cloque with the shibori resist thread removed. By
Ryoko Kohbata.

Open leno weave in linen (*asa karami*). 7.6 x
7.6 cm (3 x 3 in.).

hinode tatsumaki shibori on linen leno weave (*asa karami*)

Hinode literally means "sunrise" and this traditional method involving stitching rows of small half-circles across the width of a fabric results in a repeated pattern of shapes resembling rising suns. These rows are usually spaced about every 5 to 10 centimeters (2 to 4 in.), depending on the scale of design desired. They should be staggered rather than lined up, since this allows the fabric to pleat diagonally, which creates radiating lines when the stitching thread is pulled. After completing the stitching of horizontal rows for the entire length, the threads are pulled tightly, and the fabric is gathered up into a narrow width. This makes the stitched half-circles become puckered and stand out from the rest of the fabric. The fabric is then ready for the *tatsumaki* process.

Tatsumaki literally means "tornado" or "dragon binding"; the name refers to both the way resist threads are wound and the way the ropelike resisted cloth resembles a dragon. In this traditional technique, cloth is usually pleated and then bound around a rope core and dyed, as shown in the photograph at right. The pleated fabric is placed over a rope core and a knot is tied around one end; the thread is then wound around at intervals of about 5 to 8 centimeters (2 to 3 in.) so that the gathers of cloth are kept intact on the rope and the puckers are allowed to protrude from the bound portion. Next, the final resist binding thread is applied with a strong thread to the entire length at 8-millimeter (1/4-in.) intervals.

After the resist thread is wound around, the cloth is treated with lye to shrink the exposed portion before dyeing. The recipes for cloque (8, page 193) and fiber-reactive dye (11, page 194) should be followed. When the dyed piece dries, all resist threads are removed. The small puckers become dyed circles with lines radiating from them, evoking the sunrise with rays of light shining from it. In this modern interpretation, the puckers and pleats create an interesting texture and pattern.

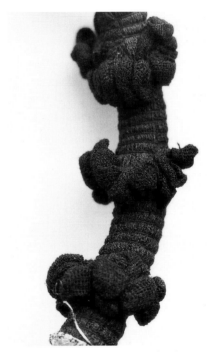

Process of *hinode tatsumaki* shibori, after cloque and dyeing.

Finished cloth by Hiroshi Murase.

Open leno weave in linen (*asa karami*; same fabric as on page 175). 7.6 x 7.6 cm (3 x 3 in.).

kikaigumo shibori on linen leno weave

This specially developed linen cloth with open leno weave is ideal for cloque treatments; the open weave offers great allowance for the yarns to shrink and move and also holds shibori textures extremely efficiently.

Kikaigumo is a variation of hand-pleated classical *kumo* shibori (for another variation, see page 165). In *kikaigumo*, the tip of the cloth is held by a hook attached to a simple motorized tool. Both hands are used to gather the cloth into a horn shape, and the tool helps to gradually pull the cloth into shape while at the same time quickly winding threads around the horn shapes. The size of the binding units that can be produced with the mechanical tool is limited, and therefore *kikaigumo* offers an efficient way to produce fields of small spires of spiderweb designs. Cloque makes it possible to retain these shibori textures (see recipe 8, page 193).

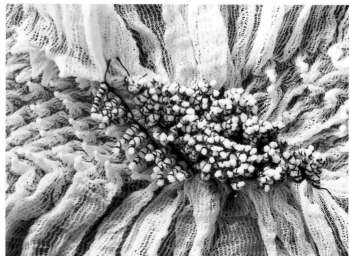

The sheer linen material is covered with short protruding tentacles created with *kikaigumo*. The three-dimensional shapes inherent in the shibori process are permanently captured by lye shrinkage of the bound piece. The sheerness of the fabric and the shibori texturing allow interaction with light and shadow, making the piece airy and dimensional. This process has great potential for use in home furnishings such as partitions or drapery sheers.

Kikaigumo shibori is partially opened after the cloque process.

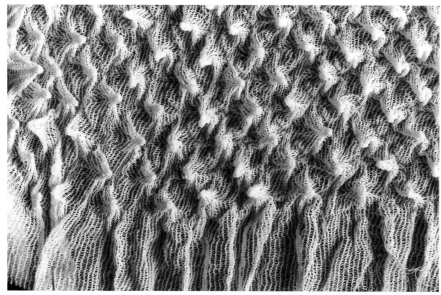

A finished white-on-white textured linen by K. Takeda & Co.

degumming silk

Silk can offer amazing possibilities as an experimental creative apparatus when the influence of technology dovetails with the characteristics of natural materials and ingenious handwork.

The tradition of silk weaving and hand dyeing of silk cloth has been an integral part of Japanese society and its aesthetic. Yet currently less than four percent of the raw silk materials (reeled silk yarn and cocoons) used to produce Japanese silk textiles are actually produced in Japan. Competition from foreign imports, textile manufacturers' indifference to the quality of raw materials, and the greatly reduced popularity of the kimono challenge the viability of labor-intensive sericulture. The Department of Agriculture in Gunma Prefecture formed the Gunma Prefectural Society for Sericulture Promotion (GPSSP) to solicit expertise from advisors including Jun'ichi Arai and me, from a wide range of fields, to promote silk and the artistry involved in raising silkworms and making silk yarn (filature), thereby ensuring the production of quality indigenous silk textiles for continued exploration by artists and designers.

In 1998, I collaborated with Masao and Mayumi Koshizuka of Koshimitsu Textile Mill in Kiryu (a textile center in Gunma Prefecture) to design and produce a collection of silk fabrics in leno weave, crepes, silk and linen mixes, and engineered pintucked fabrics in Western widths using the silk yarns provided by the prefecture. I conducted Project Metamorphosis, a research and development effort in which a group of international artists and designers were given a length of these Gunma silk fabrics to experiment with and in return would donate the works they created. I was interested in exploring the inherent qualities of silk, particularly in combining its two types of proteins (fibroin and sericin) with high-twist yarns and cellulose fibers. This is achieved by working with greige goods (untreated fabric) and manipulating the fabric at each stage of the treatment process, such as creping, degumming, resisting, dyeing, and finishing. For example, when weaving overspun twist yarn against regularly spun yarn in a particular woven structure, the degummed and non-degummed materials shrink to different degrees, producing a variety of subtle textures and densities with areas marked by softness or stiffness. Artists can selectively degum designated areas using mechanical resist methods such as shibori techniques, which can also simultaneously shape the two-dimensional fabric. The most conducive resist methods are fold and clamp (*itajime*), diagonal pole-wrap (*arashi*), stitch and gather (*nui*), and various binding and knotting techniques. These designs may be enhanced by dyeing the silk after selectively degumming and shaping the cloth, using carefully chosen dyes to obtain certain effects, of which there are many. In terms of untreated silk with sericin left in the fabric, commercial silk organza is the only readily available and less costly alternative to Gunma silks. However, weavers should know that weaving their own cloth with untreated silk yarns in combination with any other techniques is possible and rewarding.

A finished scarf by Ana Lisa Hedstrom. The resisted, untreated area is darker than the part that has been degummed and creped.

Untreated silk fabric (GS1) with high-twist weft in S and Z shapes, produced by Koshimitsu Textile Mill under the direction of Yoshiko I. Wada. 7.6 x 7.6 cm (3 x 3 in.).

arashi shibori on gunma silk

Traditional *arashi* shibori (diagonal pole-wrap resist) is one form of *bomaki* (pole-wrap) shibori, in which fabric is wrapped over a pole and compressed—in other words, where a pole is used as a core to protect one side of the cloth from the dye. In traditional *arashi*, a single layer of cloth is always wrapped diagonally on a pole. However, many American artists tend to work with a shorter PVC pipe instead of a long wooden pole and to use the diagonal orientation interchangeably with a parallel one. Many traditional *arashi* patterns evoke rainstorm or windstorm. In this example, Ana Lisa Hedstrom combines *arashi* shibori and degumming and dyeing of Gunma silk to create unusual textures and surface images.

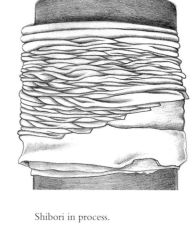

Shibori in process.

This untreated silk fabric (GS1) by Koshimitsu Textile Mill is woven alternately with highly spun yarn in S and Z twists on the weft. The cloth is wrapped diagonally around the PVC pipe, whose circumference is large enough to accommodate the cloth without overlapping. It is helpful to use masking tape to tack the cloth against the pipe while thread is wound around at quarter-inch intervals. The tension and spacing of the winding thread should be kept consistent so that when the cloth is pushed into a tiny fold on the pipe, the cloth moves evenly, creating regular folds. Consideration should be given to the balance between the weight of the winding thread and the fineness of the cloth as well as the spacing of the resist thread over the cloth and pipe. Resist marks left on the cloth from using a heavy winding thread may become an added design element. When working with a long yardage, a new length of cloth may be wrapped on the pipe every 51 centimeters (20 in.), to make it easier to wind the thread and to manipulate the large amounts of cloth over the pipe.

In this particular pattern, the length of cloth is shaped into tiny folds on the pole, and the whole thing is immersed in a pot of mild soda-ash solution for degumming (see recipe 9, page 194). After degumming, the cloth is opened to reveal an *arashi* pattern in the stiff, sheer, and flat areas that were reserved in the original texture. Hedstrom then applies an additional resist to the cloth by binding off a large area and degummed the rest of the cloth further. This helps make the final design more dramatic, and different from the expected *arashi* "look," which is a field of small ripples and diagonal linear shapes. When the resist patterning is completed, the cloth is released from its binding and removed from the pole. The cloth is then immersed in an acid dye to bring out the untreated area, which absorbs the dye more effectively, becoming much darker than the soft creped and degummed ground.

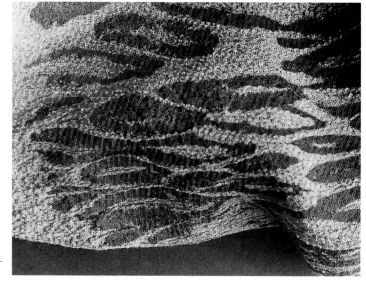

Detail of silk fabric after shibori resist, degumming, and dyeing.

Untreated silk fabric (KS4) with high-twist (S only) weft, produced by Koshimitsu Textile Mill under the direction of Yoshiko I. Wada. 7.6 x 7.6 cm (3 x 3 in.).

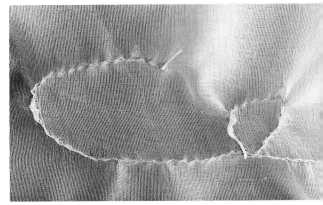

Orinui (folded-and–edge-stitched) shibori in process. The stitching thread will be gathered tightly before degumming. 7.6 x 12.7 cm (3 x 5 in.).

orinui shibori and creping on gunma silk

This untreated silk fabric (KS4) from Gunma is woven with highly twisted (S only) weft yarn. This single crepe fabric will shrink mainly on the width, creating fine permanent vertical pleats.

A linear design, which is enlarged to take the eventual shrinkage into account, is marked on the cloth. Stitching is done along the edge of the pinched cloth following the linear marking, as in traditional *orinui* shibori (folded-and–edge-stitched resist). After the entire design is stitched, the thread is pulled lightly. If a clear resist linear design is planned, the thread must be pulled tightly to resist the dye. However, designs in white-on-white are also quite effective when light plays over the permanently altered surface texture and the fabric moves.

The stitched fabric is cooked in soda-ash solution to crepe and degum it (recipe 9, page 194). The resulting soft, pleated fabric retains its shaped pattern permanently, even after hand-washing in cold water with neutral soap.

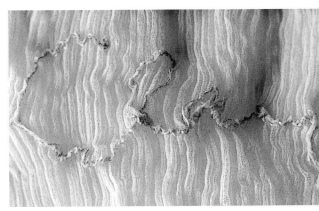

Detail of creped *orinui* shibori. 7.6 x 12.7 cm (3 x 5 in.).

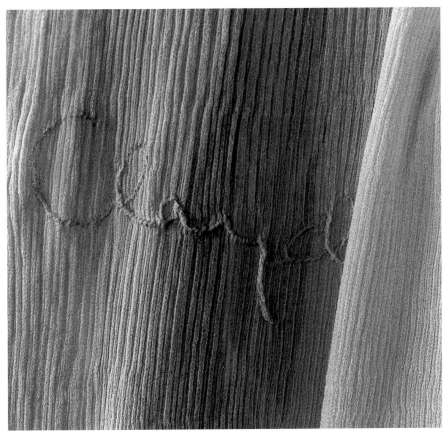

Finished piece by Yoshiko I. Wada, degummed and with stitching thread removed, executed by Ryoko Kohbata.

Untreated silk fabric (GS1) with high-twist (S and Z) weft, produced by Koshimitsu Textile Mill under the direction of Yoshiko I. Wada. 7.6 x 7.6 cm (3 x 3 in.). Same fabric as on page 178.

itajime shibori on gunma silk

This untreated silk fabric (GS1) from Gunma Prefecture is woven alternately with shots of S and Z highly twisted crepe yarns in the weft. The fabric is accordion-folded along first the length and then the width into a small rectangular shape, and is sandwiched between a pair of rectangular boards, as in classical *itajime* shibori (folded-and-clamped resist). A couple of C-clamps are used to compress the folded fabric tightly. When the fabric and boards are secured, the whole thing is cooked in a soda-ash solution for twenty to thirty minutes to remove the sericin coating from the silk yarn (see recipe 9, page 194). This cooking also crepes the fabric into a soft rippled surface, which contrasts with the sheer, stiff, and flat reserved areas. When the patterned fabric is dyed, the untreated parts turn darker and transparent, whereas the creped, degummed, soft areas become lighter in color and opaque. Hand-washing in cold water with neutral soap is advised. A steam iron should not be used.

Detail of a dyed scarf showing the clamp-resisted, flat, and crisp area where the sericin of the silk fiber has not been removed; next to this is an area that is creped and degummed. The halo of white around the edges of the patterns is created by dyeing the clamp-resisted cloth twice with the artist's own dye recipes.

Finished scarf with a transparent untreated pattern against a creped and degummed ground, by Ana Lisa Hedstrom.

Silk organza fabric. 7.6 x 7.6 cm
(3 x 3 in.).

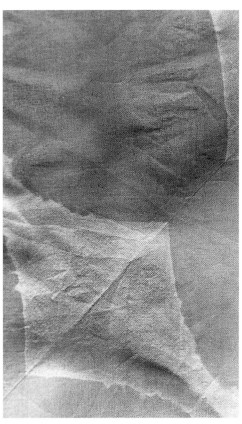

itajime shibori on organza

One hundred percent silk organza is a version of China silk that is sheer and crisp. Usually silk organza is reasonably priced and available in local fabric stores or through most textile or silk fabric suppliers (see Resources, page 195). Organza is sheer and stiff because the untreated silk filaments used to weave it are coated with a natural protein called sericin. Commercially available silks are usually degummed in order to bring out the luster and drapiness associated with silk's central protein, fibroin, but organza is not. *Itajime* shibori can easily create large reserved areas that are effective in emphasizing contrasts in texture created by the degumming process.

A square piece of organza is folded into fourths and pressed. Starting from one end of the pleated fabric, the cloth is folded into triangular shapes by reversing the fold, as in accordion pleating. After the entire length of fabric has been folded, the resultant triangular bundle is clamped securely between a pair of 7.6 x 7.6 centimeter (3 x 3 in.) boards. In this example, the boards were placed along the center of the triangular bundle and compressed. A variety of patterns can be achieved by changing the placement of the boards as well as the shape of the boards. The clamped material is soaked in water for ten minutes or more to ensure resistance to the scouring agents that seep under the clamped boards. Saturating the fabric with water will deter this capillary action. Conversely, if a soft-edged design is preferred, the clamped fabric should be added to the dyebath dry and opened after dyeing before the fabric dries. After fabric is degummed, the clamps are removed and the fabric is rinsed well and then dyed.

Detail of the clamped-and-resisted pattern, which looks darker next to the lighter opaque area that was degummed.

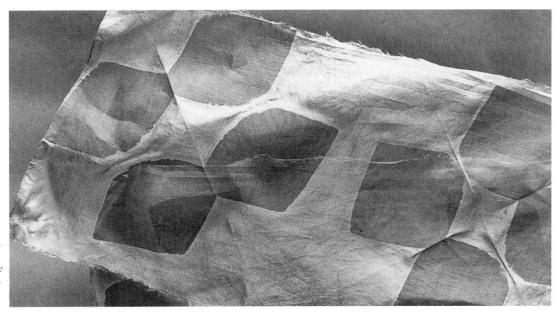

Finished piece showing the contrasting pattern of the untreated darker, transparent area versus the degummed, lighter, opaque area. By Ryoko Kohbata and Lindsay Robinson.

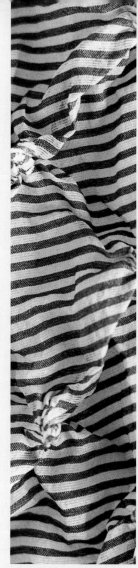

mixed fibers

Building on knowledge contained in the vital craft traditions practiced for centuries in Japan, modern technology is being used to create a variety of advanced yarns, much to the benefit of Japanese designers and artisans. Microfibers such as nylon, polyester, acrylic, and polyurethane are often combined successfully with half-natural yarns such as viscose rayon, with natural cellulose yarns like cotton and linen, or with natural protein fibers such as silk and wool, to weave fabrics that are unique in appearance and characteristics. A wide range of finishing treatments can be applied to the woven microfiber fabric that will completely transform its texture, color, and shape.

Blending synthetic and natural fibers improves performance, and also presents a wide range of unexpected design effects. There is a growing trend in the textile industry to combine two or more materials that differ in form or composition to produce a new material with improved performance characteristics. Artists who are willing to experiment by constructing materials—whether by weaving, knitting, felting, or some other method—will benefit from integrating traditional and technologically advanced materials.

Shibori techniques are a natural fit for creating pattern, texture, and shape in contemporary synthetic or mixed-fiber textiles. For example, patterns emerge when white cloth woven with mixed fibers is dyed or treated with certain chemicals, since each fiber has a different reaction. For example, in fabric woven with polyester and cellulose, the patterns do not become visible until the cloth is dyed in fiber-reactive dye that only affects cellulose fiber. Similarly, wool or silk can be combined with cotton or linen and dyed in an acid dyebath, which affects only protein fibers. The proportions and design of two opposing fibers in the cloth can contribute to an additional effect—for example the shrinking and puckering of the woolen ground next to the non-fulling cotton pattern. Or a certain amount of polyester fiber in the blend will allow three-dimensional shapes of shibori processes created by heat-setting to remain permanent.

Fabric woven with 50% rayon (black) and 50% polyester (white) stripes is used to create two very different effects. The original fabric was white before the shibori units were tied; it was then dyed in black fiber-reactive dye, leaving the polyester stripes in the original white. The thermoplastic quality of the polyester fiber content contributes to the permanency of the shibori texture set by heat. *Above right*: The three-dimensional surface of this treated fabric breaks the stripes, transforming the pattern into interesting, chaotic lines. *At left*: This is the same material treated with exactly the same processes, but here the fabric was ironed out flat to reveal the white resist pattern over the stripes. By Hiroshi Murase.

Original white material, 29% polyester, 21% linen, and 50% cotton. 7.6 x 7.6 cm (3 x 3 in.).

Yokobiki shibori in process.

yokobiki kanoko shibori on polyester and cellulose blend gingham check

A white polyester (twenty-nine percent) and cotton blend woven in a gingham check pattern yields interesting results with *yokobiki kanoko* shibori. Polyester threads in the cloth remain white since they are not affected by the fiber-reactive dye, while cellulose (cotton fifty percent, linen twenty-one percent) threads take the dye and turn black. The gingham check pattern becomes visible only after the cloth is dyed. *Yokobiki kanoko* shibori is a variation of the classic *kanoko* shibori, where a small portion of cloth is pinched and plucked into a tiny triangular pucker and bound with a thread.

Yokobiki kanoko shibori is done using a simple tying stand with a small needle or hook and a small spool or bobbin held by the tyer. The hook/needle is used to catch a bit of cloth that is tied with a thread coming out of the bobbin. The same thread can be used continuously to tie the rest of the design. After dyeing with fiber-reactive dye (see recipe 11, page 194), the cloth is rinsed thoroughly and dried completely before removing the binding thread. The resist thread will pop off when the cloth is pulled apart firmly with two hands and stretched and pulled diagonally along the bias.

The small dots in *yokobiki kanoko* shibori are arranged in a widely spaced diagonal grid. The rows of dots are tied from one end of the design field, or selvedge of the cloth, to the other end, working along the bias of fabric. After completing the tying of the entire design, there are two options in terms of patterning treatment. One effect is the textured look in the photo at right, which is achieved by heat-setting the shibori shape into the cloth after dyeing. Another effect is achieved by simply dyeing the resisted cloth in the desired dark color and then ironing the finished cloth flat to reveal small white rings scattered over the gingham checks, as below.

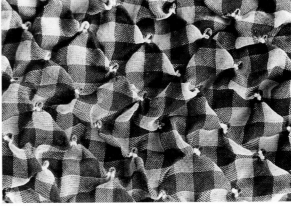

Shibori piece dyed in fiber-reactive dye, which dyed only the cellulose part of the cloth, leaving the polyester unaffected. The shibori shape is set by heat.

The same fabric as in the photo above is ironed flat to reveal *yokobiki kanoko* resist rings in white against a black-and-white gingham check pattern. By Hiroshi Murase.

Original white fabric of rayon velvet on a polyester sheer ground. 7.6 x 7.6 cm (3 x 3 in.).

kumo shibori on rayon and polyester velvet

Cellulose and polyester blend fabrics, or variations thereof with protein fibers and polyester, are great candidates for experimentation with combinations of dévorée and complex resist-dyeing processes. As illustrated in this polyester and rayon floral fabric patterned with a dévorée process, fiber-reactive dye affects only the rayon pile, leaving the polyester unchanged. The dévorée pattern combines the opacity and transparency of rayon velvet florals and the sheerness of polyester ground. This effect is further enhanced by *kikaigumo* shibori (see also page 150), adding complexity to the surface.

Kikaigumo shibori in process.

This white floral fabric is bound in various areas with *kumo* (spiderweb) shibori. A simple long hook with a sharp bent tip strung from a stand is used to help pluck and gather the shibori units. When the cloth is held under slight tension away from the hook, the tyer can use both hands to pleat the horn-shaped bit of cloth, and wind a thread around it from the bottom of the unit to the top and then back down to the bottom. Finishing the resist binding thread with a half-hitch knot twice around the bottom of the unit will ensure successful resist dyeing. The cloth is then immersed in a fiber-reactive dye vat, coloring the rayon without affecting the polyester ground. After dyeing, the fabric is rinsed well and opened to reveal shibori designs, which partially obscure some of the black-and-white floral patterns.

Rayon velvet dyed with fiber-reactive dye; the polyester and shaped-resist areas are not affected. By Hiroshi Murase.

Metallic tissue woven with 80% metal and 20% silk. 7.6 x 7.6 cm (3 x 3 in.)

Itajime shibori in process.

itajime shibori on silk and metal blend

Silk and metal blends capture shibori techniques beautifully. Due to the high twist of metal filament, immersing the fabric in water causes shrinkage, resulting in a rippled texture that contrasts with the resisted flat, sheer areas. Both ends of the scarf are pleated in accordion folds upward into small square units. The folded fabric is sandwiched between two small square boards, clamped firmly with a C-clamp, and immersed in a hot acid dyebath. The heated bath not only dyes the fabric but also sets the pleats. The whole thing should be rinsed well before the clamps are removed. The silk yarns in the cloth take acid dye or fiber-reactive dye. Working with a unique fabric with a tendency to curl and ripple, like this silk and metal material, adds subtle elegance to the otherwise bold and simple *itajime* shibori (folded-and-clamped resist).

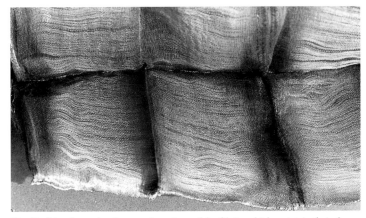

Detail of the clamped and reserved portions of the fabric, which maintain their sheer quality.

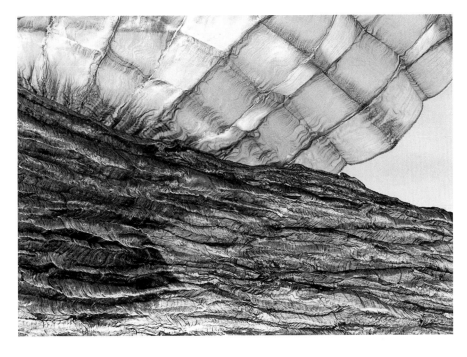

A scarf by Inge Dusi. The clamped areas are left undyed and flat. The contrast between the sheer geometric shibori pattern against the heavy rippled pleated body of the scarf is dramatic.

Metallic tissue woven with 80% metal and 20% silk. (Same fabric as on page 185.) 7.6 x 7.6 cm (3 x 3 in.).

marble shibori on silk and metal blend

The dimensions of the finished fabric will be considerably less than those of the original because of the high number and overall volume of the three-dimensional shaping around the marbles. So it is best to use this technique on a large piece of fabric or to create decorative motifs in small areas of a scarf or garment. Starting at one corner, each marble is encased in cloth and the cloth is bunched up around it and tied by winding string around the base with two half-hitch knots. After the entire design is tied with marbles, the piece is steamed to set the shape (see recipe 2, page 192). When completely dried, it is ready to be opened.

The metal filament in the material brings a cool sensation to the neck when the fabric is worn as a scarf. The iridescent bubbles spring back with life when pinched, reflecting light effectively. The three-dimensional effect can be maintained permanently if the piece is used as a sculptural object. Since the high metal content in the cloth makes it susceptible to wrinkling and to pressure, the bubbled texture will flatten with extended wear, opening itself to a new aesthetic.

Marbles being inserted and bound.

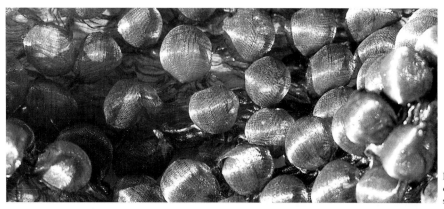

Detail of marble shibori just after heat-setting and the removal of marbles. The cloth perfectly retains the three-dimensional shape of the marbles. Designed by Matthew Dick.

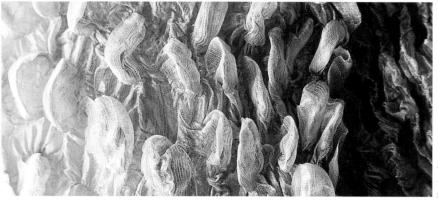

The marble shibori in silk and metal tissue after substantial wear. The bubbles have become much flatter, creating a softer appearance.

Silk woven with highly spun weft yarn in S and Z twists that will unwind back and make a rippled crepe surface that contrasts with intermittent bands of linen threads in the weft. Produced by Koshimitsu Textile Mill under the direction of Yoshiko I. Wada. 7.6 x 7.6 cm (3 x 3 in.)

arashi shibori on silk and linen

Artist Ana Lisa Hedstrom chose this special lightweight silk and linen material (GS5) from Koshimitsu Textile Mill in Gunma to create a kind of plaid—combining a linear *arashi* shibori motif and the weft linen stripes. On untreated fabric (a greige good), the white linen stripes float subtly on natural white silk. On a piece colored with acid dye, on the other hand, the linen stripes remain white and more pronounced against the dark silk ground (see recipe 10, page 194). Another interesting effect can be obtained by dyeing the cloth with a fiber-reactive dye that colors linen as well as silk but gives slightly different shades on cellulose and protein fibers.

Fabric is wrapped around a pole with the directional orientation of weft stripes in relationship to the *arashi* folds. When a long piece of fabric has stripes running along its length, the bands created during the compressing process will run perpendicular to the weft stripes. The fabric is temporarily anchored with masking tape or string, to make wrapping it on the pole easier. The weight and spacing of the winding thread will vary with the weight of the fabric and the intended design. A string is tied around the pole over the fabric and secured with a knot; it is then wound over the fabric-covered pole, and the pole rotated with one hand while the spacing and tension of the thread are carefully controlled. At 15- to 51-centimeter (6- to 20-in.) intervals (depending on the length of the fabric and the pole, as well as the fineness of the pattern), the wound cloth is compressed, while thread tension is maintained. To achieve consistent *arashi* motifs, compression must be even. Continue winding the thread and compressing, until complete. When fabric is compressed on the pole by being pushed straight, the resulting pattern is diagonal lines. Pushing the fabric while rotating in a twisting motion results in a pattern of diagonal, thin, leaflike broken lines. The string is secured with a knot. The whole pole is immersed in a light lye bath and cooked for degumming (see recipe 9, page 194). The fabric is then unwrapped and dyed in a cold water dye or indigo bath.

The opacity and softness of the degummed areas enhances the transparency of the stiff and sheer areas, which are reserved from the degumming. Broken blades of light purple linear pattern weave in and out of larger bands of dark purple silk. The movement of horizontal stripes adds depth and interest to the subtle ripples of the *arashi* design.

The fabric is wrapped diagonally on a pole and a thread wound over it. It is then pushed into small, tight folds on a pole before degumming.

Finished fabric by Ana Lisa Hedstrom showing the untreated and dyed areas in a darker color against the degummed and dyed areas, which are much lighter. The linen and silk areas take the same dye quite differently.

dye discharge

There is a wide range of fibers and many ways to dye them. Some colors dye certain fibers permanently while others are modifiable and can be discharged from the fiber. As an alternative to the conventional approach of adding colors and designs to white fabric, the textile industry has been patterning using methods to create patterns effectively by deducting colors from the fabric. There are two ways to remove color. The more widely known method, practiced in Europe since 1803, is through oxidation, using chemicals such as chlorine. The industry no longer uses chlorine, due to the environmentally hazardous byproducts of the oxidation process; chlorinated carbon does not decompose. Since 1900, a different method—discharge through reduction—has been used. Certain chemicals are introduced to interfere or react with electrons in the bonds of the dye molecules; chemical bonds are broken and, to varying degrees, dye is separated from the fiber. Thiourea dioxide (thiox), a reducing agent, is commonly used for discharges (see recipe 12, page 194) and is readily available from dye suppliers.

In the discharge process, one must begin with colored fabric. The most common combination of base fabric and dye is cellulose fiber with a widely available fiber-reactive dye such as Procion, or a more easily removable indanthrene dye such as Remazol. Another base fabric and dye combination is natural protein fibers including silk and wool with acid dye or fiber-reactive dye. The simplest way to understand the process is to remove the color from store-bought, already dyed fabric. However, this is not always predictable unless the dye being removed is susceptible to the discharging agent. Furthermore, color does not always discharge to white, but may instead turn orange, yellow, or gray. Experimentation and tests are therefore essential in planning one's work.

A whole different angle in discharging is to use a class of dyes called vat dyes to dye over an existing color (which must not be a vat dye). This, in effect, removes the preexisting color by replacing it. Vat dye is mixed with alkali, formosul (sodium formaldehyde sulfoxylate), glycerin, and water and is made into a paste with dextrin or gum. The dye paste is applied to the fabric and the fabric is then heated and washed thoroughly in cold water to oxidize the dye. Saturated heat (high steaming) activates the dyestuff and chemical agents required for binding to take place between the dye and the fiber. Vat dye is very stable and dyes cellulose fiber well. Another unexpected result can be obtained by discharging with vat dye on lightweight cellulose fabric such as cheesecloth. The steaming with alkaline paste on the fabric causes the fiber molecules to swell and the fabric to shrink, resulting in a shrunken and stretchy cellulose fabric (for more information on this effect, see pages 173-76).

Gunma silk (GS2) with linen weft stripes discharged from black by clamp resist. By Ana Lisa Hedstrom, prepared by Lindsay Robinson.

clamp on silk and linen stripes

The silk fabric (GS2) produced by Koshimitsu Textile Mill is woven alternately with highly spun yarn in S and Z twists on the weft and accented by fine linen weft stripes. The cloth is dyed in black, creped, and degummed.

Clamp resist is a derivation of Japanese *itajime* shibori, in which a set of boards sandwich a bundle of folded cloth and clamp it tightly to create resistance to dye penetration. The pattern is created by dyeing the peaks of the folds that are exposed. In this modern, Western variation, the cloth is accordion-folded and metal/plastic paper clips are used to clamp portions of cloth along the peaks of folds. The cloth is then immersed in a discharging solution of soda ash and heated until the desired lighter shade is obtained. With soda ash the black silk turns a light bluish gray, whereas thiourea dioxide (thiox) often yields a warmer tan color. The fine linen stripes discharge faster and become almost white over the gray silk ground, leaving the resisted black pattern floating against the speckled background.

Folded-and-clamped resisted piece. The use of this type of paper clip for clamp resist has been extensively explored by Inge Dusi.

The black fabric has been discharged, rinsed well, and opened. The photo shows the original black portion that was reserved with clamps. The ground was affected by a discharging agent, thiourea dioxide, which created varying shades of white to dark gray. By Ana Lisa Hedstrom and prepared by Lindsay Robinson.

Commercially dyed black silk fabric. 7.6 x 7.6 cm (3 x 3 in.).

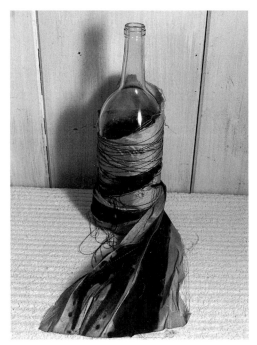

Arashi shibori wrapped on a wine bottle and discharged.

arashi shibori on black silk

Traditional *arashi* shibori (diagonal pole-wrap resist) is one form of *bomaki* (pole-wrap) shibori, and is covered on page 187. Inspired by the classical pole-wrap resist process, California artist Judith Content ingeniously makes the *arashi* shibori process her own by utilizing readily available wine bottles on which to wrap fabric to create the resist pattern. Rather than being limited by the size of the bottle, the artist uses the small quantity of fabric from each dyeing to her advantage.

A piece of commercially dyed black silk cloth is pleated to reduce the surface area and wrapped around the bottle, which is much easier to handle than the huge wooden poles used in Japan. A thread is tightly wound over, leaving a fine resist mark on the cloth when discharged. A discharging solution of thiourea dioxide is poured over until the desired lightened shade is obtained (see recipe 12, page 194). Depending on the dye used to color a piece of black silk, the discharged color will vary, from near ecru to bright orange or brown. After a sufficient amount of black color is removed, additional hues can be dyed over it. Black rayon, cotton, and linen all work quite well for this process; however it is important to keep in mind that the results are not predictable, and it is best to run a test before undertaking a project. There are many options in the choice of discharging agent as well as in the choice of black fabric. Material can also easily be dyed black to an artist's specifications.

The fabric is rinsed well and dried, then opened to reveal the resulting pattern.

Detail of a finished quilt with dye discharge on black silk. By Judith Content.

Dobby-weave black cotton fabric designed and woven by Emily DuBois with complex patterns. 7.6 x 7.6 cm (3 x 3 in.).

Detail of discharged cotton fabric with stitch resist.

woven colors and structure

The black material was woven on a computer-aided Dobby loom by Emily DuBois with specific treatment processes in mind to alter the images. Various kinds of black cotton yarn were tested for their ability to discharge dye and were used as the warp for weaving according to particular patterns, to be enhanced later by other black yarns similarly chosen for the weft. Some black yarns were completely discharged to white and some were not affected at all. This black pattern-weave cloth was then resisted using shibori techniques; some were folded and clamped, while others were stitched and tied. After discharging, the complex fine weave patterns were revealed and positioned to interact with larger, bolder design elements in the overall composition. Blending of different fibers such as black cotton and black polyester can yield a similar result.

The weave pattern itself can accommodate a structure for physical resist. For example, the pattern of weaving that creates floating threads (floats) in the fabric can be used to simulate *nui* shibori. Pulling the floats to gather the woven ground and then resist-dyeing the cloth has been explored extensively by Catharine Ellis Muerdter. This type of weaving resist was actually invented in Arimatsu in 1912, when an artisan wove a cloth with a waxed warp thread in a stripe pattern, and pulled the thread to gather up the whole length of cloth to resist dye. This resulted in dark and light vertical broken lines, along with the holes left by the removal of the warp thread after dyeing. The process and pattern were both called *taiten* shibori, or coronation shibori, to mark the enthronement of Emperor Taisho. Weaving the base material to be resisted presents endless possibilities for expanding one's visual vocabulary.

Overview of a discharged pattern using clamp resist. By Emily DuBois.

dyes and tips

Only select recipes are given here, as instructions are sometimes specific to a particular manufacturer's dye, and in many cases can easily be obtained from suppliers' Web sites.

Before you begin: For dyeing, basic equipment is required such as Pyrex containers, measuring cups and spoons, a gram scale, an enamel or stainless-steel pot, stirring rods or wooden sticks, a stove, a respirator, and good ventilation.

1. Heat-setting polyester (for examples and further explanation, see pages 146–50)

The thermoplastic quality of polyester can be used to texture the fabric or to create three-dimensional effects. Ideally, polyester fabric should be heated to around 200°–220°C (392°–428°F) and held in its shape for twenty to thirty minutes to set the three-dimensional texture in the fabric. In a home studio, a large pressure cooker (the size often used for canning) is ideal to achieve the requisite high temperature (a steamer for cooking can be substituted but will not produce temperatures as high as a pressure cooker). After fabric has been manipulated and bound, it is folded into a manageable size, wrapped in newsprint paper, and tied with a string to make a packet. The packet should fit comfortably in the pot and be set on a rack so that the bottom remains dry. Follow the pressure cooker instructions and cautionary advice carefully. Cook for thirty minutes or so, depending on the thickness of the material. Allow the pot to cool to room temperature before opening the lid.

Recommended care for polyester shibori fabric set by heat: Do not iron. Hand-wash in cold water and block dry.

2. Heat-setting silk (for examples and further explanation, see page 152)

Heat-setting of silk shibori is achieved by boiling or steaming. The temperature should not exceed 140°C (284°F). Dyeing in hot dye liquid or steaming followed by drying the shaped form also contribute to the setting of texture, but the effects are not as permanent as with polyester. Heat-set silk shibori articles should be kept away from steam or high temperature. Dry cleaning is advised to retain the texture.

3. Heat-transfer with disperse dye (for examples and further explanation, see pages 154–59)

Disperse dye is available from many textile and dye suppliers (see Resources, page 195). They provide recipes for mixing the dyestuff with water and adding thickener to make a paintlike dye that can be applied to a sheet of paper with a sponge brush or roller. A sheet of thin strong paper, like that used to cover a doctor's examination table, works well for making the disperse dye paper, usually by painting it a solid color. In my workshops I begin by having students prepare dye paper in the three primary colors as a starting point for experimentation. Some artists prefer heavier stock paper, which is easier to use for painting multicolored patterns and images. In the textile industry, a huge roll of paper is printed with disperse dye and then used to print a bolt of polyester fabric through a heat-transfer machine. Some stationery stores carry gift bags made of recycled paper from industrial dye-transfer, which can be used again to transfer onto polyester. The dried dye papers can be stored for later use, and can also be cut out and arranged to create new designs. Lay them face down on the polyester fabric. In a home studio, ironing at a high setting (without steam) heats the paper to the point that the dye sublimates and binds with the fiber. An old-fashioned iron with no steaming holes heats more evenly, and a dry mount press or mangle works even better, since the dye-transfer paper and the fabric surface can be airtight. Remember that any time the printed fabric is heated, the dye sublimates; therefore the fabric must never be ironed.

Caution: Wear rubber gloves, an apron or old clothes, and never use utensils that have been used for dyeing in food preparation.

4. Disperse dye for immersion vat (for an example and further explanation, see page 151)

Polyester can only be dyed with disperse dye, which became prevalent around 1953 with polyester's initial rise in popularity. Penetration into the fiber is achieved during dyeing either by high temperature under pressure or by atmospheric pressure with a carrier. (Carriers are chemicals that help the dye penetrate the fiber at lower temperatures. Most are considered hazards to both health and environment.) Disperse dyes for immersion dyeing in home

studios are available through suppliers but only in pastel colors. Proper ventilation and a respirator are mandatory.

Caution: Observe all cautions mentioned throughout this section.

5. Melt-off (for examples and further explanation, see pages 160–63)

Melt-off is akin to dévorée in that metal is dissolved or "melted-off" selectively from metallic fabric or lamé. The most effective result is achieved with the film-slit yarn type because of its greater transparency when the metal is dissolved. Some metallic yarns are double-ply and will not be affected by alkaline solutions. The following recipe for melt-off is from Jun'ichi Arai:

- Make a mild alkaline solution of 30 to 50 grams (1 to 1¾ oz.) of soda ash to 1000 cubic centimeters (1 qt. + 2 fl. oz.) of water to achieve a pH of 11.
- Heat solution to 30°C (86°F).
- Place resisted fabric in the solution and boil for about fifteen minutes for lightweight fabrics and longer for heavier fabrics or tighter weaves.
- Watch the melt-off progression and stop when the metallic color disappears.
- Rinse with water, neutralize with a vinegar solution, and rinse well with water.

Caution: Mild but hot lye solution will burn natural protein substances such as skin and eyes. Protective glasses, rubber gloves, shoes, and aprons must be worn.

6. Fulling (for examples and further explanation, see pages 164–67)

Fulling is achieved through a process similar to felting. A loosely woven or knitted fabric is agitated through washing, causing shrinkage from the matting of fibers, as in felting. In shibori fulling, a resisted fabric is washed in a washing machine, in cold water with no soap. The amount of fulling depends on the kind of yarn, the weave and weight of the fabric, and the type of shibori process used, as well as the performance and length of washing cycle of a particular machine. Testing is essential to determine the ideal combination of those elements. A loosely woven or knitted garment that is sewn or constructed two or three times the size of the finished garment can be shaped sculpturally by selectively shrinking specific areas to enhance body shape.

7. Dévorée (for examples and further explanation, see pages 168–72)

The form of dévorée most commonly practiced in the U.S. uses mixed-fiber cloth of rayon and silk with an acid salt devorant. The chemical decomposes at high temperatures to release minute amounts of sulfuric acid that then react with the cellulose (rayon), burning it out, but that leave the silk intact.

Mixed-fiber cloth, such as a blend of wool with a synthetic like acrylic or polyester, or two layers of opposing materials stitched or woven together (see page 171), is essential for the process of dévorée. After the desired shaped-resist process is applied, lye paste is brushed onto the surface of the fabric. After several hours the fabric is washed carefully and rinsed with vinegar to neutralize the alkali. Ready-made mixed chemicals are available from suppliers and come with instructions. The recipe for lye paste below is used by Ana-Lisa Hedstrom:

- Make thickener by mixing 100 grams (3.2 oz.) guar gum or gum arabic with 900 milliliters (30.6 fl. oz.) water.
- Make lye paste by mixing 700 grams (1 lb. + 6.4 oz) thickener (above) with 300 grams (9.6 oz.) solid sodium hydroxide crystals (lye, caustic soda).
- Make acid neutralizer by mixing 8 liters (2 gal.) water with 50 cubic centimeters (1.7 fl. oz.) acetic acid (CH^3COOH).

Caution: The lye will make heat and fumes while dissolving. Extreme caution must be used.

A strongly alkaline solution (one part alkali to three parts water) usually works in two minutes on lightweight fabric and up to eight minutes with heavier and tighter cloth.

Japanese dyers use a much milder alkaline solution combined with heat, cooking it for one hour. This is safer in terms of avoiding burns from alkali, but it takes much longer to get the same result.

- Make thickener by mixing 100 grams (3.2 oz.) guar gum or gum arabic with 900 milliliters (30.6 fl. oz.) water.
- Make lye paste by mixing 1000 grams (2 lb., 3 oz.) thickener (above) with 50 grams (1.75 oz.) of sodium hydroxide.
- Make acid neutralizer by mixing 8 liters (2 gal.) water with 50 cubic centimeters (1.7 fl. oz.) acetic acid (CH^3COOH).
- Brush lye paste mixture onto the surface of the shibori-resisted fabric.
- Let fabric dry completely, then wrap in newsprint, and tie with string to make a packet.
- Suspend packet over a steamer (tying it to sticks to keep it from getting wet) and steam for one hour.
- Remove cloth from the packet and soak in the acid-neutralizing solution for a few minutes.
- Rinse well in cold water.

Caution: When working with either of these dévorée methods, good ventilation is essential and using a respirator is a good idea. As a safety measure, set a plastic or stainless container in an ice water "bath" while adding lye to water. Wear goggles, gloves, and a respirator while making and using the paste. Lye can cause severe burns and is especially dangerous if it comes in contact with the eyes. Use this recipe at your own risk. When disposing of the lye solution, check the pH with a piece of litmus paper, and neutralize it with an acetic acid solution.

8. Cloque (lye shrink; for examples and further explanation, see pages 173–76)

Cellulose fiber shrinks with exposure to alkali; therefore the surface of lightweight open-weave cellulose fabric selectively exposed to lye will shrink and pucker, becoming transparent and opaque. Experimentation is essential to find the right combination of fabric and treatment procedure.

- Soak resisted fabric in 3% sodium hydroxide (30 g lye to 1000 cc water) for fifteen minutes.
- Rinse well with water, neutralize with acid solution, and rinse well again with water.

Caution: Observe precautions elaborated under the dévorée section above.

9. Degumming silk (for examples and further explanation, see pages 177–81)

Commercial silk organza is the only readily available and less costly alternative to the Gunma silks mentioned on pages 178–80, in terms of a fabric of untreated silk with sericin left in the fiber. A heavier silk organza called gazar, available from Exotic Thai Silk, contains sericin and yields interesting effects (see Resources, page 195).

The degumming, or scouring, process removes sericin (the outer layer of protein on the silk filament) from the silk fiber. The results of scouring will vary according to the yarn, weave, and weight of the fabric, as well as the type of shibori process. Try this recipe with your particular fabric and shibori process to discover what produces your desired results.

- Weigh the fabric you are scouring.
- Measure soda ash equivalent to 8 to 10% of the fabric weight (for example, if fabric weighs 50 grams [1.75 oz.], use 5 grams soda ash).
- Measure water in cubic centimeters, using 40 times the weight of fabric (for example, if fabric weighs 50 grams [1.75 oz.], use 2,000 cubic centimeters [1 gal., 4 fl. oz.] water).
- Mix soda ash in water. The resulting solution should have a pH of about 10.
- Bring to boil and simmer the silk in the solution for about thirty minutes. (For softer silk, boil longer. If this does not produce the desired softness, use more soda ash.)
- Rinse fabric well and neutralize with a light vinegar solution (14.7 cubic centimeters [0.5 fl. oz.] vinegar to 6 liters [6 qt., 11 fl. oz.] water), and rinse again.
- Dry flat.

Caution: Observe the precautions noted above in the dévorée section.

10. Acid dye for silk, nylon, wool, angora, and mohair (for examples and further explanation, see pages 152, 162–63, 169–70, 172, 177–78, 180–81, 185, 190)

Acid dyestuff for immersion dyeing, such as Nyloamine dye, is widely available through suppliers, and comes with recipes and instructions (see Resources, page 195). It is normally applied at a boil and heated only up to 85°C (186°F) for silk. Testing is recommended before undertaking a large project. The suppliers' recipes give quantities in both grams and measuring spoons.

Caution: It is important to observe all the precautions noted throughout this section.

Acid dye does not color non-protein fibers such as cellulose and synthetics. As a result, dyeing mixed-fiber fabrics can offer wide possibilities for achieving a more complex design with a single dyebath.

11. Fiber-reactive dye for cotton, linen, rayon, and silk (for examples and further explanation, see pages 169, 182–84, 187)

Fiber-reactive dyes such as Procion MX for immersion dyeing are widely available through suppliers, and come with recipes and instructions (see Resources, page 195). The equipment needed for dyeing is mentioned above.

Caution: It is important to observe all the precautions noted throughout this section.

Fiber-reactive dye does not color synthetics totally and only affects wool slightly. Dyeing mixed-fiber fabric such as a linen and silk blend with MX dye results in two slightly different colors achieved in one bath.

12. Dye discharging (for examples and further explanation, see pages 188–91)

There are a few other chemicals that strip or remove color, which are available through suppliers (see Resources, page 195). Bleach, for example, is readily available but is not good for the environment or for fabrics.

Thiourea dioxide is sodium hydrosulfite, one of a family of reductive discharge reagents that are used to remove color from cellulose fiber. Boiling black-dyed silk in soda ash solution sometimes removes the color to blue-gray (see degumming recipe, this page). Depending on the dye that was used to color the fabric, some colors will not strip totally. The shades of discharged color from an original black fabric can range from orange, brown, beige, or cream to white. Black organza dyed in acid color can be discharged into blue-gray with soda ash and thirty minutes of heating, using the same recipe for degumming. Once the wash has reached the desired color, usually in fifteen to twenty minutes, remove the cloth and rinse well.

A family of dyes called vat dyes, which uses strong lye, can be used as a discharging agent over colors dyed with fiber-reactive dye. This makes it possible to obtain rich colors side by side, or to simultaneously degum and dye untreated silk.

For further information, please refer to Karren Brito's article, "Honorable Discharge: Decolorization of Natural Fabrics."

RESOURCES

suppliers of dyes, chemicals, fabrics, and tools

UNITED STATES

Aurora Silk
5806 N. Vancouver Ave.
Portland, OR 97217 US
T: +1 (503) 286-4149
F: +1 (503) 286-6247
E-MAIL: cheryl@aurorasilk.com
www.aurorasilk.com

Bryant Laboratory, Inc.
1101 Fifth St.
Berkeley, CA 94710 US
T: +1 (510) 526-3141 OR +1 (800) 367-3141
F: +1 (510) 528-2948
E-MAIL: bry_lab@sirius.com
www.sirius.com/~bry_lab/index.htm

Clotilde Sewing Notions
B3000, Louisiana, MO 63353-3000 US
CUSTOMER SERVICE:
T: +1 (800) 545-4002
www.clotilde.com

Dharma Trading Co.
MAILING ADDRESS: PO Box 150916
San Rafael, CA 94915 US
T: +1 (415) 456-7657 OR +1 (800) 542-5227
F: +1 (415) 456-8747
STREET ADDRESS: 654 Irwin St., San Rafael, CA
 94901
STORE ADDRESS: 1604 Fourth St., San Rafael, CA
 94901
E-MAIL: service@dharmatrading.com
www.dharmatrading.com

Earth Guild
33 Haywood St.
Asheville, NC 28801 US
T: +1 (828) 255-7818 OR +1 (800) 327-8448
F: +1 (828) 255-8593
E-MAIL: inform@earthguild.com OR
catalog@earthguild.com
www.earthguild.com

Gunma Silk
Koshimitsu Textile Mill, Gunma, Japan
U.S. CONTACT:
Yoshiko I. Wada

696 Hilldale Ave.
Berkeley, CA 94708 US
E-MAIL: yiwada@pacbell.net OR shibori8@pacbell.net

Kasuri Dyeworks
1959 Shattuck Ave.
Berkeley, CA 94704 US
T: +1 (888) 841-6997
F: +1 (510) 841-4511
E-MAIL: mailorder@kasuridyeworks.com
www.kasuridyeworks.com

Pro-Chemical
PO Box 14
Somerset, MA 02726 US
T: +1 (508) 676-3838 OR (ORDERS ONLY)
 +1 (800) 228-9393
F: +1 (508) 676-3980
E-MAIL: pro-chemical@worldnet.att.net
www.prochemical.com

Test Fabrics, Inc.
PO Box 26
West Pittston, PA 18643 US
T: +1 (570) 603-0432
F: +1 (570) 603-0433
E-MAIL: testfabric@aol.com
www.testfabrics.com

Thai Silks
252 State St.
Los Altos, CA 94022 US
T: +1 (650) 948-8611 OR +1 (800) 722-7455
F: +1 (650) 948-3426
E-MAIL: info@thaisilks.com
www.thaisilks.com

JAPAN

Seiwa Dye Supplies
1-1-1 Shimo-ochiai, Shinjuku-ku
Tokyo 161-8552 Japan
T: +81 3-3364-2112
F: +81 3-3364-2115

Tanaka Nao Dye Supplies
Nishi-iru, Karasuma
Matsubara-dori, Shimogyo-ku
Kyoto 600-8427 Japan
T: +81 75-351-0667
F: +81 75-221-0276
Takara Building 3F, 1-26-30 Higashi

Shibuya-ku, Tokyo 150-0011 Japan
T: +81 3-3400-4894
F: +81 3-3400-4969
www.tanaka-nao.co.jp

ENGLAND

George Weil/Fibrecraft
Old Portsmouth Road
Peasmarsh, Guilford
Surrey GU3 1LZ England
T: +44 1483-565800
F: +44 1483-565807

Kemtex Educational Supplies
Chorley Business and Technology Centre
Euxton Lane, Chorley
Lancashire PR7 6TE England
T: +44 1257-230220
F: +44 1257-230225
www.kemtex.co.uk

Princess Pleaters
Checkley Fields
Hereford HR1 4ND England
T: +44 1432-851040
F: +44 1432-851180
E-MAIL: info@princess-pleaters.co.uk
www.princess-pleaters.co.uk

R A Smart Screen Supplies, Ltd.
Clough Bank, Grimshaw Lane
Bollington, Macclesfield
Cheshire SK10 5NZ England
T: +44 1625-576255

Wild Barfield, Ltd.
Delegation Road, Diglis
Worcester WR5 3BT England
T: +44 1905-352440
www.wildbarfield.co.uk

CANADA

Maiwa Handprints
#6-1666 Johnston St.
Granville Island
Vancouver, BC V6H 3S2 Canada
T: +1 (604) 669-3939
F: +1 (604) 669-0609
E-MAIL: maiwa@maiwa.com
www.maiwa.com

Batik Oetoro
203 Avoca St.
Randwick NSW Australia 2031
T: +61 2-9398-6201
F: +61 2-9398-1173
E-MAIL: orders@dyeman.com
www.dyeman.com

GERMANY
Galerie Smend
Mainzer Strasse 31
50678 Köln, Germany
T: +49 221-312047
F: +49 221-9320718
E-MAIL: smend@smend.de
www.smend.de

organizations and fiber publications

UNITED STATES
The Fabric Workshop and Museum
1315 Cherry St. 5F
Philadelphia, PA 19107 US
T: +1 (215) 568-1111
F: +1 (215) 568-8211
E-MAIL: info@fabricworkshopandmuseum.org
www.fabricworkshop.org

FiberArts Magazine
67 Broadway
Asheville, NC 28801 US
T: +1 (800) 284-3388
E-MAIL: customerservice@fiberartsmagazine.com
www.fiberartsmagazine.com

Friends of Fiber Arts International
PO Box 468
Western Springs, IL 60558 US
T/F: +1 (708) 246-9466

Handweavers Guild of America
3327 Duluth Highway, Suite 201
Duluth, CA 30096-3301 US
T: +1 (770) 495-7702
F: +1 (770) 495-7703
E-MAIL: weavespindye@compuserve.com
www.weavespindye.org
PUBLICATION: *Shuttle, Spindle & Dyepot*

Ornament Magazine
PO Box 2349
San Marcos, CA 92079 US
T: +1 (760) 599-0222
F: +1 (760) 599-0228

Quilt National
PO Box 747
Athens, OH 45701 US
T: +1 (740) 592-4981
F: +1 (740) 592-5090
E-MAIL: hilary@dairybarn.org
www.quiltnational.com

Surface Design Association
PO Box 360
Sebastopol, CA 95473-0360 US
T: +1 (707) 829-3110
F: +1 (707) 829-3285
E-MAIL: surfacedesign@mail.com
www.surfacedesign.org
PUBLICATION: *The Surface Design Journal*
ORGANIZER: Surface Design Conference

Textile Society of America
PO Box 70
Earleville, MD 21919-0070 US
T: +1 (410) 275-2329
F: +1 (410) 275-8936
E-MAIL: tsa@dol.net
http://textilesociety.org
FOR MEMBERS ONLY: Textile Society of America
 Newsletter

World Shibori Network
E-MAIL: shibori8@pacbell.net
www.shibori.org
ORGANIZER: International Shibori Symposium (ISS)

JAPAN
Senshoku to Seikatsu Sha
Nishi-iru, Karasuma
Matsubara-dori, Shimogyo-ku
Kyoto 600-8427 Japan
T: +81 75-343-0388
F: +81 75-343-0399
PUBLICATION: Senshoku Alpha
(Japanese-language textile art magazine)

CANADA
**Le Centre de Recherche et de Design en Impression
 Textile de Montréal
(Design & Impression Textile)**
4710, rue Saint-Ambroise, Atelier 326
Montréal, Québec H4C 2C7 Canada
T: +1 (514) 939-2150
F: +1 (514) 939-9906
E-MAIL: crditm@cam.org
www.designtextile.qc.ca

GERMANY
European Textile Network
ETN Secretariat
PO Box 5944
D-30059 Hannover, Germany
T: +49 511-817006
F: +49 511-813108
E-MAIL: ETN@ETN-net.org
www.etn-net.org
PUBLICATION: Co-editor of *Textile Forum* Magazine
 (see below)
FOR MEMBERS ONLY: ETN-NET Newsletter
ORGANIZER: European Textile Conference

Textile Forum Magazine
Textilwerkstatt-Verlag
PO Box 5944
D-30059 Hannover, Germany
F: +49 511-813108

E-MAIL: tfs@etn-net.org
www.etn-net.org

Transatlantic Textile Network (TTN)
Institut für Textiltechnik der RWTH-Aachen
Eilfschornsteinstrasse 18
D-52062 Aachen, Germany

schools with fiber programs

UNITED STATES
Anderson Ranch Arts Center
PO Box 5598
5263 Owl Creek Rd.
Snowmass Village, CO 81615 US
T: +1 (970) 923-3181
F: +1 (970) 923-3871
E-MAIL: info@andersonranch.org
www.andersonranch.org

Arrowmont School of Arts and Crafts
556 Parkway
Gatlinburg, TN 37738 US
T: +1 (865) 436-5860
F: +1 (865) 430-4101
E-MAIL: info@arrowmont.org
www.arrowmont.org

Cranbrook Academy of Art
39221 Woodward Ave.
Box 801
Bloomfield Hills, MI 48303-0801 US
T: +1 (248) 645-3300
F: +1 (248) 646-0046
E-MAIL: caainfo@cranbrook.edu
www.cranbrook.edu

Fashion Institute of Technology (FIT)
Seventh Ave. at 27 St.
New York, NY 10001-5992 US
GENERAL INFORMATION:
T: +1 (212) 217-7999
E-MAIL: fitinfo@fitsuny.edu
www.fitnyc.suny.edu

Haystack Mountain School of Crafts
PO Box 518
Deer Isle, ME 04627 US
T: +1 (207) 348-2306
F: +1 (207) 348-2307
E-MAIL: haystack@haystack-mtn.org
www.haystack-mtn.org

Kansas City Art Institute
Office of Admissions
4415 Warwick Blvd.
Kansas City, MO 64111-1874 US
T: +1 (816) 474-5224 OR +1 (800) 522-5224
F: +1 (816) 802-3309
E-MAIL: admiss@kcai.edu
www.kcai.edu

Mendocino Art Center
45200 Little Lake St.
PO Box 765

Mendocino, CA 95460 US
T: +1 (707) 937-5818
E-MAIL: mendoart@mcn.org
www.mendocinoartcenter.org

Oregon School of Arts and Crafts
8245 SW Barnes Rd.
Portland, OR 97225 US
T: +1 (503) 297-5544 OR +1 (800) 390-0632
www.ohwy.com/or/o/orschart.htm

Penland School of Crafts
PO Box 37
Penland, NC 28765 US
T: +1 (828) 765-2359
F: +1 (828) 765-7389
E-MAIL: office@penland.org
www.penland.org

Rhode Island School of Design
Two College St.
Providence, RI 02903 US
TEXTILE DESIGN DEPARTMENT:
T: +1 (401) 454-6136
F: +1 (401) 454-6101
www.risd.edu

The Sewing Workshop
2010 Balboa St.
San Francisco, CA 94121 US
T: +1 (415) 221-SEWS
E-MAIL: sewingworkshop@langan.net
www.sewingworkshop.com

JAPAN
Kyoto University of Art and Design
Uryuzan 2-116
Kitashirakawa, Sakyo-ku
Kyoto 606-8271 Japan
T: +81 75-791-9122
www.kyoto-art.ac.jp

Kyoto City University of Arts
13-6 Kutsukakecho
Oe, Nishikyo-ku
Kyoto 610-1197 Japan
T: +81 75-332-0701
www.kcua.ac.jp

Otsuka Textile Design Institute
Sugacho 10, Shinjuku-ku
Tokyo 160-8560 Japan
T: +81 3-3357-3671
F: +81 3-3226-9745
E-MAIL: info@otsukagakuin.ac.jp
www.otsukagakuin.ac.jp

Tama Art University
DEPARTMENT OF PRODUCT AND TEXTILE DESIGN
Hachioji Campus
2-1723 Yarimizu, Hachioji
Tokyo 192-0394 Japan
T: +81 426-76-8611
F: +81 426-76-2935
www.tamabi.ac.jp/wsc/english

ENGLAND
Goldsmiths College
University of London
New Cross, London SE14 6NW England
VISUAL ARTS DEPARTMENT:
T: +44 20-7919-7671
F: +44 20-7919-7673
E-MAIL: visual-arts@gold.ac.uk
www.goldsmiths.ac.uk

Royal College of Art
Kensington Gore
London SW7 2EU England
T: +44 20-7590-4444
F: +44 20-7590-4500
E-MAIL: info@rca.ac.uk
www.rca.ac.uk

The Surrey Institute of Art and Design,
 University College
Farnham Campus
Falkner Road, Farnham
Surrey GU9 7DS England
T: +44 1252-722441
www.surrart.ac.uk

Winchester School of Art
University of Southampton
Southampton SO17 1BF England
T: +44 1703-596718
F: +44 1703-593868
E-MAIL: artsrec@soton.ac.uk
www.wsa.soton.ac.uk

University of Leeds
SCHOOL OF TEXTILES AND DESIGN
Leeds LS2 9JT England
T: +44 113-2333-700
F: +44 113-2333-704
E-MAIL: texjem@leeds.ac.uk
www.leeds.ac.uk/textiles

AUSTRALIA
The Australian National University
Canberra School of Arts-Textiles
Canberra, ACT 0200 Australia
TEXTILES:
T: +61 2-6125-5833
E-MAIL: valerie.kirk@anu.edu.au
www.anu.edu.au

The Whitehouse Institute of Design
The Whitehouse School Pty Ltd.
Level 3, 53-55 Liverpool St.
Sydney NSW 2000 Australia
T: +61 2-9267-8799
F: +61 2-9267-6947
E-MAIL: enquiry@whitehouse-design.edu.au
www.whitehouse-design.edu.au

GERMANY
Reutlingen University of Applied Sciences
(Fachhachschule Reutlingen)
Alteburgstrasse 150
D-72762 Reutlingen, Germany
GENERAL INFORMATION:

T: +49 7121-271-0
F: +49 7121-271-224
www.fh-reutlingen.de/english

BELGIUM
Flanders Fashion Institute
Elermarkt, 13
2000 Antwerp, Belgium
T: +32 3 226 14 47
F: +32 3 232 63 96
E-MAIL: ffi@dma.be

DENMARK
Danmarks Designskole
Strandboulevarden 47
2100 Copenhagen, Denmark
T: +45 35 27 75 00
F: +45 35 27 76 00
E-MAIL: mail@dk-designskole.dk
www.dk-designskole.dk

FINLAND
Kehitysmaayhdistys INDIGO ry
Mariankatu 40
33200 Tampere, Finland
T: +358 3 213 2475
F: +352 3 212 6025
E-MAIL: kehitysmaayhdistys@indigo.pp.fi
www.indigo.pp.fi

INDIA
JD Institute of Fashion Technology
Hemu Arcade, Station Road
VileParle (West)
Mumbai 400 056 India
T: +91 22-898-2239
F: +91 22-898-2240
E-MAIL: jdinstitute@vsnl.com
www.jdinstitute.com

National Institute of Design
TEXTILE & APPAREL DESIGN DEPARTMENT
Paldi Ahmedabad
380 007 India
T: +91 79-663-9692 OR 660-5243
F: +91 79-662-1167
E-MAIL: info@nid.edu
www.nid.edu

National Institute of Fashion Technology (NIFT)
NIFT Campus, Hauz Khas
Near Gulmohar Park
New Delhi 110-016 India
F: +91 11-6851198

PAKISTAN
Indus Valley School of Art, Architecture and Design
3, Modern Co-operative Housing Society
Block 7&8, Sharah-e-Faisal
Karachi 75350 Pakistan

museums with important collections of historical or contemporary shibori

UNITED STATES

American Craft Museum
40 West 53 St.
New York, NY 10019 US
T: +1 (212) 956-3535
www.americancraftmuseum.org

The Art Institute of Chicago Museum
111 South Michigan Ave.
Chicago, IL 60603-6110 US
T: +1 (312) 433-3600
F: +1 (312) 433-0849
TEXTILES COLLECTION:
T: +1 (312) 433-3696
www.artic.edu

DeYoung Museum
Golden Gate Park
San Francisco, CA US
(UNDER CONSTRUCTION; SET TO REOPEN IN 2005)

Fashion Institute of Technology (FIT) Museum
Seventh Ave. at 27 St.
New York, NY 10001-5992 US
THE MUSEUM AT FIT:
T: +1 (212) 217-5970
TEXTILE/SURFACE DESIGN:
Building B, Room 521
T: +1 (212) 217-7670
E-MAIL: fitinfo@fitsuny.edu
www.fitnyc.suny.edu

The Field Museum
1400 S. Lake Shore Dr.
Chicago, IL 60605-2496 US
T: +1 (312) 922-9410
www.fieldmuseum.org

Museum of the American Quilters Society
215 Jefferson St.
Paducah, KY 42001 US
T: +1 (270) 442-8856
F: +1 (270) 442-5448
E-MAIL: info@quiltmuseum.org
www.quiltmuseum.org

Museum of Fine Arts, Boston
Avenue of the Arts
465 Huntington Ave.
Boston, MA 02115-5523 US
T: +1 (617) 267-9300
www.mfa.org

Museum of Modern Art (MoMA)
11 West 53 St.
New York, NY 10019 US
T: +1 (212) 708-9400
www.moma.org

Oakland Museum of California
1000 Oak St.
Oakland, CA 94607 US
T: +1 (510) 238-2200
ART DEPARTMENT (DECORATIVE ARTS AND CRAFTS):
T: +1 (510) 238-3005

F: +1 (510) 238-6925
HISTORY DEPARTMENT (COSTUME AND TEXTILES):
T: +1 (510) 238-3842
F: +1 (510) 238-6579
www.museumca.org

Renwick Gallery of American Crafts
Smithsonian American Art Museum
Washington, DC 20560-0510 US
T: +1 (202) 357-2700
F: +1 (202) 357-1729
E-MAIL: info@si.edu
www.si.edu

The Textile Museum
2320 S St., NW
Washington, DC 20008-4088 US
T: +1 (202) 667-0441
F: +1 (202) 483-0994
E-MAIL: info@textilemuseum.org
www.textilemuseum.org

Wustum Museum of Fine Arts
2519 Northwestern Ave.
Racine, WI 53404-2299 US
T: +1 (414) 636-9177
www.wustum.org

JAPAN

Shosoin Repository
TREASURES OF THE SHOSOIN ARE SHOWN
 ONCE A YEAR, IN AUTUMN, AT:
Nara National Museum
50 Noborioji-cho
Nara 630-8213 Japan
T: +81 742-22-7771
F: +81 742-26-7218
www.narahaku.go.jp

ENGLAND

Victoria and Albert Museum
Cromwell Rd., South Kensington
London SW7 2RL England
T: +44 870-442-0808 OR +44 20-7942-2000
E-MAIL: vanda@vam.ac.uk
www.vam.ac.uk

THE NETHERLANDS

Gemeentemuseum Den Haag
Stadhouderslaan 41
PO Box 72
2501 CB The Hague, the Netherlands
T: +31 70 338 11 11
F: +31 70 338 11 12
E-MAIL: post@gm.denhaag.nl
www.gemeentemuseum.nl

SWITZERLAND

Museum fur Volkerkunde
Augustinergasse 2
PO Box 1048
CH-4001 Basel, Switzerland

FRANCE

Musée de l'Impression sur Etoffes
(Museum of Printed Textiles of Mulhouse)
14, rue Jean-Jacques Henner-BP 1468-68072
Mulhouse cedex, France
T: +33 3 89 46 83 00
F: +33 3 89 46 83 10
E-MAIL: accueil@musee-impression.com
www.musee-impression.com

Musée des Tissus
34, rue de la Charité
F-69002 Lyon, France
T: +33 4 78 38 42 00
F: +33 4 72 40 25 12
E-MAIL: musees@lyon.cci.fr
www.lyon.cci.fr/musee-des-tissus

PERU

Museo Amano
Calle Retiro 160, Miraflores
Lima 18 Peru
T: +51 1-441-2909
F: +51 1-442-1007

Museo de Arqueologia y Antropologia e Historia del Peru
(National Museum of Anthropology, Archaeology and History)
Plaza Bolivar s/n
Lima 21 Peru
T: +51 1-463-5070
F: +51 1-463-2009

CHILE

Museo Chileno de Arte Precolombino
Bandera 361
Santiago, Chile
www.precolombino.cl

INDIA

Calico Museum of Textiles
Sarabhai Foundation
Shahibag 380004
Ahmedabad, India
T: +91 79-786-8172
F: +91 79-786-5759

ACKNOWLEDGMENTS

In the 1970s, the work of people like Jack Lenor Larsen and Alfred Buhler, as revealed in the book *The Dyer's Art*, sparked the imagination of artists who loved the patterns and magic of resist-dyeing. With Mary Kellogg Rice and Jane Barton as coauthors, I undertook an ambitious book project, *Shibori: The Inventive Art of Japanese Shaped-Resist Dyeing*, with support from the Japan Foundation. Since the publication, nearly thirty years have passed. Jack Lenor Larsen continues to challenge me to define and redefine the creative potential of textile. After nine printings of the first shibori book, once again, I have the privilege of working with Kodansha International in Tokyo and its dedicated editors, Elizabeth Floyd and Shigeyoshi Suzuki and designer, Kazuhiko Miki.

While teaching, curating exhibitions, organizing conferences, and witnessing the blossoming of the field of shibori as an important creative force, I conceived the idea for *Memory on Cloth: Shibori Now* and carried it within me for a long time. But to give birth to the book required tremendous labor. With its great potential it grew to a monstrous size, demanding patient and skilled midwifery by project editor Elizabeth Floyd and my personal developmental editor Diana Young. Their caring hearts and craft with words helped the book to take form, and their unwavering support encouraged me to materialize the vision and finally bring it to light.

A part of the research on American shibori and the tie-dye phenomenon was supported by the Renwick Fellowship of the Smithsonian Institution; my advisor was Milton Sonday at the Cooper-Hewitt National Design Museum. The pre-Columbian shibori research was supported by the Matsushita International Foundation. The Amano Museum and the National Museum of Archeology, Anthropology, and History in Peru, the Museum of Fine Arts in Boston, and Diane Mott of the M. H. de Young Memorial Museum in San Francisco gave me opportunity to study invaluable extant examples. The Indo-U.S. Subcommission on Education and Culture Fellowship made possible my firsthand study of Indian shibori.

Constant organization of massive communications along with a colossal amount of visual and written materials required careful attention and diligent work by Aimee Baldwin, Linda Lee Kerr, Akiko Hiraide, Carol Nakaso, Ryoko Kohbata, and my capable right hand, Nancy Salumbides. Versatile assistants Ryoko Kohbata and Lindsay Robinson worked with testing recipes, photographing, illustrating, and documenting modern techniques.

I cannot possibly mention all the friends with expertise who came forth to help. Joy Boutrup, Karren Brito, and Jun'ichi and Masanao Arai provided technical and scientific knowledge. Andres and Vanessa Moraga made certain that I kept up with the Andean textile field. Kozo Takeda has been my source of information on the Arimatsu shibori tradition since the first shibori book. Ana Lisa Hedstrom—a fellow "shibori-ite" for a quarter of a century—has been a great sounding board. Finally my partner, Hercules Morphopoulos, and my parents, Shusuke and Sonoko Tsuchiya, have supported my spirit and helped me to carry on my daily life, which has given me the equilibrium needed to complete the project. My family and friends have endured my preoccupations and single-mindedness.

None of this would have been possible without the huge number of artists and designers who held a piece of cloth and shaped and transformed it into art, who agreed to be part of this book. As a result of their generosity in sharing their creative lives and work, I am able to celebrate one of the most vibrant traditions in the surface design field, and to illustrate the vitality and importance of textile traditions. I am forever grateful.

ADDITIONAL PHOTO AND ILLUSTRATION CREDITS

photos

Arai, Masanao Plate 35

Barnwell, Tim Plate 113

Beytebiere, D'Arcie Plates 74–75

Bouwkamp, Jacinta Plate 73

Bunn, Christopher Plate 81

Cherington, Molly Plate 40

Chesser, Kyle Plate 125

Clayden, Roger Plates 64–65

Cooper, John F. Plate 76

DeAntonis, Angelina Plates 47 and 49

Departure Plate 106

Em, Joan Plate 68

Farinati, Lucia Plate 61

Fonville, Carley Plates 124 and 126

Friedman, John Plates 3 and 19; page 49

Graham, Willson Plate 122

Guelton, Marie-Hélène Plate 112

Hatakeyama, T. Plate 100

Hayakawa, Kaei Plate 101

Iwatsubo, Mie Plate 91

Kane, Mike Plate 78

Keenan, Elaine F. Plate 127; pages 149 (bottom right) and 159 (bottom right)

Kohbata, Ryoko Figures 3, 4, 5, 6, 7, 11, 13, 14, 15, 25; Plates 7, 28, 63; pages 34, 151 (bottom right), 152 (all), 154 (all), 156 (top left, center right, bottom left), 157 (bottom left, bottom right [both]), 158 (center right, bottom right), 159 (top right, left), 160, 161 (top left, bottom left), 162 (top left, bottom left), 163 (top left, right, bottom left), 164, 165 (top left, right, bottom left), 166 (top left, bottom left), 167 (top left, bottom left), 168–170 (all), 171 (top left [both], bottom left), 172–177 (all), 178 (top left, bottom right), 179–180 (all), 182 (all), 183 (top left, right, bottom left), 184 (top left, bottom left), 185 (top left, center right, bottom left), 186 (top left, bottom left [both]), 187–191 (all)

Matsuo, Shigeharu Plate 58

McFarland, Matthew Plate 128

McGee, Dan page 104 (all)

Miura, Kenji Figures 21–22

Morris, Joan Plate 43; front jacket

Newbury, Sam Plate 114

Northup, Brian Plate 85

Novoa, Patricia Plate 109

Okano, Yuh Plate 41

Paterson, David Plate 104

R. Kohbata/L. Robinson pages 148 (top left, bottom left), 149 (left, top right, center right), 150 (top left, bottom left [both]), 151 (top left, top right, center right), 181 (all)

Ross, Carolyn Plate 67

Rowe, Jeffrey Plate 123

Schmeisser, Jörg Plate 107

Shapiro, Barry Plate 108

Sighel, Michele Plate 59

Smith, Carter Plate 66

Soubeyran, Hélène Plates 129 and 131

Takahashi, Hideko Plate 36

Taymor, Julie Plate 42

Tourenne, Patrice Plate 130

Tsuchiya, Shusuke Plate 6

Tuttle, Don Plate 111

Van De Hatert, Joe Plate 79

Vargas, Guillermo Plate 77

Wada, Yoshiko Iwamoto Plates 5, 9, 102–103

Watten, Jane Plate 72

Williams, Shevaun Plate 80

Yano, Makato page 153 (bottom right)

illustrations

Kohbata, Ryoko Figures 2, 9, 16–17

Petersen, Jeff pages 148 (right [both]), 150 (right), 156 (top right), 157 (right), 161 (right), 162 (top right), 163 (top right), 165 (bottom right), 166 (bottom right), 167 (right), 171 (right), 178 (right), 183 (top right), 184 (right), 185 (top right), 186 (right)

NOTES

the meaning of shibori

1 Mildred Constantine and Laurel Reuter, *Whole Cloth*, 9.

1. the history of shibori

WORLD

1 Camelid fibers are spun from the hair of animals of the Camelidae family, including the Bactrian camel and the Llama genus of vicuna, alpaca, guanaco, and llama. These specialty fibers possess a high degree of fineness, "hand," or luster (*American Fabrics and Fashions Magazine Encyclopedia of Textiles*, 151-53).

2 Scaffold weaving is composed of a number of small woven modules (square, L- or U-shaped, stairstep-shaped, or sometimes long and rectangular), each of which is woven with a continuous warp and a continuous weft, so that all edges are finished. Since the finished patchwork textile is assembled from modules, it is classified as discontinuous warp and weft weaving.

3 Although a direct link to pre-Columbian traditions has not been firmly established, the latter area did come under the influence of highland Andean cultures, particularly during the Tiwanaku and Inka periods.

 Vanessa Moraga, a textile historian who has studied *amarra* ponchos from the pampas of Argentina, points out that there are also other surviving post-conquest traditions of resist-dyed textiles, such as the nineteenth-century ikats made by the Mapuche of southern Chile and Argentina and, more rarely, by the Aymara of the Bolivian altiplano. She suggests that while there are no known examples of pre–nineteenth century *amarra* textiles, further study of those regional textile traditions, focusing on the relationship between tie-dyeing cloth and tie-dyeing yarns before weaving, may eventually shed more light on the history of *amarra* and its pre-Columbian roots.

4 A majority of Japanese shibori terms refer to the particular process required to create a specific pattern. For clarification, equivalent English terms such as stitched-and-capped resist, clamp resist, or pole-wrap resist are included. Japanese terms are explained in greater detail in the glossary.

5 A group of artists and designers in the United States and India formed this study group. James Bassler, fiber artist and professor at the University of California at Los Angeles, presented their initial replication pieces and outlined the process at the third ISS in Santiago, Chile, 1999. Initial funding was provided by the Matsushita International Foundation.

6 For more information on pre-Hispanic textiles in Andean cultures, see Rebecca Stone-Miller, *To Weave for the Sun*.

7 My information on North African traditions is from Irmtraud Reswick, *Traditional Textiles of Tunisia*.

8 This information is from Noriko Sasaki, a textile researcher and dealer who has traveled in Morocco and Tunisia.

9 Raffia, or raphia, is a fiber made from the leaves of a palm tree, *Raphia ruffis* or *Raphia taedigera,* that grows extensively in the tropical forests of central and western Africa and on the island of Madagascar. The mature leaves can be as long as fifteen meters (about fifty feet), but only young and tender leaves are used for fiber.

10 *Adire* is a Nigerian (Yoruba) term for a variety of resist-dyed textiles, including tie-dyed and cassava resist-dyed textiles.

11 The information on shibori in Nigeria is from Joanne Buboltz Eicher, *Nigerian Handcrafted Textiles*, 60-63.

12 Documentation provided by Loan Oei, who located the information in Rita Bolland, "Tellem Textiles."

13 Ikat is another resist-dye technique in which skeins of yarn are tie-dyed with careful planning before weaving to create fluid soft-edged motifs that are in the cloth.

14 Veronica Murphy and Rosemary Crill, *Tie-dyed Textiles of India,* 125.

15 Ibid., 129.

16 Ibid., 171-2.

17 See Blair B. Kling, *The Blue Mutiny: The Indigo Disturbances in Bengal, 1859-1863.*

18 John Guy, *Woven Cargos,* 7.

19 Alfred Buhler, Eberhard Fischer, and Marie-Louise Nabhotz, *Indian Tie-Dyed Fabrics,* 18.

20 John Guy, *Woven Cargos,* 95.

21 Larsen and Buhler, *The Dyer's Art*, 34.

22 The province of Yunnan shares borders with Vietnam, Laos, Myanmar, and Tibet, and is inhabited by twenty-four major ethnic groups, the largest number of any province in China. Minority populations represent nearly one-third of the province's predominantly Hang Chinese population of 10,650,000. Three million people from those minority populations live in remote, less developed parts of Yunnan.

23 Veronica Murphy and Rosemary Crill, *Tie-dyed Textiles of India,* 161.

24 Kaneo Matsumoto, *Jodai-gire.*

JAPAN

25 Tetsuro Kitamura, *Shibori,* 3-4.

26 This interesting subject is covered in depth in Betsy Sterling Benjamin's *The World of Rozome.*

27 In 1996, 2,441 pieces of *hangi* (carved board) were found in a warehouse in Osaka and brought to the Kyoto Zokei Geijutsu Daigaku (Kyoto University of Art and Design) to be studied. Research on the pieces culminated in the exhibit "*Kyo beni itajime*: Collection of *Hangi* and Kimono" being held at the university museum in 1999; an exhibit catalog was also published.

28 This period, during which the emperor and court were under the influence

and control of the Fujiwara clan, a powerful aristocratic family, takes its name from the capital city, Heian, which was later renamed Kyo.

29 The Japanese calendar is organized around the successive eras of each emperor's rule.

30 Although Narumi is cited as the forty-first or forty-second station in many famous woodblock prints of the Edo period, it is in fact the fortieth.

31 1603-1867. Also known as the Edo period. The two-and-a-half centuries when Japan was ruled by shoguns of the Tokugawa clan.

32 Today the annual Shibori Festival, held in Arimatsu during the first weekend in June, is a testament to the central role that shibori continues to play in the town's economic life: one street after another is lined with stalls that overflow with clothing, cloth, towels, umbrellas, stuffed animals, and many other products, all dyed with shibori.

33 The *benibana* (safflower; *Carthamus tinctorius*) plant. The petals, which contain both yellow and red dyes, are plucked and dried for storage or fermented to make a concentrated dye. The yellow dye, which is commonly available, is first washed away, then red is extracted by steeping the petals in an alkaline solution such as the lye from tree ash (Monica Bethe, *When Art Became Fashion*, 151).

34 There are many plant sources for indigo in the world, but in Japan the type used has been *tade ai* (buckwheat family; *Polygonum tinctorium* Lour), which is said to have come from South China in the third or fourth century.

35 The western and northern coastal trades and folk textiles of these regions are described in the exhibit catalog, *Riches from Rags: Saki-ori and Other Recycling Traditions in Japanese Rural Clothing*, by Shinichiro Yoshida and Dai Williams.

CONTEMPORARY DEVELOPMENTS

36 Museum director Paul Smith wrote in the catalog: "Tie-dye, fold-dye, stitch-dye, all of these are ancient methods for decorating fabrics ... [T]he end result, vibrations of color and pattern, relate directly to the youth culture today—their music, their interest in the mystical, and their life style."

37 The book grew out of a series of courses I taught with Donna Larsen at the Fiberworks Center for the Textile Arts in Berkeley; Rice and Barton both took the first shibori workshop in 1975, as did Ana Lisa Hedstrom, now a leading surface-design artist.

38 Gallerie Smend in Cologne, Germany, has been a major exponent of surface design and wearable art, sponsoring workshops, exhibitions, and publications. Since 1990 the European Textile Network (ETN) and its magazine *Textilforum* have been assimilating and disseminating information and providing networking opportunities for textile artists.

39 "Lié Délié: Le Teinture à Reserves: Art Traditionnel et Contemporain" (To tie, to untie: Resist dyeing, a traditional and contemporary art) was sponsored by Le Départment de Drôme, la Conservation des Châteaux Départmentaux.

40 The SDA was founded in 1976 in Kansas City. Its magazine, *Surface Design Journal,* has been in circulation since 1977, and membership has risen over the years to 3,200.

41 When I taught an *arashi* workshop with Kaei Hayakawa, an artist from Arimatsu, at the SDA Conference in 1995, we used the industrial process of dévorée on wool/polyester and rayon/silk fabrics. Both the process and the material were familiar to Hayakawa from his work in Japan.

42 The 1992 ISS attracted around 800 participants, including nearly 150 from outside Japan—in fact from twenty different countries.

43 This metal was conceived as a labor-saving alternative to conventional tying with string. Although its potential has not yet been explored, it may have interesting applications in patterning as well.

44 Major international fashion collections are shown twice a year—once each for spring/summer and fall/winter.

45 For more on the *mingei* philosophy, see Soetsu Yanagi, *The Unknown Craftsman*.

46 Katano coauthored a limited-edition volume on his work, *Katano Motohiko sakuhinshu*, which was published in 1976 and reprinted in 1999.

47 More than thirty thousand people visited the three exhibitions and the crafts bazaar and attended workshops and lectures at the ISS in Ahmedabad. The opening address by Pupul Jayakar was the last major public appearance of this visionary leader of India's handloom and handicrafts movement, who was also a founder of the Indian National Trust for Art and Cultural Heritage (INTACH).

48 "Shibori Traditions" showed a historical Japanese shibori kimono collection and examples of important shibori pieces from other cultures for the first time in that country; "Miniature Shibori Art" showcased works that extend the boundaries of traditional shibori craft; and "Art-to-Wear" presented the fantastic creations of designers and artists from diverse parts of the world, including Australia, Canada, Europe, Asia, and the United States.

49 "Historical and Traditional Shibori of Africa, India, and Japan" included several rare indigo-dyed kimono shown for the first time. "Shibori Expression in Contemporary Art" included Hélène Soubeyran's alabaster-like slab of resin-impregnated shibori silks. "Wearable Art" featured avant-garde high fashion in polyester by Yoshiki Hishinuma and sophisticated clothing created collaboratively by Chilean designers and shibori artists.

50 The exhibit catalog, "Amarras: El Arte de Teñir en los Andes Prehispanicos" (*Amarras*: The art of dyeing in the pre-Hispanic Andes), published by MChAP, is still in print.

51 James Bassler, fiber artist and professor at the University of California at Los Angeles, reported at the ISS on the replication research group's work with scaffold weaving and shibori done with natural dyes on alpaca.

2. tactile memory: fabric art

1 The HGA's magazine, *Shuttle, Spindle & Dyepot*, is published quarterly, with an international readership of artists, educators, and curators, and a circulation of over 8,000 to members, guilds, schools, craft stores, and galleries.

2 Since 1972 "Convergence" conferences have been held biennially in many cities in North America. During Convergence 2000 in Cincinnati, the main conference events were attended by 3,800 people, 1,800 of whom also participated in over 200 workshops and seminars and 115 lectures.

3 Awa Cissé's resumé was translated from the French by Nathalie Waag.

4 *Taiten* shibori was invented by an Arimatsu artisan who wanted to commemorate the enthronement (*taiten*) of the Taisho emperor. Probably influenced by the industrialization taking place in Japan in the 1920s, which was incorporating new, faster approaches to shaping cloth, he wove a bolt of long narrow kimono cloth, intermittently placing waxed linen warp threads in a kind of vertical stripe. After the cloth is woven, the stronger linen threads are pulled, gathering the fabric tightly to resist the indigo dye and produce a small shirred and puckered pattern. After dyeing, the heavier threads are removed, leaving a series of tiny holes that simulate a leno weave.

3. art for the body: wearable art and fashion

1 Miyake Design Studio, *Issey Miyake and Miyake Design Studio 1970–1985*, p. 57.

2 Much of the information on Hishinuma was taken from Meij's exhibit catalog, "Yoshiki Hishinuma."

4. inner journey: fabric and beyond

1 Some of this information is taken from Hubbell, "Found in Translation."

2 Davis, "Images of Thread."

modern techniques

1 Sarah E. Braddock and Marie O'Mahony's *Techno Textiles* contains a good deal of information on the processes and materials described throughout "Modern Techniques."

2 A microfiber is constructed with yarn containing a count of one denier or less. (A denier is a unit of fineness of yarn, weighing one gram for every 9,000 meters. So 9,000 meters of a ten-denier yarn weighs ten grams. The smaller the denier, the finer the yarn.)

3 Regenerated yarn comes from a natural source, such as wood pulp, that is chemically treated to create a new fiber. The first such yarn to be developed was viscose rayon, which could be described as half-natural and half-synthetic. By contrast, pure synthetics are made from petrochemicals.

4 The filaments are produced by extruding the liquid chemical through a spinneret, which can allow for production of filaments of many different deniers.

HEAT-SET ON POLYESTER OR SILK

5 Much of the information from this point about polyester and its treatment techniques is taken from Boutrup, "Possibilities in Polyester."

6 An *obi* is a heavy sash or wide beltlike article worn around the waistline with a kimono. The *obi-age* is a sash to hide the small pillowlike *obi* knot holder.

HEAT-TRANSFER ON POLYESTER

7 Carriers are chemicals that help the fiber absorb the dye at lower temperatures. Most are toxic and thus unsuitable for general use.

CLOQUE

8 Patent law is different in Japan and the United States. In Japan a patent is awarded to the first person to apply for it, whereas in the United States a patent is given to the inventor of the object or process. Additionally, in Japan, there exist industry-wide "gentleman's agreements" that recognize that patents will tend to be awarded to those who fulfill certain conditions—for example, those who have been using an object or process openly for a long time before applying for a patent, or those who have made a deal with the person holding the patent.

BIBLIOGRAPHY

American Fabrics and Fashions Magazine Editorial Staff. *AF Encyclopedia of Textiles*. Englewood Cliffs, NJ: Prentice-Hall, 1960.

Balfour-Paul, Jenny. *Indigo*. London: British Museum Press, 1998; Chicago: Fitzroy Dearborn Publishers, 2000.

Benjamin, Betsy Sterling. *The World of Rozome: Wax-Resist Textiles of Japan*. Reprint. 2002. Tokyo: Kodansha International, 1996.

Bethe, Monica. *When Art Became Fashion*. Los Angeles: Los Angeles County Museum of Art, 1992.

Bolland, Rita. "Tellem Textiles: Archeological Finds from Burial Caves in Mali's Bandiagara Cliff." With contributions by Rogier M. A. Bedaux and Renee Boser-Sarivaxevanis. Bulletin of the Royal Tropical Institute, no. 324. Amsterdam: Rijksmuseum voor volkenkunde; Leiden: Institut des Sciences Humaines; Bamako, Mali: Musée National, 1991.

Boutrop, Joy. "Possibilities in Polyester." *Textile Forum* no. 4 (2000), 33–36.

Braddock, Sarah E., and Marie O'Mahoney. *Techno Textiles: Revolutionary Fabrics for Fashion and Design*. New York: Thames and Hudson, 1998.

Brito, Karren. "Honorable Discharge: Decolorization of Natural Fabrics." Surface Design Newsletter (Winter 2001).

Alfred Buhler, Eberhard Fischer, and Marie-Louise Nabhotz, *Indian Tie-Dyed Fabrics*. Ahmedabad, India: Calico Museum of Textiles, 1980.

Clark, Vicky A. "A Search for Light: Jan Myers-Newbury's Adaptation of Shibori." *Surface Design Journal* 22, no. 1 (Fall 1997): 20–24.

Clyne, Robert. "Impact of Textiles on Social Organization in Yoruba Society." Paper presented at the third International Shibori Symposium, Santiago, Chile, 1999.

Constantine, Mildred, and Laurel Reuter. *Whole Cloth*. New York: Monacelli Press, 1997.

Dale, Julie. *Art-to-Wear*. New York: Abbeville Press, 1986.

Davis, Virginia. "Images of Thread: Marie-Hélène Guelton." *Surface Design Journal* (Fall 2000): 24–28.

de Osma, Guillermo. *Mariano Fortuny: His Life and Work*. New York: Rizzoli International, 1980.

Eicher, Joanne Buboltz. *Nigerian Handcrafted Textiles*. Ile-Ife, Nigeria: University of Ife Press, 1976.

Fleischmann, Isa, and Brigitte Tietzel. Exhibit catalog: "Koromo/Stoffe: Zwischen Zwei Welten" (on work of Jurgen Lehl). Köln, Germany: Eine Ausstellung des Museums für Angewandte Kunst Köln, 1998.

Fondation Cartier pour l'art Contemporain. *Issey Miyake Making Things*. With contributions by Kazuko Sato, Raymond Meier, and Hervé Chandès. Zurich, Switzerland: Scalo, 1999.

Guy, John. *Woven Cargos: Indian Textiles in the East*. New York: Thames and Hudson, 1998.

Hiesinger, Kathryn B., and Felice Fischer. Exhibit catalog: "Japanese Design: A Survey Since 1950." Philadelphia: Philadelphia Museum of Art, 1994.

Holborn, Mark. *Issey Miyake*. Köln, Germany: Benedikt Taschen Verlag, 1995.

Hubbell, Leesa. "Found in Translation: An Artist Finds Her Voice Through Science" (on work of Joan Morris). *Surface Design Journal* 22, no. 1 (Fall 1997): 25–28.

Kling, Blair B. *The Blue Mutiny: The Indigo Disturbances in Bengal, 1859–1863*. Philadelphia: The University of Pennsylvania Press, 1966.

Koren, Leonard. *New Fashion Japan*. Tokyo: Kodansha International, 1984.

Larsen, Jack Lenor. *Jack Lenor Larsen: A Weaver's Memoir*. New York: Harry N. Abrams, Inc., 1998.

Larsen, Jack Lenor, and Alfred Buhler. *The Dyer's Art: Ikat, Batik, Plangi*. New York: Van Nos Reinhold, 1977.

Lehl, Jurgen. *Koromo: Jurgen Lehl's Fabrics Photographed by Yuriko Takagi*. Tokyo: Treville Co., Ltd., 1997.

Matsumoto, Kaneo. *Jodai-gire: Seventh- and Eighth-Century Textiles in Japan from the Shoso-in and Horyuji*. Kyoto: Shikosha Publishing, 1984.

Meij, Ietse. Exhibit catalog: "Yoshiki Hishinuma." The Hague, the Netherlands: Gemeentemuseum Den Haag, 1999.

Meij, Ietse, and Jurgen Lehl. Exhibit catalog: "Fashions by Jurgen Lehl." The Hague, the Netherlands: Gemeentemuseum Den Haag, 2000.

Mioni, Mascha. *Art to Wear I*. Wangen, Switzerland: Greina Verlag, 1996.

———. *Art to Wear II*. Wangen, Switzerland: Greina Verlag, 2001.

Muerdter, Catharine Ellis. "Woven Shibori." *Shuttle, Spindle & Dyepot* vol. XXXI, no. 1 (Winter 1999/2000), 32–35.

Murphy, Veronica, and Rosemary Crill. *Tie-dyed Textiles of India: Tradition and Trade*. New York: Rizzoli International, Inc.; London: The Victoria and Albert Museum, 1991.

Reswick, Irmtraud. *Traditional Textiles of Tunisia and Related North African Weaving*. Los Angeles: Craft and Folk Art Museum, 1985.

Seeman, Annette. Exhibit catalog: "Transitions" for exhibit (on work of Moira Doropoulos): "Unraveling Tradition." Craftwest and the Verga, Perth, Australia, 2000.

Smith, Paul. Exhibit catalog: "Fabric Vibrations: Tie- and Fold-dye Wall Hangings and Environments." New York: American Craft Museum, 1972.

Soubeyran, Hélène. "Africa's Living Art of Tie-Dyeing." Paper presented at the third International Shibori Symposium, Santiago, Chile, 1999.

Stevens, Rebecca A. T., and Yoshiko Iwamoto Wada, eds. *The Kimono Inspiration: Art and Art-to-Wear in America*. Washington, D.C.: The Textile Museum; San Francisco: Pomegranate Artbooks, 1996.

Stone-Miller, Rebecca. *To Weave for the Sun: Ancient Andean Textiles in the Museum of Fine Arts, Boston*. 1992. New York: Thames and Hudson, Inc., 1994.

Wada, Yoshiko. "New Twist on Shibori: How an Old Tradition Survives in the New World When Japanese Wooden Poles Are Replaced by American PVC Pipes." Paper presented at the biennial symposium of the Textile Society of America, Los Angeles, CA, 1994.

Wada, Yoshiko Iwamoto, Mary Kellogg Rice, and Jane Barton. *Shibori: The Inventive Art of Japanese Shaped-Resist Dyeing*. Reprint. 1999. Tokyo: Kodansha International, 1983.

World Shibori Network. "Shibori: The Art of Tying and Dyeing." Catalog of the third ISS. Santiago, Chile: Museo Nacional de Bellas Artes, 1999.

Yanagi, Soetsu. *The Unknown Craftsman: A Japanese Insight into Beauty*. Adapted by Bernard Leach. Revised ed. 1989. Tokyo: Kodansha International, 1972.

Yoshida, Shinichiro, and Dai Williams. *Riches from Rags: Saki-ori and Other Recycling Traditions in Japanese Rural Clothing.* San Francisco: Museum of Craft and Folk Art (formerly the San Francisco Craft and Folk Art Museum), 1994.

Hishinuma, Yoshiki, and Nobuyoshi Araki. *Yoshiki Hishinuma by Nobuyoshi Araki: 100 Flowers, 100 Butterflies.* Tokyo: Kodansha International, 2000.

IN SPANISH

"Amarras: El Arte de Teñir en los Andes Prehispanicos (Amarras: the art of dyeing in the pre-Hispanic Andes)." Exhibit catalog. Santiago, Chile: Museo Chileno de Arte Precolombino, 1999.

IN FRENCH

Guelton, Marie-Hélène. "Le shibori, son origine." In "Les Tissus que l'on Manipule: Pliages, Plissages, Plangi—Technique Artisanale de Coloration à Travers le Monde." Exhibit catalog. Mulhouse, France: ACL Edition and Musée de l'Impression sur Etoffes, 1987, 17-22.

IN DANISH

Wellejus, Grethe. *Shibori, Reservierungstechniken.* Denmark: Verlag Tommeliden, 1997.

IN JAPANESE

Katano, Motohiko, and Kaori Katano. *Katano Motohiko sakuhinshu: Shibori to ai.* Reprint. 1999. Osaka: Sodosha, 1976.

Kitamura, Tetsuro. *Shibori.* Tokyo: Unsundo, 1970.

Miyake Design Studio. *Issey Miyake and Miyake Design Studio 1970-1985.* Tokyo: Obunsha, 1985.

Tsurumoto, Shozo, ed. *Issey Miyake: Bodyworks.* Tokyo: Shogakukan, 1983.

Yamaguchi, Michie, Hiroshi Ishizuka, Seishi Namiki, and Yoichi Onagi. *Kyo beni itajime: Collection of Hangi and Kimono.* Kyoto: Kyoto Zokei Geijutsu Daigaku, 1999.

GLOSSARY

a l'aguille: Lit., "with a needle." Technique used to weave and resist-dye cotton and raffia in central and French West Africa.

a l'attache: Lit., "with ties." Technique used to weave and resist-dye cotton and raffia in central and French West Africa.

acid dye: Dye derived from sodium salt of organic acids and having a direct affinity to protein fibers such as silk and wool.

adire: Term used by the Yoruba of Nigeria to refer to a range of resist-dyed textiles and techniques, including shibori and cassava paste–resist.

adire eleko: Cassava paste–resist dyeing technique practiced widely in western Africa, particularly in Nigeria.

adire oniko: Term used by the Yoruba of Nigeria for a method of tying done on raffia. One type of *oniko* is *onikan*, in which peaks or puckers are formed by inserting such small objects as seeds, pebbles, or corks into each tied unit, and removing them when dyeing is complete.

ai (indigo): The indigo plant grown in Japan is *tade ai (Polygonum tinctorium)*, which was introduced from South China in the third or fourth century. It was grown throughout Japan and soon became the most readily available dyestuff. One factor in its popularity is that it works well with plant fibers as well as with silk. During the Edo period, Awa (Tokushima Prefecture) became known for production of indigo dyestuff, which requires natural decomposition of leaves. *See also* indigo

aigi (*kasane aigi*): Inner layer of a kimono set, of two or more pieces, worn traditionally in Japan; the practice of wearing *aigi*, however, virtually disappeared after World War II. *Aigi* was constructed to be nearly identical to the outer kimono, except that the coloring tended to be bolder and brighter, and to feature such sharply contrasting combinations as red and white. See also *beni itajime*

alabere: African tradition of stitch resist involving hand- or machine-sewing.

amagi shibori: Shibori originating from the small island of Amagi in Kyushu that was a center for shibori production in the seventeenth through early nineteenth centuries.

amarra: Derived from the Spanish word *amarrar*, "to tie," refers to pre-Columbian shibori. *Amarra* textiles are extraordinary textiles, constructed with esoteric and complex techniques and with camelid or cotton fibers.

appliqué: Method of creating patterns on a cloth surface by stitching on cut-out fabric shapes onto it.

arashi ("storm") shibori: Diagonal pole-wrap resist invented by Kanezo Suzuki in 1880 in Arimatsu. Many variations of this technique have been developed in recent decades by North American artists. See also *bomaki* shibori

art-to-wear: *See* wearable art

asa no ha ("hemp leaf"): Popular geometric hexagonal pattern deriving from the hemp leaf (*Cannabis sativa*) and symbolizing the strength of this common plant, whose bast fiber is often used to weave cloth.

bandana (bandanna, bandanno, and bandanne): Many variants have appeared as anglicized words; they are all derived from Indian *bandhani* or *bandhana* (shibori-dyed cloth).

bandhani (*bandhana*): Deriving from the Indian word *banda*, "to tie," this term refers to a group of shibori textiles decorated primarily by plucking cloth with fingernails into many tiny bindings that form a figurative design. *Bandhani* are the prototype from which Western bandanas were first copied. Similar to *kanoko* shibori.

bast: The fibrous mass lying beneath the outer covering and the inner core of certain plants, including hemp, ramie, and banana. Bast fibers are used around the world to make cloth, nets, bags, and cords.

batik: Derived from Javanese *ambatik*, "to mark with spots or dots," refers to the resist dye–process in which liquified wax, or sometimes paste, starch, resin, or clay, is applied to cloth so as to reserve the original colors. Also commonly used to refer to wax-resist dyeing in general.

bazin riche: Popular damask cotton linen imported from Germany by Lebanese traders in Mali, Africa. The cloth is decorated with shibori and made into gowns for men and women and into loincloths and headdresses.

beni itajime (red–board clamp): Traditional Japanese carved board–clamp-resist dyeing technique, in which several bolts of long narrow kimono cloth are folded and clamped with multiple boards and dyed with the safflower red that was often used to color under-kimono. *See also* fold-and-clamp resist, *itajime* shibori, *kyokechi*

benibana (safflower red): The petals of *benibana* safflower (*Carthamus tinctorius*) contain both yellow and red dyes. A huge amount of petals are necessary to produce fermented dye concentrate. The yellow dye, which is commonly available from other sources, is first washed away so that the red dye can be extracted by steeping petals in an alkaline solution (e.g., lye from tree ash). The resulting color is not permanent.

bomaki (pole-wound or pole-wrap) shibori: Process in which a pole is used as a core to protect one side of shaped cloth from the dye. An umbrella term for *arashi* shibori, *murakumo* shibori, and *shirokage* shibori.

boshi (capped) shibori: Process in which stitching is applied to delineate a pattern that is then capped with a protective covering, such as a bamboo leaf or a piece of plastic, to completely reserve the pattern from the dye.

boubou: Loose-fitting gown worn by men and women in West Africa.

bound-resist: Technique or pattern that involves plucking or gathering a piece of cloth and knotting or binding it to block the penetration of dye into certain areas.

burn-out: *See* dévorée

butterfly-flower ("baby-bee") stitch resist: Dyeing technique or pattern practiced in southwestern China among the Chinese minority people.

camelid: Fibers spun from the hair of the Camelidae family of animals, which includes the Bactrian camel and the Llama genus of vicuna, alpaca, guanaco, and llama.

capping: See *boshi* shibori

carrier: Chemical that helps fiber absorb dye at lower temperatures, which is essential for vat-dyeing polyester fabrics. Most carriers are toxic and thus unsuitable for general use.

carved board clamp–resist: See *kyokechi*, *beni itajime*

cassava paste–resist: See *adire*

chakubatsu: Method of discharging dye in which cotton or linen already dyed with fiber-reactive dye is then printed with vat-dye paste that contains lye. As a result, the reactive color is removed and the cellulose fiber shrinks.

chunari: Indian term for a woman's head-covering or large veil decorated with *bandhani*.

clamp resist: See *itajime* shibori, *kyokechi*

cloque (lye shrink, lye crimping): Patterning method used to create opaque and transparent or flat and crinkled surfaces using specific chemicals that shrink particular fibers, such as alkali for cellulose, and calcium nitrate for silk.

crisscross stitch resist: Method of stitching along the fold of a piece of cloth, practiced in southwestern China among the Chinese minority people.

degumming: Process of removing sericin (a kind of stiff protein), which is the natural, gummy outer coating of silk filaments, to reveal the inner protein, fibroin, which is glossy and soft.

dévorée (burn-out): Technique in which part of a mixed fabric is eaten away by chemicals (such as sulphuric acid) that are applied by printing or painting. The fabric must contain a large amount of two fibers that behave differently, such as cellulose (cotton or viscose) versus protein fibers (silk or wool) or synthetics (polyester or acrylic), and only one of the opposing fibers should be affected by the chemical. Can be used to produce delicate fabric with both semitransparent and opaque areas. Referred to in Japanese as *oparu kako*, or "opalization."

discharging (dye discharge): Process done to alter the color of fabric by removing, rather than adding, dye. Some dyes color certain fibers permanently, while others are modifiable and can be removed or reduced. The process involves introducing chemicals that interfere or react with electrons in the bonds of the dye molecules, breaking chemical bonds and, to varying degrees, separating dye from the fiber.

dyebath (dye vat): Solution of water, dye and assistants in which fabric is immersed for coloring.

felting (felt): (v.) Process in which raw woolen fibers, or fleece, are placed in the form of a sheet on a screen or a cloth that is then rolled, washed, and beaten. The agitated fleece begins to matte and to turn into the tighter structure known as "felt." (n.) One of the oldest nonwoven fabrics, made by applying water and friction to cause microscopic woolen fibers to interlock.

fiber-reactive dye: Dye that reacts chemically in an alkaline solution with cellulose fiber molecules to achieve a permanent bond, resulting in exceptional colorfastness.

filature: Act of spinning, drawing, or twisting into threads or reeling raw silk from cocoons. Also, establishment where silk reeling is performed to produce skeins of silk filament strands that are then twisted into yarns for weaving, sewing, and embroidery.

floats: Threads loose on the surface of a woven structure that are still an integral part of the fabric.

fold-and-clamp resist: Dyeing process in which cloth is folded in two or more directions into a neatly shaped bundle and then clamped between boards or sticks to block the penetration of dye into certain areas. This results in mostly geometric patterns, except in the case of carved board–clamp resist. See also *beni itajime, itajime* shibori, *kyokechi*

fulling: Process in which a loosely woven or knitted fabric is agitated through washing, causing shrinkage from matting of fibers. The original fabric is transformed to a denser, heavier woolen cloth. *See also* felting

furisode: Lit., "swinging-sleeve." A type of kimono with long sleeves, worn by young, unmarried women on formal or festive occasions.

greige good: Fabric as it comes off the loom, without any finishing treatment.

habutae: Fine, paper-thin silk.

hanawa shibori: Purple and red shibori made in the vicinity of the town of Hanawa in the northeastern part of Japan's main island of Honshu. This mountainous region was once a dyeing center using the plants, madder (*akane*) and purple root (*shikon*) that yield scarlet and purple hues respectively; in the past these plants were wild and abundant there.

hand: Tactile qualities of a fabric that can be perceived by touch—e.g., softness, firmness, elasticity, drape, fineness, and resilience.

heat-set: Maintaining texture in fabric by applying heat; the effect is permanent in the case of polyester and semipermanent in the case of silk.

hinode ("sunrise") shibori: Pattern composed of small repeated shapes suggesting rising suns; it is executed by stitching half-circles across the width of the cloth and then gathering the cloth and laying it over a rope core. The whole thing is then bound tightly so that only exposed portions of the fabric will be dyed.

hitta kanoko (all-over dots with squares in a grid) shibori: Tiny resisted squares with dots in the center; usually repeated very close together, with the lines of separation creating a dense grid. See also *kanoko* shibori

hon hitta kanoko ("true" all-over dots with squares in a grid) shibori: The clear square form of the tiny resisted areas and extremely small size of the center of the dots distinguish *hon hitta kanoko*. Was often used to decorate silk in the Muromachi, Momoyama, and Edo periods.

hosoito ichido kairyo (diagonal stripes): A basic *arashi* process, in which cloth is placed on a pole at a 45-degree angle and wrapped around counterclockwise. The pole is then rotated counterclockwise to wind the thread. The cloth is pushed straight down the length of the pole to compress it into folds, and then dyed. If the cloth is also twisted while being pushed down the pole, small leaflike motifs appear instead of straight diagonal lines.

ikat: Malay Indonesian term for the process of binding segments of yarn before cloth is woven; in other words, ikat differs from shibori in that ikat involves resist-dyeing of threads *before* they are made into fabric. Those parts of the yarn that are to remain undyed are covered with an impermeable resist material. The process includes various types, such as warp ikat, weft ikat, and double ikat, which differ in the placement of the resist design.

indican: Blue coloring substance found in more than fifty varieties of plants. The term derives from the Greek *indikon*, meaning "a substance from India." *See also* indigo

indigo: One of the oldest, most widely used dyestuffs in the world. Indigo is found in the leaves of many different types of plants, including the woad that is native to Europe and contains indican. Indigo dye is insoluble in water, but through the reduction process the dye becomes soluble in alkali. After fiber absorbs the dye liquid, oxygen must be introduced to the fiber by airing, to change indican back to a stable form, which is blue. It is during a repeated process of immersion and oxidation that the fiber turns dark blue. See also *ai*, indican

itajime (clamp-resist) shibori: Process in which flat pieces of wood (or other materials) cut to an appropriate size and shape are used to sandwich folded and bundled cloth, and traditionally a binding cord is used to compress the bundle of cloth securely between the boards during dyeing. See also *beni itajime*, fold-and-clamp resist, *kyokechi*

juban: Under-kimono, often decorated in a specific style and technique. *Beni itajime* is often used for *juban* and for *aigi*. See also *aigi*

jumputan: Malay term referring to tie-dyeing fabric for shibori or tie-dying yarns for ikat weaving that is more accurate than the plangi that is widely used in the West (and which originated from the Malay term *pelangi*).

kanoko (fawn-dot) shibori: Fabric plucked with the fingernails and bound with fine gummed silk floss, producing a pattern that resembles fawn dots or bound squares. See also *hitta kanoko* shibori, *hon hitta kanoko* shibori

katano shibori: Process that produces a repeating pattern across the width of the cloth in variegated blues, white lines, and areas that look softly airbrushed.

Sometimes referred to as *ori nuishime* shibori (easily confused with *orinui* shibori). Nagoya shibori artist Motohiko Katano extensively explored this technique, which is named for him.

katazome (stencil dyeing): Method of patterning fabric by applying rice paste through a specially treated paper stencil and dyeing the cloth after the paste dries.

kembangan: Indonesian textile form usually featuring a single large central rectangular shape delineated by stitching; capping is then used to dye the center area and surrounding border different colors.

kesa: A Buddhist monk's shawl or stole, traditionally constructed by piecing small pieces of cloth and worn over a robe.

kikaigumo ("tool-aided spiderweb") shibori: Bound-resist process that produces a spiky, sculptural textile. Replicates the classical *kumo* shibori pattern, but in a more mechanical style and on a limited scale. See also *kumo* shibori, *tegumo* shibori

kodi dana: Decorative cowrie shell motifs used in the fine cotton *bandhani* of Rajasthan, India. Stitching is used to delineate the shapes, which are then resist-dyed.

kokechi: Ancient term for tied or bound resist, which has now been replaced by the term shibori. Examples from the seventh and eighth centuries are found in the Shosoin Repository, Nara, Japan.

koshimaki: Simple sliplike wrap worn by women next to the skin, under traditional Japanese clothing.

kosode: Originally an undergarment during the Heian period, with sleeves and sleeve openings smaller than those of the outer robes (such as the *juni-hitoe*, or twelve-layered kimono). Later it developed into the outer garment and then evolved into the modern kimono.

kozo: Japanese term for paper mulberry, the bast (inner bark) of which is traditionally used for making paper, or for weaving.

kumo ("spiderweb") shibori: Bound-resist process in which precise portions of the fabric are pulled into narrow cone shapes. Thread is wound tightly around each cone from the base to the tip, and then from the tip to the base. Removing the thread after dyeing reveals a circular, spiderweb-like design. See also *kikaigumo* shibori, *tegumo* shibori

kyo kanoko shibori: *Kanoko* shibori done in Kyoto. See also *kanoko* shibori, *hitta kanoko* shibori

kyokechi: Ancient Japanese resist process in which cloth is folded and clamped between a pair of carved wooden boards. Several colors are applied through holes in the boards. Extant examples from the seventh and eighth centuries are found in the Shosoin Repository in Nara, Japan. See also *beni itajime*, fold-and-clamp resist, *itajime* shibori

laharia (*laheria*, *lahariya*): Coiled and bound resist; derives from the Hindi word *lahar*, or "wave." In this unique process, cloth is rolled diagonally, edge to edge, into a coil, then bound in selective areas and passed through several dyebaths to create a complex design of parallel diagonal lines or plaids. *Laharia* is still being practiced in Rajasthan and Gujarat, India.

lamination: Process of uniting two or more materials with a bonding agent, usually heat pressure.

leno weave: Weaving technique in which pairs of warp ends are twisted between each insertion of weft.

lye shrink: *See* cloque

makiage shibori: Process in which each design motif is delineated by stitching, gathering, and binding with a binding thread, giving a distinctive effect of narrow and wide dark lines crisscrossing and radiating out from the heart of each motif.

makinui (overcast stitch) shibori: Process in which a linear chevron pattern is created by using a long needle to stitch fabric with an overcast stitch, picking up the cloth in a circular motion.

mechanical resist: A range of processes in which an additional surface layer such as wax, rice or another starch paste, or a stencil is applied to cloth to block the penetration of dye.

melt-off: Process in which lye solution is used to dissolve the metallic coating on slit-film yarn, leaving behind a transparent cloth. Has been extensively explored by Jun'ichi Arai.

microfiber: Thin synthetic yarn with a count of one denier or less.

mingei: Folk craft movement. (For more information on the *mingei* philosophy, see Soetsu Yanagi, *The Unknown Craftsman*.)

miura shibori: Technique of looped binding invented by one Mrs. Miura of Kyushu and widely practiced in Arimatsu-Narumi.

mokume (wood-grain) shibori: Process in which parallel running-stitches are applied across the width of the cloth and gathered tightly to create a pattern evocative of tree bark or the grain of wood.

mordant: Chemical used to fix natural dye on natural fiber by forming an insoluble compound to increase the fiber's affinity for dye.

muga silk: Silk produced by the wild silkworm *Antheraea assamensis* of the northeastern regions of India, which feeds on the leaves of the trees *Machilus*, *Litsea*, and *Quercus*. Yields shiny brown filaments.

nuet: Term used in northern Africa for simple binding on woven wool and silk cloth. Also, a small fabric sachet of herbs for steeping infusions or tea in hot water.

nui (stitch) shibori: Umbrella term for all shibori processes incorporating any of a wide variety of types of stitching, and in which fabric is then gathered tightly to resist dye.

odhani: This clothing article is primarily used as a shawl or head-covering in western India and is part of a woman's traditional costume, worn with a skirt and blouse. Also sometimes referred to as a *dupatta* or a *chunari*; the *chunari* is always decorated with *bandhani*.

oke (tub) shibori: Traditional shibori process using a tub with lids on the top and bottom. A large design and ground areas are delineated with stitching and then gathered. The stitched outlines are placed along the rim of the tub, and the areas to be protected are stuffed inside the tub. The lids are placed onto the tub with portions of the cloth hanging out, and secured tightly. The entire tub is then immersed in the dye vat.

onikan: Yoruba term used in Nigeria for a shibori method of inserting small objects such as seeds and pebbles inside each tied unit. See also *adire oniko*

orinui (fold-and-stitch) shibori: A method of applying running stitch along a creased fold and gathering it tightly to resist dye.

osage (braid) shibori: Braided and bled shibori.

patola: The famed silk double-ikat weaving from Patan in western India.

pelangi: Malay term for intricately patterned silk shibori textiles found in Indonesia, translated as "rainbow cloth." The motifs are created by extensive stitching, binding, and dyeing in multiple colors.

piliya: Lit., "yellow cloth." Hindi term for a *bandini odhani* dyed in yellow and red and given to a woman when her first child is born, particularly in Rajasthan.

plaiting: Technique that differs from weaving—which has a perpendicular warp and weft—in that it involves interlacing fibers diagonally.

plangi: Western term derived from the Malay textile form known as *pelangi*. The term "plangi" is often used by Westerners to refer to tie-dye in general; however, the original textile found in Indonesia is also decorated with extensive stitching and binding.

polyvinyl chloride (PVC) pipes: Pipes that are polymerized from vinyl chloride monomers and compounded with plasticizers and other additives. PVC pipes for plumbing are the ones used by modern practitioners of *arashi* shibori.

Procion dye: Type of fiber-reactive dye for cellulose fibers, which also dyes silk.

purple dye: During the Nara period, the roots of the *murasaki* plant (*Lithospermum erythroryzon*), which grows wild in Japan, were the source of purple dye, reserved for the garments of royalty. Used today for medicinal purposes rather than as a dyestuff, the dried roots can be purchased in Chinese medicinal herb shops.

PVC: *See* polyvinyl chloride

raffia (raphia): Fiber made from the leaves of a palm tree, *Raphia ruffis* or *Raphia taedigera*, that grows extensively in the tropical forests of Central and West Africa and on the island of Madagascar. The mature leaves can be as long as fifty feet, but only young and tender leaves are used for fiber.

regenerated yarn: Yarn made from a natural source such as wood pulp that is chemically treated to create a new fiber. An example is half-natural, half-synthetic viscose rayon. *See also* synthetic yarn

resist: Technique or material that creates patterns on cloth by impeding dye or pigment from penetrating fabric. All resist techniques are based on the principles of compressing a shaped fabric surface or yarns, or of covering a two-dimensional surface.

rokechi: Ancient term for wax-resist dyeing. Examples from the seventh and eighth centuries are found in the Shosoin Repository in Nara, Japan.

ruche: Pleated, fluted, or gathered strip of fabric used for trimming.

sabada: Diagonally pleated shibori design popular in Nigeria in the 1960s.

safflower dye: See *benibana*

scaffold weaving: Pre-Columbian, Andean weaving comprised of a number of small woven modules, each woven with a continuous warp and weft so that all edges are finished. Since the finished patchwork textile is assembled from modules, it is classified as discontinuous warp and weft weaving.

scouring: *See* degumming

sekka (folded flowers) shibori: Process in which a long piece of cloth is accordian-folded lengthwise and repeatedly reverse-folded into a triangular, square, or rectangular form. This produces a bundle of folded cloth that is then fitted between two boards held in place by a vise or by heavy cords. The exposed edges of the multiple folds absorb the dye, resulting in repeated geometric patterns sometimes resembling snowflakes. See also *itajime* shibori

sericulture: Raising of silkworms from egg to cocoon for the production of silk filaments.

shirokage ("white shadow") shibori: Japanese shibori technique, practiced in Arimatsu, of combining stitching and pole-wrapping to produce a dyed motif on a white ground.

space dyeing: Similar to ikat in that yarns are bound intermittently, enabling dyes of different colors to be applied to them, creating variegated patterns.

stitch resist: See *nui* shibori

sublimation: Evaporation of dye from a solid state, allowing it to move directly from one material to another, as in heat-transfer printing on polyester.

suji (pleats or stripes) shibori: Process in which cloth is pleated, by hand or machine, prior to dyeing, and the ropelike cloth is then bound intermittently to reserve the inside of the pleated folds from dye penetration.

Surface Design Association (SDA): Group founded in 1976 in Kansas City. Its magazine, *Surface Design Journal*, has been in circulation since 1977, and membership has risen over the years to 3,200.

synthetic yarn: Yarn derived from petrochemicals. *See also* regenerated yarn

taiten (accession) shibori: Shibori technique invented in Arimatsu to commemorate Emperor Taisho's accession in 1912. The resist threads are woven in vertically, then pulled to gather the cloth, creating a small all-over pattern. The resist warp threads are removed after dyeing, leaving small, open dots in the cloth.

tan: A 12.9-yard bolt of 14-inch wide kimono cloth. All traditional garments in Japan are made of narrow cloth. The width is determined by the most convenient measure to weave by hand, particularly on the backstrap loom widely used in Japan. The width of the cloth (35.5 cm/14 in.) was standardized during the Kamakura period (1185–1333), likely as an aid to computing quantities of the silk that was exacted as tax.

tegumo ("hand spiderweb") shibori: The original, classic form of *kumo* shibori, done by hand. See also *kumo* shibori, *kikaigumo* shibori

teritik: Malay term referring to a shibori textile or pattern characterized by small white dots created by stitching, practiced in Indonesia.

tesuji (hand pleats or stripes) shibori: *Suji* shibori done by hand.

tritik: Western term referring to "stitch resist" and derived from the Indonesian textile form *teritik*.

tsujigahana: Lit., "flowers at crossing." Name given to a group of textiles that became fashionable during the latter part of the fifteenth through the early seventeenth centuries. Most of the garments (*kosode*, *dobuku*) known from the literature or from surviving examples are silk.

tsutsugaki: Paste-resist dyeing technique in which a tube is used to draw over lines sketched onto fabric.

uchikake: Outer kimono robes.

vat dye: Dyes that are insoluble in water and must be chemically dissolved before they will adhere to fibers; their color develops only when they are exposed to the air or to an oxidizing agent. Vat dyes have a strong affinity to cellulose fibers and silk.

warp: In woven cloth, the lengthwise or vertical element that is threaded into the loom. The warp is composed of many yarns, individually called "ends."

wearable art: Fiber art movement born out of the 1970s milieu to express individuality and demonstrate appreciation of quality craftsmanship and design, expressing a desire for body adornment, freeing art from the museum wall.

weft: Horizontal threads in woven cloth that interwork with warp threads, individually called "shots."

woad: Plant (*Insatis tinctoria*) native to Europe, containing indican, a blue colorant. Was the only source of blue dye available in Europe before the seventeenth century.

yokobiki kanoko (pulled-sideways square ring dot) shibori: Process in which square or rectangular resisted rings are made on a dark ground by hand with a small tool, a bobbin, and cotton binding thread. Developed in Arimatsu as a faster and less costly version of *hitta kanoko*.

yuhata: Ancient Japanese term for shibori, meaning "bound/knotted cloth."

yukata: Traditional casual summer cotton kimono.

yuzen dyeing: Silk painting with paste resist. Multicolored painted paste-resist method developed and refined in Kyoto.

INDEX

現代の絞り染 MEMORY ON CLOTH

2002年4月19日 第1刷発行

著 者 和田良子
発行者 野間佐和子
発行所 講談社インターナショナル株式会社
　　　　〒112-8652 東京都文京区音羽1-17-14
　　　　電話：03-3944-6493（編集部）
　　　　電話：03-3944-6492（営業部・業務部）
　　　　ホームページ http://www.kodansha-intl.co.jp

印刷所　共同印刷株式会社
製本所　牧製本印刷株式会社

落丁本・乱丁本は、小社業務部宛にお送りください。送料小社負担にてお取替えします。なお、この本についてのお問い合わせは、編集部宛にお願いいたします。
本書の無断複写（コピー）、転載は著作権法の例外を除き、禁じられています。

定価はカバーに表示してあります。

© Yoshiko Iwamoto Wada 2002
Printed in Japan
ISBN 4-7700-2777-X